AN AMERICAN COLLECTION

WORKS FROM THE AMON CARTER MUSEUM

AN AMERICAN COLLECTION

WORKS FROM THE AMON CARTER MUSEUM

PATRICIA JUNKER, BARBARA MCCANDLESS, JANE MYERS,

JOHN ROHRBACH, AND RICK STEWART, *authors*

WILL GILLHAM, *general editor*

HUDSON HILLS PRESS, NEW YORK
IN ASSOCIATION WITH THE

AMON CARTER MUSEUM

First Edition

© 2001 by the Amon Carter Museum
3501 Camp Bowie Boulevard
Fort Worth, Texas 76107–2695
817.738.1933
www.cartermuseum.org

Published in the United States by Hudson Hills Press, Inc.
1133 Broadway, Suite 1301
New York, NY 10010–8001

Distributed in the United States, its territories and possessions, and Canada by National Book Network.
Distributed in the United Kingdom, Eire, and Europe by Windsor Books International.

Editor and Publisher: Paul Anbinder

Manuscript Editors: Phil Freshman and Susan Curvin Jones

Proofreaders: Evan A. Bates, Lydia Edwards

Indexer: Karla J. Knight

Designer: David Skolkin

Composition: Angela Taormina

Manufactured in Japan by Toppan Printing Company.

Library of Congress Cataloging-in-Publication Data

Amon Carter Museum of Western Art.
 An American collection: works from the Amon Carter Museum / Patricia Junker
 . . . [et al.], authors; Will Gillham, general editor.—1st ed.
 p. cm.
 Includes bibliographical references and index.
 ISBN: 1–55595–198–8 (cloth : alk. paper)
 1. Art, American—19th century—Catalogues. 2. Art, American—20th century—
 Catalogues. 3. Art—Texas—Fort Worth—Catalogues. 4. Amon Carter Museum of
 Western Art—Catalogues. I. Junker, Patricia A. II. Gillham, Will. III. Title.

N6510 .A65 2001
709′73′0747645315—dc21

 2001024472

Contents

ACKNOWLEDGMENTS

Any publication of this scope and magnitude involves the devoted contributions of a host of collaborators. As director of publications for the Amon Carter Museum, and on behalf of its curators and director, I am pleased to recognize here those whose kindness and assistance were essential in bringing this book to completion.

My gratitude goes first and foremost to the museum's namesake, Amon G. Carter. Were it not for Mr. Carter's generosity, philanthropic principles, and love of fine art—and for the determination of his daughter Ruth Carter Stevenson in making his wishes manifest—this remarkable institution would not exist.

The following institutions, organizations, and individuals granted permission to reproduce the various works herein for which they hold copyright: Robert Adams/Fraenkel Gallery; Aperture Foundation, Inc./Paul Strand Archive; Artists Rights Society/Estate of Alexander Calder; Artists Rights Society/Estate of Louise Nevelson; Keith Carter; Linda Connor; Robert Frank/Pace/MacGill Gallery, New York; the late Jacob Lawrence; Abelardo Morell/Bonni Benrubi Gallery; the Georgia O'Keeffe Foundation; Estate of Paul Outerbridge, Jr./Courtesy G. Ray Hawkins; Gordon Parks; Estate of Peter Sekaer; Aaron Siskind Foundation/Robert Mann Gallery; VAGA, New York, NY/Estate of Stuart Davis; and VAGA, New York, NY/Estate of David Smith.

This book also profits greatly from extensive research on the collection conducted over the years by the distinguished scholars of American art who have served on the museum's curatorial staff, including Linda Ayres, Kathleen Bennewitz, Doreen Bolger, Sarah Cash, Carol Clark, Peter H. Hassrick, Carol Roark, Martha A. Sandweiss, Thomas Southall, and Ron Tyler. For their technical analyses of a number of paintings represented in these pages, I am indebted to Claire Barry, chief conservator of paintings, and Isabelle Tokumaru, associate conservator of paintings, both of whom occupy the laboratory jointly maintained by the Kimbell Art Museum and the Amon Carter Museum. Holly Krueger, senior paper conservator at the Library of Congress and co-owner of Krueger Art Conservation, Inc., Alexandria, Virginia, thoroughly researched various subtleties of media and technique in numerous works. Thomas E. Hill, art librarian at Vassar College Art Library, Poughkeepsie, New York, and Glenda Stevens, senior archivist at Texas Christian University, Fort Worth, expediently answered vital research queries. At an early stage, Paul Anbinder, president of Hudson Hills Press, demonstrated an earnest and determined interest in producing and distributing this

book. His editor Phil Freshman (assisted by Susan C. Jones) applied a learned and practiced hand to the manuscript, and designer David Skolkin dressed the volume elegantly.

Finally, I wish to recognize those on the museum's staff who worked resolutely on behalf of this publication. Director Rick Stewart and Associate Director Bob Workman were effective proponents of the book, eagerly supporting its development. Publications Assistant Miriam Hermann was an exceptional right hand, precisely inputting edits and maintaining an organized approach. Editor Peter Keefe culled answers to editorial queries from the stacks and lent his careful proofreader's eye to the typeset pages. Photographers Rynda Lemke and Steven Watson demonstrated yet again the art of producing exceptional transparencies for reproduction; the latter also brought a much appreciated pragmatism to the project and oversaw the printing of the book. Assistant Curator of Paintings and Sculpture Rebecca Lawton proved to be an excellent eleventh-hour research asset, and Curatorial Associate Helen Plummer harvested information from a myriad of artist files and helped write a number of the biographies. Collections Database Manager Geoffrey Dare and Collections Research Assistant Tamara Wootton-Bonner attentively reviewed the complexities of object information. Registrars Melissa Thompson and Courtney DeAngelis gracefully cleared the way for all permissions and copyrights of works that are reproduced here. Installation and Design Coordinator Tim McElroy, along with Preparator Fran Baas, greatly facilitated the curators' research in the vaults. Acting Librarian Sam Duncan, with Karin Strohbeck and Alice Frye, procured many interlibrary loans for the authors. Archivist Paula Stewart responded quickly and efficiently to a steady stream of requests for information from the museum's records. Curatorial Administrative Assistant Jane Posey supplied research support to the curators. Finally, Mary Jane Harbison, Angela Castillo, and Sandy Schneider provided critical production assistance to the department of publications.

The Amon Carter Museum is committed to serving an educational role through publications devoted to the study of American art. This volume is representative of the museum's endeavors to fulfill that ongoing mission.

WILL GILLHAM
Director of Publications
April 2001

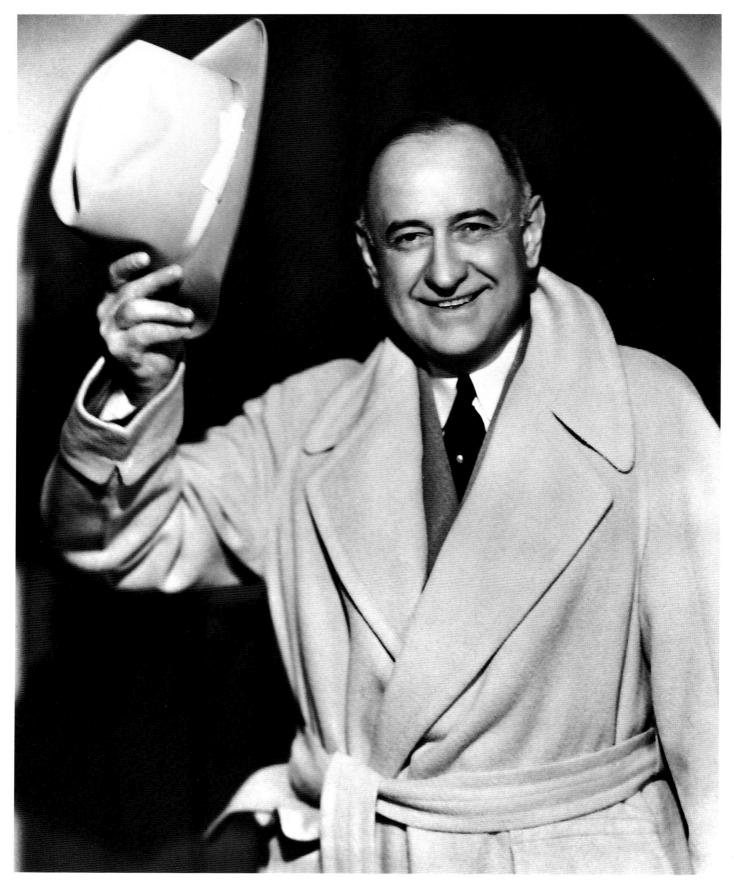

Amon G. Carter, ca. 1938.

Rick Stewart

"AS A YOUTH, I WAS DENIED THE ADVANTAGES which go with the possession of money," Amon G. Carter wrote in his last will and testament, made public after his death in 1955. "I am endeavoring to give to those who have not had such advantages, but who aspire to the higher and finer attributes of life, those opportunities which were denied to me."

Carter's lifetime of philanthropy grew out of his humble beginnings and self-made rise to success. Born in 1879 in a log cabin in Wise County, Texas, he quit school at age eleven and showed early ambition by working at a series of jobs in the small town of Bowie, northwest of Fort Worth. One of his enterprises involved selling chicken sandwiches to passengers on the Fort Worth and Denver train during its daily stop in town. In his early twenties Carter became a traveling salesman for the American Copying Company, a Chicago-based firm that specialized in oil-colored photographic portraits. Within a year he rose to the position of national sales manager, working in the company's San Francisco office. While there, he developed a philosophy for his corps of traveling salesmen based on his homegrown concept of "strong talk." "It is not what you say to a man that impresses him, but the way you say it," he wrote. "Never lose your nerve, get discouraged or homesick, and never give up the ship." For Amon Carter, this was a lifelong credo.

In 1904 Carter began working for a San Francisco advertising firm, and a year later he turned down lucrative job offers there to move back to his native state. He settled in Fort Worth, where he established a one-man business that he named, in rather grandiose fashion, the Texas Advertising and Manufacturing Company. His astute business sense led to his being hired as advertising manager for the *Fort Worth Star*, a new and independent newspaper to rival the *Fort Worth Telegram*. He soon became the paper's business manager, selling peaches from his small farm in order to help support its struggling operations. In 1908 Carter convinced an investor to buy the rival newspaper, and the two were combined into the *Fort Worth Star-Telegram*, with Carter serving as both its business and advertising manager. Now his talents for initiative and salesmanship made themselves felt. Over the next few

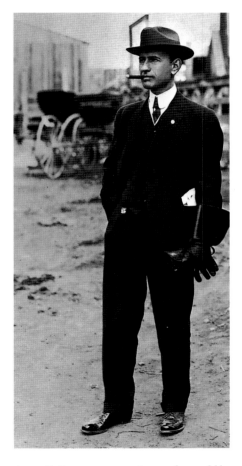

Amon G. Carter, ca. 1910. In 1911 he would be instrumental in bringing the first airplane to Fort Worth, beginning a lifelong involvement in the development of America's aviation industry.

9

years, he devised a marketing approach characterizing the arch-rival city of Dallas as part of "East Texas" and Fort Worth as the place "Where the West Begins." Under his direction, the energetic newspaper staff fanned out over the ninety-odd counties that constitute the western half of Texas to consolidate the reputation of the *Star-Telegram* and Fort Worth as the region's true representatives.

From this point onward, Carter was Fort Worth's leading citizen and champion. He was a consummate entrepreneur, always quick to take advantage of new opportunities. In 1911 he became the youngest individual to serve as president of the Fort Worth Chamber of Commerce. Around the same time, he was instrumental in bringing the first airplane to the city (on a railroad flatcar), beginning a lifelong involvement with the development of America's aviation industry. As vice-president and general manager of the *Star-Telegram*, he visited other cities in the country to entice their prominent citizens either to relocate to his adopted city or invest in its growing potential. His efforts were bolstered and the city's fortunes given a major boost when oil was discovered in 1917 on a farm in West Texas. That same year, in the low hills west of the city, the U.S. Army established Camp Bowie, a training facility for World War I recruits. Three years later Carter was elected president of the Fort Worth Club, an organization founded in 1885, and immediately began raising funds to erect a twelve-story, $2-million structure to serve as the club's new home. In 1922 he established radio station WBAP (motto: "We Bring A Program"), the first in Fort Worth.

Carter was named president and publisher of the *Star-Telegram* in 1923. The newspaper had actively lobbied for "a great state college on the plains" to serve the people of West Texas. In Carter's first year at the helm, Texas Technical Institute (now Texas Tech University) was founded in Lubbock, with Carter as the first chairman of its board of trustees. He purchased 780 acres along the shores of Lake Worth (created in 1914 by the damming of the West Fork of the Trinity River), built a house and outbuildings on the site, and named the property Shady Oak. Over the next thirty years, some of the world's richest and most famous people visited him there. Carter became legendary for his hospitality. He developed the habit of presenting his guests with a short-brimmed Stetson that he dubbed the "Shady Oak hat." If a visitor already had a hat, Carter confiscated it for his own collection. He also nurtured a keen interest in the preservation and presentation of the frontier history of which he felt he had been a part, installing artifacts and historic buildings on his property as a kind of open-air museum that he would enthusiastically show to all who visited.

Among Carter's frequent guests at Shady Oak was the humorist Will Rogers (1879–1935), whose nationally syndicated daily newspaper column appeared in the *Star-Telegram*. The two had met in 1918, when Rogers was a stage performer in New York City. They became fast friends, and whenever they were together the question arose as to who upstaged whom. On the bottom of a photograph taken in the late 1920s showing the tight-lipped men looking into the camera, Rogers wrote, "Amon—this is a remarkable photo—it caught us both not talking." As the Depression years began taking their toll, Rogers crisscrossed the country raising money for the American Red Cross, frequently with Carter's help. "No other city in America has anything approaching such a public citizen as Amon Carter," Rogers said of his friend. Carter's feelings for the Oklahoman ran deeper still. "He likes people," he told one reporter. "His nature overflows with kindness and tolerance. The most striking characteristic in Will's nature, to my mind, is his genuine sincerity. I do not think it too much to say that Will Rogers is our most outstanding American."

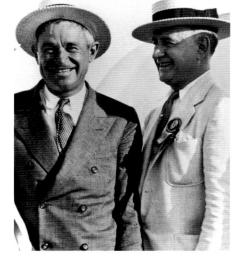

"I do not think it too much to say that Will Rogers is our most outstanding American," Carter once said of his dear friend. The two were photographed together many times; this image was taken ca. 1930.

FREDERIC REMINGTON (1861–1909)
His First Lesson, 1903
Oil on canvas
27¼ × 40 in. (69.2 × 101.6 cm)
1961.231

Besides mutual admiration for their accomplishments, the two men shared a fascination with the fledgling aviation industry. In 1934 Carter became involved in the creation of American Airlines, successfully lobbying for its air-transportation offices to be headquartered in Fort Worth. Two years earlier, he and Rogers had been among the first to make reservations for the inaugural flight of the Pan American Clipper, which was scheduled to take passengers from San Francisco to Hong Kong and back in 1936. But tragedy intervened: on August 15, 1935, Rogers and the pioneering aviator Wiley Post were killed in a plane crash at Point Barrow, Alaska. A grieving Carter served as Texas' fund chairman for the Will Rogers Memorial Commission, which raised money in Rogers' name for crippled and underprivileged children. In an editorial for the *Star-Telegram*, Carter urged his city and state to "lead the nation in per capita contributions," and Texas generated more funds than any other state.

Carter always maintained that it was Will Rogers who primarily sparked his interest in the work of the two greatest artists of the American frontier, Frederic Remington (1861–1909) and Charles M. Russell (1864–1926). Rogers and Russell had been close friends, and Rogers' admiration for the Montana artist's work was boundless. At the same time, Carter was very familiar with the notable collection of Remington's work that had been formed by one of his political allies in Houston, William C. Hogg. In 1935, shortly before Rogers' death, Carter made his first documented art purchases: a lively Remington oil painting, *His First Lesson* (1903), and a group of nine Russell watercolors. Although Carter had to take out a bank loan to buy these works, his fortunes were about to change. That same year, after drilling more than ninety dry holes in West Texas and New Mexico, he struck oil; two years later,

he was even more successful with the discovery of the famed Wasson pool in Gaines and Yoakum Counties. His collecting activity increased, and he learned to seek the advice of those who were knowledgeable about his two favorite artists. One of his closest advisors in such matters was the Texan Cyrus Rowlett ("C. R.") Smith (1899–1990), president of American Airlines, who lived in New York City. Smith, a shrewd and discerning man, was himself an avid collector, and Carter grew to rely on him for direction, especially when it involved judgments of quality or authenticity.

In 1941 Smith purchased the estate of Charles M. Russell's widow, Nancy Cooper Russell (1878–1940). Carter himself had been thinking for some time about how he could best utilize his increasing wealth to benefit the city that had helped nurture his rise to success. "Amon started low and ended high," Smith later recalled, "[and] while much of that came as a result of his own application of ability and energy, much of it also came from the willingness of the community to recognize his ability. For that, I am sure, he had gratitude." In 1945 Carter established the Amon G. Carter Foundation as a nonprofit corporation to further charitable, religious, and educational undertakings throughout the region. At the same time, he continued his activities on behalf of West Texas by becoming president of the Texas Big Bend Park Association, a group that would eventually get that area designated as a national park. Always, though, his collecting was of paramount interest to him, and he was coming to important conclusions regarding the future of his art holdings. *Time* magazine reported that he paid a record price for the Remington masterwork *A Dash for the Timber* (1889, p. 127), which had been in the collection of Washington University in St. Louis. The following year he bought a portion of the Nancy Russell estate from Smith, telling him that he was "working out a collection for a Remington and Russell museum." The quality and importance of his purchases became primary objectives; he acquired a number of highly important Remington and Russell paintings, sculptures, watercolors, and drawings from several notable sources, including Russell's stepmother,

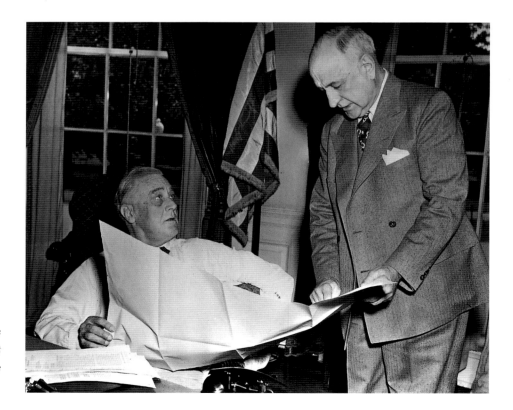

Amon G. Carter, then president of the Texas Big Bend Park Association, presents President Franklin D. Roosevelt with the deed to the 800,000-acre park, 1944.

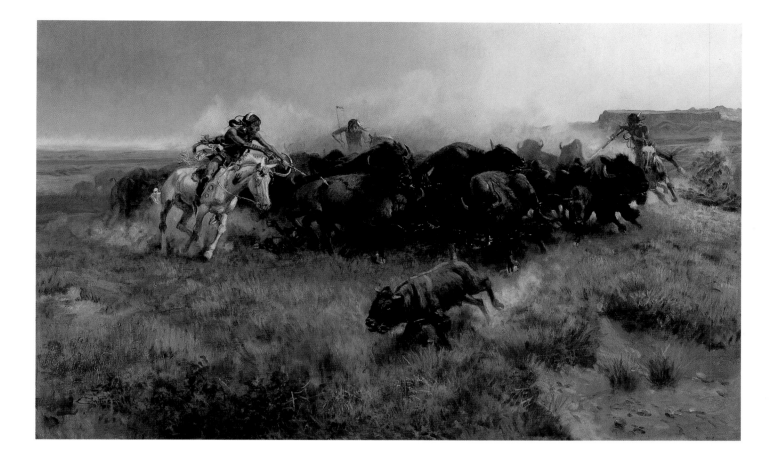

CHARLES M. RUSSELL (1864–1926)

The Buffalo Hunt [No. 39], 1919

Oil on canvas

30⅛ × 48⅛ in. (76.5 × 122.2 cm)

1961.146

Florence M. N. Russell, and the collector Sid W. Richardson. In 1948 he obtained a painting that had special significance, Russell's great *Buffalo Hunt [No. 39]* (1919). It had been a prized possession of Will Rogers.

By 1949, when the city of Fort Worth celebrated its centennial, the idea of a public art museum housing his collection was fully formed in Amon Carter's mind. He told Harold McCracken—founding director of the Whitney Gallery of Western Art and the Buffalo Bill Historical Center, and one of the experts who was helping him find important works—that he hoped to carry the plan through himself. Other endeavors, however, afforded him little time to devote to the project. Still, he managed to continue his program of insightful acquisitions, which included significant libraries comprising rare books on the two western artists and volumes that contained examples of their illustrations. On October 3, 1950, Carter wrote W. O. Jones, the city manager, to announce: "It is my purpose to erect and equip a museum and present it to the city of Fort Worth. There will be approximately 150 to 200 Charles M. Russell and Frederic Remington paintings, watercolors, and bronzes. Those now on hand and others should make it one of the finest collections of its kind to be found anywhere." Carter requested that the city council designate a high point of land west of the city, bounded on the north by Camp Bowie Boulevard and on the south by Lancaster Avenue, as the future location for the museum. Within ten days, the council complied with his request.

After this, Carter redoubled his collecting efforts, even as his health began to fail. In 1953 he suffered a series of heart attacks, and on June 23, 1955, he died at his Fort Worth home. His thirty-two-page will provided for the establishment of a museum devoted to American art—a museum that he would never see. "I have learned while climbing the steep path of fortune and I have come to realize that they who acquire wealth are more or less stewards in the

application of that wealth to others of the human family who are less fortunate than themselves," he wrote. "I desire and direct that this museum be operated as a nonprofit artistic enterprise for the benefit of the public and to aid in the promotion of the cultural spirit in the city of Fort Worth and vicinity, to stimulate the artistic imagination among young people residing there."

Carter's words also alluded to his view of himself as "part of the heritage of Texas," a member of the pioneer strain "that peopled the wide spaces and laid the foundations of a happy future." C. R. Smith believed that this was one of the principal reasons why Carter had begun collecting in the first place. "I very much doubt that Amon was interested in art, *per se*," he wrote Carter's daughter, Ruth Carter Stevenson, nearly ten years later.

> Rather, he looked upon the paintings by Russell and Remington as pictorial history, the history of a time and section with which he was acquainted and for which he had lasting affection. He understood the pioneer, he believed that he contributed to the good of the community and he wanted a preservation of his history. He could as well have been interested in books, documents, and manuscripts about the same time and section, but he believed, rightly in my opinion, that pictures would do better; would be better understood and more readily appreciated.

Following Carter's death, the Amon G. Carter Foundation and members of his family laid plans for the museum. The architect chosen for the task was Philip Johnson (b. 1906), who in 1950 had designed the Museum of Modern Art annex in New York City and, three years later, its Abby Aldrich Rockefeller Sculpture Garden. In December 1958 Johnson wrote a foundation board member that he was visualizing "a timeless classicism, and I feel you will like the approach." The resulting design, with its classically styled portico that afforded a broad view of downtown Fort Worth, was indeed suggestive of ancient temples and Renaissance loggias. Its primary materials were a creamy limestone infused with fossil shells from a quarry near Austin; a pink and gray-flecked Maine granite; large panels of beautifully figured, book-matched Burmese teak; and a sharp-edged yet richly colored and softly finished extruded bronze. On presenting the design, Johnson commented that although the structure would comprise a relatively small twenty thousand square feet, its setting would be large. He advanced a plan for a series of terraces and broad steps extending from the building's east front, with an expansive sunken, grassy plaza as a centerpiece. Inside the elegant building, which had the appearance of a memorial, the architect arranged a series of small galleries emanating from a larger open space that rose to the full height of the building. Here Amon Carter's collection, consisting of some four hundred works by Frederic Remington and Charles M. Russell, opened to the public on January 21, 1961.

From the beginning, the foundation and the Carter family intended the museum to be a vibrant institution. Not only would the collection grow, but the mission would evolve as well. Instead of serving only as a Remington and Russell repository, the museum would expand to encompass works by other artists who depicted the American West. Within a few years this vision was modified to include American art as a whole, for the museum's first director, Mitchell A. Wilder, believed that the history of American art could be interpreted as the history of artists working on successive frontiers. As a result, the holdings grew in fascinating ways. Wilder and the museum's trustees realized at the outset that it was nearly impossible to assemble a comprehensive col-

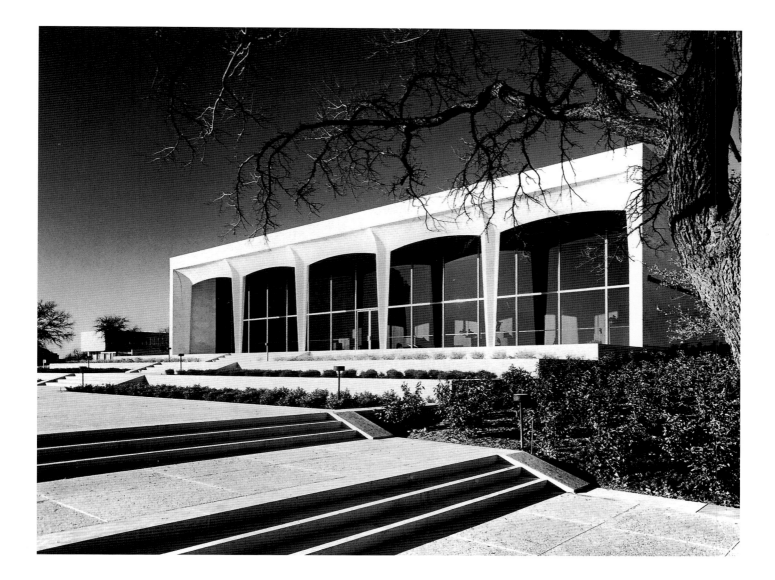

The Amon Carter Museum in 1961, its inaugural year.

lection of American art at such a late date, so they opted for quality over quantity. One trustee, René d'Harnoncourt, explained that the desired works should represent "stepping stones" in the history of American art, major pieces that not only revealed the high points of an artist's career but that also summarized the essential elements of a broader artistic style. Although funds were limited in those early years, Wilder and the trustees managed to acquire a number of important works. Significantly, the acquisitions were not limited to paintings and sculpture. Watercolors, drawings, prints, photographs, and books were added yearly, and the total number of objects greatly increased. By 1986, when the museum celebrated its twenty-fifth anniversary, its holdings comprised nearly sixty-four hundred works of art, not including photography. The photography collection itself had grown to more than a quarter-million objects, making it one of the nation's most important collections.

As the institution's permanent collection evolved, so did its programs. Not long after opening its doors, the museum presented the first of many staff-organized special exhibitions. These exhibitions were often accompanied by catalogues, some of which were full-length treatments of a given subject. Over the years, the museum achieved a notable reputation for the quality of its exhibitions and publications as well as for the interdisciplinary and scholarly approach that it brought to its subjects. From the start, the institution was a pioneer in the field of western studies and is now recognized for its significant

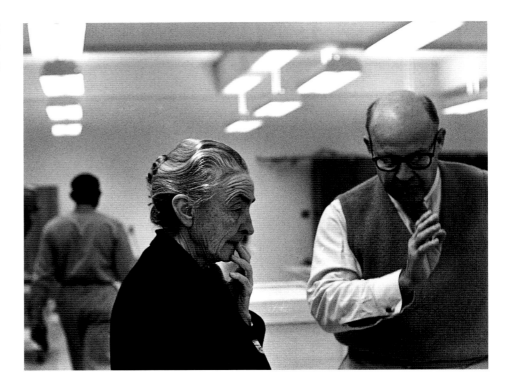

contributions to the study of American art. An important part of this endeavor was the continuous growth of the library. From Amon Carter's original bequest of some four thousand volumes, the library today encompasses nearly ten times that number, supplemented by an extensive range of microforms and electronic resources. With the advent of the digital age, the museum is carrying its programs into a new century, where the boundaries of learning seem as limitless as the American frontier did two centuries ago.

Although the Amon Carter Museum's collections and programs greatly expanded between the 1960s and the 1990s, its physical spaces did not keep pace. A modest addition was built in 1964, enabling both floors of Philip Johnson's 1961 structure to contain galleries for the display of art. In 1977 a more ambitious addition opened, designed by Johnson and his partner John Burgee. It comprised spaces for a library, theater, offices, and care of the collection, but the need for new galleries was left unmet. Meanwhile, the collections continued to increase, and the staff was forced to pass up important traveling exhibitions or cut down their size due to limited room. In 1995 the trustees decided to act. A fresh plan was approved that called for expanded facilities. Philip Johnson reviewed the plan and began developing a design for a wholly new structure, situated behind the original 1961 building, that would replace the 1964 and 1977 additions. Although considerably larger, this building would act as a backdrop to the older structure when viewed from the front. As such, the new addition would be sheathed in a richly colored, dark brown granite to offer an appealing contrast to the cream-colored shell stone of the 1961 edifice. But the main objective of the design was to increase gallery space for the permanent collection as well as to provide adequate areas for the presentation of traveling exhibitions.

The Amon Carter Museum closed to the public in August 1999. The staff and collections were moved to a temporary facility, and over the course of the next twenty-two months Johnson's design was implemented, adding ninety thousand square feet to the museum. Central to the expansion is the creation of twenty thousand square feet of additional gallery space, bringing the total

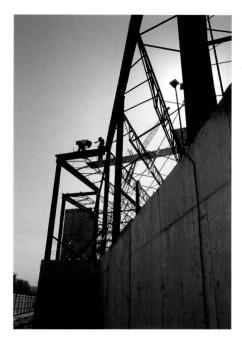

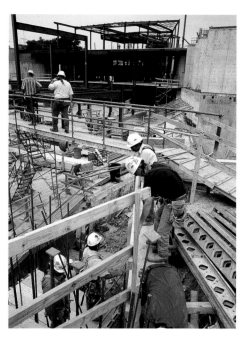

For the first extended time in its forty-year history, the Amon Carter Museum closed to the public in August 1999. Over the next two years, architect Philip Johnson's design for the expanded facility was implemented. Rising up behind his original 1961 building, which remains intact, the new structure increases the institution's size by nearly 50,000 square feet.

Top left: Ironworkers assemble the steel framework for the north wall. Including the basement level, the new museum facility has four floors and includes a paper conservation lab, both cool- and cold-storage vaults, and a 160-seat auditorium.

Top right: Hundreds of tons of concrete and earth were extracted to expand the footprint of the new facility. The museum tripled its gallery space, and its library now offers a teak-lined reading room equipped for graduate-level study.

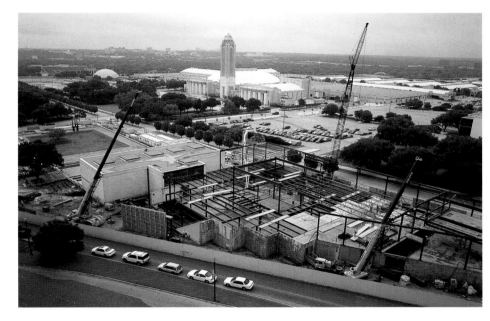

Middle: A bird's-eye view of the construction site. The museum occupies a hilltop in Fort Worth's Cultural District. The portico of the 1961 building (at left) faces east, looking out over the neighboring Kimbell Art Museum and Modern Art Museum of Fort Worth to the city beyond.

Lower left: The supporting structure for the atrium staircase required a continuous pour of thirty-five tons of concrete into an elaborate wooden form—a rare procedure in an age of prefabricated standard metal molds.

Lower right: An ironworker welds a steel spar into the framework of the vaulted lantern. This dome covers a 1,600-square-foot expanse, and the finished ceiling rises fifty-five feet above the atrium floor.

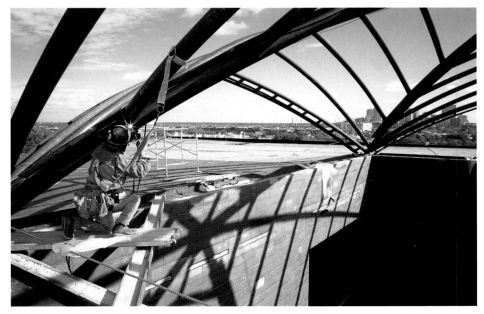

to nearly thirty thousand square feet and allowing the museum to display four times more art than it could previously. The museum's notable features now include a 160-seat auditorium, complete with advanced distance-learning technology; a library with enhanced facilities for scholars, students, and the general public; climate-control systems for both cool and cold photography storage; and a greatly expanded museum store. Additionally, Johnson and his associate Alan Ritchie helped create state-of-the-art spaces for the continuing care of the collection, to ensure its vitality well into the new century.

For the first time in its history, the Amon Carter Museum is able to exhibit the full breadth of its permanent collection in galleries specially designed for optimal viewing. Because most of the museum's holdings are works on paper, many of these galleries will host new arrangements of objects three or four times a year. Visitors to the museum can now view stellar examples from every area of the collection. There are spacious galleries devoted to photography, where viewers can see landmarks in the history of that medium as well as works that stretch its boundaries. Intimate galleries devoted to works on paper allow visitors to relish the touch of a watercolor stroke, the expressive lines of a drawing, or the rich tones of a print. Expansive spaces showcase the museum's famed paintings and sculpture, a stunning travelogue of American art. And at long last, Amon G. Carter's beloved collection of art by Remington and Russell—the most significant holdings of their works to be found anywhere—is on full view in the newly refurbished ground-floor galleries of the 1961 building. In the upper galleries, visitors encounter numerous works by artists of the American West in a rotating series of small exhibitions representing various themes.

Finally, throughout the museum visitors can now be introduced to works they have never seen before. During the two-year construction period, the staff was busy not only planning the new installations but also acquiring important objects. Every area of the museum's collection has been enriched. Alongside major works familiar to many people, these pages reveal for the first

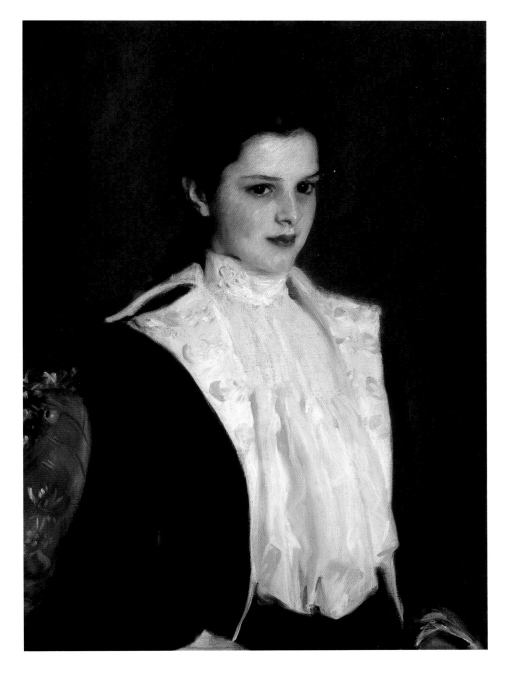

JOHN SINGER SARGENT (1856–1925)
Alice Vanderbilt Shepard, 1888
Oil on canvas
30 × 22 in. (76.2 × 55.9 cm)
1999.20

time landmark additions by the painters Stuart Davis, Marsden Hartley, and John Singer Sargent; the sculptors Alexander Calder, Louise Nevelson, and David Smith; the photographers Robert Adams, Linda Connor, and Alfred Stieglitz; and the great daguerreotypists Albert Southworth and Josiah Hawes, among many others.

As the newly reopened museum enters the twenty-first century, it is well to remember Amon G. Carter's life and accomplishments, because his vision made this all possible. He truly is part of the heritage of Texas and of the nation—and so, too, is the museum that bears his name.

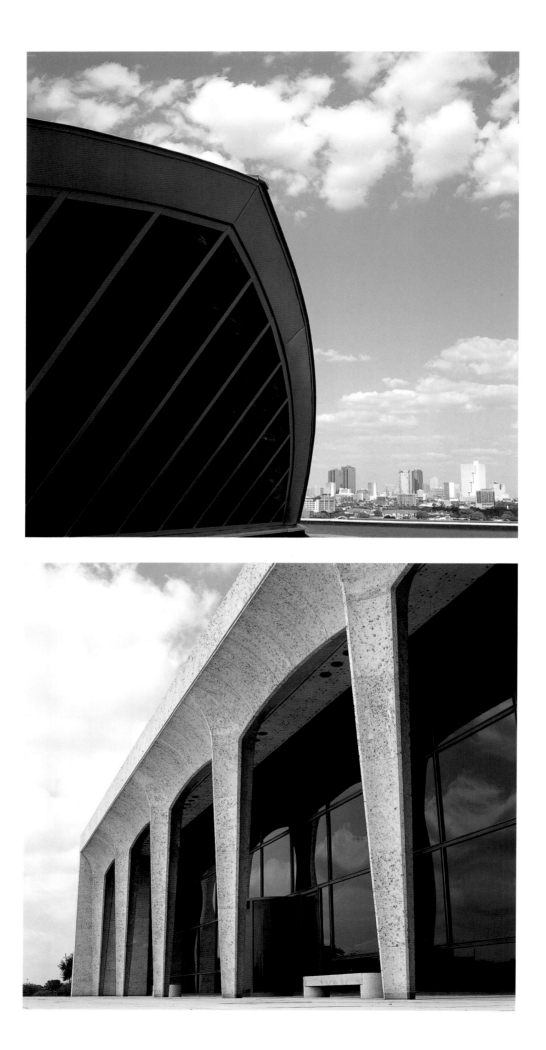

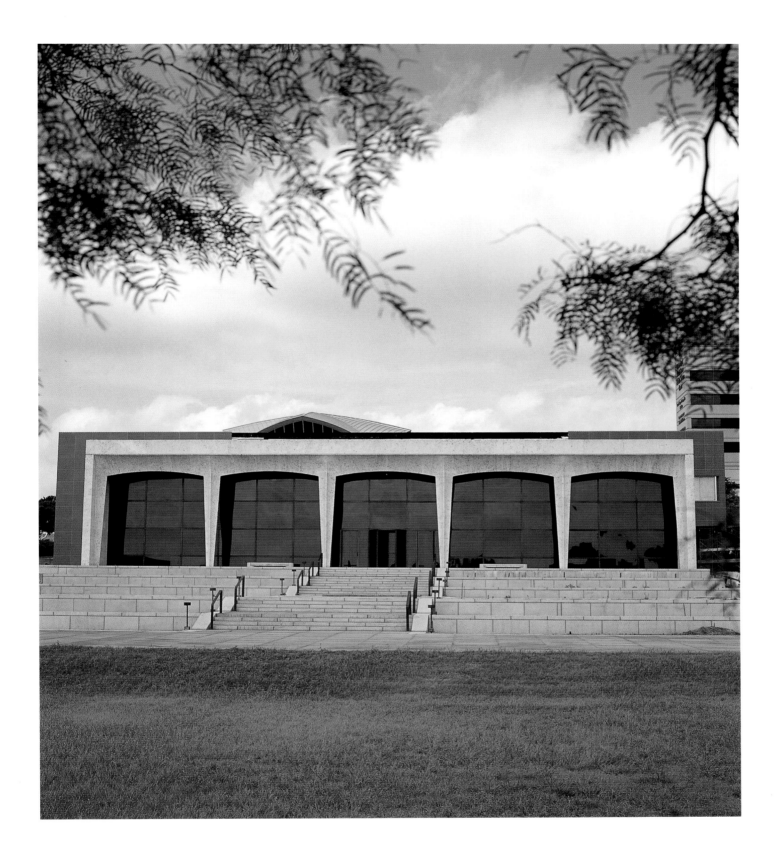

The principal components of the new Amon Carter Museum consist of a rare and complex Narjan granite, quarried in Saudi Arabia and fabricated in Italy, which covers the 2001 addition; Texas shell stone, excavated near Austin, which lines the new atrium and matches the stone of the 1961 building; beech, which finishes out the walls of the new auditorium; extruded bronze for all the doorjambs, handrails, and window mullions and frames; and book-matched Burmese teak, which encases the library reading room, the main gallery in the 1961 building, and the new members' lounge.

 As this publication went to press, shortly after this photograph was taken, the Amon Carter Museum was five months away from completion and its grand reopening.

A Note on the Catalogue

This catalogue is chronologically organized. Two or more works produced during the same year are alphabetically ordered by artist name. Where several works were begun in a given year and finished later, the one completed earliest appears first. Similarly, a work assigned an approximate date (e.g., "ca. 1941") follows one known to have been made in that year.

Sculptures are sequenced by model or design-copyright date where that date precedes the year when the cast was made. Photographs are dated according to the year when the given image was made rather than when it was printed.

Height precedes width in measurements for paintings, works on paper, and photographs; frame dimensions are not included. Height, width, and depth dimensions are provided for sculptures.

The abbreviation q.v. (for *quod vide*, which see) follows the name of any artist represented by a complete entry elsewhere in the catalogue. The reader can readily locate specific works and artists by referring to the Index. All works in this catalogue are in the collection of the Amon Carter Museum, Fort Worth, Texas.

Authors' names are abbreviated as follows:

Patricia Junker	PJ
Barbara McCandless	BMC
Jane Myers	JM
John Rohrbach	JR
Rick Stewart	RS

AN AMERICAN COLLECTION

WORKS FROM THE AMON CARTER MUSEUM

John Hill (1770–1850) for
WILLIAM GUY WALL
1792–after 1864

View near Hudson, 1822, from the *Hudson River Port Folio*, 1821–25

Etching and aquatint with watercolor on wove, cream paper; plate: 14 × 21 in. (35.6 × 53.3 cm); sheet: 18⅝ × 25¾ in. (47.3 × 65.4 cm)

Signed, dated, and inscribed, lower left, in plate: *Painted by W. G. Wall.*; lower right, in plate: *Engraved by J. Hill.*; lower center, in plate: *VIEW NEAR HUDSON. / N°:15 of the Hudson River Port Folio. / Published by Henry I. Megarey New York.*

1967.194.13

The obscure Irish watercolorist William Guy Wall would never have achieved fame without the mastery of John Hill, the most important engraver working in America in the first decades of the nineteenth century. Hill had distinguished himself in London with his aquatints of works by J. M. W. Turner (1775–1851) and others. In Philadelphia he produced this country's first quality aquatints, Picturesque Views of American Scenery *(1819–21), after paintings by Joshua Shaw (1777–1860). When the publisher Henry Megarey realized the potential of Wall's proposed pictorial survey of scenery along the Hudson River, he wisely turned to Hill to produce impressive plates. With the success of the* Hudson River Port Folio, *Wall achieved notoriety as a painter, becoming a founding member of the National Academy of Design in New York City and exhibiting frequently both there and at the Pennsylvania Academy of the Fine Arts in Philadelphia. Wall eventually returned to Ireland, where he faded into obscurity. Hill continued to produce masterly prints and trained his son, John William Hill, who became one of the leading watercolorists in America.*

ALTHOUGH WE ARE OFTEN QUICK TO IDENTIFY Thomas Cole [q.v.] as the founder of America's landscape school after 1825, it was William Guy Wall who earlier laid much of the foundation for the art and ideas of Cole and others who followed. Wall's *Hudson River Port Folio*, as engraved by John Hill, is a landmark work, one that helped stimulate interest in American scenery, among both artists and art patrons, and offered a compositional formula for picturesque and sublime views that others enthusiastically adopted. Moreover, the *Port Folio* still stands today as an extraordinary technical achievement.

Wall, an Irish-born topographical painter, set out in the spring of 1820 to travel the length of the Hudson, painting watercolor views along the two-hundred-mile course from Luzerne, just south of Lake George, to Governor's Island, off Manhattan. He projected an ambitious American landscape survey and had acquired the support of the New York publisher Henry Megarey. In 1821 Megarey announced to potential subscribers the planned release of plates engraved from Wall's watercolors. John Hill, a master engraver, was put in charge of the project, and over the next four years he produced twenty magnificent plates, the largest prints made in America to that time. He worked in aquatint, an etching technique that affords broad tonal effects, ideal for replicating watercolor washes. Hill oversaw the hand coloring of the prints as well, working from Wall's originals to realize luminous pictures with crisp foreground details and atmospheric distances. The *Hudson River Port Folio* proved to be so popular that it was reissued in subsequent editions, under other publishers' imprints, long after Megarey's first successful sets were completed in 1825.

This panoramic view of a broad stretch of the river near the town of Hudson conforms perfectly to eighteenth-century British landscape conventions. The picturesque scene is nicely framed by trees at left and right. The spectator seems to stand upon a high point, looking down onto a wide, mirrorlike expanse of river and beyond to the gentle contours of the Catskills. All is serene and lovely. Wall's choice of this site for one of his most beautiful vistas was prescient, for it was at this very spot that Thomas Cole and Frederic Church [q.v.]—painters who are today synonymous with the nineteenth-century Hudson River School—established their homes. Cole's "Cedar Grove" still stands on the west bank of the river here, and Church's grand residence, "Olana," is just opposite, outside Hudson, on a hilltop overlooking the town of Catskill.

PJ

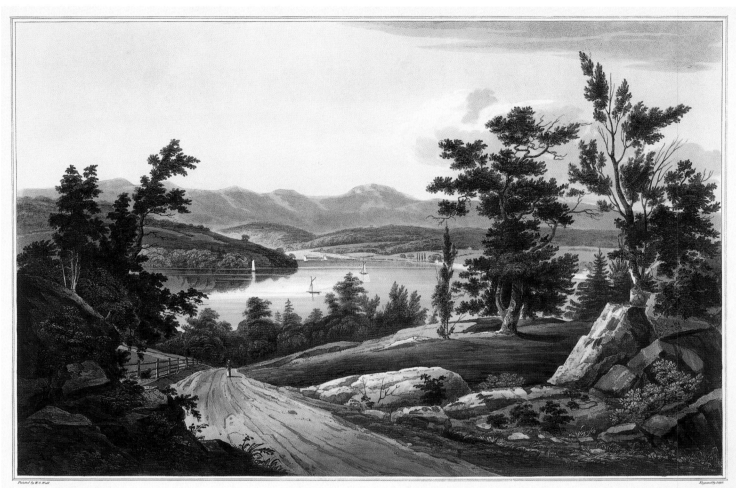

Painted by W.C. Wall. Engraved by I.Hill.

VIEW NEAR HUDSON.

N.º 15 of the Hudson River Port Folio.

Published by Henry I. Megarey New York.

William Home Lizars (1788–1859) for
JOHN JAMES AUDUBON
1785–1851

John James Audubon lived an extraordinary life. Although he claimed to have been the Bourbon Dauphin, he was in fact born to a French naval captain and his paramour in Santo Domingo (now Haiti). Raised in Nantes by his father, Audubon was only eighteen when he was sent to America in 1803 to manage a family farm in Pennsylvania. After he married and left the farm, he failed at various occupations—merchant, taxidermist, drawing instructor—always moving about on the western frontier. Sometime around 1820 he formulated his plan to document for publication all the birds of America. This enterprise took him down the Ohio and Mississippi Rivers to Louisiana, across the South, through the Northeast, and into Labrador. He published an account of his adventures, along with his scientific notes, as an Ornithological Biography, *completed in 1839. Audubon never surpassed* The Birds of America, *but he did produce a compendium of mammals,* The Viviparous Quadrupeds of North America, *completed in 1848. He died at his home just north of New York City in 1851. The first Audubon Society was founded thirty-five years later.*

—VULGO (WILD TURKEY–) Meleagris Gallapavo, 1826, from *The Birds of America*, 1827–38

Engraving with watercolor on wove, off-white paper; plate: 39 × 26 in. (99.1 × 66 cm); sheet: 39½ × 26¼ in. (100.3 × 66.7 cm)

Signed and inscribed, lower left, in plate: *Drawn by J. J. Audubon M.W.S.*; lower right, in plate: *Engraved by W. H. Lizars Edin^r.*; lower center, in plate: *Great American Cock Male—VULGO (WILD TURKEY–) Meleagris Gallapavo*; top center, in plate: *PLATE I.*

1965.24

AUDUBON SELECTED HIS GREAT IMAGE of a wild turkey cock as the first plate for his planned ornithology, *The Birds of America*. That choice was deliberate, for he intended that his effort should be introduced by one of the very largest bird specimens, a capital example of a true life-size illustration, one requiring nearly every inch of the astonishing "double elephant"–size sheets that he would use. This initial plate at once set Audubon's work apart, for no other naturalist had systematically reproduced each specimen to its actual dimensions. His skillful scientific rendering of the bird was all the more impressive at full scale. Audubon's presentation also was highly dramatic. The way he positioned the large bird on the page so as to articulate its distinguishing features fully, while also allowing it to live and breathe in a natural setting, demonstrates why his ornithological record was—and is—considered an artistic triumph.

Having gone abroad to find a skilled engraver to reproduce his watercolors, Audubon was introduced to William Home Lizars in Edinburgh in October 1826. The naturalist was impressed by work Lizars was then doing for the Scottish ornithologist Alexander Wilson, and the engraver thrilled to Audubon's idea of making life-size plates. The two collaborated briefly, with Lizars producing only ten plates, before Audubon was forced by Lizars' unreliability to give the project to the Englishman Robert Havell, Jr., in 1827.

This and fourteen other plates from *The Birds of America* in the Amon Carter Museum collection comprise possibly the first Audubon prints to make their way to America. In December 1827 Audubon sent these initial installments to the French nobleman Charles Lucien Bonaparte, a nephew of Napoléon and noted ornithologist, who was then in Philadelphia overseeing the production of his own *American Ornithology* (1825–33). Audubon hoped that Bonaparte might enthusiastically endorse the work under way and lend his royal name to the growing list of subscribers to *The Birds of America*, thereby leading other learned and moneyed gentlemen to do the same.

PJ

PLATE I.

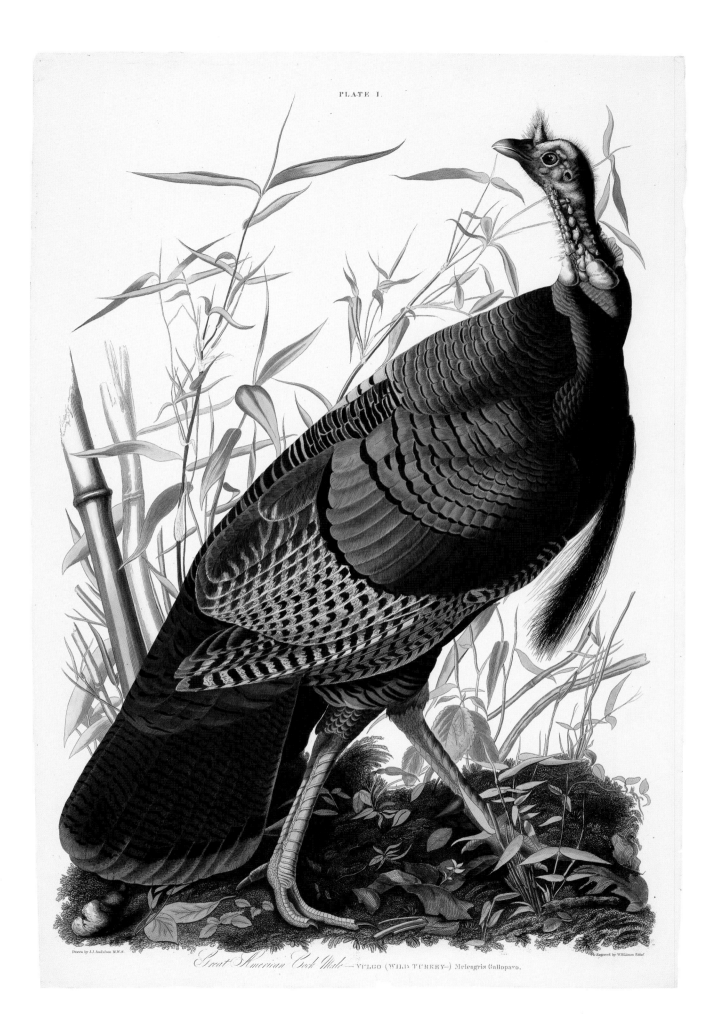

Drawn by J.J.Audubon M.W.S.

Engraved by W.H.Lizars Edin!

Great American Cock Male —— VULGO (WILD TURKEY—) Meleagris Gallopavo.

3

THOMAS COLE
1801–1848

The Garden of Eden, 1828

Oil on canvas, 38½ × 52¾ in. (97.8 × 134 cm)

Signed, dated, and inscribed lower center: *T. Cole. 1828. / NY*

1990.10

There is little in Thomas Cole's background to explain his sudden success as a landscape painter. Born in the English industrial center of Bolton-le-Moors, he was apprenticed to a textile designer before immigrating to America in 1818. In the frontier outpost of Steubenville, Ohio, he took lessons from a little-known painter and worked as an itinerant portraitist. Then he studied intermittently at the Pennsylvania Academy of the Fine Arts in Philadelphia and made drawings from nature. In New York City in 1825 the eminent artists William Dunlap, Asher B. Durand [q.v.], and John Trumbull acquired his first productions; thereafter, Cole's reputation soared. He went abroad twice, but he was always drawn to the scenery around the town of Catskill, on the Hudson River. He settled there permanently in 1836 after marrying into an old local family. The nearby mountains, steeped in history and legend, fed Cole's imagination and made a storyteller of him. Regarded as the founder of the nation's landscape school, he was, in truth, a painter of history and allegory, dedicated to a landscape art imbued with lofty, spiritual meaning. Cole was just beginning work on what he planned as his grandest series, a moral tale of Christian trial called The Cross and the World, *when he died suddenly in 1848.*

"I DO FEEL THAT I AM NOT A MERE LEAF PAINTER," Cole once wrote, although he was from his earliest efforts regarded as a deeply reverential painter of nature and American scenery.[1] By 1827 he was, he confided to a friend, formulating an idea that expressed the full extent of his true artistic ambition:

> The Garden of Eden is the subject—The scene as it exists in my mind's eye is very beautiful.... If I had time I should indulge myself in attempting to describe the scene I have imagined: but can now only say that there are in it lofty distant Mountains, a calm expansive lake, wooded bays, rocky promontories—a solitary island, undulating grounds, a meandering river... groups of noble trees of various kinds,... banks of beauteous flowers, fruits, harmless and graceful animals &c &c.[2]

It was an especially worthy subject, a landscape of high and holy meaning. His specific source was most likely John Milton's *Paradise Lost* (1667), and it so engaged Cole's fertile imagination that his depiction of Eden was brought forth in lavish detail and on a grand scale. It quickly expanded, in fact, to encompass two canvases, with a companion piece, the *Expulsion from the Garden of Eden* (1828, Museum of Fine Arts, Boston), providing the dramatic climax to the tale of Adam and Eve in Paradise. *The Garden of Eden* revealed to Cole the narrative potential of landscape art and further suggested the expansive storytelling possibilities of serial productions. It proved to be a signal achievement, pointing the way to the great epic series that were yet to come in his life's work.

PJ

1. Quoted in Louis Legrand Noble, *The Course of Empire, Voyage of Life, and Other Pictures of Thomas Cole, N.A., with Selections from His Letters and Miscellaneous Writings: Illustrative of His Life, Character, and Genius* (New York: Cornish, Lamport, and Co., 1853), 89.
2. Cole to Daniel Wadsworth, November 26, 1827, quoted in Franklin Kelly, *Thomas Cole's Paintings of Eden*, exh. cat. (Fort Worth: Amon Carter Museum, 1994), 21–22.

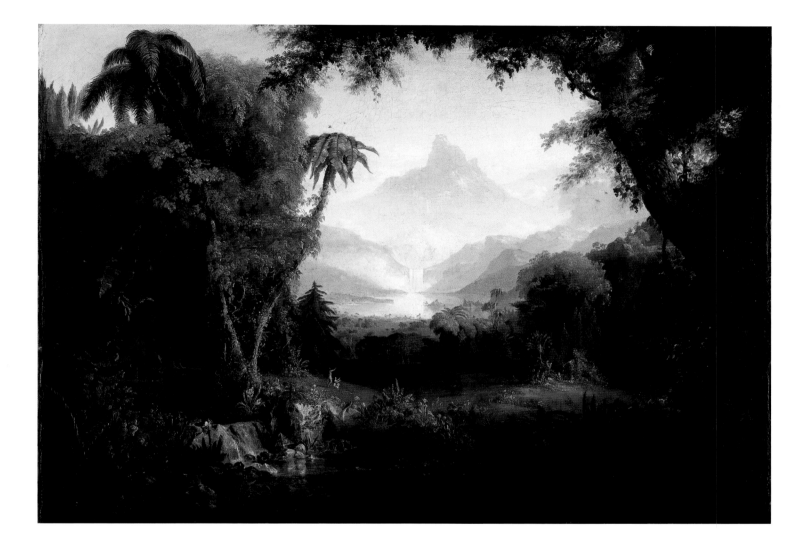

KARL BODMER
1809–1893

Päsesick-Kaskutäu, 1833

Watercolor on wove, off-white paper, 12⅛ × 9⅜ in. (30.8 × 23.8 cm)

1988.19

Karl Bodmer had the good fortune to meet a wealthy adventurer who catapulted the obscure Swiss watercolorist to international artistic fame. Born in Zurich, Bodmer began art instruction with his uncle, a painter who had studied under the celebrated Swiss romantic artist Johann Heinrich Füssli (1741–1825). Young Bodmer developed into a skilled draftsman, watercolorist, and engraver. He settled in the picturesque German town of Koblenz, on the Rhine, and distinguished himself as a sensitive watercolorist, whose sketches of the local landscape became popular with tourists. In Koblenz, Bodmer met Prince Maximilian of Wied-Neuwied, whose plan to document the topography and peoples of America's northern Plains changed the artist's life. After accompanying the prince on his western travels, Bodmer oversaw the production in Paris of the magnificent engraved plates. Later he took up painting in the Barbizon region of France. He died there, his reputation resting not on his late landscapes but on Travels in the Interior of North America between 1832 and 1834, *his monumental historical and artistic achievement of decades earlier.*

WHEN THE YOUNG SWISS ARTIST KARL BODMER SET SAIL with German Prince Maximilian of Wied-Neuwied from Rotterdam for America in May 1832, his career was set. Throughout the next decade he would dedicate himself to producing a visual record of Maximilian's exploration along the Missouri River from April 1833 through May 1834. The prince had envisioned a monumental report on the topography, natural history, and peoples along this five-thousand-mile stretch through the northern Plains, from St. Louis to Fort McKenzie in present-day Montana, and he required an artist's assistance. Bodmer was a superb, Paris-trained draftsman and watercolorist. Maximilian was a respected naturalist and ethnologist with a rigorous scientific mind and a penchant for taking copious notes of his observations. Together, artist and chronicler produced one of the fullest, most revelatory accounts of life on the early western American frontier. It was published, with elaborate folio-size engravings after Bodmer's sketches, in French, German, and English editions over the next several years.

At Fort Union, a major fur trading post at the junction of the Yellowstone and Missouri Rivers, Maximilian and Bodmer rested briefly and gathered momentum for the final leg of the return trip downriver to St. Louis. It was here on October 21, 1833, as the cold and snow of the approaching winter moved across the Plains, that the prince recorded the encounter with the Assiniboine warrior who inspired this watercolor:

> Several Assiniboins [*sic*], whom we had not seen before, arrived successively. . . . Among them was a man wearing his winter dress, having on his head a badger's skin, by way of cap, and gloves, which are very rare among the Indians. His name was Päsesick-Kaskutäu (*Nothing but Gunpowder*), and Mr. Bodmer took an admirable full-length portrait of him.[1]

PJ

1. From the journal entry of Prince Maximilian for October 21, 1833, quoted in Davis Thomas and Karin Ronnefeldt, eds., *People of the First Man: Life among the Plains Indians in Their Final Days of Glory—The Firsthand Account of Prince Maximilian's Expedition up the Missouri River, 1833–34* (New York: E. P. Dutton, 1976), 156. (The capitalization and italics of the translated Assiniboine name are the essayist's.)

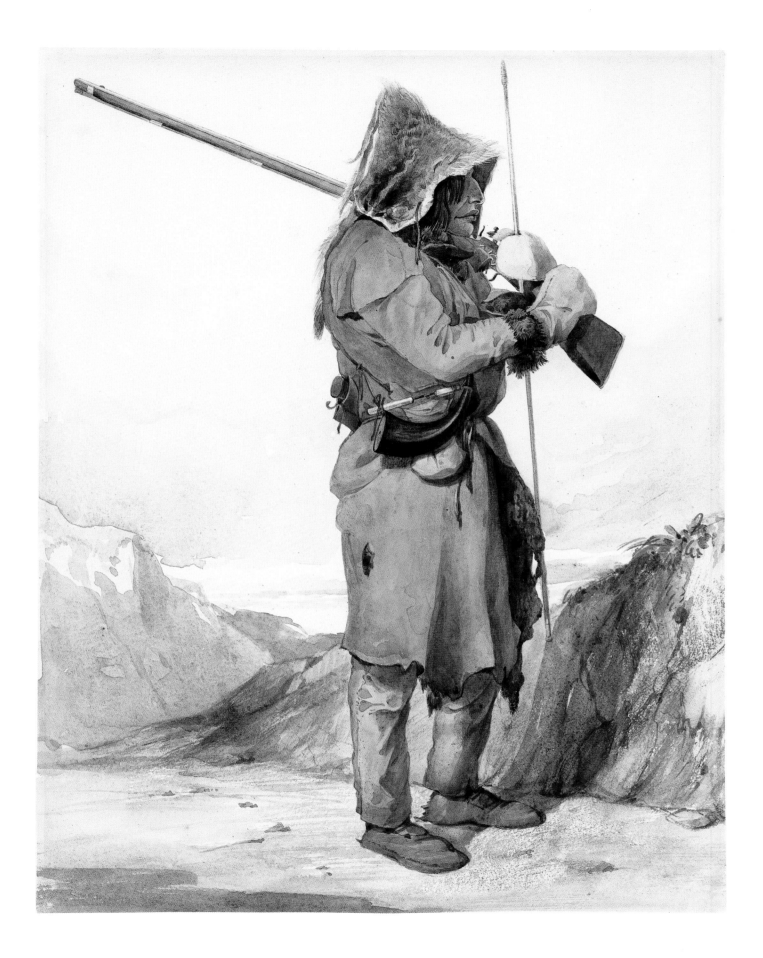

PETER RINDISBACHER
1806–1834

Assiniboines Hunting on Snowshoes, 1833

Watercolor, ink wash, and ink on wove, buff paper, 9⅞ × 16⅜ in. (25.1 × 41.6 cm)

Signed and dated lower left: *P Rindisbacher. 1833.*

1966.51

Peter Rindisbacher had little exposure to formal art training in his native Switzerland before arriving at the Red River colony. By 1814 the colony, located along the Red and Assiniboine Rivers, had attracted more than two hundred people to the northern Plains, where both America and Great Britain held economic interests. In his new home, Rindisbacher observed and depicted North American animal life; he also captured rare views of the Dakota, Cree, and Assiniboine tribes. Impressed by his skill, colony officials commissioned him to portray the settlers' activities. His family eventually abandoned the struggling colony, moving first to Wisconsin and then, in 1829, to St. Louis. Rindisbacher set up a studio in the thriving Mississippi River city in 1831. There, he continued to attract commissions, providing illustrations for the periodical American Turf Register *and making miniature paintings with the same painstaking technique evident in his drawings and watercolors. Rindisbacher died suddenly at age twenty-eight of unknown causes, just as he was attracting wider notice for his depictions of life on the prairie. Very few of his works survive.*

PETER RINDISBACHER IS BELIEVED TO HAVE BEEN the first genre painter to work in the North American interior. In 1821 the Swiss-born artist came to America with his family, lured to the Red River colony (located near what is now Winnipeg), anticipating greater prosperity. Their hopes, like those of many early European settlers on the frontier, were dashed in this isolated community. But despite ravages such as starvation and flooding, Rindisbacher managed to create a small market for his eyewitness depictions of the lives of the Red River settlers, Native Americans, and fur traders, and of the natural history of the western frontier.

Assiniboines Hunting on Snowshoes depicts a group of Indians chasing buffalo across a snow-covered terrain. Meticulously rendered with remarkable detail, the drawing contains a wealth of information about native culture and reflects Rindisbacher's training as a miniaturist in Switzerland. An ingenious invention enabling the Indians to hunt in winter, the snowshoes worn by the central figure probably originated among the Native American cultures in the mid-seventeenth century. Besides keeping the hunter from sinking, snowshoes allowed him to move quickly across deep snow. Here, one of the pursuer's arrows has already wounded his prey; to complete the kill, his four canine companions will chase the buffalo into the snow, where it will become helplessly immobilized. In the background, the artist includes additional clusters of Indians, armed with spears and clubs, pursuing buffalo that have been separated from the herd.

Although Rindisbacher often repeated this profiled figural type, he imparted independent character by giving his subjects expressive and individualized facial features. He also selectively added accents of opaque watercolor, as seen in the buffalo's red tongue and the native costumes.

JM

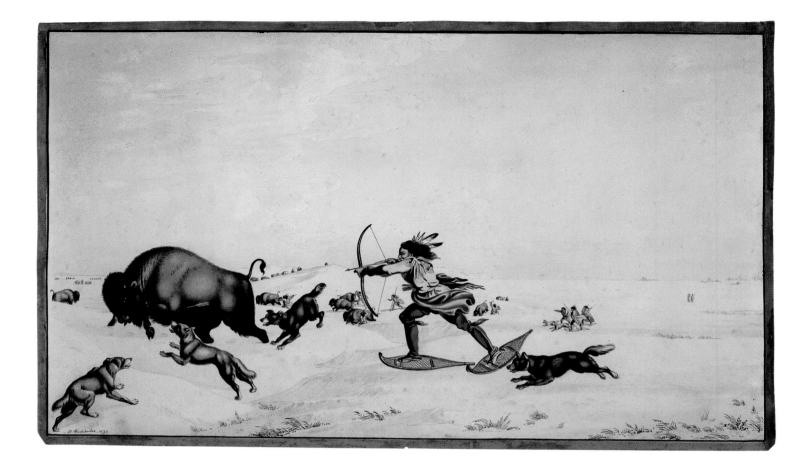

Asher B. Durand (1796–1886) after
John Vanderlyn
1775–1852

Ariadne, 1835

Engraving and etching on wove, cream paper mounted to wove, off-white paper; plate: 14⅛ × 17⅝ in. (35.9 × 44.8 cm); sheet: 19½ × 22½ in. (49.5 × 57.1 cm)

Signed, dated, and inscribed, lower left, in plate: *Painted by J. Vanderlyn*; lower right, in plate: *Eng. by A. B. Durand / Printed by A. King*; lower center, in plate: *ARIADNE / Published by A. B. Durand, New York, Hodgson, Boys, & Graves, London, & Rittner & Goupil à Paris 1835. / Entered according to act of Congress in the year 1835 by A. B. Durand in the Clerk's Office of the District Court of the Southern District of New York.*

1985.291

Born in Jefferson Village (now Maplewood), New Jersey, in 1796, Asher B. Durand was apprenticed to the master engraver Peter Maverick in Newark when he was sixteen. By 1818 he was a partner in Maverick's firm, and by 1824 he was the head of his own engraving company in New York City. Throughout the 1830s, Durand expanded his range by painting portraits, historical subjects, and landscapes. Under the influence of his growing friendship with Thomas Cole [q.v.] and with the encouragement of his friend and patron Luman Reed, he eventually abandoned engraving to focus exclusively on landscape painting. By 1848, when Cole died, Durand had become the acknowledged leader of America's landscape school. From 1845 to 1861 he served as president of the National Academy of Design. His "Letters on Landscape Painting," published in 1855 in successive issues of the newly founded art journal The Crayon, *provided the theoretical foundation for a generation of artists.*

In his memorial tribute to Asher B. Durand, the artist Daniel Huntington (1816–1906) declared that Durand had been an innovator in two realms: engraving and the practice of painting directly from nature. By 1825 he had earned a reputation as the finest engraver in America by producing such ambitious and masterly line engravings as his reproduction of John Trumbull's complex history piece *The Declaration of Independence*, published in 1823, a print that had engaged Durand for three years. In a period when engraving was the sole means by which the works of painters could be made available to a wide audience, he distinguished himself not just as a competent copyist but also as an engraver who could capture all the grace of painted form, all the lustrous beauty of light and shade, all the intricate details and effects produced with the brush. In short, he could recreate in his fine art prints, as his son John put it, "everything but color."[1] Painters sought him out and entrusted the reproduction and marketing of their pictures to him, confident that Durand would produce magnificent replicas of their works, prints that were as appealing as original paintings.

When John Vanderlyn could find no buyer for his large *Ariadne*, which he had been exhibiting at various venues throughout the country since bringing it back with him from Paris in 1815, he sold the canvas in 1831 to Durand, who wished to copy it. Durand was taken with the sheer beauty of the painted flesh and must have seen the replication of this as the supreme test of the line engraver. The project typifies his exacting approach to printmaking. Even though he had Vanderlyn's original canvas before him, Durand first painted his own scaled-down copy (now in the Metropolitan Museum of Art), which is in itself breathtaking in its delicacy, sensuality, and miniaturist's painting technique. Working at a one-to-one scale from his oil study, Durand could engrave with exactitude; he developed the copper plate through eight proofs, thus working out every element and area precisely. The rich velvety blacks of the landscape and the soft, subtle modeling of Ariadne's flesh and elegant form make this work a tour de force. Yet Durand's success with *Ariadne* proved to be no better than Vanderlyn's. "The 'Ariadne,' undertaken solely for the love of art, unconscious of pecuniary reward or public sympathy, was also, commercially speaking, a failure," Durand's son lamented.[2] The majestic portrayal of the mythological Cretan beauty asleep on the island of Naxos, soon to be discovered and awakened by an amorous Dionysus, remained too daring a subject for American art patrons.

PJ

1. John Durand, *The Life and Times of A. B. Durand* (1894; repr. New York: Kennedy Graphics, Da Capo Press, 1970), 45.
2. Ibid., 76.

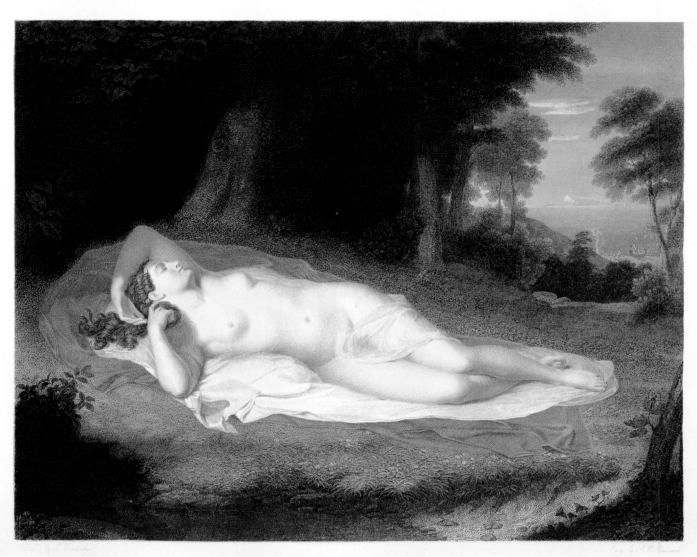

ARIADNE.

George Lehman (1800?–1870) and
Peter S. Duval (active 1831–1879) for
JAMES OTTO LEWIS
1799–1858

*Mac-Cut-I-Mish-E-Ca-Cu-Cac or Black Hawk, a Celebrated
Sac Chief*, 1836, from *The Aboriginal Port-Folio*, 1835–36

Lithograph with watercolor on wove, off-white paper; sheet: 18¼ × 11½ in.
(46.4 × 29.2 cm)

Signed, dated, and inscribed lower center, on stone: *Lehman & Duval Lith.rs /
MAC-CUT-I-MISH-E-CA-CU-CAC / or / BLACK HAWK / A Celebrated Sac
Chief. / Painted from life by J. O. Lewis at Detroit 1833. / Entered according to
act of Congress in the year 1836 by J. O. Lewis in the Clerk's Office of the
District Court of the Eastern District of Pennsylvania.*

1965.10.56

*James Otto Lewis began his career as an en-
graver in his native Philadelphia. He went west-
ward with a small theatrical troupe in 1815 and
worked as a portraitist in St. Louis. There, he
met the painter Chester Harding (1792–1866),
whose popular likenesses of Daniel Boone and
of Native Americans perhaps inspired the
struggling thespian-artist. By 1823 Lewis was
making a marginal living as a painter of minia-
ture portraits in Detroit when Michigan
Governor Lewis Cass asked him to take a like-
ness of Tens-qua-ta-was, the Shawnee Prophet,
then on an official visit to the city. Through
Governor Cass, Lewis was eventually named
by the U.S. Indian Department as official
portraitist for the various Indian councils. In
this capacity, Lewis attended many treaty coun-
cils, including those at Prairie du Chien, Fort
Wayne, Fond du Lac, and Green Bay, where he
made many portraits and sketches. These be-
came the basis for his book* The Aboriginal
Port-Folio. *Lewis died in New York City in
1858, never realizing financial gains from his
noble effort.*

ON MAY 18, 1835, the St. Louis *Commercial Bulletin* carried the announce-
ment that James Otto Lewis

> Is about to publish in numbers, a collection of Indian Lithographic por-
> traits taken by him during a residence of about fifteen years among the
> various tribes of the west.... He has succeeded in obtaining nearly one
> hundred portraits, all of which are remarkably true to nature. Some of
> the lithographs we have examined, and we are sure that they are well cal-
> culated to excite interest.[1]

What Lewis produced was the first published record of North American
Indians, a work that preceded what are today the better-known colorplate
books of the team of Thomas Loraine McKenney (1785–1859) and James Hall
(1811–1898) or that of George Catlin (1796–1872). Moreover, his enterprise
stands as one of the first significant lithographic productions made in this
country.

Lewis painted the legendary Black Hawk in 1833 in Detroit, after the
chief had been released from prison at nearby Fortress Monroe. The once-
powerful Sac leader had been humiliated by the devastating defeat of his
renegade followers in what came to be known as the Black Hawk War. In 1832
President Andrew Jackson ordered federal troops into action against Black
Hawk and his men, who had been tenaciously fighting resettlement in the
West since their lands were ceded to the United States. Capitulation to gov-
ernment demands was inevitable, of course, and by leading his men into a
bloody slaughter, Black Hawk was held in disgrace by the Sac people. This
majestic portrait suggests Lewis' respect for the still-proud man.

In creating his *Aboriginal Port-Folio*, Lewis turned to the country's lead-
ing lithographers, Lehman and Duval of Philadelphia. Master draftsmen, they
drew Lewis' images on stone and hand colored the prints. Lewis' original
watercolor paintings eventually made their way into the collection of the
Smithsonian Institution, where they were destroyed by fire in 1865.

PJ

1. St. Louis *Commercial Bulletin*, May 18, 1835, quoted in Philip R. St. Clair, "James Otto
Lewis, 1799–1858," in *James Otto Lewis: The American Indian Portfolio: An Eyewitness
History, 1823–28* (Kent, Ohio: Volair Limited, 1980), 13.

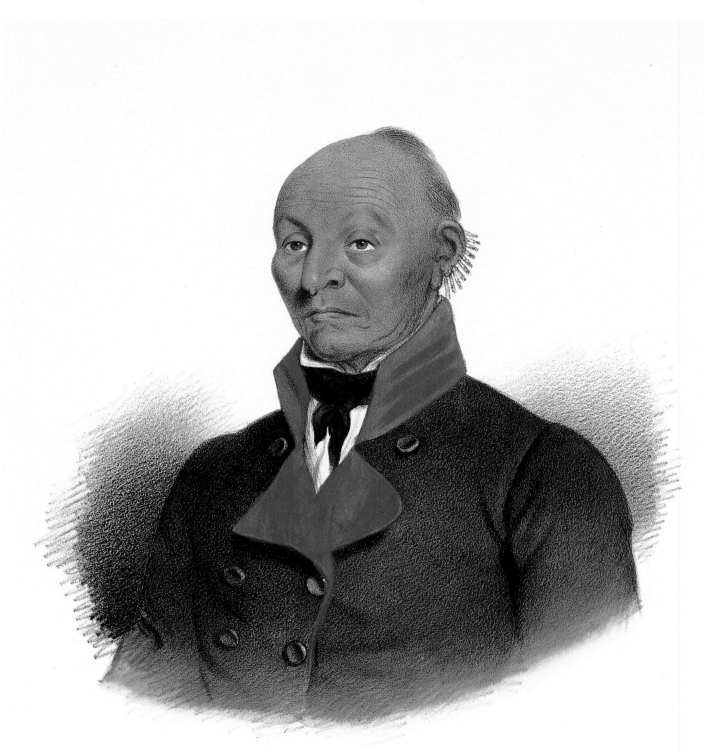

MAC-CUT-I-MISH-E-CA-CU-CAC

or

BLACK HAWK

A Celebrated Sac Chief.

Painted from life by J.O Lewis at Detroit 1833.

ARTIST UNKNOWN

[Two men], ca. 1840

Daguerreotype, sixth plate: 1¹³⁄₁₆ × 2¼ in. (4.6 × 5.7 cm)

(Object reproduced at actual size)

P1989.22.1

IN SEPTEMBER 1839, only one month after Frenchman Louis-Jacques-Mandé Daguerre (1789–1851) announced his invention of a photographic process, the daguerreotype procedure was detailed in the American press; it was soon enthusiastically adopted. Although the process was at first impractical for portraiture due to the requisite exposure time of up to thirty minutes, scientists immediately began experimenting to find ways to accelerate it. By the time this charming, casual portrait was produced, exposures could be made in under a minute; in this case, one man's hands clasped over the other's shoulder were sufficient to stabilize the two subjects.

Chemical analysis of this plate reveals that it is not gilded, a process employed after 1840 to enhance contrast and protect the image surface. A combination of other factors here—in particular, the lack of shadows from bright sunlight and the relative density of image particles seen in microscopic examination—suggests that the plate underwent multiple treatments with both iodine and bromine, two halogens that had just been discovered and were used for daguerreotype sensitization beginning in 1840. Until that time, these elements had been restricted to a few experimental medicinal uses, and access to bromine was limited to Philadelphia. The two gentlemen in this picture were probably associated with one of that city's medical schools. Additionally, the casual and affectionate nature of their pose suggests that they were participating in an experiment with the process. Perhaps a double self-portrait, this daguerreotype represents that exciting period of innovation that led to the recognition of Americans as leaders in the field of "writing with light."

BMC

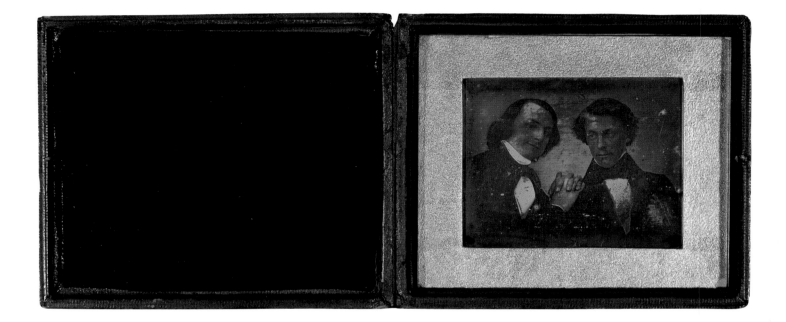

THOMAS COLE
1801–1848

The Hunter's Return, 1845

Oil on canvas, 40⅛ × 60½ in. (101.9 × 153.7 cm)

Signed and dated lower center: *T. Cole / 1845*

1983.156

Born in the English industrial center of Bolton-le-Moors, Thomas Cole was apprenticed to a textile designer before immigrating to America in 1818. A scant seven years later his first productions were purchased by eminent artists of the day, and his reputation soared. Cole settled in Catskill, New York, on the Hudson River, in 1836. The final decade of his brief life began with his second trip to Europe in 1841–42. But thereafter he concentrated on his own visions. Cole's last years in Catskill were marked by increasing introspection and deepening religious faith. The ambition and imagination that brought forth the great serial works of the 1830s had not waned. In fact, in the 1840s he was preoccupied with promoting state-supported public art, even painting one of his largest canvases for exhibition in the British Houses of Parliament in 1847. Cole was just beginning work on what he planned as his grandest series, a moral tale of Christian trial to be called The Cross and the World, *when he died suddenly in 1848. The revered nature poet William Cullen Bryant (1794–1878) gave the funeral oration for his friend, a painter whose intellect, spirit, and faith were grounded always in his love of nature.*

EVEN WHEN COLE WAS PAINTING PURE LANDSCAPE, which his patrons largely preferred to his allegorical works, American scenery served him as a point of departure for storytelling. When in 1844 he was commissioned to paint a major work for an important New York patron, the artist created *The Hunter's Return*, based on an idea he had imagined decades earlier. Lovers of American scenic views might have recognized the setting as an area in the White Mountains of New Hampshire. But for Cole this place was representative of a large idea: the idea of wilderness, of an experience that defined America and revealed a fundamental truth about human nature.

There is something of Eden in this sun-filled vale where humankind, in a state of simplicity and innocence, resides in harmony with nature. It is redolent of domestic bliss, a sweet scene of father and son returning to their rustic home from the hunt. They are joyous in their offering of a slain deer, and they are welcomed back lovingly by mother and children. The myriad details that lend charm and narrative to the scene also convey the full force of Cole's tale: the loss of innocence that the scene foretells. The fall from grace comes with the inevitable defiling of nature as settlers move ever forward toward civilization.

It is a theme Cole essayed again and again. Here, hostility is only hinted at by the stumps of this cleared wood and the trophy of the hunt. Yet these details convey an unmistakable sense of death and destruction, both realized at the hands of humankind.

PJ

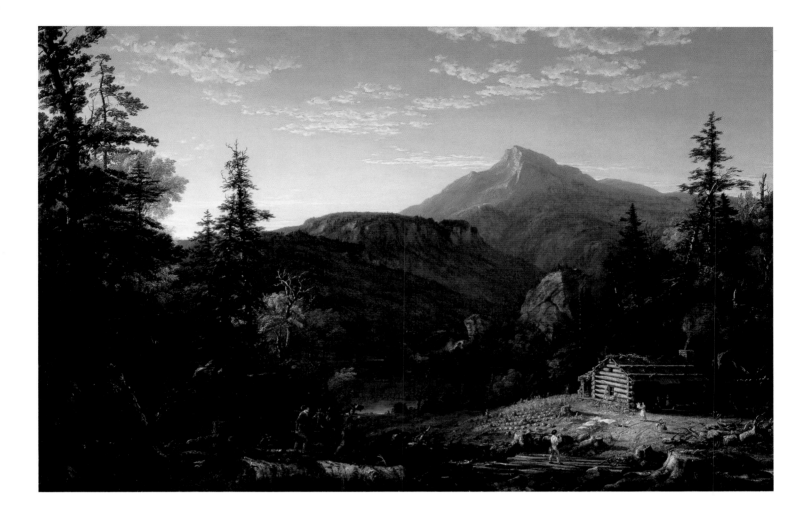

CHARLES DEAS
1818–1867

A Group of Sioux, 1845

Oil on canvas, 14⅛ × 16½ in. (35.9 × 41.9 cm)

Signed and dated lower left: *C. Deas 1845*

1980.42

Charles Deas was born in Philadelphia into a prominent family, originally from South Carolina, where his father had been a state senator. At an early age he showed a remarkable affinity for painting. His first exhibition pieces, shown at the National Academy of Design in 1838 and 1839, were so deft and appealing that critics hailed the young man as a close rival to the country's leading genre painter at the time, William Sidney Mount (1807–1868). No sooner had Deas been acclaimed in New York City than he suddenly changed direction and headed west. In the spring of 1840 he embarked on an eighteen-month sojourn among the Dakota, Fox, Ojibwa, Sauk, and Winnebago peoples. By late 1841 he was settled in St. Louis, where he both painted portraits and developed his trademark scenes of western life. In 1847 he returned to New York and exhibited his work at the major art venues. But the promise of further success was unfulfilled. Suffering from what one source called "melancholia," he was admitted to an asylum for the insane in 1848. Deas spent the remaining years of his life in such institutions.

ENTERPRISE APTLY DESCRIBES THE MOTIVATION of many of the first painters who traveled to the far West. George Catlin (1796–1872) was the first to capitalize on the East Coast audience's fascination with Indians; his traveling Indian Gallery proved immensely popular. When it was exhibited in Philadelphia in 1837, Catlin's collection of Indian portraits caught the attention of the young painter Charles Deas, who, inspired by these "trophies as eloquent of adventure as of skill," embarked on his own tour among the Plains Indians in 1840.[1] Deas traveled through the Upper Midwest and the Great Plains, attached to military-expedition parties, and "was enabled to collect sketches of Indians, frontier scenery, and subjects of agreeable reminiscence and picturesque incident, enough to afford material for a life's work."[2]

In his brief career, cut short by mental illness, Deas put that material to highly effective use, producing dramatic, colorful, beautifully painted works of Indians and frontier trappers and scouts. These won him patronage in St. Louis, where he established a studio, and critical acclaim in New York City, where they were exhibited at the American Art-Union and the National Academy of Design.

This small painting testifies to Deas' keen sense of character and subtle expression. These Sioux are restive, filled with tense anticipation as they study the smoke signal on the far horizon and watch the lone rider galloping across the plain. A range of emotion is registered in the faces of this family group, from the hawklike wariness of the warrior at left and the meditative focus of the elder at right to the fear evident in the young mother and child. This emotional intensity contributes, as much as the ethnographic detail, to the sense of authenticity that distinguishes Deas' paintings of western life.

PJ

1. Henry T. Tuckerman, *Book of the Artists: American Artist Life* (1867; repr. New York: James F. Carr, 1966), 426–27.
2. Ibid., 427.

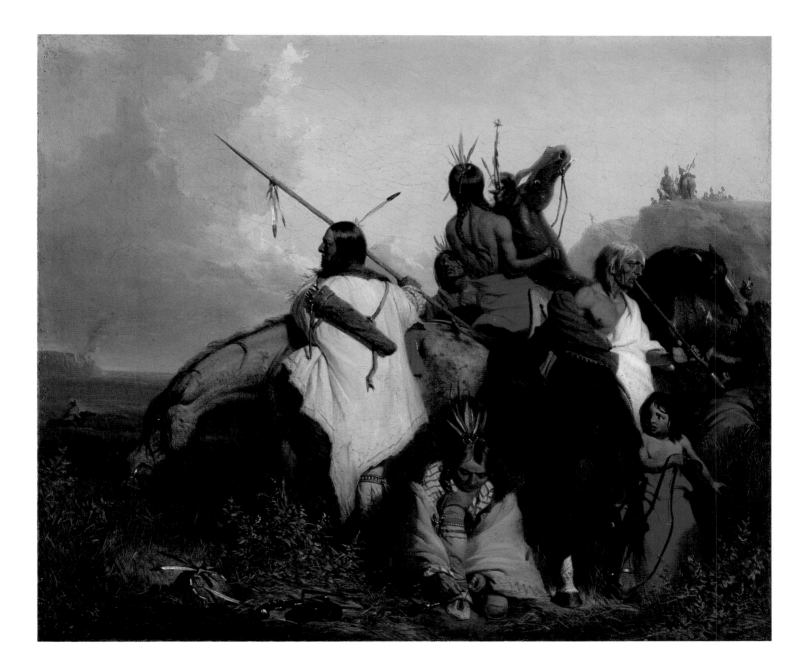

EDWARD EVERETT
1818–1903

Ruins of the Church of the Alamo, San Antonio de Béxar, 1847

Transparent and opaque watercolor and ink on wove, off-white paper, 6 × 9⅜ in.
(15.2 × 23.8 cm)

Signed, dated, and inscribed on mount, lower center: *1847*; lower right: *EDWARD
EVERETT*; lower center on separate paper mounted on card mount: *THE ALAMO*

Gift of Mrs. Anne Burnett Tandy in memory of her father, Thomas Loyd
Burnett, 1870–1938

1977.7

In 1840 Edward Everett, a native of London, immigrated to Quincy, Illinois, where his father established a dry-goods store. City directories indicate that Everett's occupations were "machinist" and "engineer." He soon joined a volunteer company known as the Quincy Riflemen. In the published narratives of his military experiences (1906), he wrote of the "Mormon War in Illinois, 1845–46," in which he and the riflemen were enlisted to help keep the peace. While on a search patrol in this capacity, he encountered the Mormon Temple in Nauvoo and made drawings of that impressive structure. When his regiment was reassembled for service in the U.S.–Mexican War (1846–48), Everett became the company clerk and, upon arriving in San Antonio, was directed to draw local buildings and other objects of interest representative of the area's culture. In Washington, D.C., after the war, Everett provided duplicates of his drawings to be lithographed for an 1850 government report on the Mexican campaign. Returning to Illinois, he served again in the quartermaster's office during the Civil War. Everett spent his final decades on the East Coast. He died in Massachusetts, where he and his wife had moved in about 1893 to be near family. Toward the end of his life, Everett wrote a lengthy recollection of his career, including an informative and detailed description of his sojourn in Texas.

IN 1846, WHEN THE UNITED STATES declared war against Mexico in a quest to expand its sovereignty westward, the First Illinois Volunteers heeded the call. One of that regiment's recruits, Edward Everett, produced the period's finest watercolors of three of San Antonio's eighteenth-century Spanish missions: San Antonio de Valero (the Alamo), Mission Concepción, and Mission San José. One of five Everett watercolors in the Amon Carter Museum's collection, *Ruins of the Church of the Alamo, San Antonio de Béxar* shows the Alamo's chapel in ruinous condition eleven years after its legendary defense by a small band of Texans and its subsequent abandonment by the Mexican Army.

Soon after Everett arrived in San Antonio, he was wounded on guard duty while trying to break up a fight. The army had already recognized his drawing skills and assigned him the task of recording points of interest in the area. As he recuperated, safely removed from the front lines, Everett continued drawing while working in the quartermaster's office, assisting with the procurement of supplies. In this capacity, he became involved in the army's efforts to convert the Alamo compound into offices and storage. Especially impressed by the facade of the chapel, he rendered it with the painstaking precision of a seasoned draftsman, a skill he had apparently gained in his civilian occupation as an engineer. In minute detail, he depicted the jagged edges of the roofless structure, empty niches that had once held iconic statues, fallen stones, damaged carving around the portal, and the vegetation that had overtaken the building.

Like many Americans, Everett revered the Alamo as a symbol of extraordinary bravery. Having recorded this truthful view for posterity, he also expressed the sensibilities of a preservationist when, years later, he wrote about further alterations to the Alamo's facade: "I regret to see by a late engraving of this ruin, that tasteless hands have evened off the rough walls, as they were left after the siege, surmounting them with a ridiculous scroll giving the building the appearance of the headboard of a bedstead."[1]

JM

1. Edward Everett, "A Narrative of Military Experience in Several Capacities," *Transactions of the Illinois State Historical Society* 10 (Springfield: Illinois State Historical Library, 1906): 215.

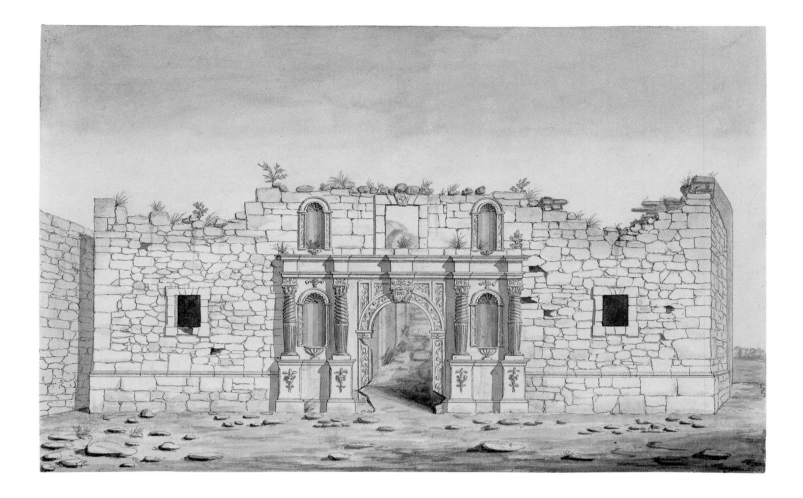

HENRY KIRKE BROWN
1814–1886

The Choosing of the Arrow, 1848

Bronze, h: 21¼ in. (54 cm); w: 6¼ in. (15.9 cm); d: 5½ in. (14 cm)

Ruth Carter Stevenson Acquisitions Endowment

1997.143

Henry Kirke Brown was the first artist to cast bronze sculpture in America. Born in Leyden, Massachusetts, he began his career as a painter in Boston, where Chester Harding (1792–1866) taught him portraiture. While working in Cincinnati in 1837 and 1838, he modeled his first portrait busts in clay. He made enough money from commissions for busts in Boston and, subsequently, in Troy and Albany, New York, to pay for a much-anticipated trip to Italy. In 1842 Brown set himself up in Florence and later the next year went to Rome. Weary of ancient historical models, he returned home in 1846, declaring his preference for naturalism over classicism. He opened a studio in Brooklyn where he created his most famous public sculpture: the monumental bronze equestrian George Washington, erected in New York's Union Square in 1856. By the time of his death thirty years later, he had been eclipsed by the younger sculptors Augustus Saint-Gaudens [q.v.] and Daniel Chester French (1850–1931). However, it was Brown who had ushered in the era of the grand public monument and established the model for naturalism in heroic representation that his successors would emulate.

IN 1848, FOLLOWING A FOUR-YEAR RESIDENCE ABROAD, Henry Kirke Brown made the first small-scale bronze sculptures cast in the United States. *The Choosing of the Arrow* was created at the foundry he established in Brooklyn, New York.

In Italy, where he operated sculpture studios, first in Florence and then in Rome, Brown was fascinated by ancient Greek and Roman sculpture and the Renaissance adaptation of their classical forms. Upon his return to the United States, he sought to merge his knowledge of these classical models with American themes. For Brown, Native Americans represented the quintessential American subject, so he traveled to Mackinac Island on Lake Superior to sketch members of the Ojibwa and Ottawa tribes firsthand.

This standing figure, based on a male model from one of the tribes, shifts his weight from one leg to another in a classic *contrapposto* stance as he reaches over his shoulder to draw an arrow from the quiver on his back. At the same time, he begins positioning his bow with his gracefully extended left arm. The warrior's finely detailed, shoulder-length hair is topped by a distinctive ornamental knot on his forehead, characteristic of the Indians of the Upper Midwest.

The Choosing of the Arrow recalls classical sculpture as reinterpreted by early Renaissance masters, such as Donatello, whose preference for naturalistic yet sensuous forms is echoed here in Brown's elegant figure. Its delicacy and refinement are enhanced by the rich brown patina, lacquered by the two foundry assistants Brown brought from France to work with him in Brooklyn.

The Choosing of the Arrow was distributed by the American Art-Union, an organization whose method of dispensing art through a lottery system played a key role in stimulating public interest in American art in the mid-nineteenth century. The sculpture's modest height—just under two feet—made it ideal for placement in domestic interiors.

JM

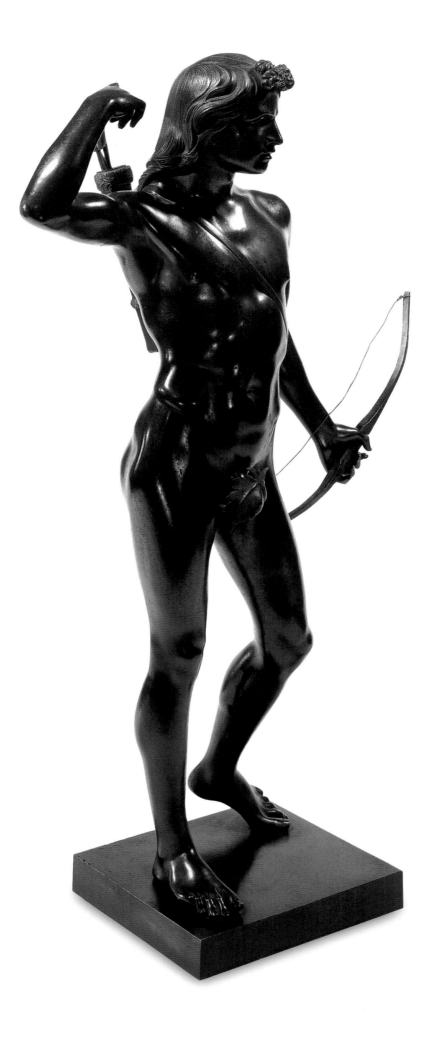

SETH EASTMAN
1808–1875

Ballplay of the Dakota on the St. Peters River in Winter, 1848

Oil on canvas, 25¾ × 35¼ in. (65.4 × 89.5 cm)

Acquisition in memory of Mitchell A. Wilder, Director, Amon Carter Museum, 1961–1979

1979.4

Seth Eastman devoted a lifetime to recording the customs of Native Americans. Born in Brunswick, Maine, he attended West Point, and his subsequent military service made possible his life's work. He taught topographical drawing at West Point from 1833 to 1840 and wrote an important early treatise on the subject. Yet he had little formal training as a painter when, in the 1840s, he began his series of oils depicting the local tribes at Fort Snelling, which was built on a bluff overlooking the confluence of the Mississippi and Minnesota Rivers. In his subsequent travels down the Mississippi in 1846 and in Texas in 1848 to 1849, he made watercolor sketches of Indians and scenery. In 1850 Captain Eastman moved to Washington, D.C., and worked on illustrations for Henry Schoolcraft's monumental work, Information Respecting the History, Condition, and Prospects of the Indian Tribes of the United States *(1851–57). In 1867 he began work on a commission from Congress to paint Indian scenes and U.S. forts, and he completed twenty-six views in the series before his death.*

SETH EASTMAN TOOK FULL ADVANTAGE of the opportunity presented him by his military service at outposts on the Great Plains and in Texas and Florida to develop a vast visual record of native peoples. By the time of his second posting to Fort Snelling in Minnesota in 1841, Captain Eastman was sufficiently skilled in drawing and painting to realize a plan to record the lives and customs of the Dakota and Ojibwa, whose lands were under U.S. Army control. Mary Eastman wrote accounts of the couple's eight years among the northern Plains Indians, while her husband composed spirited genre scenes to accompany his wife's text.

During his time at Fort Snelling, Eastman produced more than four hundred views, the most ambitious of which were, like this canvas, submitted to annual exhibitions of the American Art-Union in New York. There, they were enthusiastically endorsed as distinctly American subject matter. Eastman was so engaged by the game depicted in this work that he could reconstruct it in great detail on canvas and convey the full excitement of the contest. The Indians' game, a form of lacrosse, was more typically played in summer, so this winter version, played on a long stretch of frozen river, was especially thrilling. The elaborate dress of the contestants provided lively color notes in an otherwise gray landscape. Mrs. Eastman recalled the game this way:

> The scene was inexpressibly wild. The long, gaunt boughs of the trees, leafless, and nodding with the wind towards the dark, heavy evergreens among them; the desolate appearance of nature contrasted with the exciting motions and cries of the Indians. It was impossible even for the mere spectator to be unmoved; he must feel an interest in the game, until the ball has been at length thrown beyond one of the limits, and the tired and hard-breathing men receive the prizes awarded them.[1]

PJ

1. Mary Eastman, *The American Aboriginal Portfolio* (Philadelphia: Lippincott, Grambo, and Co., 1853), 56.

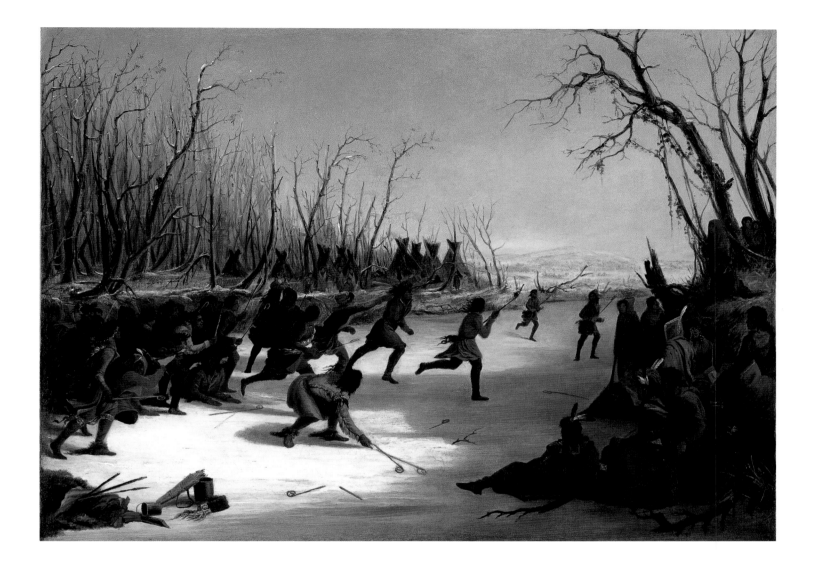

FREDERIC EDWIN CHURCH
1826–1900

New England Landscape, ca. 1849

Oil on canvas, 25⅛ × 36¼ in. (63.8 × 92.1 cm)

Signed lower left: *F. Church*

1979.11

In 1844, when he was only eighteen, Frederic Church moved from his native Hartford, Connecticut, to Catskill, New York, to study painting with Thomas Cole [q.v.]. This was a singular honor, for Cole, then America's pre-eminent landscape painter, had never before accepted a pupil. Cole and the Hudson Valley would leave their deep impress on Church. His devotion to his teacher is easily perceived in his first productions, which closely mirror Cole's works, especially in their aspirations to convey sacred meaning through the quintessential American landscape. By his technical virtuosity, Church rapidly surpassed the achievements of his renowned teacher. At age twenty-three he was elected to full membership in the National Academy of Design. Thereafter, he enjoyed unflagging success, primarily with a succession of monumental exhibition pictures and impressive scenes that were inspired by his far-ranging travels to South America, the North Atlantic, Europe, and the Middle East. Church ultimately made his home on the Hudson River, on a promontory that looked down on Cole's home. "Olana," the grand Moorish-style house that Church designed, became one of the most absorbing projects of the second half of his career.

NEW ENGLAND LANDSCAPE might well serve as a fitting tribute to Church's mentor, Thomas Cole. In every way, this early production pays homage to Cole's teaching. An idyllic view of a mill by a stream, it celebrates the picturesque in the American landscape and recalls similar scenes by Cole. It also closely follows Cole's tenets, conforming beautifully to the aesthetic ideals laid out in the painter's highly influential "Essay on American Scenery," his advice to this country's landscape painters, published in 1836.

Although the composition contains various topographical features Church sketched in and around Pittsford, Vermont, in the summer of 1848, the subject is not a specific place but rather a poetic evocation. It is an ideal representation of the sort of rural American nature that Cole saw and described as replete with moral sentiment. "Though devoid of the stern sublimity of the wild," Cole wrote of the cultivated American landscape, "its quieter spirit steals tenderly into our bosoms mingled with a thousand domestic affections and heart-touching associations—human hands have wrought, and human deeds have hallowed all around." At the center of the scene is a lone figure, a picnicker—a type Cole would have regarded as an appropriately devout student of nature—who rows quietly across a placid lake. This body of water was an essential compositional and expressive element in Cole's estimation: "In the unrippled lake, which mirrors all surrounding objects," he taught, "we have the expression of tranquillity and peace." And sunset, the magnificence of which Church painted as no other American landscape painter could, was, as Cole put it, "that wreath of glory daily bound around the world."

For Church as for Cole, the painting of landscape was a highly reverential activity, affording both painters and admirers of American scenery the opportunity to "drink from pleasure's purest cup" through such artistic re-creations of nature, thereby heightening the senses and refining one's intellectual and moral condition.[1]

PJ

1. Thomas Cole, "Essay on American Scenery," *American Monthly Magazine* (January 1836), quoted in John McCoubrey, ed., *American Art, 1700–1960: Sources and Documents* (Englewood Cliffs, N.J.: Prentice-Hall, 1965), 100, 103.

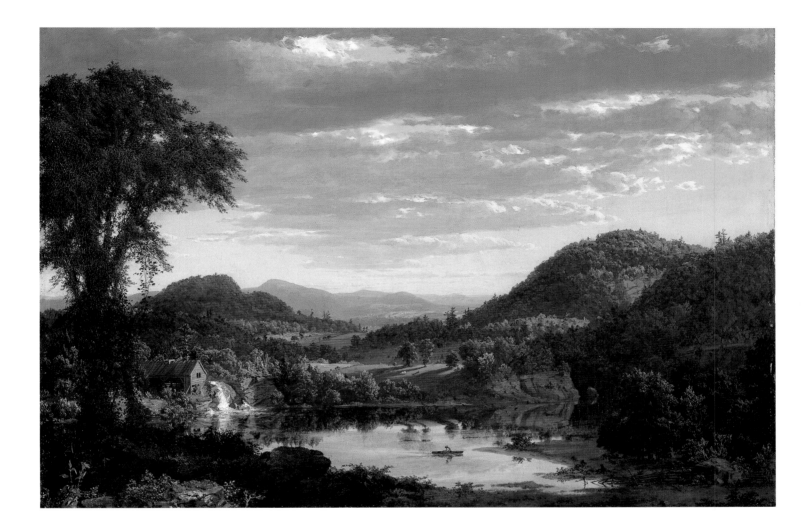

ALBERT SOUTHWORTH
1811–1894
and
JOSIAH HAWES
1808–1901

[Two women posed with a chair], ca. 1850

Daguerreotype, whole plate: 7 × 5½ in. (17.8 × 14 cm)

(Object reproduced at actual size)

P1999.13

Albert Southworth of Vermont and Josiah Hawes of Massachusetts are considered among the finest American daguerreotypists. Southworth, a druggist and teacher, and Hawes, a trained draftsman and painter, learned the process in about 1840 through the lectures of J. Fauvel-Gouraud, Louis-Jacques-Mandé Daguerre's American representative. From 1843 to 1862 Southworth and Co. (later Southworth and Hawes) built a reputation among Boston's elite at their studio on Tremont Street. The artists were innovators; by electroplating an extra layer of silver to the copper plate, they made images of great clarity and extraordinary tonal range. Southworth and Hawes exhibited regularly at the triennial exhibitions of the Massachusetts Charitable Mechanic Association, where in 1847 their daguerreotypes were judged "Best in Exhibition" and received a silver medal. Southworth left the photographic partnership in about 1862 and became a leading expert in handwriting analysis. His partner continued at the Tremont Street studio, working as a photographer until his death at the turn of the century.

"FROM TODAY, PAINTING IS DEAD!" the French painter Paul Delaroche (1797–1856) is said to have worriedly exclaimed on first seeing a daguerreotype.[1] This astonishingly lifelike portrait of two unidentified women shows why artists such as Delaroche were concerned about the possible loss of their livelihood.

The intricate detailing, especially evident in the lace collars and textures of the women's dresses, is remarkable. Clearly comfortable with their station and eschewing modesty, the subjects pose in relaxed intimacy, looking directly at the camera and the viewer. The elaborately carved chair before them symbolizes American craftsmanship and wealth. Yet Southworth and Hawes astutely balanced that elegance by placing a Greek column in the background—a reminder of this country's democratic roots. Most extraordinary, however, is the lighting: the photographers carefully exposed their plate to allow just enough radiance to fall from a ceiling skylight and illuminate their sitters in a manner suggestive of Rembrandt. By setting the two women against a blank background, the daguerreotypists effectively draw the scene forward, sharpening the edges of the women and enhancing their solidity. Such is the beguiling mastery of this image that the women seem almost within reach.

JR

1. Quoted in Helmut and Alison Gernsheim, *The History of Photography, from the Camera Obscura to the Beginning of the Modern Era* (New York: McGraw-Hill, 1969), 70.

JOHN MIX STANLEY
1814–1872

Oregon City on the Willamette River, ca. 1850–52

Oil on canvas, 26½ × 40 in. (67.3 × 101.6 cm)

1979.17

Born in Canandaigua, New York, John Mix Stanley probably worked as a house, carriage, and sign painter in nearby Buffalo before embarking on a career as an itinerant portraitist sometime around 1836. He covered a great expanse of territory, working in southern Michigan, northern Illinois, and the mid-Atlantic cities, before settling for a time in Troy, New York. There, he devised a plan to create a gallery of pictures documenting North American Indian life. To gather material, he trekked widely. From 1842 through 1846 he was in the Southwest, in Indian Territory (present-day Oklahoma), and in Texas. In 1847 he traveled to the Oregon Country, and by the next year he was in Hawaii. He began exhibiting his paintings in 1850, and in 1852 he deposited them at the Smithsonian Institution in hopes of convincing the U.S. Congress to acquire the pictures as a national collection. But Congress was unwilling to act on Stanley's petitions, and, tragically, a fire destroyed the North American Indian Gallery in 1865. He died in Detroit seven years later, never having been able to capitalize on the important documentary work he had created.

ON JULY 8, 1847, the Oregon City *Spectator* announced the arrival of "a young American artist, Mr. J. M. Stanley, who visits our territory for the purpose of transferring to canvas some portions of the beautiful and sublime scenery with which our country abounds."[1]

Although Stanley had served as a topographical draftsman on the California expedition led by Major Stephen Watts Kearny in 1846, his journey up the Columbia River, deep into the Oregon Country, was a personal quest made in search of picturesque subjects to add to his North American Indian Gallery. That ambitious enterprise yielded 152 canvases, "accurate portraits, painted from life, of forty-three different tribes of Indians, sketches, scenery, &c., and obtained at the cost, hazard, and inconvenience of a ten years' tour through the Southwestern prairies, New Mexico, California, and Oregon."[2]

When Stanley reached Oregon City, he found a lively, even poignant scene, worthy of art. Here was a sublime natural landscape, home to the Willamette Falls Indians, that was rapidly being developed into a bustling lumber town. The irony of this transformation was not lost on Stanley, who had dedicated himself to studying Indian life on the western frontier. He painted Oregon City as both a landscape of promise and a landscape of loss. Neat, new whitewashed houses and a church line the broad main street, where immigrants are seen arriving in covered wagons. Yet the lone Indian couple in the foreground, their limp bodies conveying their ruin and isolation, adds a sharp note of melancholy to the scene. The painter understood that a sense of the country's sacrifice added to the appeal of his pictures. "The time when the red men, who were once the sole occupants of our prairies and forests, will survive only in song and story is not far distant," one writer noted in celebrating Stanley's gallery the year after he died, "and these truthful and yet vivid delineations of a once great race of human beings will then constitute one of their best and most authentic records."[3]

PJ

1. *Spectator,* July 8, 1847.
2. "Auction sale of Stanley's Gallery [advertisement]," *National Intelligencer,* March 7, 1863.
3. Charles Richard Tuttle, comp., *General History of the State of Michigan; with Biographical Sketches* . . . (Detroit: R. D. S. Tyler and Co., 1873), 239–40.

WILLIAM SHARP
1803–1875

Complete Bloom [plate 5 from *Victoria Regia; or The Great Water Lily of America*], 1854

Chromolithograph on wove, white paper; plate: 15 × 21 in. (38.1 × 53.3 cm); sheet: 21¼ × 27 in. (54 × 68.6 cm)

Signed and inscribed, lower left: WM. *Sharp del.*; lower right: *Sharp & Son Chromolithr / DORCHESTER, MASS.*

Ruth Carter Stevenson Acquisitions Endowment

1999.33.E

Before immigrating to Boston in 1839, English-born William Sharp had enjoyed a productive career in London translating oil portraits into black-and-white lithographs. His ability to convert painted images into the technically demanding print form demonstrated a high degree of craftsmanship. He expanded his talents further when, in the early 1830s, he began experimenting with chromolithography. The firm Sharp established in Boston produced commercial lithographs, such as title-page illustrations for sheet music as well as portraits, in the years just before the advent of photography. He began making lithographs with the addition of one or two colors, which led to the creation of his magnum opus, his chromolithographs for Victoria Regia; or The Great Water Lily of America. *Shortly thereafter, the larger Boston printing firms that had begun working in color would overshadow Sharp's pioneering achievement. Even so, his works stand as quite possibly the finest chromolithographs executed in America up to that time.*

"IT WOULD NOT BE EXTRAVAGANT to call the beauties of this plant unsurpassable," wrote Thomas Meehan, the nurseryman and horticultural writer who first propagated *Victoria regia* in America.[1] The enormous size and astonishingly beautiful white and pink flower of this giant lily amazed its European discoverers in the early nineteenth century. The bloom itself could exceed one foot across, while its nearly circular, rimmed leaf grew up to six and one-half feet long and, it was said, could support a man's full weight.

It was appropriate, then, that a book meant to convey the character of such a plant was extraordinary as well. Indeed, the six majestic plates bound in *Victoria Regia; or The Great Water Lily of America* represent a perfect union of horticulture and color printing, two disciplines that grew increasingly sophisticated and popular as the nineteenth century progressed.

The volume reflects the varied attempts by John Fisk Allen, an amateur botanist from Salem, Massachusetts, to propagate the *Victoria regia*. A plant native to South America, it had first been grown domestically just three years earlier. The image seen here concentrates on the mature flower, a bud about a day before its unfolding, and, at the lower left, the plant's fruit.

The lavish plates in *Victoria Regia* are the work of William Sharp, a commercial printer in Boston who is credited with introducing color lithography to the United States. He had first made chromolithographs in his native England soon after the process was developed in Europe. Chromolithography marked a significant advance over black-and-white lithographs, which had to be colored by hand. The procedure was complex and involved overprinting many colored printing stones to create final images of rich depth and visual variety. Sharp surpassed any printer of his time when he turned his own drawings into the magnificent prints in this exceedingly rare book. The Amon Carter Museum has an intact copy of the volume.

JM

1. William Sharp, *Victoria Regia; or The Great Water Lily of America* (Boston: Dutton and Wentworth, 1854), 11.

FITZ HUGH LANE
1804–1865

Boston Harbor, 1856

Oil on canvas, 25½ × 42¼ in. (64.8 × 107.3 cm)

Dated lower right: *1856*

1977.14

Fitz Hugh Lane was a master of marine painting, an impeccable draftsman with a keen understanding of ships and an artist highly attuned to the nuances of light, sea, and space along the Atlantic coast. Born in the seafaring town of Gloucester, Massachusetts, Lane lived there most of his life and was understandably captivated by the view of Gloucester Harbor and the shoreline at Cape Ann. In Boston, as an apprentice in the prestigious lithography firm of William S. Pendleton, Lane acquired drawing skills and developed into an accomplished lithographer; he also encountered—and was greatly influenced by—the meticulously rendered and brilliantly luminous canvases of the English-born marine painter Robert Salmon (1775–after 1858). Back in Gloucester in 1849, he published his own lithographs and painted views distinguished by their clarity and expressive stillness. From Gloucester, he sailed often to Maine and made breathtaking views at Castine, Mount Desert, Blue Hill, and Owl's Head. Although he painted handsome ship portraits, his compositions turned increasingly spare and poetic, identifying him as an artist of uncommon vision. Lane lived to see his work become extremely popular, and several of his pieces were purchased and distributed by the American Art-Union.

BOSTON HARBOR IN THE 1850s proved the ideal subject for Fitz Hugh Lane to give free rein to his extraordinary technical skills and imagination. Lane's keen knowledge of diverse ship types that appeared in this golden age of American sea commerce and shipbuilding is a remarkable aspect of his art. His understanding of the details of hull type, rigging, and sail plan is unsurpassed in American marine painting and often overshadowed by his mesmerizing light effects.

Lane could show these widely varying ship types and complex forms from every perspective. Here, he depicts a large square-rigged bark at left head-on; an oblique port-side view of a steamer packet moving into the scene at center; the profile of a sleek, sharp-hulled modern clipper at right; and a scattering of towboats, fishing vessels, and other craft, all naturally arrayed about the harbor. "His pictures early delighted sailors by their perfect truth," the nineteenth-century critic Clarence Cook enthused:

> Lane knows the name and place of every rope on a vessel; he knows the construction, the anatomy, the expression—and to a seaman everything that sails has expression and individuality—he knows how she will stand under this rig, before this wind; how she looks seen stern foremost, bows foremost, to windward, to leeward, in all changes and guises.[1]

Lane's seascapes and harbor views are also remarkable studies of the vicissitudes of light. In this work he captures the diffuse, high, scattered clouds of a late afternoon and the still, humid air. Cook aptly praised such painting as "the work of a man who not only *knows* but has *felt* the sea."[2]

PJ

1. Clarence Cook, writing about Lane in *The Independent*, September 7, 1854, quoted in William H. Gerdts, "The Sea Is His Home: Clarence Cook Visits Fitz Hugh Lane," *American Art Journal* 17, no. 3 (Summer 1985): 48–49.
2. Ibid., 49.

Ludwig Friedrich (1827–1916) for
HERMANN LUNGKWITZ
1813–1891

San Antonio de Bexar, after 1857–ca. 1867

Toned lithograph with watercolor on wove, buff paper; plate: 17½ × 19¾ in. (44.5 × 50.2 cm); sheet: 18⅛ × 20 in. (46 × 50.8 cm)

Signed and inscribed, upper left to upper right, on stone: *Main Plaza. Alameda. Alamo. (1850.) Mission de la Concepcion [sic].*; lower center, on stone: *SAN ANTONIO DE BEXAR.*; lower left to lower right, on stone: *Mission San José. The New Bridge. San Pedro Spring. Mission San Juan.*; lower left, on stone: *Taken from nature by H. Lungkwitz.*; lower center, on stone: *drawn on stone by L. Friedrich*; lower right, on stone: *Rau & Son Lith, Dresden*

1963.3

Hermann Lungkwitz, an early Texas landscape painter and photographer, was born in Halle, a Prussian province of Saxony. From 1840 to 1843 he pursued artistic training at the Dresden Academy of Fine Arts, where he absorbed a romantic style of landscape painting popular in mid-nineteenth-century Europe. In his late thirties Lungkwitz moved to America with his mother, wife, and other relatives, reaching Texas in 1851. He earned his living as a farmer, photographer, and painter in various South Texas communities, including San Antonio and Galveston. The artist also lived in Austin, where he worked as a photographer for the General Land Office and conducted art lessons in German-English schools. Trained in the traditional academic manner, Lungkwitz first made drawings on site, then translated them into oil paintings in his studio. The works that survive, studies of mid-nineteenth-century landscapes and towns in South Texas, comprise an invaluable historical record.

THIS EXCEEDINGLY RARE PRINT shows the tranquil town of San Antonio emerging from a prolonged period of hostilities that had decimated its population. Long a frontier military post, it had weathered occupation by the Mexican army, the upheaval of the Texas Revolution (1835–36), and the U.S.-Mexican War (1846–48).

Finally, it seems, peace has come. Gone are the machines of war; the central image here reveals a serene setting featuring a team of horses, city officials, and Mexican vaqueros on a road lined with modest, single-story adobe houses leading into town. The title of the print reveals the community's Spanish eighteenth-century origins, as do the missions established to bring Catholicism to the Native Americans of South Texas. Other landmarks depicted in the vignettes above and below the central image include such hallmarks of civilization as a tree-lined promenade, a new bridge, and the town's water resources. Emphasizing the peace and prosperity of the American West, city views such as this one were created to lure settlers to burgeoning communities.

The circumstances of this print's production correspond with the history of settlement in the region. The work is based on paintings by Hermann Lungkwitz, one of Texas' first landscape artists. Born and trained in Saxony, he immigrated to New York City in 1850 and, like many of his countrymen, gravitated to south-central Texas, where a progressive German community had been established in the early 1830s. Lungkwitz sent his original paintings to Dresden to be translated into lithographs by Ludwig Friedrich, a friend and fellow art student at the Dresden Academy of Fine Arts. Friedrich transferred the images to the lithographic stone from which multiple impressions were printed and distributed. Such collaborations are representative of the fascinating, multicultural milieu in mid-century San Antonio, home to Germans, Spaniards, Native Americans, and Anglos.

JM

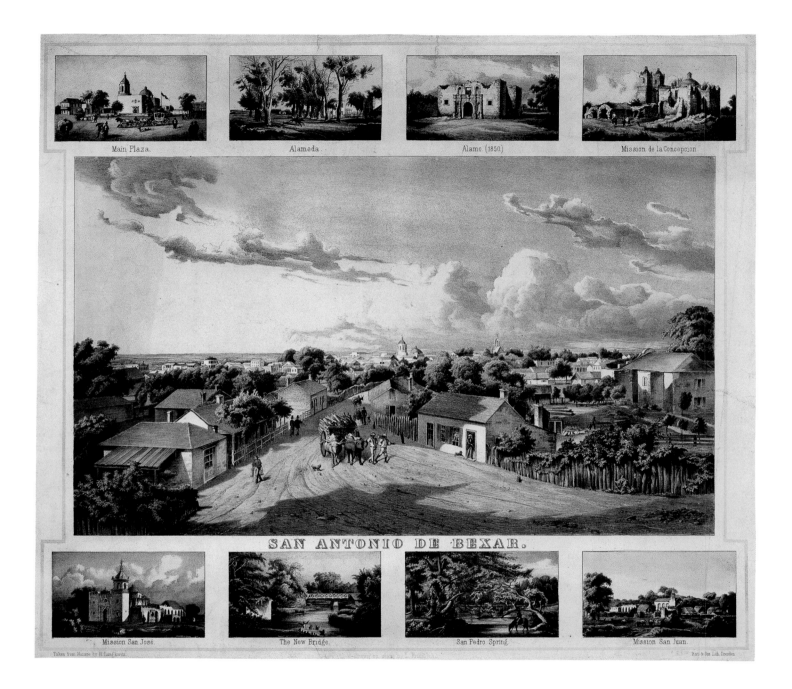

Main Plaza.

Alameda.

Alamo. (1850)

Mission de la Concepcion.

SAN ANTONIO DE BEXAR.

Mission San José.

The New Bridge.

San Pedro Spring.

Mission San Juan.

Taken from Nature by H. Lungkwitz.

Bael & Son Lith. Dresden.

James McNeill Whistler
1834–1903

James McNeill Whistler was a highly original painter, a sensitive draftsman, and a master printmaker. He was born in Lowell, Massachusetts, and, as a young man of privilege, was educated at West Point. He delighted in line drawing and etching from the time he worked as a cartographer for the U.S. Coast and Geodetic Survey in Washington, D.C. Whistler left America for Paris in 1855 and produced his first series of etchings there in 1858; ultimately, he created some four hundred works in that sensuous medium. His early etchings— landscapes of France and the Rhineland and views of London—stand in marked contrast to the portraits he was painting in oil during this same period. In Venice in 1879 he experimented further with etching, creating an extraordinary suite of intimate, tonal, atmospheric city scenes. Around this same time, he began working in lithography and used that graphic medium increasingly for the rest of his life.

Fumette, Standing, 1859

Etching, drypoint, and lavis on laid paper; plate: 13⅝ × 8¾ in.
(34.6 × 22.2 cm); sheet: 16⅜ × 11 in. (41.6 × 27.9 cm)

Signed and dated lower right, in plate: *Whistler. 1859.*

Purchase with funds provided by Nenetta Burton Carter

1981.17

FUMETTE, STANDING evokes both the professional and personal aspects of Whistler's experiences as a young art student in Paris. Living a bohemian life in the Latin Quarter, he consorted with young working-class women, the first of whom was known as Fumette. Their impulsive personalities produced a tempestuous relationship, but it also yielded several etchings by the artist. In this depiction of his lover, Whistler used animated, wiry lines, paying careful attention to her head, which turns toward him; her half smile suggests both intimacy and apprehension; and her informal posture—with one hand tucked into the pocket of her dress—implies a lack of pretension. Her sweeping skirt, less heavily worked than the head and torso, is rendered with a simple linear definition that creates volume.

One of Whistler's friends recalled Fumette's striking appearance and magnetic personality:

> She was a remarkable person. . . . As this was long before the fashion came in for women and children to wear their hair hanging loose, and not in plaits down their backs, [she] attracted the notice of passers-by almost as much as Whistler did when he was wearing "more Americano," his summer suit of white duck. . . . She used to go about bareheaded and carrying a little basket containing the crochet work she was in the habit of doing, and a volume of Alfred de Musset's poems.[1]

In Paris Whistler discovered the expressive power of the etched line, which he was soon exploiting to considerable effect. To execute this etching, he brushed the plate with acid using a technique known as *lavis*, or brush bite. The acid bit into the plate just enough to hold a faint layer of ink that appears to cast a shadow behind Fumette, providing spatial context. Whistler's use of the drypoint engraving technique, in which a sharp needle is used to scratch into a copper plate, imparts a warm, feathery quality to his lines. Such intimate, unmannered etchings launched his artistic career and strongly influenced other American printmakers, whose etching revival would begin in the 1870s.

JM

1. Thomas Armstrong, "A Memoir: Whistler in Paris," 1912, quoted in Robin Spencer, ed., *Whistler: A Retrospective* (New York: Hugh Lauter Levin Associates, 1989), 58.

Lyman Wetmore Atwater (1835–1891)
after
CHARLES PARSONS
1821–1910

Central-Park, Winter. The Skating Pond, 1862

Lithograph with watercolor on wove, cream paper; plate: 18⅛ × 26½ in. (46 × 67.3 cm); sheet: 21¾ × 30 in. (55.2 × 76.2 cm)

Signed, dated, and inscribed, lower left, in stone: *CURRIER & IVES, LITH. NY.*; lower right, in stone: *LWA/C. PARSONS, DEL.*; lower center: *ENTERED ACCORDING TO ACT OF CONGRESS IN THE YEAR 1862, BY CURRIER & IVES, IN THE CLERK'S OFFICE OF THE DISTRICT COURT OF THE UNITED STATES, FOR THE SOUTHERN DISTRICT OF NEW YORK. / CENTRAL-PARK, WINTER. / THE SKATING POND. / NEW YORK, PUBLISHED BY CURRIER & IVES, 152 NASSAU ST.*

1970.165

Born in Hampshire, England, in 1821, Charles Parsons arrived in America as a child. At age fourteen he was apprenticed to the New York lithographer George Endicott, during a time when lithography was in its infancy. He rose to the head of Endicott's art department and there made popular prints for his own firm and for Currier & Ives. He remained with Endicott for nearly thirty years, leaving in 1863 to become head of the art department at Harper and Brothers publishers. Although he spent his entire career as a commercial artist, Parsons also worked quietly as a watercolor painter, exhibiting in the annual showcases at the National Academy of Design and the Brooklyn Art Association. His friend the lithographer Lyman Atwater may have been one of Parsons' many apprentices.

LITHOGRAPHY MADE POSSIBLE the mass production of art prints, and the New York City firm established by Nathaniel Currier and James M. Ives dominated the large field of popular printmakers working in the major cities by the 1840s. The firm's vast output of prints—landscapes and marine subjects, urban views, and scenes of daily life—has helped shape our understanding of nineteenth-century America.

By 1862, when this lively scene was made for Currier & Ives, the demand for their colorful prints was so great that they were enlisting the aid of artists across New York to create new material. Charles Parsons, a skilled painter and draftsman, was head of the art department at George Endicott's lithographic firm, but he was frequently called upon to create lithographs for the Currier & Ives imprint. Parsons collaborated often with Lyman Atwater, who drew this Parsons design on stone.

One of the most ambitious and engaging lithographs Currier & Ives ever issued, this print remained popular for decades. The nation's first urban rink was opened in Central Park in 1860, and the new ice-skating craze is commemorated here. The charming animation of the figures—more than seventy skaters are pictured—owes as much to Atwater's skill in rendering Parsons' lively design upon stone as it does to the painter's grand conception of the scene. Atwater must have proved himself to Parsons as a superior draftsman since Parsons would have settled for no less in the making of popular prints. He was remembered for imparting great discipline in drawing to the many apprentice lithographers he helped train during his long career as a commercial artist. He also won the respect of many fine printmakers, including Edwin Austin Abbey (1852–1911) and Joseph Pennell (1857–1926). "Pennell has said to me more than once," a friend of Parsons recalled, "that the growth of a real and vital American art started in the department of Mr. Parsons in Franklin Square."[1]

PJ

1. From the reminiscence of W. A. Rogers, quoted in Harry T. Peters, *America on Stone* (New York: Doubleday, Doran and Company, 1931), 308.

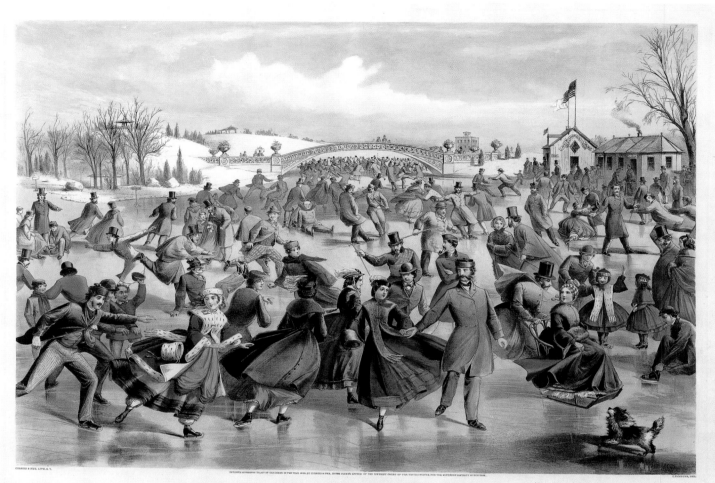

CENTRAL - PARK, WINTER.
THE SKATING POND.

JAMES GARDNER

1832–unknown; active 1860s

Ruins of Norfolk Navy Yard, Virginia, 1864; printed 1866

From *Gardner's Photographic Sketch Book of the War*

Albumen silver print, 7 × 9 in. (17.8 × 22.9 cm)

P1984.30.18

A native of Scotland, James Gardner immigrated in 1856 to the United States, where he soon was making photographs. In 1858 both he and Timothy O'Sullivan [q.v.] worked as apprentice photographers in Mathew Brady's Washington, D.C., studio, managed at the time by Gardner's talented older brother, Alexander. During the Civil War, Gardner assisted in many of his brother's early photographic field assignments, contributing to the latter's seminal work, Gardner's Photographic Sketch Book of the War *(1866). Together, they operated a portrait gallery in Washington in 1863. They both continued to document the war, and during 1864 James photographed hospitals and landmarks in Fredericksburg, as well as the Norfolk shipyards. There is reason to speculate that after the war he worked briefly with a U.S. geological survey and operated a studio in Boston. But apart from his photographic activities during the 1860s, little about his life is known.*

"A CURIOUS SPECTACLE OF INDUSTRY in the midst of ruin" was how the photographer Alexander Gardner described this Norfolk Navy Yard scene in his monumental, two-volume documentation of the Civil War.[1] On May 9, 1862, when Confederate troops were forced to abandon the city, they destroyed as much of the yard as they could—setting fire to the shops, warehouses, and barracks and leaving nearly two hundred acres in ruin. Because the area was strategically located, however, the occupying Union forces rebuilt some of the shops and continued to use the yard.

Cumbersome camera equipment largely prevented Civil War–era photographers from making pictures during battles, so much of the photographic documentation of the war is scenes of death and destruction in the wake of conflict. In 1864 James Gardner, brother of Alexander and a member of his photographic team, depicted *Harper's Weekly* illustrator Alfred Waud as he contemplated the yard's devastation. The photograph makes thinly veiled references to the ruins of the great civilizations of Rome and Greece. In fact, Waud wrote the words "Pendant to Marius in Carthage" on his own copy of this photograph; the allusion is to a Roman soldier and consul who, when cornered and ordered to leave the country, declared, "Tell the praetor that you have seen Caius Marius a fugitive sitting on the ruins of Carthage."[2]

BMC

1. Alexander Gardner, *Gardner's Photographic Sketch Book of the War* (Washington, D.C.: Philip and Solomons Publishers, 1866), vol. I, no. 18, n.p.
2. Frederick E. Ray, *Alfred R. Waud, Civil War Artist* (New York: Viking Press, 1974), 37.

JOHN WILLIAM HILL
1812–1879

Sleeping Giant, Mt. Carmel, Connecticut, 1865

Watercolor, graphite underdrawing, and gum arabic glazes on wove, off-white paper, 6⅝ × 13⅜ in. (16.8 × 34 cm)

Signed and dated lower left: *J.W.Hill / 1865*

1983.141

John William Hill, son of the engraver John Hill [q.v.], was born in London. After his family moved to New York City in 1822, he was apprenticed to his father and worked with him on the aquatint plates for the artist William Guy Wall's [q.v.] Hudson River Port Folio (1821–25). The younger Hill found additional work as a topographical illustrator of landscape and city subjects for various publishing enterprises. A follower of the English artist and critic John Ruskin (1819–1900), he associated with the group known as the American Pre-Raphaelites and traveled to New England and upstate New York in search of subjects. In addition to the American landscape, Hill made detailed watercolor still lifes of fruit, birds' nests, and game, all portrayed within the context of their natural setting. His son, John Henry Hill, also became a watercolorist and printmaker. John William Hill settled with his family in West Nyack, New York, in 1838 and died there in 1879.

JOHN WILLIAM HILL painted this tranquil summer evening scene during one of his extended trips to New England, two years after he helped found the Association for the Advancement of Truth in Art. The group, also known as the American Pre-Raphaelites, favored the application of watercolor in an exacting manner in order to provide faithful transcriptions of nature. Seeking new modes of expression, these artists had a predilection for brilliant color and minute detail achieved through sustained on-site work. Here, Hill captured this reverence for nature by depicting that moment when the sun's sinking rays cast dramatic blue shadows on the eastern slopes of the hills and lengthening green shadows across the foreground. He achieved these transitory, highly nuanced effects through a careful layering of transparent watercolors.

The so-called Sleeping Giant, a well-known landmark located in Connecticut's Mt. Carmel range, is a gently rolling configuration that suggests a reclining figure. Its almost human form, which in this composition lies with its head to the left and its feet to the right, inspired several Native American legends about its origins. Hill's meticulous technique is equally in evidence in the tiny figure that crosses the meadow on a footpath; the artist created the whites of the figure's shirt and the scattered sheep by lifting the watercolor after it had dried, thereby exposing the white paper underneath.

JM

SEVERIN ROESEN
1815 or 1816–after 1872

Still Life of Flowers and Fruit with a River Landscape in the Distance, 1867

Oil on canvas, 35⅛ × 48⅛ in. (89.2 × 123.2 cm)

Signed and dated lower right: *S. Roesen* [initials in monogram]. / *1867*

1987.9

Little is known about the life of Severin Roesen, including his birthplace. He is first listed in the New York City directory in 1848, the year he exhibited a masterful still life at the American Art-Union. His still-life paintings are among the most beautiful produced in America during the nineteenth century; they most often consist of lavish arrangements of fruits or flowers. He is possibly the same Severin Roesen who exhibited a flower painting in Cologne in 1847, and certainly his style suggests a familiarity with German, Dutch, and Flemish floral still lifes. There is evidence that by 1859 Roesen was painting in Harrisburg, Pennsylvania. The following year his wife—abandoned—identified herself in the New York City directory as "widow, occupation, seamstress." His painting activity confirms that in 1866 Roesen moved up the Susquehanna Valley and settled in Williamsport, Pennsylvania. He executed his last dated painting there in 1872.

ROESEN DELIGHTED IN PAINTING FRUIT AND FLOWERS in great profusion, often requiring extremely large canvases to accommodate his grandiose visions. The ambition of his productions is astonishing, especially given the fact that he painted them as something of an itinerant, spending much of his career moving from town to town in rural Pennsylvania. The sheer quantity of his output—more than three hundred Roesen paintings have been identified—testifies to his extraordinary popularity and success, also remarkable when we consider that he spent much of his life as an impecunious loner.

Roesen stayed longest in the lumbering center of Williamsport, where this elaborate floral still life was painted. Such bounteous displays clearly struck a chord with the region's newly prosperous residents, and he probably painted this and other canvases on commission. Although Roesen had submitted paintings to major exhibitions in New York City early in his career, once he set off into the Susquehanna Valley he seems not to have sought recognition beyond his local audience. He always worked within the same basic format—building tabletop arrangements of flowers or fruit in greater or lesser profusion. Never, it seems, was he forced to try his hand at either portraiture or pure landscape, the usual stock-in-trade of the itinerant artist. He was a master still-life painter, perhaps German-trained, who appeared in America at mid-century with his particular talent fully developed. With fortuitous timing, Roesen produced works reflective of the renewed optimism that characterized America in these years. His magnificent still lifes visually embodied the abundance and plenitude that defined the nation in the popular imagination.

PJ

CARLETON E. WATKINS
1829–1916

The Rapids with Indian Block House, Cascades, 1867;
printed 1872

Albumen silver print, 15¾ × 20¾ in. (40 × 52.7 cm)

P1989.13.2

Carleton E. Watkins was born in Oneonta, New York, and moved to California in 1851. By 1858 he had made some of the earliest photographs of San Francisco. His spectacular mammoth-plate images of Yosemite, produced in 1861, brought him great recognition and prompted Congress to pass legislation to preserve the area. In 1867 he received a bronze medal at the Paris International Exposition, but he still had to borrow money for his trip that year to Oregon and the Columbia River area. In 1869, to gain a broader audience for his work, Watkins devoted himself to the production of stereographs. But his Yosemite Art Gallery, initially a success, faltered because of his lengthy absences. Commissioned assignments served to subsidize trips to create speculative views; throughout his life he had no consistent employment. Most of Watkins' inventory, including his negatives, was purchased by I. W. Taber in 1875–76 to settle debts. Taber began to market the works under his own name, forcing Watkins to return to the same sites to make new views. By 1890 the demands of extended travel led Watkins into physical decline. Not long after his photographic negatives were destroyed in the San Francisco earthquake and fire of April 1906, he was declared mentally incompetent. In 1983 the Amon Carter Museum held the first major retrospective of Watkins' work, recognizing him as perhaps the greatest of all the photographers of the American West.

DESPITE ENCOUNTERING CONSISTENTLY DISMAL WEATHER, Watkins created some of his finest photographs along the Columbia River through the summer and early fall of 1867. Before his trip to the Northwest, he had established an international reputation as a master of his craft with magnificent photographs of Yosemite Valley in California. In photographing the Columbia River, Watkins faced a formidable challenge: its terrain lacked the grandeur of Yosemite. His mandate was to document economic development along the waterway, focusing particularly on the activities of the local steamship line that had helped finance his trip. Yet rather than merely recording and promoting the region's commercial success, the artist created delicately balanced compositions that just as effectively revealed the area's subtle beauty.

One of the project's most engaging images, *The Rapids with Indian Block House, Cascades,* shows a series of perilous rapids along the Lower Columbia and also illustrates the successful establishment of an economic entity in the vast wilderness. The substantial clapboard house or tavern, the mill at the lower right, and the rail line running along the distant riverbank no longer require the protection that the log blockhouse once provided. The central focus of the photograph is the huge lone tree surrounded by an apron of stumps. Practically, this majestic sentinel served to warn river traffic of the dangerous rapids ahead; symbolically, it evokes the rampant logging activity that both opened up the region commercially and, ultimately, depleted it.

JR

MARTIN JOHNSON HEADE
1819–1904

Thunder Storm on Narragansett Bay, 1868

Oil on canvas, 32½ × 54¾ in. (82.6 × 139.1 cm)

Signed and dated lower left: *M. J. Heade / 1868*

1977.17

Born in Lumberville, Pennsylvania, Martin Johnson Heade was largely self-taught, though when he was a young man he took lessons from his neighbor, the Quaker artist Edward Hicks (1780–1849). He began as a portrait painter, but through his travels he gained exposure to other art forms. In New York City in 1859 he had the good fortune to find quarters in the famous Tenth Street Studio building and there befriended the eminent landscape painter Frederic Church [q.v.]. His work clearly shows, however, that Heade was an artist of uncommon vision who did not follow the mainstream. On both the East and West Coasts of this country, he painted the sea in its various moods. In South America, he studied exotic flora and hummingbirds; in coastal lowlands from New England to Florida, he painted the mysterious salt marshes. In 1885 he moved to St. Augustine, Florida, and only then did he win the support of a devoted patron in Henry Morrison Flagler. Heade's highly original art was unpopular with the critics during his lifetime and was overlooked until the mid-twentieth century.

IN THE HISTORY OF NINETEENTH-CENTURY AMERICAN ART, Heade's *Thunder Storm on Narragansett Bay* is a landmark. Although the artist's name had long been forgotten when this work appeared on the New York art market in 1943, viewers were awed when it was first exhibited that year at the Museum of Modern Art. Almost overnight it reestablished Heade as one of the country's most original painters. It was a watershed event, signaling other discoveries yet to be made in American art and pointing up the creative heights that many American painters of the past—long overlooked—had achieved.

Although it inspired groundbreaking studies of Heade's life and career and of nineteenth-century landscape traditions, *Thunder Storm on Narragansett Bay* remains one of American art's most enigmatic works. The strange scene, terrifying in its black sky and sea and its disquieting calm, yet beautiful in its color pattern, invariably captivates viewers. Modern audiences have sensed affinities with surrealism in the painting's hyperrealistic, hallucinatory, visionary aspect. Light, color, and spatial effects seem illogical and unsettling. This exceedingly spare, minimal landscape is less a study of place than it is a vehicle for contemplation. Nineteenth-century viewers, accustomed to admiring Heade's brilliant, light-filled studies of marshlands and the seacoasts, were simply confounded by this creation. When it was unveiled at the Brooklyn Art Association's annual exhibition held at the Brooklyn Academy of Music in March 1868, one commentator noted:

> Everyone who has visited the Academy has observed this picture, and everyone has indulged in criticism upon it. The corner near where it is hung is always crowded, and it is really amusing to mingle with the throng and listen to the conflicting remarks which are made upon it. . . . The only point upon which everybody agrees as to Mr. Haede's [*sic*] picture is that it is "very peculiar."[1]

PJ

1. "The Art Association: Third Day of the Exhibition—More of the Pictures," *Brooklyn Daily Eagle,* March 21, 1868, quoted in Sarah Cash, *Ominous Hush: The Thunderstorm Paintings of Martin Johnson Heade,* exh. cat. (Fort Worth: Amon Carter Museum, 1994), 80.

TIMOTHY O'SULLIVAN
1840–1882

Savage Mine, Curtis Shaft, Virginia City, Nevada, 1868

Albumen silver print, $5^{11}/_{16} \times 7^{15}/_{16}$ in. (14.4 × 20.2 cm)

P1991.4.1

Timothy O'Sullivan emigrated with his family from Ireland to the United States in 1842, and he began assisting in Mathew Brady's Washington, D.C., studio when he was a young boy. In 1861 he joined Brady's team of photographers working under Alexander Gardner and made photographs of Civil War scenes. Forty-four of his images—more works than by any other photographer—appear in Gardner's Photographic Sketch Book of the War (1866). In 1867 the twenty-seven-year-old photographer joined Clarence King and the Geological Exploration of the Fortieth Parallel. He stayed with the team for two years, and they documented mining towns in central Nevada and sites along the parallel from southern Wyoming to northwestern California. Appointed official photographer of the Darien Survey in 1870, O'Sullivan traveled to the Isthmus of Panama, recording possible routes for a ship canal. He made his way west again in 1871, with Lieutenant George M. Wheeler's Survey of the Southwest. From 1867 to 1874 O'Sullivan spent almost every year, from May through September, photographing in the West. During the winter, he worked in the nation's capital as a photographer and printer.

IN FEBRUARY 1868 the eminent geologist Clarence King assigned Timothy O'Sullivan the task of photographing two mines in Virginia City's mineral-rich Comstock Lode for the Geological Exploration of the Fortieth Parallel. Before descending with the miners nine hundred feet below ground in order to make what would be some of the earliest subterranean mining photographs, O'Sullivan paused at the shaft landing to document this scene. He supplemented the natural light through the windows behind the men's heads with a combination of artificial lighting from lanterns and burning magnesium; the resulting effect is a ghostly yet balanced triptych. Three men on the left line up to descend in a cage to the lower depths, where the temperature could reach 120 degrees and "the stenches of decaying vegetable matter, hot foul water, and human excretions intensify the effect of the heat."[1] The men on the right push out ore carts containing the fruits of their labor, implying that all the industry's efforts and expenses would be offset by profits.

In 1870 this photograph became the first of the King survey photographs to be published in the official reports delivered to Congress, when *Mining Industry*, the report's third volume, was printed to emphasize the practical side of the survey's mission. Serving as the volume's lithographic frontispiece, the image was presented as a metaphor for the mining industry, as well as propaganda to encourage further exploitation of the land.

BMC

1. Richard E. Lingenfelter, *The Hard-Rock Miners: A History of the Mining Labor Movement in the American West, 1863–1893* (Berkeley and Los Angeles: University of California Press, 1974), 13.

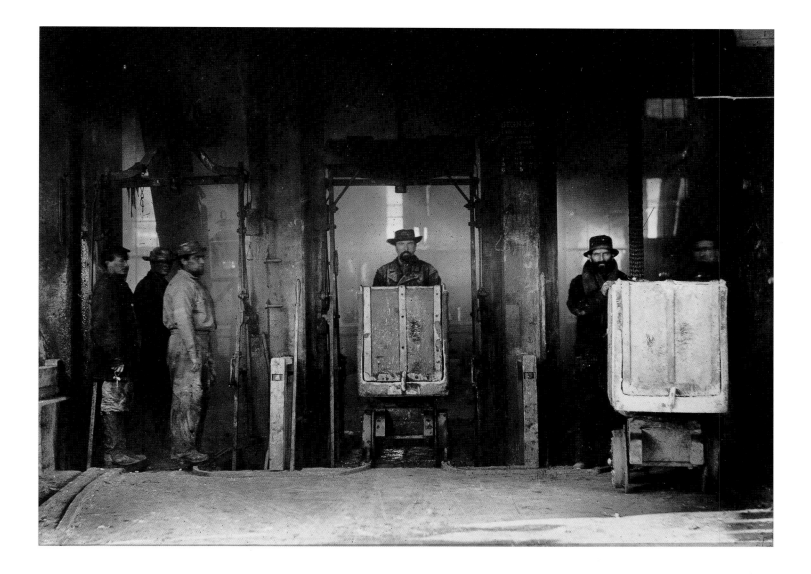

HENRY RODERICK NEWMAN
1843–1917

Kaaterskill Falls, 1869

Transparent and opaque watercolor on wove, off-white paper, 10⅜ × 10 in. (26.4 × 25.4 cm)

Signed, dated, and inscribed, lower left: *HR Newman Catskill*; lower center: *Catskill New York / August 1869*

Purchase with funds provided by the Council of the Amon Carter Museum

1998.26

Henry Roderick Newman was born in Easton, New York. Although his physician father discouraged him from pursuing an art career, the young man was intrigued by the contemporary fascination with detailed watercolor landscapes. He befriended the group known as the American Pre-Raphaelites, who, following the teachings of the English critic John Ruskin (1819–1900), advocated working from a close study of nature. In 1864 they admitted Newman to their organization, the Association for the Advancement of Truth in Art. Three years later he was elected a member of the American Society of Painters in Water Colors. Throughout the 1860s, at the peak of the American Pre-Raphaelites' popularity, Newman regularly exhibited his painstakingly executed watercolors in New York City. Long plagued by fragile health, he moved to Europe in 1870 and in the 1880s settled permanently in Florence. In 1877 he met Ruskin and became known as an important American expatriate artist. He traveled throughout Europe and North Africa, making watercolors of architectural monuments and still lifes of flowers and fruits silhouetted against their natural surroundings.

BY THE SUMMER OF 1869, when Henry Roderick Newman painted Kaaterskill Falls in New York's Catskill Mountains, the site had been satisfying the wanderlust of American landscape painters and summer tourists for more than forty years. Artists such as Thomas Cole [q.v.], who christened the mighty falls "the solitary song of the valley," featured in their compositions the most dramatic perspectives of this natural wonder.[1] These overall views embraced the imposing upper and lower falls—together, the highest in the state—as they roared down a semicircular amphitheater of stone.

Newman's viewpoint, on the other hand, was unconventional and subtle compared to those of his predecessors. In the foreground he depicted a tranquil mountain spring coursing across a sandstone ledge toward its precipitous fall of 260 feet; the deciduous trees and evergreens mirror the drop, trailing down the sharp incline into the distant valley below. One of many writers to venerate the falls in the nineteenth century echoed Newman's graceful ensemble of water, trees, and sky on a summer's day: "When the Cauterskill [*sic*] Falls are seen to the best advantage, *words which command no colors* must fail to portray the rare and exquisite effect produced by the flashing water, the rich, serious green of the foliage, and the movements of the fleecy clouds, which tremble in the sky above."[2]

To render the atmosphere of a warm August day, Newman employed a remarkable array of techniques. He blotted the watercolor after its application to form the damp mists, creating the effect of spatial recession into the distance. He also applied selective glazing to make certain passages more intense, as seen in the trees in the middle ground. Newman's delicate views of American scenery are rare. Shortly after completing this work, the artist's health declined, and he moved abroad, painting in Europe for the rest of his life.

JM

1. Quoted in John K. Howat, "A Picturesque Site in the Catskills: The Kaaterskill Falls as Painted by William Guy Wall," *Honolulu Academy of Arts* 1 (1974): 23.
2. S. S. Colt, *The Tourist's Guide through the Empire State. Embracing All Cities, Towns, and Watering Places, by Hudson River and New York Central Route* (Albany, N.Y.: Mrs. S. S. Colt, 1871), 66.

WINSLOW HOMER
1836–1910

Crossing the Pasture, 1871–72

Oil on canvas, 26¼ × 38 in. (66.7 × 96.5 cm)

1976.37

Boston native Winslow Homer was always a keen observer of the people around him. He had honed his skills as an illustrator and artist-journalist, working first for the Boston lithography shop of John Bufford and, finally, for the popular Harper's Weekly *in New York City. The wood engravings after Homer's drawings from life are unparalleled in the history of American illustration and are distinctive for their unconventional, dynamic compositions; their striking use of black-and-white line; and their dramatic narrative constructs. Although he was largely self-taught, Homer brought his innate flair for pictorial design and subtle story-telling to painting, his first oils being poignant and dramatic scenes taken among General George B. McClellan's Army of the Potomac in 1862. During the 1870s the artist produced lively genre subjects reflective of the buoyant sprit of post–Civil War America: enigmatic young women at leisure, factory girls, school-boys, and rustic types at play. By the end of the decade, Homer was recognized as a formidable talent whose originality had touched three realms: the graphic arts, watercolor, and oil painting.*

ON JUNE 7, 1871, the *New York Evening Post* reported that "Winslow Homer will spend the summer among the Catskills."[1] His weeks in and around the village of Hurley, New York, brought forth a remarkable group of interconnected paintings that take as their subjects the schoolboys and factory girls whose lives played out against the backdrop of the green hills. Working back in his Manhattan studio through the fall and winter, Homer turned out canvas after canvas that evoke the charms of rural life while retaining the freshness of his experience in the outdoors.

Crossing the Pasture, one of the largest of these canvases, typifies Homer's extraordinary powers of transcription. The boys, apprehensive as they cautiously pick their way across the pasture, are solidly drawn and expressive in their body language. The paint handling is deft; Homer's touch is light, and his colors are pure and brilliant, laid down in broad, flat dashes. "Mr. Winslow Homer . . . rarely carries his works beyond the finish of sketches"; this was a characteristic response from critics who were simultaneously amazed and confounded by the unconventional lack of "finish" in his paintings.[2]

A brilliant light and a palpable atmosphere envelop the scene, inviting the viewer almost to feel the warm sun and cool breeze in this high pasture. For the careful observer, the painting hints at a story. Homer suggests the plot only subtly: behind the tense and watchful boys is an ever-vigilant bull.

PJ

1. Quoted in Nicolai Cikovsky, Jr., and Franklin Kelly, *Winslow Homer*, exh. cat. (New Haven, Conn., and London: Yale University Press for the National Gallery of Art, Washington, D.C., 1995), 394.
2. *Art Journal* (March 1875): 2, quoted in Kristin Hoermann, "A Hand Formed to Use the Brush," in Marc Simpson, *Winslow Homer: Paintings of the Civil War*, exh. cat. (San Francisco: Fine Arts Museums of San Francisco and Bedford Arts, 1988), 108.

JAMES MCNEILL WHISTLER
1834–1903

Study for "Symphony in Flesh Color and Pink (Mrs. Frederick R. Leyland)," 1871–74

Pastel and charcoal on wove, brown paper, 11¼ × 7¼ in. (28.6 × 18.4 cm)

Signed left center: [the artist's butterfly insignia]

Purchase with funds provided by the Council of the Amon Carter Museum

1990.9

James McNeill Whistler was born to wealth in Lowell, Massachusetts, and was educated at West Point. In 1855 he went to Paris to study art and never returned to the United States. London became his permanent home after 1859. Portraiture dominated Whistler's early work and reflected his association with London society. Despite his success and connections, he left England for a time in 1879, when disputes with the critic John Ruskin (1819–1900) and his former friend and patron Frederick R. Leyland bankrupted him. He went to Venice and there redirected his art, exploring the light and atmosphere of the city in delicate pastels, watercolors, and etchings. Whistler returned to London in 1881 and lived there until the end of his life, but he never again looked upon his adopted city with the same affection. In 1890 this famously irascible artist published a memoir, a collection of letters that he called The Gentle Art of Making Enemies.

WHISTLER'S NAME IS FOREVER LINKED with that of Frederick R. Leyland, for whom the artist designed his daring "Peacock Room" in 1876, giving full rein to his decorative impulses and, in the process, alienating his longtime friend and patron. Although Whistler created a splendid and original interior for Leyland's London home, his association with the Liverpool shipping magnate ended disastrously, with Whistler declaring bankruptcy in 1879, partly because Leyland refused to pay the artist for what he regarded as a decadent scheme.

A decade earlier Leyland and his young wife, Frances, had commemorated their close friendship with Whistler by commissioning family portraits. Because portraiture was an important source of income for Whistler, he welcomed such commissions. He also delighted in the formal challenges of elevating the portrait genre to the level of decorative and expressive art. Whistler always sought in his paintings a well-organized and beautiful design, looking for color harmonies and attractive arrangements of shapes. "Nature contains the elements, in color and form, of all pictures, as the keyboard contains the notes of all music," he explained, "but the artist is born to pick and choose, and group with science, these elements, that the result may be beautiful—as the musician gathers his notes and forms his chords, until he brings forth from chaos glorious harmony."[1]

Accordingly, he conceived of Mrs. Leyland as a "symphony" in pink tones. Costume was to play a large role in Whistler's artful conceit, and he worked diligently to design a dress with just the right expressive character, making a series of costume studies in pastel. These drawings are, like the example here, lovely color notes and flights of fancy in and of themselves. Fashion was everything to Whistler, and for Mrs. Leyland's portrait he selected a modish new style of rococo-revival dress, elaborate but delicate, conveying the idea of ethereal beauty and proclaiming his subject to be a woman of highly refined taste and artistic temperament.

PJ

1. Whistler, in his famous "Ten O'Clock" lecture delivered in London in 1885, quoted in Margaret F. Macdonald, *Notes, Harmonies, and Nocturnes: Small Works by James McNeill Whistler,* exh. cat. (New York: Knoedler and Company, 1984), 11–12.

WILLIAM TROST RICHARDS
1833–1905

An Autumnal Snow on Mount Washington, 1872

Transparent and opaque watercolor over graphite underdrawing on wove, green paper, 8¼ × 14 in. (21 × 35.6 cm)

Signed and dated lower left: W^m *T. Richards 1872*

Purchase with assistance from an anonymous donor

1983.142

Based primarily in his hometown of Philadelphia, William Trost Richards received minimal training with a private art instructor both there and in Düsseldorf. After seeing the work of contemporary British artists in an exhibition at the Pennsylvania Academy of the Fine Arts in 1858, he began painting in the exacting manner typical of the group known as the American Pre-Raphaelites. He soon was acknowledged as a leader of that movement and in 1863 was unanimously elected to its organization, the Association for the Advancement of Truth in Art. Watercolor was Richards' preferred medium, and he exhibited and sold his work frequently during the 1860s and 1870s. At the same time, he visited the coasts of New Jersey, Massachusetts, and Maine, making many renderings of marine subjects. With the rise of impressionism, his meticulous technique fell out of favor, so Richards broadened his style, becoming increasingly interested in the effects of natural light. He traveled often to Europe in search of fresh subject matter. Richards remained active until the end of his life and died at his second home, in Newport, Rhode Island, in 1905.

DESPITE HIS MODEST MEANS, the Reverend Elias Lyman Magoon (1810–1886) was an avid patron of contemporary American painters. A Baptist clergyman, Magoon assembled a personal collection that reflected his belief in both the aesthetic and spiritual qualities of the landscape. After meeting William Trost Richards in 1870, Magoon became a passionate advocate of the artist's watercolors. This view of Mount Washington is among those he commissioned the artist to make of the White Mountains, located in his native New Hampshire.

Discovered by artists and writers early in the nineteenth century, the White Mountains quickly became a favorite area for tourists, who could reach the summit of Mount Washington after the Cog Railway was completed in 1869. Richards, who traveled there in 1872, portrayed a breathtaking distant vista of the mountain, the highest peak in the East. Cleverly imparting the sensation of breadth within an intimate format, he relied upon the toned paper to suggest a hazy atmosphere. To the upper two-thirds of the sheet, the artist added spare touches of white watercolor and transparent blue washes to delineate the contours of the mountain's snowcapped peak and the distant landscape. By comparison, the autumnal landscape in the foreground is more complex and highly finished. An exquisite mélange of pink, yellow, brown, green, and white defines the individual leaves, the rocks' rough edges, and a cascading stream. This naturalistic coupling of a vivid foreground with a more ethereal perspective attests to the artist's sophisticated technique, which made him one of the most popular watercolorists of his time.

JM

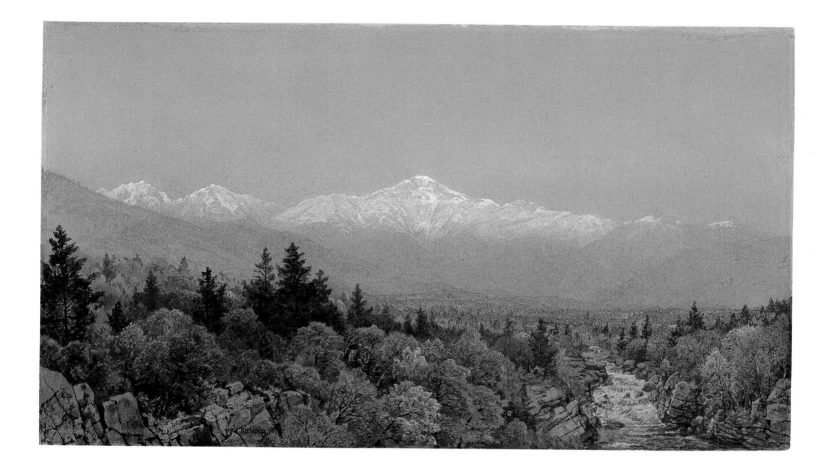

TIMOTHY O'SULLIVAN
1840–1882

View on Apache Lake, Sierra Blanca Range, Arizona, with Two Apache Scouts in Foreground, 1873; printed 1874–76

From the album *Geographical Explorations and Surveys West of the 100th Meridian—Wheeler Photographs*

Albumen silver print, 10¾ × 7¹⁵⁄₁₆ in. (27.3 × 20.2 cm)

P1982.27.32

Timothy O'Sullivan spent almost every year from 1867 to 1874 photographing in the American West. During the winter of 1872–73 he printed his negatives from Clarence King's Geological Exploration of the Fortieth Parallel and, later in 1873, entered the photographs in the Vienna World's Fair. By May he rejoined Lieutenant George M. Wheeler in the Southwest as part of the newly named Geographical Surveys West of the One Hundredth Meridian. Many sites photographed during that 1873 season were meant to correct faulty maps and erroneous illustrations in drawings from earlier expeditions. O'Sullivan's photographs of what is today New Mexico and Arizona included desert scenes, lakes, pastures, and Indian life, as well as Canyon de Chelly and various army installations. O'Sullivan returned west with the Wheeler survey for the last time in 1874, documenting the sites and peoples of southern Colorado and northern New Mexico; he made his final western pictures that year at Shoshone Falls, Idaho.

As AMERICA TIGHTENED ITS GRIP ON THE WEST after the Civil War, the federal government recognized the need to map remote areas that as yet had seen little white settlement. In the late 1860s Congress began financing a series of official exploration parties charged with surveying the terrain, fauna, minerals, and Indian activities from Arizona to Montana and from the western Rocky Mountains to the Sierras. Photographers played a central role in these summertime expeditions, recording scenes that emphasized the necessity of the missions. Through widely distributed prints and elaborate albums, their photographs helped garner continued financing of the surveys and development of the region.

Timothy O'Sullivan had been an official member of such parties almost every year since 1867. By the time he made this photograph, he had become a trusted and experienced explorer. That summer, under the auspices of Lieutenant George M. Wheeler, he led his own party through western New Mexico and eastern Arizona, visiting Zuni and Hopi pueblos, documenting the White House Ruins in Canyon de Chelly, and exploring the Colorado River just east of the Grand Canyon in a search for crossings.

O'Sullivan may well have taken this remarkable view of two Indians and an expedition member resting at the edge of a pond in Arizona's Sierra Blanca Mountains in order to counter the common belief that Arizona was a vast desert. The Indians are probably Mescalero Apaches from the recently created reservation. Most photographs of Native Americans, both at the time and for many years thereafter, treated their subjects as exotic aliens or "savages," but this view suggests relaxed trust. The three men's guns, however, signal the uncertainties that the expedition faced. In the months preceding the foray, the U.S. Army had successfully concluded an extensive, and at times brutal, campaign to defeat the Apaches of the region.

JR

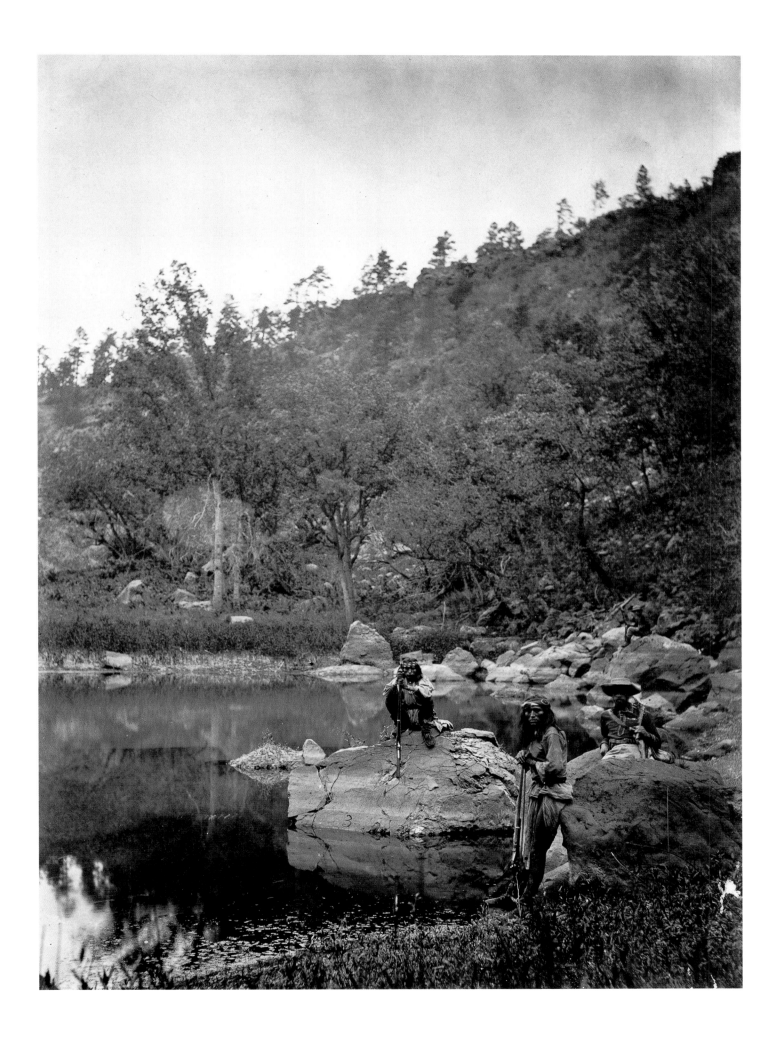

THOMAS MORAN
1837–1926

Cliffs of Green River, 1874

Oil on canvas, 25⅛ × 45⅜ in. (63.8 × 115.3 cm)

Signed and dated lower right: *TMoran* [initials in monogram]. / *1874*

1975.28

When he was five years old, Thomas Moran em-igrated with his family from England to Philadelphia. His younger brother, Peter (1841–1914), actually preceded him in traveling west-ward, painting the scenery in New Mexico as early as 1864. It is, however, Thomas' name that became synonymous with the American West. He acquired technical skills from his older brother, the marine painter Edward Moran (1829–1901). Yet it was his encounter with the boldly colored atmospheric landscapes and seascapes of J. M. W. Turner (1775–1851)—in 1862 in London—that shaped Thomas Moran's art. Hoping to find mountain scenery to sur-pass the Yosemite views of Albert Bierstadt (1830–1902), Moran attached himself to the ex-pedition party of Ferdinand V. Hayden, head of the Geological and Geographical Survey of the Territories; in this capacity he traveled west, to Wyoming Territory, for the first time in the summer of 1871. Although he would paint in the West many times thereafter, his first in-spired sketches made in Yellowstone Country provided source material for Moran throughout his career. His unprecedented watercolor views also were used as part of the successful cam-paign to designate Yellowstone as the country's first national park. In 1922, to accommodate his declining health, Moran moved to Santa Barbara, California. He died there four years later, at age eighty-nine.

"IT WAS MY GOOD FORTUNE to be among the earliest to explore this region as a guest of the U.S. Geological Survey in 1871," Moran once wrote, "and the impression then made upon me by the stupendous and remarkable Manifestations of Nature's forces will remain with me as long as memory lasts."[1] That introduction to the strange and spectacular scenery of the American West set the course of Moran's career. Reeling from the sensations of light, color, space, and topography, Moran painted the western landscape in endless variations for the rest of his life. His name is inextricably linked with Yellowstone Country, yet it was the brilliantly colored buttes along the Green River in southwestern Wyoming that first captured Moran's imagination. He duly staked his claim to this scenery, taking these cliffs as a subject for land-scape painting time and again over the next forty years. The hallucinatory effect of color and topography here captivated Moran's public just as it had mesmerized the artist when he first encountered the site. Seeing this place for the first time in Moran's field study, a commentator in 1874 marveled: "There is a castellated cliff, 1,000 feet high, formed of a yellow-toned sandstone and capped with red or blood-covered lava, which as it has become disintegrated by the action of the atmosphere runs down its perpendicular sides, one color mingling with another in rich confusion, until at the base it assumes a gray-green tone of surpassing brilliancy."[2]

Here was a landscape perfectly suited to Moran's keen color sense. Working from the field sketches he had made in watercolor, Moran required the intense hues of oil pigments and large expanses of canvas in order to real-ize fully his vision of the Green River region. This grand production, cele-brating the fantastic, multicolored land formations there, also shows how western scenery engaged the artist's romantic sensibility. Green River, rapidly transformed into a major rail crossroads even by the time Moran first visited, always remained in his mind's eye a landscape untouched by time, known only—as presented here—to a few adventuresome trailblazers.

PJ

1. Thomas Moran, "Biography by Himself," ms., Gilcrease Museum, Tulsa, Okla., n.d.
2. *New York Post*, November 18, 1874, quoted in Nancy K. Anderson, et al., *Thomas Moran*, exh. cat. (New Haven, Conn., and London: Yale University Press for the National Gallery of Art, Washington, D.C., 1997), 73.

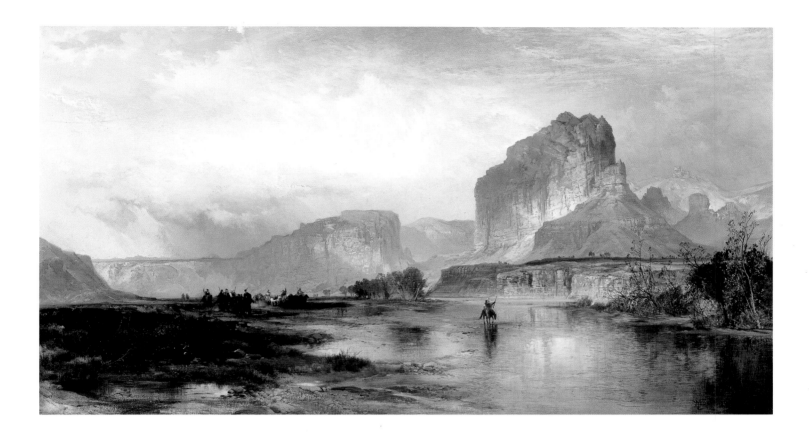

MARTIN JOHNSON HEADE
1819–1904

Two Hummingbirds above a White Orchid, ca. 1875–90

Oil on canvas, 18⅛ × 10⅛ in. (46 × 25.7 cm)

Signed lower right: *M. J. Heade*

1981.33

While other American painters went to South America to paint the magnificent Andes of Ecuador, Martin Johnson Heade was drawn to that continent by something else altogether: his consuming desire to see and study humming-birds. His plan to prepare an illustrated book on hummingbirds may have been spurred by his New York friend and patron John Russell Bartlett, a book publisher with a fascination for science and exploration whom Heade had known since the late 1850s. Unfortunately, Heade's proposed work, The Gems of Brazil, *was never published. But his desire to document the birds was unquenchable. Between 1864 and 1870 he made three trips to Central and South America in his quest to record them. Heade was a serious student of nature, and from 1880 onward he published numerous articles on all manner of wildlife and sporting activities in* Forest and Stream. *Not surprisingly, his last piece, published just weeks before his death on September 4, 1904, was devoted to hummingbirds.*

"I'VE PAINTED NOTHING BUT ORCHIDS THIS SUMMER," Heade wrote to a relative in October 1888.[1] His fascination with the subject, evidenced in his work as early as 1871, continued unabated throughout his career. His studies of orchids and hummingbirds in their natural habitats are unprecedented in still-life painting and testify to his mystical absorption in nature.

Ever the adventurer, Heade had made an ornithologist's study of hummingbirds in Brazil in 1863–64. In 1870 he was back in the tropics, in Jamaica, this time drawn as much to flora as to the brilliant and elusive hummingbirds. From that point forward, he studied orchids cultivated in and around New York City, building upon the sketches he had made on his travels. With the precision of a naturalist, he reproduced at full scale each species of hummingbird and orchid he had observed. In this example, Heade depicts the *Lealia pupurata,* the national flower of Brazil, together with two amethyst woodstar hummingbirds—perfect magenta and green complements to the orchid. Around these jewel-like specimens, he has painted an expansive and lush tropical landscape, emphasizing the integral relationship of plant and bird life to their surroundings. In his orchid and hummingbird paintings, Heade created works that transcend the category of still life to become windows onto a land of surpassing natural beauty, an Edenic New World that is awesome in its vastness and the variety, delicacy, and fragility of its gifts.

PJ

1. Heade to "Aunt Sue" (Mrs. Susan Mather), October 8, 1888, quoted in Theodore E. Stebbins, Jr., *The Life and Works of Martin Johnson Heade* (New Haven and London: Yale University Press, 1975), 149.

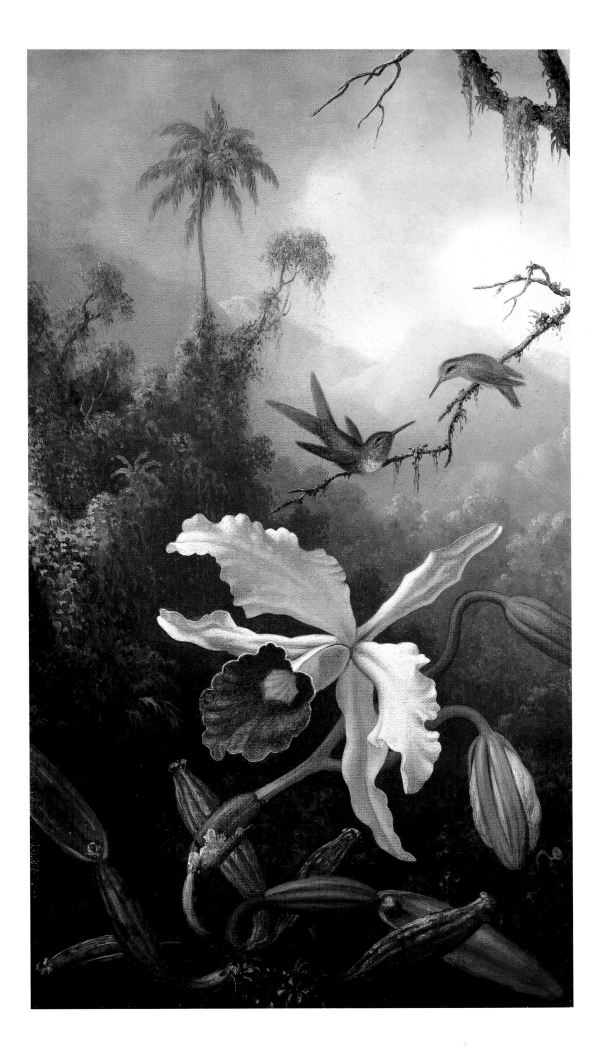

35

FRANCIS AUGUSTUS SILVA
1835–1886

An August Morning, 1876

Opaque and transparent watercolor on paper mounted on canvas,
13⅛ × 20 in. (33.3 × 50.8 cm)

Signed, dated, and inscribed, lower left: *F•A•SILVA•76*; on stretcher:
An August morning—

Gift of Anne T. and Robert M. Bass

1989.18

A poetic stillness, detailed passages of precise brushwork, and an emphasis on naturalistic renditions of light and atmosphere distinguish Francis Augustus Silva's work. Little is known about his life. The son of a barber, Silva was born in New York City, where be began his career as a carriage and sign painter. He served the Union as a captain in the Civil War. Although there is no evidence that he received formal artistic training, he began painting professionally during the late 1860s. Silva's drawings and evocative paintings depicting seascapes indicate that he traveled extensively along the northeastern seaboard. Late in life, he focused on New Jersey scenes. He died suddenly from pneumonia in New York in 1886.

THIS EXEMPLARY COASTAL VIEW attests to the quality of nineteenth-century American landscape watercolors, which enjoyed considerable popularity during the 1860s and 1870s. A self-taught artist specializing in paintings depicting the Atlantic coast, Silva acknowledged the vogue for watercolor by presenting *An August Morning* in the manner of a traditional oil painting. When he exhibited the work at New York's National Academy of Design in 1877, the artist mounted the large sheet—which approximates the size of an oil painting of the period—on canvas and displayed it in a gilt frame.

The scene depicts two spits of land, one containing a lighthouse and its ancillary buildings, which include a pitched-roof structure on stilts housing a large bell that served as a fog signal. A rigged ship lies at anchor between the landforms. By employing opaque watercolors, the artist evoked a summer morning's moisture-laden atmosphere. Used as a highlight, opaque white pigment convincingly records both the sun as it breaks through the cloud cover and its sparkling reflections, which skip across the water toward the lower edge of the canvas.

With their romantic associations of danger and survival, lighthouses had long symbolized American fortitude. When Silva painted this work, the 1876 Centennial Exhibition in Philadelphia was paying homage to the structure's vital role in American maritime culture by featuring examples of related equipment, such as massive lanterns and lenses. In addition, visitors could see a full-scale, functioning lighthouse made of iron that had been reconstructed on the fairgrounds. By the 1870s these isolated outposts of safety were firmly ensconced in the folklore of American culture, and they figured in popular poetry, ghost stories, and tales of the sea.

JM

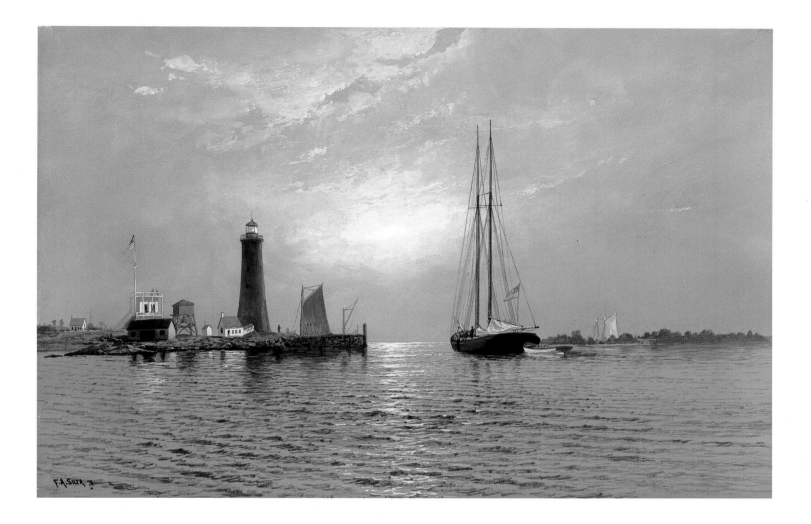

WILLIAM M. HARNETT
1848–1892

Attention, Company!, 1878

Oil on canvas, 36 × 28 in. (91.4 × 71.1 cm)

Signed and dated upper left: *WMHARNETT* [initials in monogram]. */1878.*

1970.230

The Irish-born William Michael Harnett immigrated with his family to Philadelphia when he was a year old. There, at age seventeen, he began working as an engraver. He studied at the Pennsylvania Academy of the Fine Arts in 1866 and, three years later, moved to New York City. In 1875 he abandoned engraving as a profession and began exhibiting his trompe l'oeil paintings. What inspired his fascination with trompe l'oeil is not known. Precedents for such painting in America were few, and Harnett's training to that time had consisted largely in drawing from plaster casts of antique sculpture. Yet he effectively brought the practice of "fool the eye" painting to life in this country in the 1870s. His cleverness was extraordinary, as was his technique. His early friendship with John Frederick Peto [q.v.] in Philadelphia proved to be fruitful for both artists. Harnett's earliest paintings were of highly novel subjects: money still lifes and even a trompe l'oeil portrait of a child. Only after he had demonstrated his ability at home did he travel abroad to hone his technical skills and study the Northern European still-life tradition. Exhibiting his works widely, Harnett attracted wealthy patrons. Although critics disparaged his efforts throughout his career, he directly influenced like-minded contemporaries, particularly John Haberle (1853–1933). His critical reputation was posthumously kindled by a 1929 exhibition at New York's Downtown Gallery.

IN AN ANCIENT GREEK PARABLE, the celebrated painter Zeuxis, hoping to trump his chief rival, audaciously attempted a trompe l'oeil, or "fool the eye," study of a living child holding a bunch of grapes. He was judged a failure, however, when his lifelike subject could not frighten off the birds that flew down to steal the painting's deceptively realistic fruit.

With *Attention, Company!*, Harnett seems to have set for himself the challenge of Zeuxis: the totally convincing imitation of a human being, living and breathing. To this point, the young painter had established his trompe l'oeil skills with conventional tabletop still lifes in which he replicated with uncanny precision the complex textures of fruit, worn paper currency, or the torn leather bindings and yellowed pages of discarded books.

This, the painter's only known figural painting, is a bold departure from his earlier efforts. "To find a subject that paints well is not an easy task," Harnett once explained, making all the more intriguing his decision here to focus on a black child's face.[1] His remark also makes us wonder how the artist may have approached the painting of this subject. Did he work from a live model? Or might he have used sketches or even a photograph? This painting further challenges the traditional notion of Harnett as an artist concerned with appearances and not with deeper meanings. The young boy, frozen at attention as a make-believe soldier, rivets our gaze. Who is he? What does he feel? "I endeavor to make the composition tell a story," Harnett once said.[2]

So what narrative does he impart here? These and similar questions are prompted by the disparate and extraordinarily realistic details: the boy's tattered clothes; his funny, crisp newspaper hat with its colored-paper cockade; the graffiti-covered wall behind him; and his expressionless face. Far more than a portrait, the young boy's deadpan countenance is a vehicle for contemplation. Harnett's true sleight of hand here is the way he captures his subject in suspended animation and draws the viewer into a sustained study not just of the boy's appearance but also of his humanity.

PJ

1. Harnett, in a *New York Times* interview, 1889 or 1890, quoted in Alfred Frankenstein, *After the Hunt: William Harnett and Other American Still-Life Painters, 1870–1900*, rev. ed. (Berkeley and Los Angeles: University of California Press, 1969), 55.
2. Ibid.

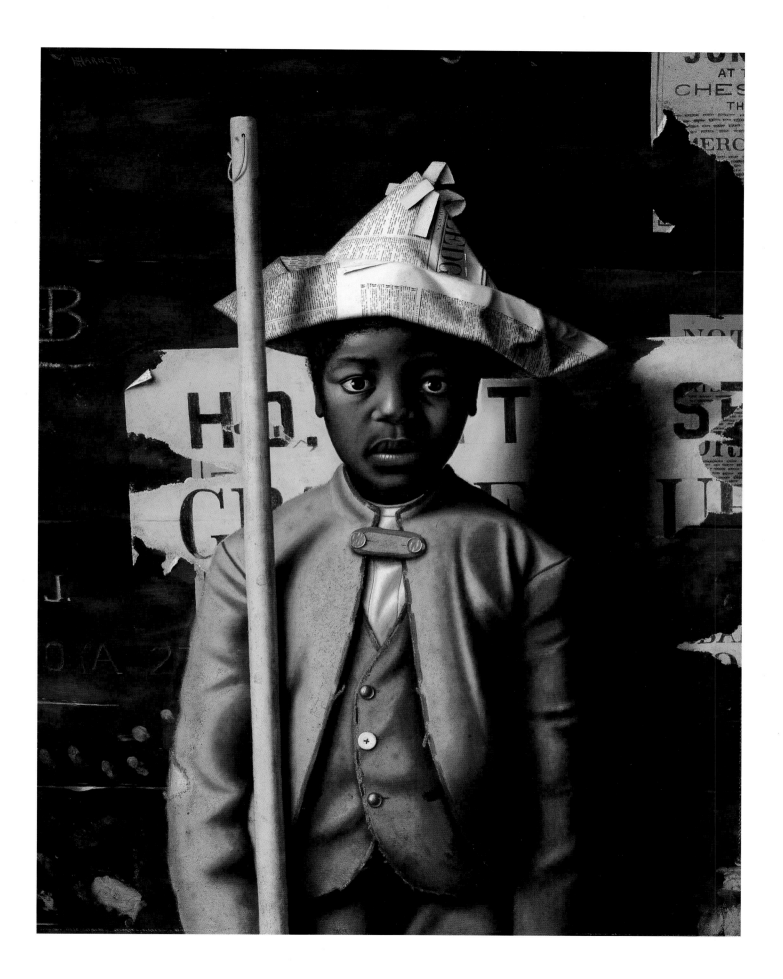

JOHN K. HILLERS
1843–1925

Big Navajo, 1879

Albumen silver print, 9¼ × 7⅛ in. (23.5 × 18.1 cm)

(Object reproduced at actual size)

P1967.2539

In 1871 the German-born John K. Hillers had a chance meeting with Major John Wesley Powell in Salt Lake City. Powell, who was in charge of the Geographical and Geological Survey of the Rocky Mountain Region, hired Hillers to join the survey as a boatman on its expedition down the Colorado River. Hillers assisted the official survey photographer, E. O. Beaman, on the trip, and his affinity for the medium led to his being named the expedition's chief photographer in 1872. For seven years he depicted Native Americans—who named him "Myself in the Water" because he seemingly caused pictures to appear as he washed his plates in the rivers—and he made many landscape images in Utah, New Mexico, Arizona, and Oklahoma. When not in the field, he photographed the Indian delegations that met in Washington, D.C. By 1885 Hillers was in charge of the photographic laboratory for both the U.S. Geological Survey and the Bureau of American Ethnology; professional responsibilities curtailed his travels, and he retired at the end of the century. His photographs were exhibited internationally and were included in the historian Robert Taft's landmark study, Photography and the American Scene *(1938). The publication of Hillers' diary in 1972 prompted renewed interest in his visual legacy.*

THIS PENETRATING STUDY OF A HOPI MAN was among the first government-authorized photographs made after the Bureau of Ethnology (later renamed the Bureau of American Ethnology) was established. Congress created the new bureau under the Department of the Interior in March 1879, appointed the geologist and explorer John Wesley Powell as its first director, and allocated funds for the first expedition to survey and photograph the pueblo villages of New Mexico and Arizona. Led by James Stevenson and with John K. Hillers as field photographer, the expedition left for the Southwest on August 1, spent all of October with the Hopi, and returned to Washington, D.C., in December.

Although Hillers produced numerous realistic documentary images throughout the pueblos, he also resorted to posed and contrived sets to make his portraits or anthropological "types." Typically, he did not record the subjects' names, opting instead to use descriptive, sometimes erroneous, generic titles. Hillers positioned his subjects in front of either a blank backdrop or several artfully arranged Navajo blankets; he frequently had them look to one side. Translated, the word *Hopi* means "the peaceful ones." But this man's expression recalls the perhaps more perceptive impression of the Hopi articulated by the photographer Edward S. Curtis (1868–1952): "Presume on this affability, and you encounter cold reserve, ill-concealed disapproval or outspoken resentment."[1]

BMC

1. Edward Sheriff Curtis, *The North American Indian* (self-published, 20 vols., 1907–30), vol. 12, "General Description," 3.

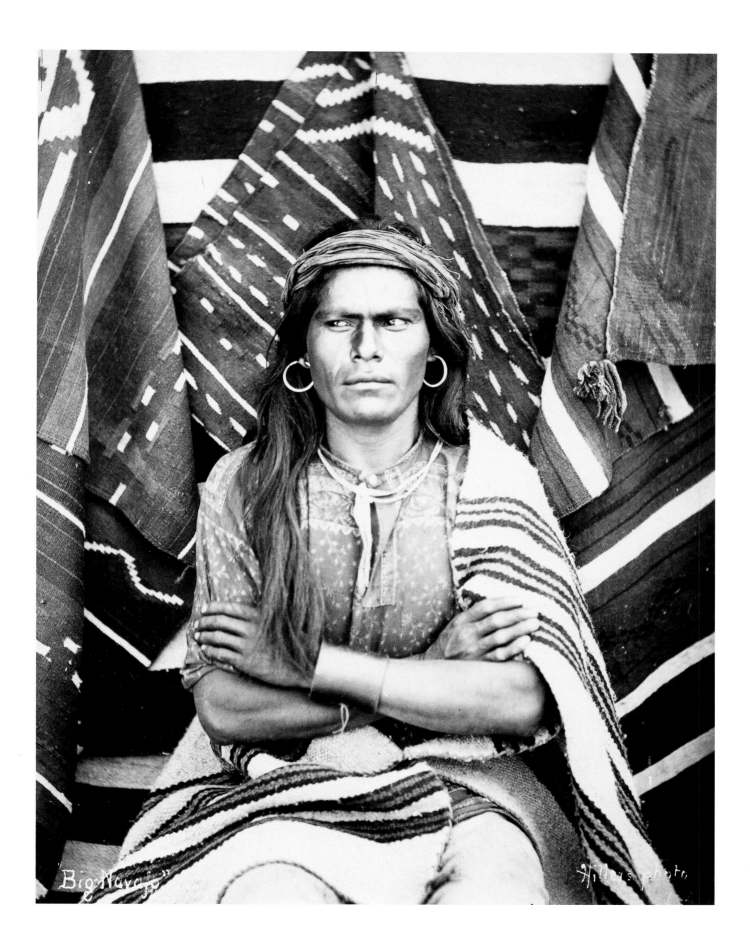

"Big Navajo" Hillers photo

GEORGE INNESS
1825–1894

The Old Apple Trees, 1880–84

Transparent and opaque watercolor on wove, cream paper, 10 × 13 in.
(25.4 × 33 cm)

Signed lower right: *G. Inness*

Purchase with funds provided by the Council of the Amon Carter Museum

1991.15

Born near Newburgh, New York, George Inness first exhibited at the National Academy of Design in New York at age nineteen. His early landscapes reflect the Hudson River School style, but his work in the 1860s changed the course of American landscape painting. His moody studies, painted in closely keyed tones, stand in sharp contrast to the crisply defined scenes bathed in effulgent light that character-ize much of the country's landscape painting at the middle of the nineteenth century. Inness' landscapes, inspired by the works of the Barbizon painters he encountered in France in the early 1850s, are intuitively painted and typ-ically essay simple, rustic themes, often subjects from around his home in rural Medfield, Massachusetts. He increasingly eschewed topo-graphical detail in his work, and by the 1880s he was painting almost amorphous landscapes, twilight scenes that dissolve into pure color ef-fects. These reflect his growing fascination with the spiritualism of the philosopher Emanuel Swedenborg (1688–1772). In fact, Inness' late paintings endeavor to create the visual equiva-lent of the Swedenborgian teaching that the earthly realm is continuous with the heavenly one. He settled in Montclair, New Jersey, in 1878 but traveled widely, usually to improve his poor health. He worked in Florida and northern California, where he profoundly in-fluenced that region's innovative landscape school. He died while traveling in Scotland.

As we follow the action of the artist's hand and brush in this watercolor, we see precisely the aspects of this place and time of day that moved George Inness to depict them. The sheet is richly layered with cool greens and grays, suggesting the dark, damp stillness of an apple orchard at dusk. The lovely arabesques of the squat, gnarled tree trunk leaning lazily to the right have a calligraphic beauty that matches the character of an old apple tree. The fresh dashes of peach color, laid down on top of the deep green tree-top and the silver gray of the sky, are warm color notes supplied by the setting sun and seem especially joyful finishing touches.

Watercolor sketching in the open air was a favorite activity for Inness, who reveled in the moods of nature. His obvious command of the medium, so clearly displayed in this beautiful example, suggests extensive experience with varying wash and opaque techniques. However, few watercolor paintings by Inness are known today beyond the sketches he made on his travels abroad. Perhaps the artist treated such studies casually, as exercises in recording tran-sitory effects. It is possible, too, that these were intensely private works. This watercolor remained with the large body of sketches and unfinished oils that Inness kept in his studio and the public did not see until after his death. The artist may have made it in Milton-on-Hudson, New York, where he summered from 1880 through 1884, working in a makeshift studio in an old barn beside an apple orchard. This evocative study of apple trees appears to be the work of a summer's evening, when the artist preferred to sketch in the cool country air.

PJ

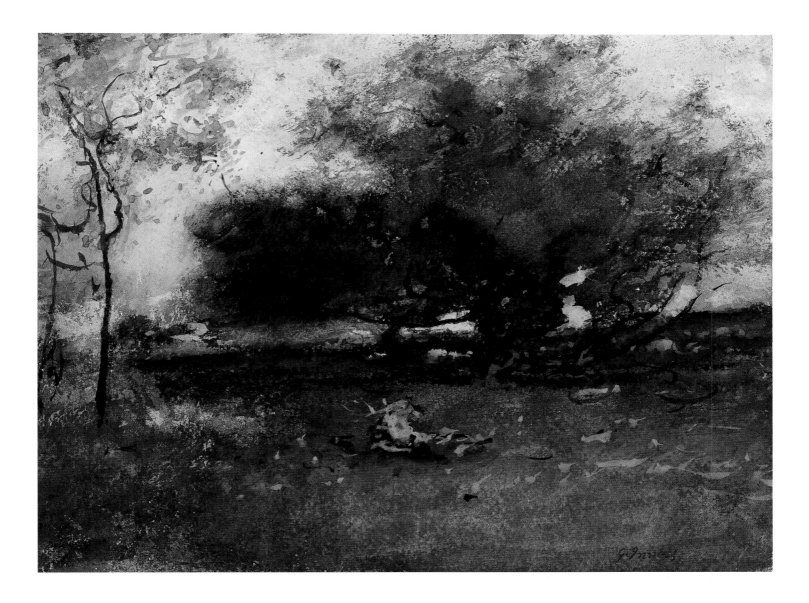

WINSLOW HOMER
1836–1910

Blyth Sands, 1882

Charcoal, graphite, ink, chalk, and opaque white on laid, gray paper, 17 × 22⅝ in. (43.2 × 57.5 cm)

Signed and dated lower right in graphite: *HOMER 1882*

1982.58

Born in Boston, Winslow Homer began his career as an illustrator at age twenty-one. Always fascinated with the lives of various groups of people he encountered, he found in Gloucester, Massachusetts, a subject that would engage him for the rest of his life: men and women who live by the sea. In the summer of 1880, he isolated himself on Ten Pound Island in Gloucester Harbor and focused on the subjects at hand with a new intensity, producing more than one hundred watercolors and drawings unprecedented in their loose wash technique and intuitive feeling for color and paint. That experience inspired his trip the following year to the English fishing village and artists' colony of Cullercoats, on the North Sea, where he spent eighteen months drawing and painting in watercolor those who toiled with the fishing fleet. When he returned, he settled in Prout's Neck, Maine, and built a studio at the edge of the sheer cliffs. He spent the remainder of his life there, painting the sea before him. He relied less and less upon figures and storytelling but found expressive power in the one contest that endlessly played itself out there day after day: crashing waves pounding against unyielding rocks.

IN 1882 WINSLOW HOMER RETURNED from an eighteen-month stay on England's North Sea coast with an extraordinary number of drawings. Executed on large sheets, they consisted primarily of figure studies of the fisherfolk he observed in towns such as Blyth and Cullercoats, where he had centered his activities. These drawings in monochrome on tinted papers were to be his tools, of course, for his paintings in watercolor and oil. But clearly Homer found charcoal and graphite media especially appropriate to his subject, and in these drawings he created powerful depictions of a spare and somber place and the people there who inspired him as no others had before.

These drawings are moving tributes to the coastal people among whom he lived, especially to the wives and daughters whose lives on shore were as arduous as those of the fishermen at sea. Their jobs were various: gathering mussels for bait, mending nets, hauling in the catch when the fleet returned. "They are big strong lasses, with hands and arms 'very large'" is how one writer described them.[1] Homer responded to their muscularity, drawing them almost as monumental sculptures encased in form-revealing draperies, their heavy, wet skirts wrapped around them by the winds. Mostly these women waited—expectantly, fearfully through long nights, foggy days, and terrifying storms—for their men to return home. They walked the beaches and watched from the cliffs. Homer saw them as introspective, self-sustaining, and heroic, and he drew them as eloquent symbols of the indomitable human spirit.

PJ

1. An observer writing of the women of the North Sea fishing town of Filey in 1864, quoted in Nicolai Cikovsky, Jr., and Franklin Kelly, *Winslow Homer*, exh. cat. (New Haven, Conn., and London: Yale University Press for the National Gallery of Art, Washington, D.C., 1995), 201.

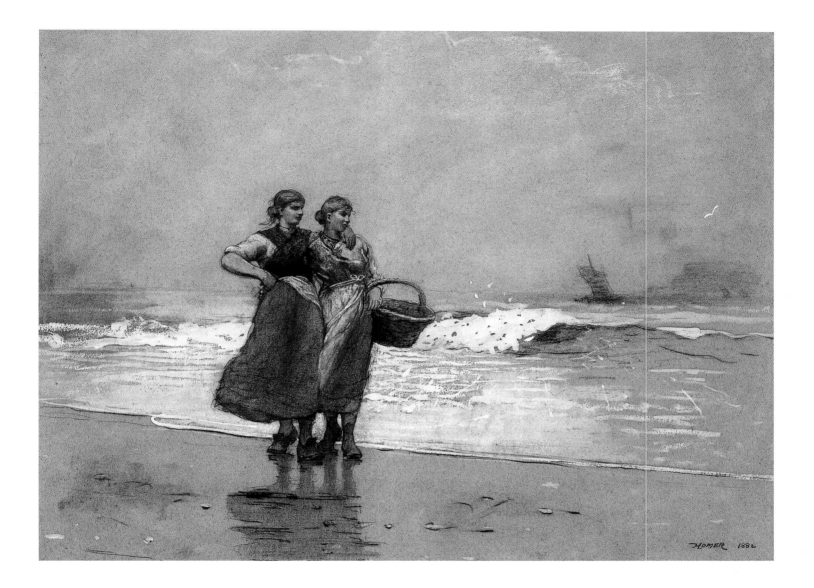

THOMAS HOVENDEN
1840–1895

Chloe and Sam, 1882

Oil on canvas, 22½ × 27 in. (57.1 × 68.6 cm)

Signed and dated lower right: *Hovenden / 1882*

Purchase with funds provided by the Council of the Amon Carter Museum

1992.3

Thomas Hovenden was killed by a locomotive near his hometown of Plymouth Meeting, Pennsylvania, in August 1895, when he was at the height of his popularity. This Irish-immigrant artist had struck a chord in late-nineteenth-century America with his touching, highly realistic paintings of romantic literary figures and humble folks at home. The emotional impact of Hovenden's narrative paintings stems from the deeply affecting interplay among figures who seem to live and breathe on his canvases. He developed his naturalism under the tutelage of the French historical painter Alexandre Cabanal (1823–1889), working with him from 1874 to 1875, during a six-year sojourn in Paris and Brittany. In 1886, after settling in Philadelphia, Hovenden succeeded Thomas Eakins [q.v.] as professor of painting and sculpture at the Pennsylvania Academy of the Fine Arts. Although his work was voted the favorite of visitors to the 1893 Chicago World's Columbian Exposition, Hovenden's romantic realism had by then become outmoded, eclipsed by the more colorful and buoyant impressionism of both French and American painters.

THOMAS HOVENDEN WAS ALWAYS A LITERARY PAINTER. With his eye for authentic historical detail and character, he re-created on canvas such touching scenes as the death of Tennyson's Elaine and the last moments of John Brown as recounted in John Greenleaf Whittier's abolitionist poem "The Sentence of John Brown" (1844). Hovenden's move in 1881 to Plymouth Meeting, Pennsylvania, to a house that had served as a stop on the underground railroad, must have been deeply affecting, for it sparked a series of paintings honoring the proud heritage of abolitionism that distinguished this Quaker town. He found a touching subject in his neighbor old Samuel Jones, who had arrived in Plymouth Meeting in 1849 and lived there as a free black man. Before Jones' death early in 1882, Hovenden had made him the subject of at least six canvases, including this vignette with, presumably, Jones' wife, Hester.

Hovenden's studies of Jones are richly layered stories that bring to life characters and scenes reminiscent of those introduced in literature by Harriet Beecher Stowe (1811–1896) and others. In the "abolition barn" that was his studio, one visitor reported, Hovenden constructed an elaborate set: "He has collected a great variety of country furniture, and he can pose his models in the very light that they would have in their own homes . . . he has cupboards and ironing tables, and pots and pans complete, and he sets up the whole picture before he begins to paint at all."[1] The artist's storytelling is perhaps evident in his title here: Sam's Hester, if indeed she was the model for the elderly woman depicted, is now "Aunt Chloe." This name was immediately recognizable to late-nineteenth-century viewers as that of Uncle Tom's wife, a literary creation synonymous with the stalwart black domestic and backbone of the antebellum Southern household. This glimpse of daily life in the Jones' simple home brings to mind Stowe's moral charge to her readers: "Think of your freedom every time you see UNCLE TOM'S CABIN."[2]

PJ

1. "John Brown: Thomas Hovenden's Picture of the Old Hero's Last Moments," Philadelphia *Times*, January 25, 1884.
2. Harriet Beecher Stowe, *Uncle Tom's Cabin, or Life among the Lowly* (1852; repr. New York: Library of America, 1982), 509.

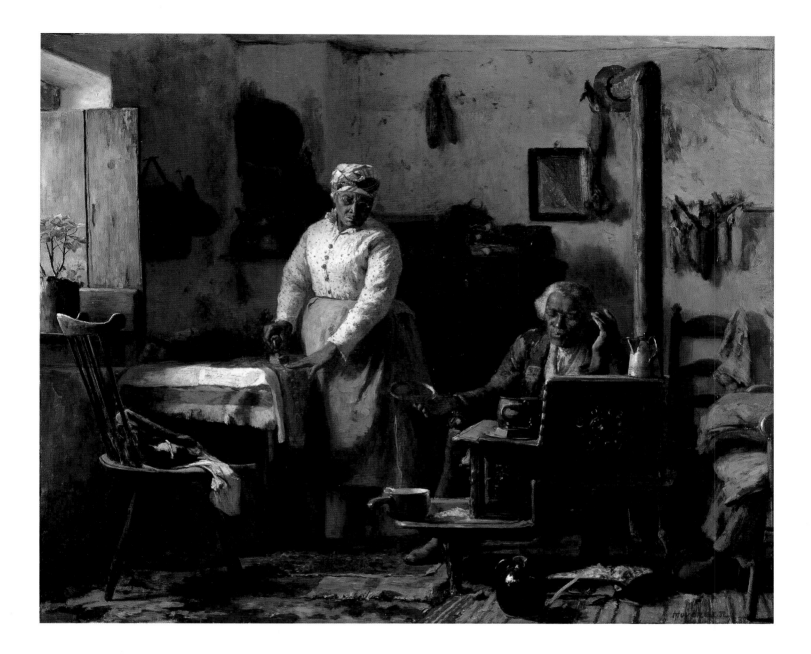

WILLIAM HENRY JACKSON
1843–1942

Canon of the Rio Las Animas, 1882; printed 1883

Albumen silver print, 21⅛ × 16¹⁵⁄₁₆ in. (53.7 × 43 cm)

P1971.94.18

William Henry Jackson, born in Keesville, New York, was practicing photography in Omaha, Nebraska, when in 1870 he was hired by Ferdinand V. Hayden of the Geological and Geographical Survey of the Territories. For the next eight years, Jackson traveled with the Hayden survey, making pictures throughout the West and Southwest and returning from the field to photograph the Indian delegations in Washington, D.C., for the Bureau of Ethnology (later renamed the Bureau of American Ethnology). With the photographer Albert E. Rinehart, he operated a portrait studio in Denver from 1879 until 1884; this endeavor provided the financial stability that allowed Jackson to devote his energies to landscape imagery. The Denver and Rio Grande Railway, among other railroad companies, commissioned assignments from Jackson that helped sustain him through the 1890s, enabling him to create some of his most extraordinary work. These photographs, spectacular in their clarity and breadth, were translated into engravings for illustrated tour books, among them Ernest Ingersoll's popular Crest of the Continent *(1885). Indeed, Jackson's published photographs and myriad stereographs introduced the West to the burgeoning nation as a land of recreation and investment. In 1897 he acquired part ownership of the Detroit Photographic Company, which continued to market his views and postcards. He retired in 1924 and, two years before his death, published a widely read autobiography,* Time Exposure *(1940).*

BY THE 1880s RAILROAD COMPANIES HAD COMPLETED many of their main trunk lines across the West and had started extending branch lines to more remote regions. Realizing that views of that newly opened terrain would stimulate travel, the companies hired photographers to create picturesque images along the new routes. William Henry Jackson made rail scenes his specialty during these years, and he quickly became the leading practitioner of the genre. At times, painters, such as his friend Thomas Moran [q.v.], and writers, such as Ernest Ingersoll, would join him on these promotional excursions. Generally working out of his own private railcars, the photographer enjoyed complete freedom of movement, traveling or not, whenever and wherever he liked. In return, the railroad companies gained exquisitely composed and printed eighteen-by-twenty-two-inch views of remote canyons and picturesque ridge tops to grace the walls of their rail stations and ticket offices; in addition, they received myriad smaller views for sale to tourists.

This dizzying sight along the Animas River in southwestern Colorado, made in late summer 1882, is one of Jackson's most spectacular photographs. Here, the photographer's train stands unnervingly pinned within the shadow of a sheer cliff. Yet the telegraph line and distant bridge reassure viewers that this is just one stop along a vast national web, and the huge antlers appended to the front of the locomotive deliver a playful reminder of opportunities for big-game hunting. The final effect suggests a comfortable excursion into a vast, slightly dangerous wilderness—exactly the kind of twist to catch the imagination of a Gilded Age Easterner looking for vacation excitement.

JR

1037. CAÑON OF THE RIO LAS ANIMAS.

JOHN LA FARGE
1835–1910

Still Life of Petunias in a Glass Vase, 1884

Pastel on wove, gray paper, 14 × 12 in. (35.6 × 30.5 cm)

Signed and dated lower left: *Jno La Farge 1884*

Acquisition in memory of Bartlett H. Hayes, Jr., Trustee, Amon Carter Museum, 1968–1976

1988.20

John La Farge was an artist of extraordinary intellectual depth, uncommon interests, and eclectic tastes who, by his originality in both painting and decorative art, anticipated the late nineteenth century's modern movements. He was raised in New York City in a prosperous and cultivated household. A trip abroad in 1856 and a brief time in the Paris studio of Thomas Couture (1815–1879) convinced La Farge of his calling, and in 1859 he went to Newport, Rhode Island, to study with the innovative painter William Morris Hunt (1824–1879). He developed a distinctively free and delicate style, painting landscapes in the open air that were comparable to contemporary French experiments in impressionism. By the late 1850s he was collecting Japanese prints and was among the first to introduce Japanese design concepts into his art. In the 1870s La Farge turned to mural painting and stained glass, advancing stained-glass technique to an unprecedented level of subtlety and complexity. He created important ecclesiastical interiors, including that of Boston's Trinity Church, and produced sumptuous designs for the wealthiest patrons of the Gilded Age, decorating interiors in the mansions of New York and Newport.

MANY OF HIS CONTEMPORARIES chose flower subjects for their symbolic content, but John La Farge turned to still life as a means of studying light and color—as is clearly evident in this pastel. Although he rarely worked in pastel, it perhaps appealed to him in this instance because of the intensity of hue that it affords.

Drawing with pastel, which can approximate the effect of raw pigment, is like drawing with pure color, and here La Farge has fully exploited the medium, using it to convey brilliant petals in light and striking reflections on glass and blending it to suggest blooms in shadow. The drawing may appear spontaneous and intuitive, but it is unmistakably the result of careful observation. La Farge has captured the lively dance of fragile petunias, flashing their brilliant red and purple hues before they fold in upon themselves. They are "as tender and true suggestions of flowers—not copies—as nature ever grew," to quote the nineteenth-century critic James Jackson Jarves, who preferred La Farge's impressionistic still lifes to the more academic productions of other painters.[1]

Pastel allowed La Farge to work quickly to record these ephemeral colors, an exercise that served to hone his skills for painting in oil and watercolor. He described his approach in these words:

My painting of flowers was in great part a study; that is, a means of teaching myself many of the difficulties of painting, some of which are contradictory, as, for example, the necessity of extreme rapidity of workmanship and very high finish. Many times in painting flowers I painted right on without stopping, painting sometimes far into the night or towards morning while the flower still retained the same shade, which it was sure to lose soon. This obliged me also to know the use of my colors . . . for the difference between daylight and lamplight is very great, and the colors as one sees them in one light are not the colors of another.[2]

PJ

1. James Jackson Jarves, *The Art Idea: Sculpture, Painting, and Architecture in America*, 5th ed. (New York: Hurd and Houghton, 1877), 253.
2. Quoted in Royal Cortissoz, *John La Farge: A Memoir and a Study* (Boston and New York: Houghton Mifflin Company, 1911), 135.

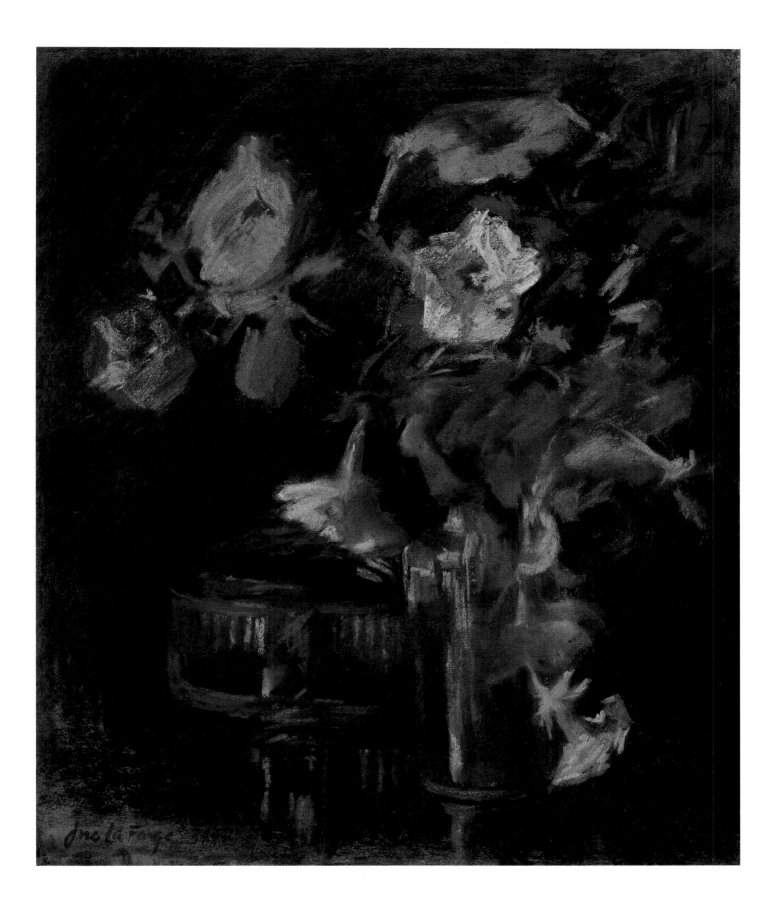

43

EADWEARD MUYBRIDGE
1830–1904

*Gazelle, Spavin Right Hind Leg (.099 Second),
Almost One Stride*, ca. 1884–85; printed 1887

From *Animal Locomotion: An Electro-Photographic Investigation of
Consecutive Phases of Animal Movements*

Collotype, 9⅞ × 11¼ in. (25.1 × 28.6 cm)

P1970.55.9

Eadweard Muybridge emigrated from England to the United States, settling finally in San Francisco in 1867. He made 360-degree panoramic views of that city—one of which was an amazing seventeen feet, four inches in length. Muybridge's views of the West, including Yosemite and the Pacific Coast, brought him international acclaim as a landscape photographer. But his work for the former California governor Leland Stanford in 1873 led to his most astonishing achievements. He photographed Stanford's trotter and in 1878 published the first sequential photographs ever made of a horse in motion. The University of Pennsylvania funded Muybridge's continuing research from 1884 to 1886, and the artist and teacher Thomas Eakins [q.v.] used the photographer's plates as lantern slides in his classes at the Pennsylvania Academy of the Fine Arts. In 1887 Muybridge published his seminal work, Animal Locomotion, *a series of 781 collotype plates of both animals and people in motion. His images stand as the bridge between photography and the advent of cinema; they made it possible to "see the unseen" and thus dramatically expanded the boundaries of visual understanding. Muybridge's notion about regulating time and motion continues to make an impact on artists today.*

IN 1872 THE SAN FRANCISCO PHOTOGRAPHER Eadweard Muybridge took up a challenge that changed the course of art. He accepted a commission from the former California governor Leland Stanford to photograph Stanford's favorite trotter, Occident, at full gallop. Legend has it that Stanford had a bet to resolve as to whether or not all four of a horse's legs are simultaneously off the ground while the animal is running.

Still contending with wet-plate negatives and cumbersome view cameras, photography had not yet captured the world in motion. Muybridge spent six years devising a way to do it. Finally, by setting up a line of cameras—each attached to a trip string—in front of a wall, he made a remarkable discovery. Rather than splaying their legs out in hobbyhorse fashion when they had all four feet off the ground, as was commonly believed, horses tucked them under their bellies. When Muybridge's grid of photographs was published, on the cover of the October 19, 1878, issue of *Scientific American*, he immediately became a celebrity, toasted by artists as established as the French painter Edgar Degas (1834–1917) for having corrected a long-held misinterpretation.

In 1884 Muybridge moved to the University of Pennsylvania to continue his motion studies. Over the next three years, he photographically catalogued hundreds of animals and humans in motion, creating an invaluable archive of the "unseen" for both artists and scientists. This plate showing the lame horse Gazelle, with its elegantly attired rider, comes from that important study. Comprised of twenty-four individual photographs captured at almost one-tenth-of-one-second intervals in front of a gridded wall, the image provides unparalleled detail regarding the exact positions of the horse and its rider in full stride. With the publication of Muybridge's extensive archive of movement studies in 1887, artists finally could consult definitive models when depicting both animals and people in action.

JR

Thomas Eakins
1844–1916

Swimming, 1885

Oil on canvas, 27⅜ × 36⅜ in. (69.5 × 92.4 cm)

Signed and dated at center (on rock pier): *EAKINS 1885*

Purchased by the Friends of Art, Fort Worth Art Association, 1925; acquired by the Amon Carter Museum, 1990, from the Modern Art Museum of Fort Worth through grants and donations from the Amon G. Carter Foundation, the Sid W. Richardson Foundation, the Anne Burnett and Charles Tandy Foundation, Capital Cities/ABC Foundation, *Fort Worth Star-Telegram*, the R. D. and Joan Dale Hubbard Foundation, and the people of Fort Worth

1990.19.1

Thomas Eakins was born in Philadelphia, the city that remained the center of his life and art. The son of a drawing master, he also took up drawing—at the Pennsylvania Academy of the Fine Arts. At age twenty, he was observing anatomy demonstrations at Jefferson Medical College. He honed his painting skills under Jean-Léon Gérôme (1824–1904) in Paris, and he studied the works of seventeenth-century masters in Spain. In 1870 Eakins returned to Philadelphia and thereafter rarely ventured away from it. He depicted rowing contests on the Schuylkill and sailboats on the Delaware. But he focused most intensely upon the human figure, painting evocative, historical genre scenes and portraits of family, friends, and, occasionally, patrons. Always striving for scientific accuracy, he studied perspective drawing and anatomy extensively and used photography to gain a better understanding of locomotion. His empirical approach to art's fundamentals made him the most progressive teacher of his day; it also made him the most controversial, and in 1886 he was forced to resign as director of the Pennsylvania Academy of the Fine Arts. His penetrating realism never garnered him wide popularity or financial success, but it unquestionably changed the course of modern American art.

SWIMMING was a signal work for Thomas Eakins. It was the summation of his ideals as a realist painter and as a teacher, marking his ascent to the directorship of the most progressive art school of the day, the Pennsylvania Academy of the Fine Arts, in his native Philadelphia. It was, as well, a singular honor paid the artist by an academy trustee who wished to show his support by commissioning a work that might one day represent Eakins in the institution's permanent art collection.

With *Swimming*, Eakins delivered what has been aptly called his "pictorial manifesto," in which he unflinchingly declared his belief in the study of the human figure from life as the basis of modern art and the foundation of the academy's teaching.[1] Setting his subjects at a swimming hole, he evoked a time-honored scene from antiquity, suggesting Arcadia, while providing a logical setting for his celebration of the nude male body. By his study of human anatomy and locomotion and his use of photography in preparation for the painting, he brought the bathers to life. Indeed, his graphic realism undermined his noble intentions with the picture. That his subjects were easily identifiable as Eakins himself (swimming toward the rock) and his academy students led to charges of impropriety against the artist and, subsequently, to his forced resignation from his post.

Although it stands today as arguably Eakins' masterpiece, *Swimming* surely represented to the artist the pain of misunderstanding that he would endure throughout his career. Returned to him by his patron, Francis Hornor Coates, *Swimming* remained in Eakins' studio and was not sold until years after his death. In 1925 the painting was purchased from the artist's widow by the Friends of Art in Fort Worth, who gave it to the city's Art Association as a worthy addition to its public art gallery.

PJ

1. Kathleen A. Foster, "The Making and Meaning of *Swimming*," in Doreen Bolger and Sarah Cash, *Thomas Eakins and the Swimming Picture*, exh. cat. (Fort Worth: Amon Carter Museum, 1996), 13.

FRANK JAY HAYNES
1853–1921

Cascades of Columbia, 1885

Albumen silver print, 16⁵⁄₁₆ × 21⁷⁄₁₆ in. (41.4 × 54.5 cm)

P1989.28.2

Born in Saline, Michigan, Frank Jay Haynes absorbed the landscape tradition by poring over the chromolithographs that derived from the paintings of Frederic Edwin Church [q.v.] and others. He began his career as a photographer in Moorhead, Minnesota, in 1874, and two years later was appointed the official photographer of the Northern Pacific Railroad, making promotional views to encourage western industry, settlement, and tourism along the rail line. Three years after his first visit to Yellowstone National Park in Wyoming in 1881, he was appointed official photographer of that vast area. The lucrative summer-season studio he operated on the park grounds was the first such commercial enterprise officially licensed in Yellowstone, and it would meet with no competition until the 1920s. During the winter months from 1885 until 1904, Haynes traveled and sold commissioned trackside photographs from his Haynes Palace Studio Car, a customized Pullman railcar. After 1905 he concentrated on making Yellowstone views and profitable tour-group photos, marketing his images as postcards through the Detroit Publishing Company, which printed them by means of its Photochrom process.

THIS VIEW OF FISHERMEN PULLING SALMON out of the Columbia River rapids is one of many that Frank Jay Haynes produced to promote the natural resources along the Northern Pacific Railroad (NPRR) line. Following the completion in 1883 of the railroad's transcontinental line, which connected the Great Lakes to the Pacific Ocean, the company conducted a publicity campaign to attract settlers and tourists. Haynes, the NPRR's official photographer, supplied the railroad with numerous photographs to use in its ambitious advertising efforts. Beginning in 1883, he also began producing mammoth prints, such as this one, for exhibition in public offices and at fairs worldwide.

The Cascades, the area of rapids where the Columbia River cuts through the Cascade Range, had been a favorite fishing locale for native peoples, who stood at the river's edge and speared the fish migrating upriver to spawn. With the completion of the railroad line, sport fishermen could reach the site as well. Haynes oriented the camera to show the simple scaffolding constructed to position the fishermen above the churning water. He also used the relatively slow speed of the photographic technology to transform the choppy rapids into impressionistic white swirls, which are then echoed by the blurred movement of the netted fish. The result suggests the ease of harnessing the wilderness for human recreation.

BMC

WILLIAM M. HARNETT
1848–1892

Ease, 1887

Oil on canvas, 48 × 52¾ in. (121.9 × 134 cm)

Signed, dated, and inscribed on reverse: *Painted to order / by / Wm M. Harnett. / 1887. Studio. 28 E. 14ᵗʰ. St / New York.*

1972.2

Born in Ireland, William Michael Harnett was raised in Philadelphia. He began his career at age seventeen as an engraver but abandoned the medium in 1875 to devote himself wholly to painting. By 1880 he had established himself in his hometown as a trompe l'oeil still-life painter and had exhibited his highly original works there. That year he departed for Europe, intending to study the great masters. Settling in Munich, he discovered a vital school of young still-life painters and was immediately attracted to their virtuoso painting technique and, most particularly, to their hunting and sporting still-life subjects: interiors filled with illusionistically rendered game, accoutrements of the hunt, and other bric-a-brac characteristic of a Victorian man's world. This encounter with the Munich painters led Harnett to adopt the "after the hunt" theme, and he painted a series that culminated in his 1885 masterpiece After the Hunt *(Fine Arts Museums of San Francisco). Harnett's still lifes also became increasingly luxurious after his time abroad; his dark, interior, tabletop compositions now reflected the influence of Dutch and German prototypes. Back in New York, where he settled upon his return, he enjoyed popular if not critical success. Chronic illness took its toll, and he died in 1892 at age forty-four.*

Harnett was a master of the eloquent object replete with meaning. He elevated still life to the level of character study, and by his painted arrangements of personal artifacts he created composite portraits that can be more revealing and engaging than a depiction of a face.

Ease amply demonstrates Harnett's skill and insight. Commissioned by James T. Abbe, a Holyoke, Massachusetts, paper manufacturer, it affords a glimpse into this Victorian gentleman's private world, a corner of his library. Significantly, Harnett selected items that show the emotional, intellectual, and spiritual sides of this self-made man of commerce. Among Abbe's well-worn books are an aged Bible, Homer's *Iliad*, Scott's *Poetical Works*, and William Cullen Bryant's *Popular History of the United States*, all of which identify him as a man of learning, of patriotic sentiment, and of faith. We also imagine him as a man of music, especially fond of the flute and the violin. His taste for the well-wrought object, such as the Renaissance-style, brass repoussé ewer and the medieval bronze cup, suggest that he was a man of the world. He has, as well, an eye for beauty—cornflowers and roses and the simply elegant palm-leaf form of a Japanese fan. All these qualities might also be ascribed to the artist, who so acutely observed and sensitively rendered each artifact.

Abbe is a very real presence in this interior. He has momentarily set down his lighted cigar, and he will return, we feel certain, before it burns further through the newspaper. "It fairly seems as if one smelt the fragrance of the smoke that rises," one nineteenth-century viewer commented, "a little hurt, perhaps, by the mingling of the paper odor."[1]

PJ

1. This quote is drawn from an extended commentary on the painting that appeared in the *Springfield* (Mass.) *Daily Republican*, November 7, 1887.

DENNIS MILLER BUNKER
1861–1890

In the Greenhouse, 1888

Oil on canvas, 18 × 24 in. (45.7 × 61 cm)

Acquisition in honor of Adelyn Dohme Breeskin, Trustee, Amon Carter Museum, 1972–1982

1996.11

Although Dennis Miller Bunker was born in New York City and studied there, his artistic reputation is inextricably linked with the Boston art community. After attending the Art Students League and the National Academy of Design, like so many American artists of his generation he moved in 1882 to Paris, where he remained for two years. In 1885 Bunker settled in Boston; there, he taught at the Cowles Art School, had his first solo exhibition, and painted portraits on commission. It was in Boston as well that he enjoyed the patronage of Isabella Stewart Gardner and, in November 1887, met John Singer Sargent [q.v.]. Although no paintings by Bunker are known to exist from the summer of 1888, which he spent with Sargent in England, his subsequent works incorporate the tenets of impressionism while retaining the more restrained qualities of his academic training. In 1889 he returned to New York, where he taught and painted. He died unexpectedly the following year, just three months after marrying Eleanor Hardy, a Boston native.

THIS VIBRANT DEPICTION OF CHRYSANTHEMUMS growing in the greenhouse of the Boston art patroness Isabella Stewart Gardner is one of the most inventive American impressionist paintings. An outstanding early example of the transference of the French impressionist aesthetic to the United States, the work reveals the bravura, spontaneous brushwork and rich chromatic range Bunker discovered through his association with John Singer Sargent. He worked with Sargent in England during the summer of 1888, when the latter was under the influence of Claude Monet (1840–1926), whom Sargent had visited in Giverny the previous year. The two Americans emulated their French contemporaries by painting side by side outdoors, or *en plein air,* to better capture the atmospheric effects of light and color.

Bunker's grasp of the essential impressionist tenets was a dramatic departure from the traditional academic training he had received in his native New York City and in Paris. Although the innovative European style was gaining some adherents, many Americans regarded it suspiciously as a radical trend. Returning to Boston, Bunker executed his first two extant impressionist paintings: *Chrysanthemums* (1888, Isabella Stewart Gardner Museum, Boston) and *In the Greenhouse. Chrysanthemums* is the larger, more highly finished of the two, while *In the Greenhouse* is notable for its unrestrained brushwork. In it, Bunker let touches of vivid color stand for entire flowers, rather than detailing each individual form. He applied thick paint for the deep red and brilliant yellow chrysanthemums and created the lavender, pink, and blue blooms by brushing through wet paint to produce colors of subtle variety. The lively painted surface, ranging from strokes of thin pigment to dabs of high impasto, re-creates a lush display of one of Mrs. Gardner's favorite flowers.

JM

THOMAS MORAN
1837–1926

Mountain of the Holy Cross, Colorado, 1888

Etching on wove, buff paper; plate: 26½ × 18½ in. (67.3 × 47 cm); sheet: 33⅛ × 24¼ in. (84.1 × 61.6 cm)

Signed, dated, and inscribed, lower right, in plate: *TMORAN* [initials in monogram] *1888*; lower right: *Etched by / T. Moran, N.A.* [now rubbed out]; lower center: *Copyright & Published by The New Brunswick Royal Art Union, Limited.*

1983.154

Thomas Moran's distinguished career as a printmaker parallels the development of graphic art in America through the second half of the nineteenth century. He was first trained as a commercial wood engraver in his native Philadelphia, as the new illustrated weeklies were becoming popular, but he found the medium unsatisfying and abandoned it in 1857. Around that time, Moran acquired copies of illustrated books that reproduced as etchings and mezzotints the works of painters J. M. W. Turner (1775–1851) and Claude Lorrain (1600–1682). Inspired by those examples, he took his first etching lessons from John Sartain in Philadelphia in 1860. He also tried his hand at cliché-verre, *a technique of etching on a glass plate to produce a photographic negative. He learned lithography from his brothers, Peter and Edward, and excelled at drawing on stone. In the 1860s, the heyday of the popular color lithograph, Moran used the medium for intensely personal artistic expressions in rich-toned monochrome. In the 1870s he reproduced his popular paintings in marketable woodcut and chromolithography, and by 1880 he was a leader of the etching revival in both the United States and Great Britain. He died in Santa Barbara, California, at age eighty-nine.*

MOUNTAIN OF THE HOLY CROSS, COLORADO, a signature print for Thomas Moran, was taken directly from one of his grandest canvases. The view is of that magnificent peak in the Rockies identified by the awe-inspiring cross formed by two great crevices that are perpetually filled with snow. Few in Moran's time failed to see this landmark as anything but the handiwork of God in American nature, a notion that accounted for the popularity of Moran's painting of the site.

In the 1880s, as print publishers clamored for etchings reproducing modern paintings, Moran offered this image as an exceptionally large plate. Banking on its commercial success, J. D. Waring, a New York print publisher, paid Moran the handsome sum of $2500 to etch the plate. For a rapidly growing group of etching devotees in the early 1880s, his elaborate production was admired as a technical tour de force. The etching impresses by both its scale—it is one of the artist's largest plates—and its complexity. Moran articulated a wealth of topographical detail with fluid delicacy, and this plate demonstrates beautifully his characteristic light touch. He also managed to create stunning light and atmospheric effects, even in monochrome.

Moran and his wife, Mary Nimmo Moran (1842–1899), were at the forefront of the etching revival in England and the United States. They were founding members of the Society of Painter-Etchers in London, the New York Etching Club, and the Society of American Etchers. Both exhibited their etchings widely to critical acclaim and contributed original etchings to the fine-art journals that were promoting the medium as a vehicle for technical innovation and creativity.

PJ

JOHN SINGER SARGENT
1856–1925

Alice Vanderbilt Shepard, 1888

Oil on canvas, 30 × 22 in. (76.2 × 55.9 cm)

Signed and dated, upper left: *John S. Sargent*; upper right: *1888*

1999.20

Born to expatriate American parents in Florence, the cosmopolitan John Singer Sargent remained abroad—primarily in London—most of his life. His reputation as an emerging artist of talent escalated meteorically with the exhibition in 1884 of his mesmerizing and notoriously seductive portrait of Madame Pierre Gautreau, popularly known as Madame X *(Metropolitan Museum of Art). During his trip to America in 1887 to paint portraits on commission, he received his first solo exhibition in Boston at the St. Botolph Club; his reception there was both critically and popularly acclaimed. Throughout his life Sargent traveled extensively, shifting among exotic European locales where he would sketch and paint. By 1907, tired of the incessant commissions that attended his vast popularity as a portraitist, he vowed to abandon them in favor of other artistic interests, including landscape painting and watercolor. During his later years, Sargent concentrated on the murals he designed for the Boston Public Library. Following his death in London, three memorial exhibitions were immediately organized—at the Museum of Fine Arts in Boston, the Metropolitan Museum of Art in New York City, and the Royal Academy in London.*

WHEN JOHN SINGER SARGENT MADE A WORKING VISIT to Boston and New York City in 1887, he already had achieved significant acclaim as a painter of high society in Europe, where he lived the life of a well-to-do expatriate. The American trip was a triumphant one. During the four months the artist spent in New York, prosperous patrons, who found his portraits both remarkably flattering and strikingly individualized, clamored to sit for him. It was on this trip that Sargent painted the portrait of Alice Vanderbilt Shepard (1874–1950); this remarkable work is distinct from most of his other portraits because the sitter was a subject of his own choosing.

Sargent met the young girl when he was executing a commission for her father, the lawyer and newspaper publisher Elliott Fitch Shepard. While painting a portrait of his wife, Margaret Louise Vanderbilt Shepard (San Antonio Museum of Art), over repeated sittings, Sargent became acquainted with the family. According to family lore, so captivating was the eldest daughter's beauty that Oscar Wilde was purported to have declared there were only three worthwhile destinations in America: Niagara Falls, the Grand Canyon, and Alice Shepard.[1]

When Sargent asked permission to make Alice's portrait, Mrs. Shepard demurred, relenting only when she received assurances that the sittings would be limited in order to preserve her daughter's delicate constitution. The resulting work is one of Sargent's most naturalistic and incisive portraits. Poise, refinement, and grace, coupled with intimations of innate intelligence, capture Alice's considerable character. Her radiant face is the most carefully worked passage in the portrait, which is overall loosely and thinly painted. The bravura treatment of detail on her jacket and the soft folds of her Garibaldi blouse are comprised of brilliant white pigment combined with passages of blue and hints of pink. A great-granddaughter of the railroad magnate Cornelius Vanderbilt (1794–1877), Alice did not rest on her life of privilege but rather grew to be an accomplished woman. She studied at Radcliffe College and married the lawyer and diplomat Dave Hennen Morris, who shared her active involvement in the movement to create "Interlingua," a language for international communication; it is still used today by medical and scientific professionals worldwide.

JM

1. Elaine Kilmurray and Richard Ormond, *John Singer Sargent* (Princeton, N.J.: Princeton University Press for the Tate Gallery, London, 1998), 136.

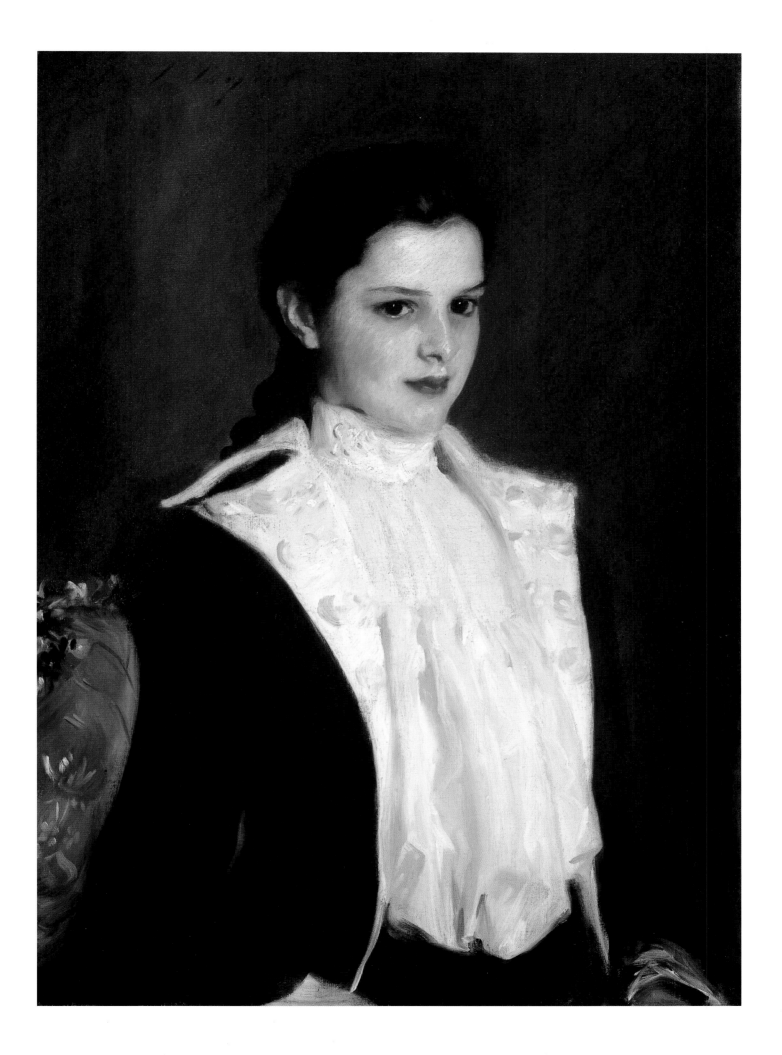

WILLIAM J. McCLOSKEY
1858–1941

Wrapped Oranges, 1889

Oil on canvas, 12 × 16 in. (30.5 × 40.6 cm)

Signed, dated, and inscribed lower right: *W. J. McCloskey N.Y. 1889 COPYRIGHT*

Acquisition in memory of Katrine Deakins, Trustee, Amon Carter Museum, 1961–1985

1985.251

William J. McCloskey's focus on still-life painting is somewhat surprising, for his early training consisted primarily of drawing the human figure from casts of antique sculpture and from life. Born in Philadelphia, he studied at the Pennsylvania Academy of the Fine Arts and was a student of the young Thomas Eakins [q.v.]. McCloskey participated in Eakins' life-drawing class for four years, through 1881. The next year he left his hometown for Denver. He taught life drawing there and met a talented young artist from Los Angeles named Alberta Binford. The two married, and thereafter their art became closely interconnected. Both painted illusionistic still lifes of fruit and flowers in simple tabletop arrangements that were so similar that it often is difficult to distinguish William's work from Alberta's. The peripatetic couple frequently exhibited together and lived at various times in London, Paris, San Francisco, and Los Angeles before they separated in 1898. McCloskey, who painted in his late-nineteenth-century illusionistic style well into the 1920s, died in 1941.

"PAINT AN ORANGE. After you have it done, introduce a white thing. . . . Take an egg or an orange, a piece of black cloth, and a piece of white paper and try to get the light and color."[1] So Thomas Eakins instructed his students at the Pennsylvania Academy of the Fine Arts. McCloskey seems to have taken that lesson to heart. On one level, his paintings of tissue-wrapped oranges are characteristic of the decorative tabletop still lifes that enjoyed new popularity in Victorian households. But on another, more significant level they are studies of light and the way it defines color and the subtlest characteristics of texture.

The intensity of the artist's focus on color and light is palpable in this painting of wrapped oranges. The subject proved endlessly fascinating to McCloskey; he painted tissue-wrapped oranges repeatedly throughout his career in what apparently was a relentless pursuit of perfection within this limited format. Typically, he painted only a few oranges—and at times lemons, apples, or other fruit—always at close range, his subjects placed on simple tabletops in a shallow space. He scrutinized his isolated subjects as a portrait painter might study a sitter's face and body language; he imparted to each specimen a distinctive character, with the tissue acting as a veil that suggested the color and form of the orange within, subtly altered by the translucent paper. "Master of the Wrapped Citrus" is an apt sobriquet for McCloskey, for his painting of this tissue wrapping, so thin and crisp, is a marvel of illusionism, and his specialization in that unusual genre distinguished him from other still-life painters of his day.[2]

PJ

1. From Charles Bregler, "Thomas Eakins as a Teacher—I," *Arts* 17, no. 6 (March 1931), quoted in Maria Chamberlin-Hellman, "Thomas Eakins as a Teacher," Ph.D. diss., Columbia University, 1981, 267.
2. William H. Gerdts, *Painters of the Humble Truth: Masterpieces of American Still Life, 1801–1939*, exh. cat. (Columbia, Mo., and London: University of Missouri Press with the Philbrook Art Center, Tulsa, Okla., 1981), 206–7.

FREDERIC REMINGTON
1861–1909

A Dash for the Timber, 1889

Oil on canvas, 48¼ × 84⅛ in. (122.6 × 213.7 cm)

Signed and dated lower left: *Frederic Remington / 1889 / Frederic Re*[mington] [18]89

1961.381

Although Frederic Remington was born and raised in upstate New York near the St. Lawrence River and studied art on the East Coast, he became one of the most accomplished and influential artists of the American West. His formal artistic training was limited to three semesters at the Yale College of Art, when he was seventeen, and three months at the Art Students League in New York City eight years later. Remington made his first trip westward in 1881, vacationing in Montana Territory. In 1883 he moved to Kansas and became involved in a series of short-lived business ventures while continuing his artistic pursuits. Returning to New York City in 1885, he established a working relationship with Harper's Weekly, *then the largest pictorial newspaper in the world. Remington's rise to prominence was meteoric: within a few years, he was considered one of the best and most prolific artist-correspondents of the day. In 1888 the jurors for the annual exhibition of the National Academy of Design voted him a young artist of promise. He amply rewarded their faith in him with his next entry,* A Dash for the Timber. *In his lifetime, Remington produced some twenty-five bronzes in addition to three thousand paintings and drawings. The Amon Carter Museum is a major repository of his work.*

BETWEEN 1885 AND 1888 Remington made a number of trips to the Southwest, principally to cover the U.S. Cavalry and its pursuit of the Apaches. The stark landscape and dramatic human events he encountered there greatly influenced his artistic development. Remington filled his diaries with observations, made countless field sketches, took many photographs with the latest equipment, and collected numerous artifacts to use in his paintings. "I have a big order for a cowboy picture and I want a lot of 'chapperas'—say two or three pieces—and if you will buy them off some of the cowboys and ship them to me by c.o.d. I will be your slave," the artist wrote to a friend in Arizona in April 1889. "I want *old ones*—and they should all be different in shape.... I have four pairs now and want some more and as soon as I can get them will begin the picture."[1]

He was probably referring to *A Dash for the Timber*, which launched his career as a major painter when it was exhibited at the National Academy of Design in New York City in 1889. "This work marks an advance on the part of one of the strongest of our younger artists, who is one of the best illustrators we have," a critic wrote in the *New York Herald*. "The drawing is true and strong, the figures of men and horses are in fine action, tearing along at full gallop, the sunshine effect is realistic and the color is good."[2] Remington's delineation of the horses is a particular artistic triumph; they charge toward the viewer with nostrils flaring and every muscle strained to its limits. The headlong motion of horses and riders seems suspended above patches of cool purple and blue shadow, contrasting with warmer tones of yellow and orange in the surrounding landscape. The overall effect is cinematic, and this action-filled portrayal of the struggle for life on the frontier anticipates the genre of the western film, which was to follow a generation later.

RS

1. Remington to Powhatan H. Clarke, April 2, 1889, Clarke Collection, Missouri Historical Society, St. Louis.
2. *New York Herald*, November 16, 1889.

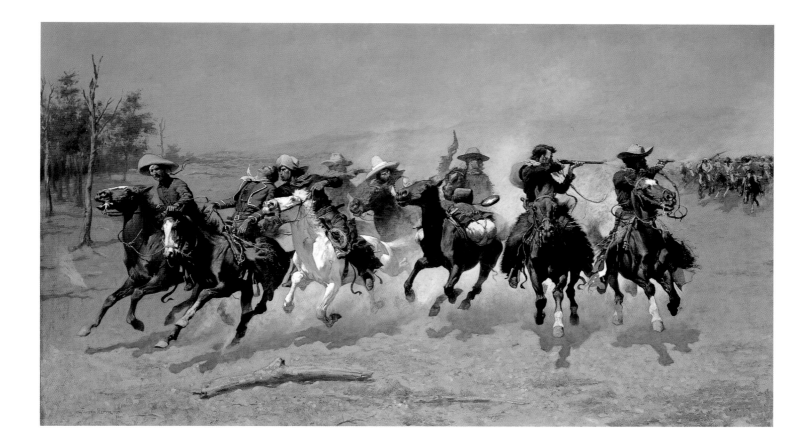

FREDERICK MACMONNIES
1863–1937

Diana, modeled 1890; cast 1894 or later

Bronze, h: 30¼ in. (76.8 cm); w: 20¾ in. (52.7 cm); d: 19⅛ in. (48.6 cm)

Signed, dated, and inscribed on back of base: *F MacMonnies / 1890 / Copyright 1894*; circular stamp: *E GRUET / JEUNE / FONDEUR / 44 BIS AVENUE DE CHATILLON.PARIS.*

Gift of the Board of Trustees in honor of Ruth Carter Stevenson

1986.36

Frederick MacMonnies was born in Brooklyn, New York, and had many important commissions in the United States, but he lived and worked in France for much of his career. He became a studio assistant to the sculptor Augustus Saint-Gaudens [q.v.] in New York City when he was only eighteen. In 1884 he went to Paris with the intention of studying painting; instead, he enrolled in the sculpture classes of Jean-Alexandre-Joseph Falguière (1831–1900) at the École des Beaux-Arts and eventually became his teacher's assistant. Having assimilated Falguière's modeling style, he created works for his American patrons that epitomized the fashionable French taste for naturalism. In 1893 he produced the monumental Triumph of Columbia, *the sculptural centerpiece of the World's Columbian Exposition in Chicago; and with that his reputation soared. He completed several important public works, including the bronze* Nathan Hale *for City Hall Park in New York, dedicated in 1893. In 1905 he returned to France, this time to Giverny, where he opened a school and became a popular member of the vital local American artists' colony. He returned home to New York a decade later, focusing increasingly on painting until his death from pneumonia in 1937.*

By 1890, WHEN MacMONNIES MODELED this small *Diana*, the Roman goddess of the hunt had inspired something of a modern-day cult following among French and American sculptors. Diana as wood nymph was an especially playful and slightly erotic subject, and such figures became popular for small-scale cabinet sculpture in the 1880s.

MacMonnies seems to have derived his interpretation directly from an earlier, immensely popular work by his master, the acclaimed Jean-Alexandre-Joseph Falguière—called "the great sculptor of flesh"—in whose Paris studio he was then apprenticing.[1] But he probably also was aware of growing public interest at this time in another Diana sculpture under construction in the United States—the monumental wind vane *Diana* (1886–91), created by Augustus Saint-Gaudens for the tower of Stanford White's newly built Madison Square Garden in New York. Saint-Gaudens had begun the piece in 1886, only months after MacMonnies completed work in the sculptor's Cornish, New Hampshire, studio. MacMonnies had served an apprenticeship with Saint-Gaudens, so he surely would have followed the progress of his mentor's most talked-about new sculpture. MacMonnies' *Diana* even shares the wind vane's buoyancy, poised lightly as she is on one foot, as if caught on the run. From the day she was unveiled in 1891, Saint-Gaudens' *Diana* was the most famous nude in America. MacMonnies perhaps realized that he could easily capitalize on the public's fascination with her as he marketed his own small *Diana* in beautiful casts made at the best American and Paris foundries. Yet the distinctive, lively grace and sensuality that he imparted to his bronze sculpture make it a standout in its own right. "His art is a joyous one," wrote the sculptor Lorado Taft (1860–1946) in 1903, referring to his friend's facility in modeling, "which must find playful and quick expression. He delights in the 'feel' of the clay and handles it like a magician." His works, Taft said, were "wrought with the caressing finish of the medieval goldsmith."[2]

PJ

1. Lorado Taft, *The History of American Sculpture* (1903; repr. New York: Arno Press, 1969), 336.
2. Ibid., 333–34.

MARY CASSATT
1844–1926

Maternal Caress, 1890–91

Drypoint, aquatint, and soft-ground etching on laid, white, paper; plate: 14⅜ × 10½ in. (36.5 × 26.7 cm); sheet: 16⅞ × 11⅞ in. (42.9 × 30.2 cm)

Signed and inscribed lower right: *Imprimée par l'artiste et M. Leroy / Mary Cassatt*

Ruth Carter Johnson Fund Purchase

1978.22

Born in Pittsburgh into an old, prosperous Pennsylvania family, Mary Cassatt received her primary artistic education at the Pennsylvania Academy of the Fine Arts in Philadelphia, which she entered in 1860, and after the Civil War in Paris, where she studied with several renowned French masters, including Jean-Léon Gérôme (1824–1904) and Thomas Couture (1815–1879). By the mid-1870s she had settled in France permanently. Her friendships with Edgar Degas and Camille Pissarro coincided with a transition in her work toward the dynamic brushwork and high-keyed colors of impressionism. Cassatt devoted herself to portraiture, most frequently depicting women and children, often members of her extended family. The French impressionists invited her to participate in their 1879 exhibition; thereafter, she moved comfortably within their circle, actively exhibiting and selling her paintings, pastels, and prints. Around this time she also began producing etchings and drypoints, which would ultimately number more than two hundred. Later in life she became a supporter of the women's suffrage movement, and during World War I she aided Belgian refugees in France. Although the vigorous modernist movement emerged well before her death, Cassatt never approved of abstract art, which lacked the finish and careful methodology that she herself practiced. Failing eyesight plagued her in her later years. She died in France in 1926, at age eighty-two.

IN 1890 PARISIANS FLOCKED TO AN EXHIBITION OF JAPANESE PRINTS at the École des Beaux-Arts. The American expatriate Mary Cassatt returned to the exhibition many times, writing excitedly to her friend the French painter Berthe Morisot (1841–1895): "You who want to make color prints you couldn't dream of anything more beautiful. I dream of it and don't think of anything else but color on copper."[1]

The impact of the Japanese aesthetic is evident in Cassatt's series of ten color prints depicting women in domestic roles. Like the Japanese, the artist drew upon scenes of everyday life, employed a shallow pictorial space, and emphasized pattern against flat, unmodulated passages of color.

Cassatt's color prints comprise her most daring explorations of intimate subject matter, coupled with innovative technique. *Maternal Caress* is a touching variation on one of her favorite themes: mothers caring for their children. Eyes closed, the mother pulls her child toward her, a gesture reciprocated by the contented child as their cheeks touch. The composition reiterates the protective sentiments of motherhood by enveloping the child within a closed, oval format. Indeed, all the compositional elements draw attention to the infant, the smallest form, framed by alternating layers of clearly demarcated patterns and solid receding planes. Cassatt used etching and drypoint sparely to define the subjects' eyes and hair, while the aquatint process imparted a range of soft colors—the light gray lavender of the dress, the shades of brown and yellow that define the room, and the pale blue linen on the bed.

Cassatt intended to show the ten color prints at the annual Société des Peintres-Graveurs Français exhibition held in Paris. Upon learning that she was excluded because she was not a French native, she responded by displaying the prints in an adjoining gallery. Her new works received accolades from contemporary French artists such as Edgar Degas (1834–1917), Paul Gauguin (1848–1903), and Camille Pissarro (1830–1903), all of whom shared her enthusiasm for printmaking.

JM

1. Cassatt to Berthe Morisot, April 1890, in Nancy Mowll Mathews, ed., *Cassatt and Her Circle: Selected Letters* (New York: Abbeville Press, 1984), 214.

WILLIAM MERRITT CHASE
1849–1916

Idle Hours, ca. 1894

Oil on canvas, 25½ × 35½ in. (64.8 × 90.2 cm)

Signed lower left: W^M *M. Chase.*

1982.1

William Merritt Chase was born in Williamsburg, Indiana, and by age twelve was taking private drawing lessons. In 1869 he studied under Lemuel Wilmarth at the National Academy of Design in New York City. Three years later, he traveled to Munich, where he acquired the brush technique that distinguished his work. Chase's style evolved through the 1880s from a characteristic dark palette reminiscent of the Old Masters to one of brilliant color, an impressionism that naturally followed his embrace of plein-air *painting. The grand rooms he occupied in New York's famous Tenth Street Studio building lured students and fellow artists alike. Chase was an influential teacher who trained many of the leading artists of the early twentieth century. He taught at the chief art academies and founded the Chase School of Art and the Shinnecock Summer School of Art on Long Island. When he died in 1916, he was still regarded as one of the country's preeminent artists, even though his lyrical art had been eclipsed by a new urban realism and by the modern movements introduced to Americans at the landmark New York Armory Show of 1913.*

THE SANDY SHINNECOCK HILLS, on the southern shore of Long Island near Southampton, encourage idling. Here, among the vacation homes of New York's fashionable elite, William Merritt Chase directed a summer art school for the practice of open-air painting. The low, heather-covered hills that wrap around the brilliant blue inlets present a broad expanse of subtle, ever-changing color, light, and atmosphere that never failed to fascinate Chase. He came here every summer for more than two decades, even after the Shinnecock school closed in 1902, and built a grand house designed by Stanford White (1853–1906). He painted delicate, luminous oil sketches of this stretch of beach in all its moods. "I carry a comfortable stool that can be closed up in a small space, and I never use an umbrella," Chase said of his working method. "I want all the light I can get. When I have found the spot I like, I set up my easel, and paint the picture on the spot. I think that is the only way to interpret nature."[1]

Idle Hours, one of the largest of Chase's *plein-air* productions, captures and conveys the joy he knew at Shinnecock. Here he has painted his wife and children at ease among the grasses—brilliant white and red color notes in a field of green beside an azure sea. The painting seems unselfconscious, the artist's intuitive brushwork describing the dry sand, coarse scrub, and the heavy cloud at left, which casts a slight shadow as it moves across the sky.

PJ

1. Quoted in A. R. Ives, "Suburban Sketching Grounds: 1. Talks with Mr. W. M. Chase, Mr. Edward Moran, Mr. William Sartain and Mr. Leonard Ochtman," *The Art Amateur* 25, no. 4 (September 1891): 80.

ARTHUR WESLEY DOW
1857–1922

The Wanderer, ca. 1895–1910

Cyanotype, 6¹⁄₁₆ × 8⅛ in. (15.4 × 20.6 cm)

P1997.4

In 1884 the twenty-seven-year old Arthur Wesley Dow traveled to Paris and studied at the Académie Julian, where he first encountered the work of James McNeill Whistler [q.v.]. After his return to the United States in 1889, he taught at the Pratt Institute in Brooklyn (1895– 1904) and then at Teachers College, Columbia University (1904–22). His enormously influential manual, Composition: A Series of Exercises in Art Structure for the Use of Students and Teachers *(1899), advocated the use of freely constructed images and harmonic relationships among line, color, and pattern. His groundbreaking notions transformed art theory and art education and influenced a broad range of American artists, including both painters and photographers, at the turn of the century. Through his art, teaching, and writing, Dow is largely credited with ushering in the abstract principles of form that fostered the American modern-art movement.*

ALTHOUGH ARTHUR WESLEY DOW was born and raised in Ipswich, Massachusetts, it was not until after he studied the *plein-air* mode of painting in Brittany that he truly came to appreciate the Ipswich countryside for its similarities to the Breton coast. With its white sand dunes, black tidal river, and marshes dotted with haystacks, the area attracted many who had recently worked in the Brittany region because it offered acceptable "French" views. Shortly after returning from France, Dow discovered the woodcuts of the Japanese *ukiyo-e* artist Katsushika Hokusai (1760–1849) and began incorporating into his work the compositional principle known as *notan*, the particular arrangement of light and dark masses. He promoted his philosophy of the three compositional elements of line, color, and *notan* in his landmark book, *Composition: A Series of Exercises in Art Structure for the Use of Students and Teachers* (1899).

Better known for his painting and printmaking, and especially for his influence on art education, Dow used photography to test compositional ideas. For its evocative blue tones and the simplicity of processing, he favored the cyanotype, or blueprint process, which is based on the photosensitivity of iron salts. Like this image of an abandoned boat in a marshy field, most of Dow's photographic studies were made in and around his Ipswich home, where he conducted a summer art school from 1891 to 1907. He created his bucolic color woodcut *The Derelict* (1916, Amon Carter Museum) working from this cyanotype, wherein he raises the eyes of the viewer up to provide a more pleasing curve of the water line as it trails into the horizon.

BMC

56

The Fall of the Cowboy, 1895

Oil on canvas, 25 × 35⅛ in. (63.5 × 89.2 cm)

Signed lower right: *Frederic Remington*

1961.230

Born and raised in upstate New York near the St. Lawrence River, Frederic Remington began his career as a painter in the late 1880s, after gaining recognition as an illustrator. In 1888, during his second year of exhibiting at the National Academy of Design in New York City, he won both the Hallgarten Prize for artistic promise and the Thomas B. Clark Prize for the best figure painting. In 1889 his work was featured in the Universal Exposition in Paris, where his subjects stood out as uniquely American. Remington's captivating realism was the result of firsthand observation; in the late 1880s and 1890s he traveled frequently in the West as an artist-correspondent for the illustrated magazines, making sketches to develop into large oils. Despite his early acclaim and growing popularity, he was increasingly viewed as a conservative painter in the 1890s, as critics embraced the new impressionism. Remington responded to this waning interest with an extraordinary coloristic innovation of his own— his stunning nocturnes, closely toned paintings of night subjects that would be celebrated as the great achievement of his last years.

"SAY WISTER—GO AHEAD PLEASE—make me an article on the evolution of the puncher—the 'passing' as it were," Remington wrote in the fall of 1894 to his friend Owen Wister (1860–1938).[1] Remington had been collaborating with the young writer from Philadelphia on a series of articles for *Harper's New Monthly Magazine*. Wister's "The Evolution of the Cow-Puncher" appeared in the magazine's September 1895 issue accompanied by Remington's illustrations, including *The Fall of the Cowboy*.

Beneath a sky of gunmetal gray tones, two cowboys have halted their horses in a wintry landscape. One has dismounted to remove the rails of a gate so they can pass through. The scene is infused with the slow rhythms and somber shades of an elegy. "Three things swept [the cowboy] away," Wister wrote, echoing what Remington had told him, "the exhausting of the virgin pastures, the coming of the wire fence, and Mr. Armour of Chicago, who set the price of beef to suit himself."[2] Remington—like the other great popularizer of the West in this period Theodore Roosevelt—viewed the cowboy as the last figure of American frontier history: hardy, self-reliant, and tragically doomed to extinction in the wake of civilization's progress. Wister's influential western novel *The Virginian*, published in 1902, immortalized this mythic image.

RS

1. Remington to Wister, September or October 1894, quoted in Ben Merchant Vorpahl, *My Dear Wister: The Frederic Remington–Owen Wister Letters* (Palo Alto, Calif.: American West Publishing Company, 1972), 47.
2. Owen Wister, "The Evolution of the Cow-puncher," *Harper's New Monthly Magazine* 91, no. 544 (September 1895): 615.

BESSIE POTTER VONNOH
1872–1955

An American Girl, 1895

Tinted plaster, h: 14½ in. (36.7 cm); w: 10½ in. (26.6 cm); d: 11½ in. (29.1 cm)

Signed, on back of base: *Potter*; underneath base: *Bessie Potter / Vonnoh* [likely added after 1915]

Ruth Carter Stevenson Acquisitions Endowment

1993.1

Born in St. Louis, Bessie Potter moved to Chicago as a child. Due to a childhood infirmity, her growth was checked, and she never grew beyond four feet eight inches tall. When she was only fourteen, she met the sculptor Lorado Taft (1860–1946) and studied with him, first privately and then at the School of the Art Institute of Chicago. With other students, she assisted Taft on his large sculptural groups for the 1893 World's Columbian Exposition and produced her own heroically scaled figure, Art, for the Illinois State Building at the fair. She preferred portraiture to allegorical types, however, and delighted in modeling small terracotta and plaster statuettes and busts that could be easily exhibited in private homes. Large-scale public sculpture followed these first small-scale enterprises, including a monumental bust of Major General S. W. Crawford, part of a Civil War memorial for Philadelphia's Fairmount Park. In 1899 Potter married the painter Robert Vonnoh (1858–1933), whom she had met in Taft's studio. The couple made their home in New York and, later, Lyme, Connecticut. In 1913 she had an exhibition at the Brooklyn Institute of Arts and Sciences and saw her work included in the groundbreaking Armory Show of modern art in New York. During the 1920s she turned increasingly to garden sculpture. Active into the 1930s, she died in New York in 1955.

CREATED AT THE BEGINNING OF VONNOH'S ILLUSTRIOUS CAREER, this tinted-plaster sculpture was among several such works the artist exhibited in Chicago in 1895. Bessie Potter (she had not yet married the painter Robert Vonnoh) invited her friends, dressed in their stylish attire, to pose for her statuettes. *An American Girl* is a type, however, rather than a portrait. The work captures the elegant and refined feminine ideal of a period when women were increasingly well educated and becoming more active in social and religious causes.

Critics were taken with the delicate beauty and refinement of these works, which they dubbed "Potterines," and Potter was hailed as a rising star in the art world. Her creations were especially notable for their originality, expression of character, and subtle relationship to certain forms of classical Greek sculpture. The spontaneous effect of the artist's modeling can be seen in the numerous fingerprints and tool marks on the plaster. With her brush, Potter applied a thin rose-colored tint to the entire surface. *An American Girl* is one of the finest of her plaster studies, which were intended for display in the home.

RS

CHARLES M. RUSSELL
1864–1926

Indian Family with Travois, 1897

Watercolor and graphite on wove, off-white paper mounted to board,
13¾ × 22¼ in. (34.9 × 56.5 cm)

Signed and dated lower left: *CMRussell / 1897* [the artist's signature skull]

1961.141

Charles M. Russell was as much a painter of northern Plains Indians as he was of the cowboy life that he himself had lived. He left his St. Louis home when still a young man to work in Montana Territory, and he filled letters to friends with watercolor sketches of the cattle drives and the Native Americans he encountered there. In the summer of 1888 Russell and a cowboy friend holed up in Alberta, where he came to know the local Blackfeet. A keen observer, he recalled scenes from this experience decades later and made them subjects of his art. He read avidly about Indian customs and collected artifacts to lend additional authenticity to his paintings. A commission from a St. Louis patron in 1893 prompted him to produce some of his first major watercolors, with Plains Indians figuring prominently in these and subsequent works of the late 1890s. By this time Russell had settled in Great Falls, Montana, and he achieved national and international recognition with his acclaimed solo exhibitions in New York City (1911) and London (1914).

IN THIS MASTERLY WORK OF TRANSPARENT WATERCOLOR, Russell amply demonstrates both his keen understanding of Blackfoot culture and his eye for narrative detail. A crucial item in the life of the Blackfeet, the horse travois was an A-shaped drag—two long shafts made of lodgepole pine, with a loading platform and a hitch for attachment to the horse, all bound with rawhide. The poles were tied with a wet tendon from the back of a buffalo's neck, which was wrapped with a cover of soft-tanned skin. Generally, the poles were cut a little longer to allow for wear when they were dragged over rough ground; even so, a travois often had to be replaced after a year's use. The hitch, visible here as the decorated martingale above the horse's forelegs, was a flat strip of rawhide connected to two rawhide lines; the latter, about two fingers wide, were wrapped the length of the two poles to the lower part of the platform, where their ends were left long to tie loads. These lines, also visible in Russell's depiction, were crucial to the operation of the travois; they carried the weight of the load and prevented the poles from splitting.

Russell shows us that the women of the tribe made the travois and used it to transport people or materials, such as robes and bedding. The women referred to the hitch as "my load" and to the platform as "my broad road."[1]

This Blackfoot woman has paused with her young son to allow the horses to drink. The decorated cradle hanging from the front saddle horn was a luxury item among the Blackfeet; most women carried their babies on their backs. A large skinning knife, with its tack-studded sheath, can be seen on her belt, and she holds an elk-horn-handled quirt in her right hand.

RS

1. John C. Ewers, *The Horse in Blackfoot Indian Culture* (Washington, D.C.: Smithsonian Institution Press, 1980), 105.

JOSEPH T. KEILEY
1869–1914

Philip Standing Soldier, 1898–99

Glycerine-developed platinum print, $7^{11}/_{16} \times 5^{5}/_{8}$ in. (19.5 × 14.3 cm)

(Object reproduced at actual size)

P1984.14

Joseph T. Keiley was born in Baltimore, graduated from New York Law School in 1892, and began his practice in New York City. There, he met the photographers Gertrude Käsebier and Alfred Stieglitz [q.v.]. A dedicated photographer himself by 1898, Keiley exhibited at the American Institute and by 1899 had become an active member of the New York Camera Club, serving as editor of its journal, Camera Notes. *At the turn of the century, he had achieved international recognition with his photographic portraiture. Consequently, he was elected to the exclusive British photography group known as the Linked Ring; at that time he was only the fourth American invited to join. Stieglitz left the Camera Club in 1902, and Keiley helped him establish the Photo-Secession, a group dedicated to photography as an art form. Keiley also helped Stieglitz organize that group's first exhibition in the Little Galleries of the Photo-Secession, or 291 as it came to be known. In 1903 Keiley became associate editor of Stieglitz's new journal,* Camera Work. *Keiley remained faithful to the pictorialist aesthetic, defending it as an art form through his persuasive, eloquent writing in* Camera Work *until his death in 1914 of Bright's disease.*

JOSEPH KEILEY WAS A MAJOR FIGURE in the pictorialist photography movement, which endeavored to promote photography as a fine art. Working together, he and his close friend Alfred Stieglitz invented the glycerine-developed platinum print. When glycerine was applied to a developed print, localized areas could be further developed and warm tones applied. The process softened the details of a photograph and called attention to the intriguing interaction of light and dark.

Keiley met Philip Standing Soldier, one of nine Oglala Lakota from the Pine Ridge Indian Agency in South Dakota, while attending an afternoon tea at the popular studio of the photographer Gertrude Käsebier (1852–1934) on Fifth Avenue in New York City. The Lakota were performing in Buffalo Bill's Wild West show, and every year from 1898 until 1912 Käsebier played hostess to his troupe of Native Americans. Although Keiley never wrote about his photographs of the Lakota, he revealed his sentiments when commenting on Käsebier's portrait of Chief Iron Tail in 1899:

> Too proud to protest, too thoroughly a warrior to complain, or to bow to the new order of things, he watches stoically; and unbending awaits the inevitable end. On his face there is written a sort of fierce sadness, such a look as is ever to be found in the faces of a strong people whose possessions have been usurped. . . .[1]

BMC

1. Joseph T. Keiley, "Tonality," *Camera Notes* 2, no. 4 (April 1899): 139.

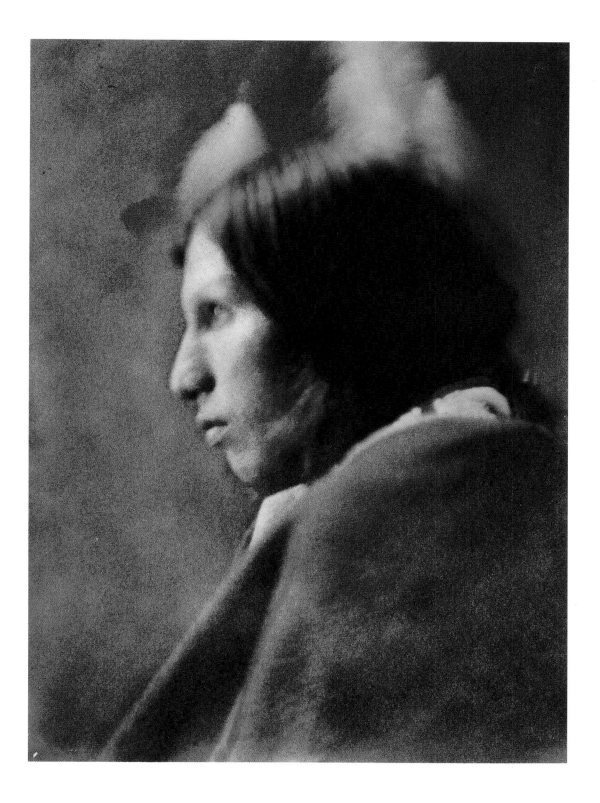

AUGUSTUS SAINT-GAUDENS
1848–1907

Robert Louis Stevenson, modeled 1899; cast after 1900

Bronze, 17¼ × 24⅜ in. (43.8 × 61.9 cm)

Signed, dated, and inscribed, upper right: ·*AUGUSTUS·* / ·*SAINT-GAUDENS·* / ·*FECIT*; lower left, © · / ·*BY AUGUSTUS·* / ·*SAINT-GAUDENS·* / ·M· / ·DCCCXC· / ·IX·; lower right: *AUGUSTUS* / *SAINT-GAUDENS* / *MCM*

Ruth Carter Stevenson Acquisitions Endowment

1987.21

Seven months after he was born in Dublin, Augustus Saint-Gaudens immigrated with his family to New York City. By age sixteen he was attending drawing class at the Cooper Union and apprenticing in the studio of a cameo cutter. Earlier American sculptors had typically gone to Florence or Rome to study the classical tradition. But Saint-Gaudens went to Paris in 1867, to the École des Beaux-Arts, where he discovered artists working not in marble but in bronze—modeling works in clay or wax to be cast, patinated, and polished. Contemporary French sculpture was fresh and spontaneous, revealing the creator's hand. Saint-Gaudens also went to Italy, where he found inspiration in Renaissance bronzes and in the artful plazas that sculptors and architects together had created to honor heroic men and celebrate civic virtue. During the boom years following the Civil War, American public spaces in growing urban centers were ideal sites for similar tributes, and Saint-Gaudens collaborated with the architect Stanford White (1853–1906) to realize the dramatic possibilities of sculpture in these settings. Dividing his time between New York and his studio in Cornish, New Hampshire, he remained active until his death, creating naturalistic sculptural landmarks to beautify and ennoble the urban landscape.

SHORTLY AFTER ROBERT LOUIS STEVENSON DIED IN 1894, Augustus Saint-Gaudens was asked to create a memorial to the revered Scottish author for St. Giles Cathedral in Edinburgh. This was a singular honor for an American sculptor but one not wholly unexpected, for Saint-Gaudens had earlier produced a beautiful and much-admired bas-relief portrait of Stevenson from studies he had made during brief visits with the writer in New York City in 1887. His was an especially touching and riveting portrayal of the frail author as he had encountered him, propped up in bed, animated even though weakened by tuberculosis. Saint-Gaudens was enthralled by the man as he had earlier been moved by his writing; he claimed that Stevenson's *New Arabian Nights* (1882) had "set me aflame as have few things in literature."[1] Although their subsequent friendship evolved mostly through letters, Saint-Gaudens never forgot the time he spent with the sensitive Scotsman: "My episode with Stevenson has been one of the events of my life," he wrote to a friend.[2]

Saint-Gaudens had always looked to ancient Roman and Renaissance civic sculpture as models for suitable public tributes, and he conceived of the Stevenson memorial as a grave stele, bearing a portrait relief of the deceased. He used a variant of his 1887 portrait from life and augmented it with appropriate commemorative devices from the antique, including a garland of laurel, here entwined with the heather of Stevenson's homeland and the hibiscus native to Samoa, where the writer was living at the time of his death. In this, a reduced version of the memorial that is one of possibly ten casts, the tablet is inscribed not with a Latin epitaph but with Stevenson's own poetry on the enduring life of words:

> BRIGHT is the ring of words
> When the right man rings them,
> Fair the fall of songs
> When the singer sings them.
> Still they are carolled and said—
> On wings they are carried—
> After the singer is dead
> And the maker buried.[3]

PJ

1. Quoted in Homer Saint-Gaudens, ed., *The Reminiscences of Augustus Saint-Gaudens*, 2 vols. (1913; repr. New York and London: Garland Publishing, 1976), vol. 1, 373.
2. Saint-Gaudens to the artist Will Low, quoted in Saint-Gaudens, *Reminiscences*, vol. 1, 384.
3. Robert Louis Stevenson, from "Songs of Travel," in *Collected Poems*, ed. Janet Adam Smith (London: Rupert Hart-Davis, 1950), 254.

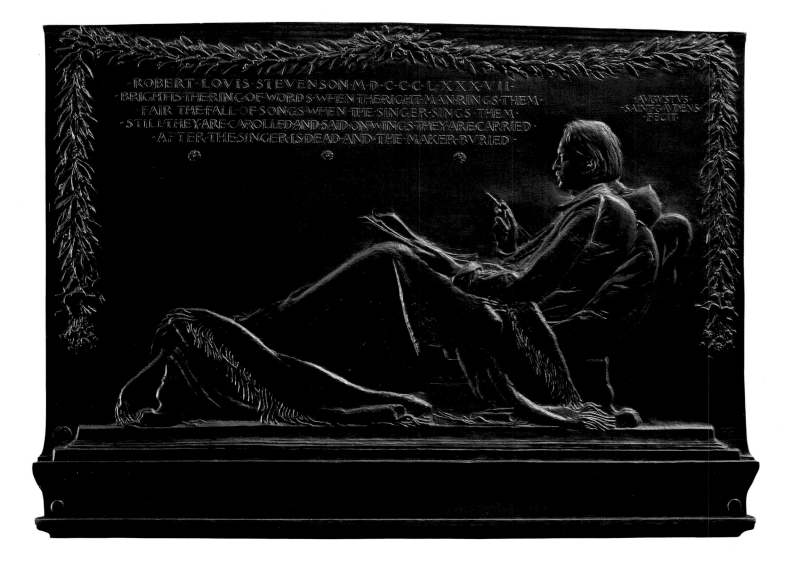

ROBERT·LOVIS·STEVENSON·M·D·C·C·C·L·XXXX·VII·
·BRIGHT·IS·THE·RING·OF·WORDS·WHEN·THE·RIGHT·MAN·RINGS·THEM·
·FAIR·THE·FALL·OF·SONGS·WHEN·THE·SINGER·SINGS·THEM·
·STILL·THEY·ARE·CAROLLED·AND·SAID·ON·WINGS·THEY·ARE·CARRIED·
·AFTER·THE·SINGER·IS·DEAD·AND·THE·MAKER·BVRIED·

·AVGVSTVS·
·SAINT·GAVDENS·
·FECIT·

JOHN FREDERICK PETO
1854–1907

A Closet Door, 1904–6

Oil on canvas, 40¼ × 30⅛ in. (102.2 × 76.5 cm)

Signed upper left: *John F Peto* [as a compositional device]

1983.158

John Frederick Peto was born in Philadelphia in 1854. His father had been a dealer in picture frames, which probably stimulated his son's interest in painting. Peto enrolled at the Pennsylvania Academy of the Fine Arts in 1877. Although he aspired to a painting career, he rarely exhibited his work and chose not to move in Philadelphia's art circles; his fascination with still life pushed him further outside the artistic mainstream. In 1889 Peto and his wife moved to the resort community of Island Heights, on the New Jersey shore; he lived there the rest of his life, playing the cornet at local camp revival meetings and painting in isolation. Even long after his death in 1907, Peto was erroneously considered a follower of Philadelphia's William M. Harnett [q.v.]. As Harnett's reputation soared early in the twentieth century, many of Peto's works actually appeared on the art market with spurious Harnett signatures. Although Peto knew and respected Harnett, and although they occasionally essayed similar subjects, his soft painting style differs dramatically from Harnett's crisp realism, and his often autobiographical compositions set him apart from other trompe l'oeil painters as an artist with a distinct vision and an expressive power.

THE LETTER RACK IS A FITTING CONCEIT for a personalized still life, and Peto painted many of these compositions, sometimes on commission and other times purely on speculation. Each painted arrangement of notes, cards, and mementos served as a complex composite portrait of a particular patron. Generally, they were displayed in specific places of business, where the elements reflected their owners and the appropriate occupation or trade. Peto also employed the letter rack as a means of self-expression, creating, especially in the last years of his life, compositions with items that apparently had a deep personal meaning. His seemingly autobiographical compositions provide a glimpse into this reticent painter's private world, and their muted color tones and studied sense of disarray suggest that his life may have been troubled.

A Closet Door, Peto's last known letter-rack painting, seems to be both self-referential and retrospective. The artist's name appears as if carved upon the rickety wood-plank door. The door is weathered, a rusted hinge is broken, and the old letter rack is frayed. All is soon to fall. An aura of age, decay, and collapse casts a melancholy shadow over these enigmatic objects and strange juxtapositions, perhaps reflecting Peto's own exhaustion as he slowly succumbed to a painful kidney disease. A self-addressed envelope postmarked "Philadelphia" is possibly intended to recall the city of Peto's birth, his art training, and his first success. But the other items—including a yellowed print of George Washington, an old crumpled almanac, and a worn dime novel, *Adventures of a Beauty*—are obscure, and the artist has provided no key.

PJ

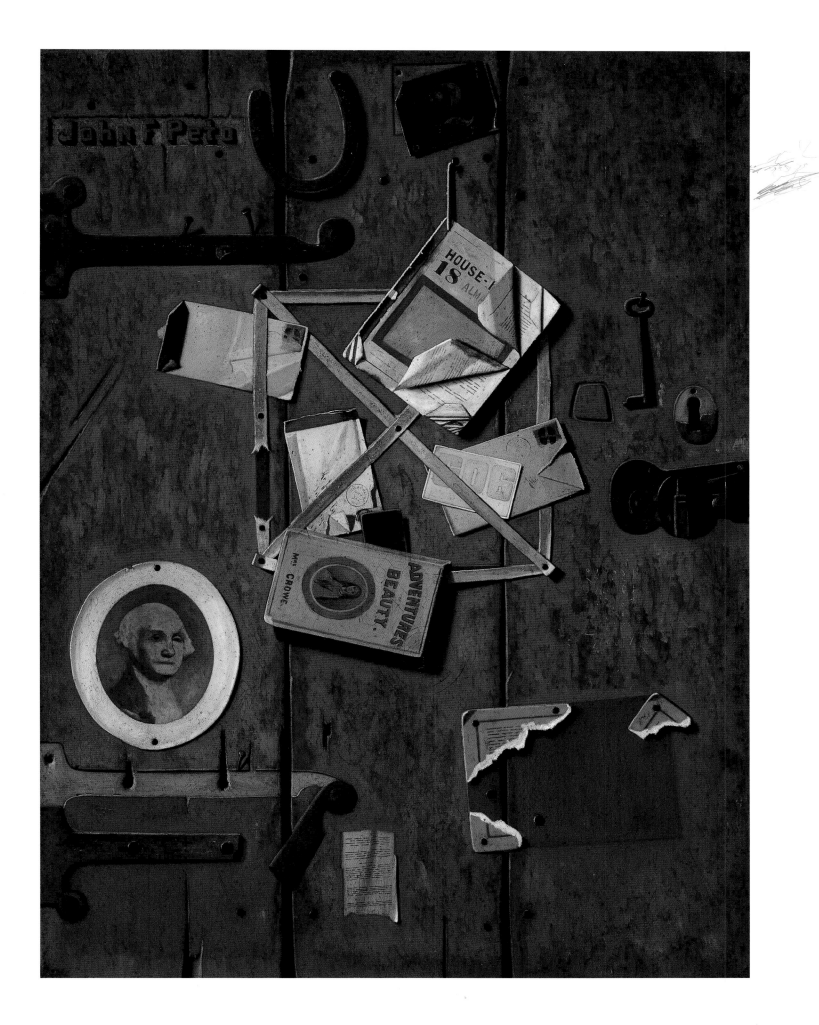

ERWIN E. SMITH
1886–1947

Turkey Track Cowboys Crossing the Wichita River,
Turkey Track Ranch, Texas, 1906; printed ca. 1936

Gelatin silver print, 10⅜ × 13½ in. (26.4 × 34.3 cm)

Copyright 1986, Amon Carter Museum, Fort Worth, Texas

Bequest of Mary Alice Pettis

P1986.42.129

Born in Honey Grove, Texas, Erwin E. Smith made his first photographs during summer visits to his uncle's ranch in Foard County, Texas. Determined to be an artist, he enrolled in the School of the Art Institute of Chicago in 1905 to study with the noted sculptor Lorado Taft (1860–1946). In the fall of 1906 he returned to Texas, where he made many photographs that captured the waning days of the cowboy on the vast, open ranges in the Southwest. He resumed his education the next year at the School of the Museum of Fine Arts in Boston, where he studied for three years and used his photographs as the basis for drawings and sculptures. He always spent summers making photographs on the ranchlands of the Southwest, accompanied by his friend the writer George Pattullo. Pattullo wrote articles on his western experiences for the Saturday Evening Post, *and he used Smith's photographs to illustrate them. Smith, who remained in Texas for the rest of his life, tried his hand at several moneymaking ventures that, by the mid-1920s, left him broke. Although his attempts to market his photographs were modest and unsuccessful, his work remains a valuable record of a lost way of life.*

ERWIN SMITH GREW UP IN NORTH TEXAS, and he idolized the cowboys there, whom he saw as heroic figures and "wandering knights of [the] plains."[1] For Smith, the Texas Panhandle remained the only place where traditional ranching was still practiced, and even the few remaining old-style ranches there were on the verge of extinction. He determined to document the traditions of life on the open range, originally intending to use his photographs as studies for sculpture. Over time, his images became some of the best-known photographs of southwestern range life.

After studying for a year with the sculptor Lorado Taft at the School of the Art Institute of Chicago, Smith spent the fall of 1906 near the base of the Texas Panhandle. Eager to utilize his artistic training to create truthful images that would contrast with the cowboy stereotype popularized in dime novels, he won the cooperation of several members of the Turkey Track Ranch outfit. Accompanied by ranch boss Ed Bomar, riding his cutting horse, Rabbit, Smith made more than thirty exposures of the men conducting their routine roundup activities. Knowing that the riders' reflection in the water would create a more dynamic composition, Smith probably galloped ahead to set up his camera.

BMC

1. Erwin Smith, untitled manuscript, 1904, n.p., Erwin E. Smith Collection, Nita Stewart Haley Memorial Library, Midland, Tex.

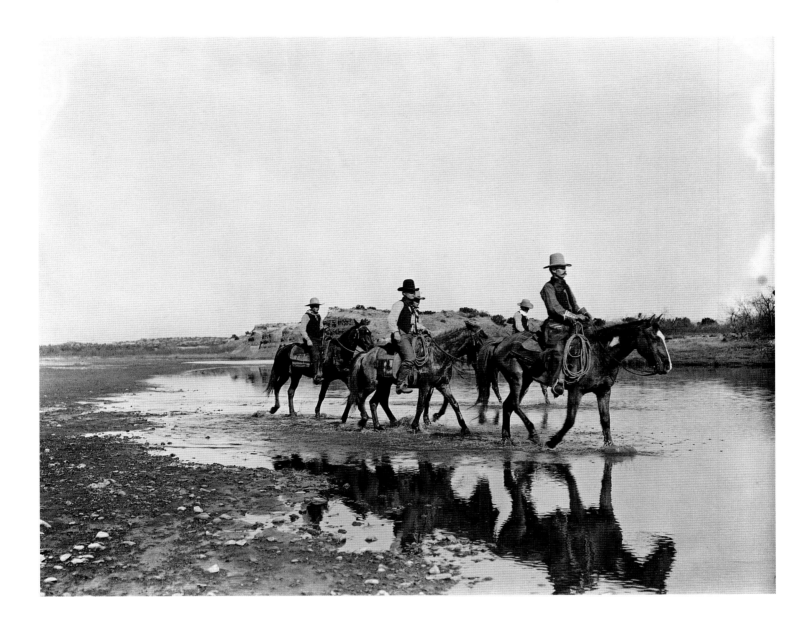

FREDERIC REMINGTON
1861–1909

The Outlaw, design copyright 1906; cast 1907

Bronze, h: 23½ in. (59.7 cm); w: 14¼ in. (36.2 cm); d: 7¾ in. (19.7 cm)

Signed and inscribed, on top of base: *copyright by Frederic Remington*; on edge of base: *Roman Bronze Works N.Y.*; on underside of base: *N 4*

1999.22

Almost as soon as he established himself in New York City in 1885, Remington, a native of upstate New York, knew extraordinary success as an illustrator and a painter. Ten years later he began experimenting with sculpture. Encouraged and counseled by the sculptor Frederic Ruckstull (1853–1942), Remington began modeling a wax depiction of a cowboy on a bucking bronco, and in a few months—with virtually no prior training as a sculptor—he had created The Bronco Buster, *one of the most technically accomplished and aesthetically satisfying equestrian subjects in the history of American sculpture. By 1900 Remington had learned of the lost-wax casting process and began working with a new Brooklyn foundry, the Roman Bronze Works, to produce bronze sculptures that were increasingly daring in style and technique. His ambitious pieces were critically acclaimed and proved to be highly profitable. Remington became interested in monumental sculpture after 1905, when he was commissioned to create* The Cowboy *for Philadelphia's Fairmount Park; he died in December 1909, only months after the work was installed.*

BY THE TIME HE CREATED THE DESIGN for *The Outlaw*, his fourteenth bronze, Remington had achieved fame for his spirited and well-crafted bronzes depicting life in the American West. In 1905 he sent a Christmas card to Riccardo Bertelli at the Roman Bronze Works with a sketch showing himself and Bertelli with the proposed bronze, a difficult composition of a cowboy on a bucking horse. The horse was shown with its hindquarters raised high in the air, its front legs stabbing the ground in an effort to dislodge the rider. "Can you cast him?" the artist asks in the sketch. "Do you think I am one of the Wright Brothers?" Bertelli replies.[1]

This finely detailed lifetime cast retains its original greenish-black patina. Numerous areas on the work bear direct evidence of Remington's hand, for example, brushstrokes on the surface, fingerprints, and tool marks where the artist refined the wax model. The meticulous details apparent in every rock and plant on the base reflect the care and attention invested in the making of the cast. Even the smallest elements—the folds in the rider's hat, for example, and the detailing on the handle of his quirt—are finely wrought.

Most extraordinary of all is the composition itself, remarkable for the painstaking pitch, slant, and carefully controlled balance of its figures. When seen from the side, the center of gravity is just behind the forward pitch of the group; this makes the sculpture come alive, for it seems that the horse and rider will fall forward at any moment. Viewed from the front, this daring composition creates a graceful yet complex curve as the rider shifts his weight against the horse's sidelong movement.

RS

1. Reproduced in Michael D. Greenbaum, *Icons of the West: Frederic Remington's Sculpture* (Ogdensburg, N.Y.: Frederic Remington Art Museum, 1996), 135. The sketch is in the collection of the R. W. Norton Art Gallery, Shreveport, La.

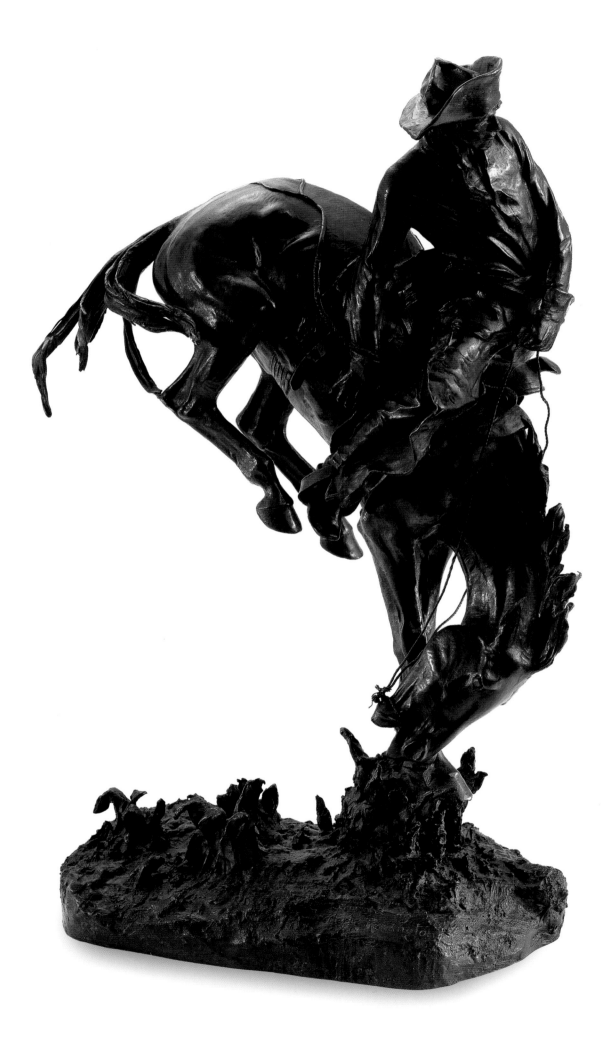

GEORGE SEELEY
1880–1955

Maiden with Bowl, ca. 1907–9

Gum platinum print, 13⁷⁄₁₆ × 10⁵⁄₈ in. (34.1 × 27 cm)

Signed and inscribed, lower left: *George H. Seeley / Stockbridge, Massachusetts. / U.S.A.*; on reverse, upper center: *Maiden with Bowl. / by / George H. Seeley / Stockbridge, / Mass. / U.S.A.*

P1984.18

A native of Stockbridge, Massachusetts, George Seeley began studying photography in earnest about 1902, after visiting the Boston studio of the preeminent pictorialist photographer F. Holland Day (1864–1933). Two years later Seeley exhibited fourteen prints at the First American Photographic Salon in New York City, receiving enthusiastic reviews and an invitation from Alfred Stieglitz [q.v.] to join the influential organization known as the Photo-Secession. While teaching art in the Stockbridge public schools from 1904 to 1912, Seeley continued making photographs. A laudatory article in Photo-Era *magazine in 1905, along with the publication the following year of photogravure reproductions of his work in the journal* Camera Work *and a solo show at Stieglitz's 291 gallery in 1908, sealed his reputation. The 1910* International Exhibition of Pictorial Photography *at the Albright Art Gallery in Buffalo marked the climax both of his career and of the pictorialist aesthetic. He continued exhibiting into the 1930s, even as public attention was declining in the wake of the modernist movement. Seeley received his first retrospective exhibition at the Berkshire Museum in Pittsfield, Massachusetts, in 1986— thirty-one years after his death.*

GEORGE SEELEY WAS ONE OF MANY turn-of-the-century pictorialist photographers who, in an effort to establish photography as a respected fine art, turned for inspiration to European symbolist painting and poetry. Reacting to the prevailing strains of pragmatism and materialism in American culture, the symbolists expressed an inner world of imagination and spirituality.

In this allegorical portrait of a woman with a large bowl, Seeley incorporated several direct references to symbolist iconography; he focused on the woman's head and hands, which were thought to be the seats of a person's intellect and character. Pictorialists also stressed that the eyes were reflections of the soul and should confront the viewer with a mysterious stare, as this woman's eyes do. The inclusion of the bowl—another pictorialist convention, along with an orb or a glass jar—was borrowed from the Belgian writer and mystic Maurice Maeterlinck (1862–1949), who poetically referred to a glass jar as the vessel of his inner soul, both sheltered and separate from the outside world. An allegorical portrait of a woman holding a round vessel is also a traditional reference to motherhood and purity.

A master of this subjective language, Seeley proved to be among the most influential photographers of the period. Within a decade, however, photography critics considered this style unfashionable, and Seeley passed from favor.

BMC

65

ARTHUR G. DOVE
1880–1946

The Lobster, 1908

Oil on canvas, 25⅞ × 32 in. (65.7 × 81.3 cm)

Signed and dated lower right: *DOVE / 08*

Acquisition in memory of Anne Burnett Tandy, Trustee, Amon Carter Museum, 1968–1980

1980.29

Born and raised in upstate New York, Arthur Dove graduated from Cornell University in 1903, the same year he moved to New York City and began a career as an illustrator for periodicals. He also took up painting and in 1908 traveled with his wife to Europe, where he honed his craft working in the French countryside. The Lobster was Dove's first major oil painting; it was exhibited in the 1909 Salon d'Automne in Paris and in 1910 in the landmark exhibition Younger American Painters, held at Alfred Stieglitz's 291 gallery. The exhibition in New York featured work by some of the more progressive painters of the day, including Marsden Hartley [q.v.] and John Marin [q.v.], and marked the American introduction of native artists influenced by European modernism. Dove would prove to be a pioneering abstract painter whose work was rooted in his response to nature.

IN 1908 THE TWENTY-SEVEN-YEAR-OLD ARTHUR DOVE gave up his job as a freelance illustrator in New York City and left for France. There, inspired by the contemporary French masters, particularly Paul Cézanne (1839–1906) and Henri Matisse (1869–1954), the young American created *The Lobster*, a depiction of a cloth-covered table bearing a sumptuous feast of ripe fruit and lobster set against richly patterned wallpaper. When Dove departed Europe, he left the painting behind to be exhibited in the 1909 *Salon d'Automne*, a Parisian showcase for some of the more progressive tendencies in contemporary painting.

The following year *The Lobster* marked Dove's introduction to the inner circle of artists around Alfred Stieglitz [q.v.], the impresario of the fledgling New York avant-garde scene. When Stieglitz exhibited the painting in his seminal 1910 exhibition *Younger American Painters*, only a few members of the city's art world were enthusiastic about modern art, and the critics' assessment of *The Lobster* reflected the curiosity and bewilderment of contemporary audiences. Some reviewers derided the painting for what they perceived as radical and insidious French traits: the high-keyed violet, orange, and pink hues; the thick, roughly applied paint; and the tilting of the pictorial plane to flatten the image. Viewers saw these innovations as peculiar and even crude distortions of revered artistic traditions. One critic lamented that Dove "went to Europe and was attacked by the epidemic rather badly, too, judging from his picture of fruit."[1] Despite this wary response to his initial appearance on the American art scene, Dove soon became one of most influential and inventive artists of the era.

JM

1. B. P. Stephenson, quoted in "'The Younger American Painters' and the Press," *Camera Work*, no. 31 (July 1910): 44.

CHARLES M. RUSSELL
1864–1926

The Medicine Man, 1908

Oil on canvas, 30 × 48⅛ in. (76.2 × 122.2 cm)

Signed and dated lower left: *C M. Russell / 1908* [the artist's signature skull]

1961.171

Charles M. Russell called himself "the Cowboy artist." Born and raised in St. Louis, he was drawn to the frontier at an early age, working in Montana Territory as a cowhand and as a hunter and trapper when he was only fifteen. At the same time, he was drawing and modeling the people and wildlife around him, relying solely on his natural artistic abilities. Russell's talent received significant recognition in 1887, and over the next decade he managed to make a modest living with his paintings and watercolors. His fortunes changed dramatically after 1896, when he married Nancy Cooper (1878–1940). Although she was only seventeen when they wed, she was ambitious and very smart. It was her steady encouragement of Russell and her tireless promotion of his work that would propel him to unimagined success. During a visit to New York City in 1904, he made contacts with the magazine editors who would assure his fame as an illustrator for Leslie's, McClure's, *and* Scribner's. *At his studio back in Great Falls, Montana, Russell continued painting in oil and watercolor, demonstrating how the influence of fellow artist-illustrators was honing his technical skills.*

"'THE MEDICINE MAN' I consider one of the best pieces of my work," Russell wrote to Willis Sharpe Kilmer, who had purchased the painting from an exhibition of the artist's work in New York City. He offered this outline of its subject:

The medicine man among the Plains Indians had more to do with the movements of his people than the chief and he is supposed to have the power to speak with the spirits and the animals. This painting represents a band of Blackfeet Indians with their Medicine Man in the foreground. The landscape was taken from a sketch I made on Loan [*sic*] Tree Creek in the Judith Basin and I remember when this was game country. . . . The Blackfeet once claimed all country from Saskatchewan south to the Yellowstone and one of their favorite grounds was the Judith Basin. This country today is fenced and settled by ranchmen and farmers with nothing but a few deep worn trails where once walked the buffalo but I am glad Mr. Kilmer I knew it before nature's enemy the white man invaded and marred its beauty.[1]

In Russell's painting, the medicine man sits erect in his saddle on his pinto horse, gazing proudly ahead while the other warriors and the rest of the village fan out on either side behind him. He wears an antelope-horn medicine pendant around his neck, and white ermine skins dangle from the feather medallion on the side of his head. His face and body are painted with designs in red, the most readily obtainable earth color that the Blackfeet employed. He holds a crooked lance trimmed with a scalp lock and feathers. Russell maintained that "where the head man stuck his lance in the ground is where the women put up their lodges. The Blackfeet called these men wolf men. If a Blackfoot said a man was a wolf it was no insult it meant the man was very smart. In the sign language wolf and smart are the same."[2]

RS

1. Russell to Kilmer, April 24, 1911, Amon Carter Museum.
2. Russell to Joe De Yong, n.d., Richard J. Flood Collection, C. M. Russell Museum, Great Falls, Mont.

JOSEPH STELLA
1877–1946

Portrait of a Bearded Man, ca. 1909

Metalpoint on prepared paper, 11⅝ × 8⅜ in. (29.5 × 21.3 cm)

Signed lower center: *Joseph Stella*

1984.28

Joseph Stella claimed that beyond his classical education as a youth in his hometown of Muro Lucano, Italy, his real artistic study took place on the streets of New York City, where he lived after 1896. He drew relentlessly, sketching people in parks, on elevated trains, and in the public library. He dismissed as irrelevant his three years of study with William Merritt Chase [q.v.], though Chase reinforced Stella's strongest inclinations: his respect for the Old Masters and his love of drawing. In drawing fellow immigrants, Stella produced vivid images of their suffering; his first work appeared in social-reform weeklies. The studies he made in 1908 with the photographer Lewis Hine [q.v.] of men in Pittsburgh's steel mills are timeless comments on human endurance and exploitation. Revisiting Europe in 1909, Stella was introduced to Italian futurism, and today he is known as the movement's first great exponent in America. He found New York's kaleidoscopic scene perfectly suited to his new interest in color and dynamic composition. Yet by 1920 his modernist impulse gave way to a mystical absorption in nature. Silverpoint became his favorite medium as he focused on the delicate beauty of plants and birds. Throughout his career he explored themes from the symbolic to the commonplace. He died a year after falling down an open elevator shaft in a warehouse while serving as a judge for the 1945 exhibition Portrait of America.

"I DEDICATE MY ARDENT WISH to draw with all the precision possible, using the inflexible media of silverpoint and goldpoint that reveal instantly the clearest graphic eloquence."[1] Stella wrote this as a private "confession," and for him, creating an image in metalpoint was indeed an act of supreme devotion. The challenging medium requires an artist's total absorption in his craft, technical mastery, and penetrating powers of perception—the ability to see, feel, and draw with a sure hand the essential contours and linear details. This is no medium for trial and error. As the term implies, in metalpoint—often silver, as we see here, or sometimes gold, lead, or copper—the drawn lines are made with a metal stylus dragged across a prepared surface. For Stella, that surface was typically a coating of thin, creamy, water-based pigment, which he prepared and applied, as is evident in this example. In drawing, traces of the metal are deposited on this finely textured ground. Every movement of the stylus is recorded, and no mark can be erased. The medium rewards a confident hand with a delicate, precise line of warm tone, shimmering as it catches the light.

Metalpoint is most often associated with Renaissance masters, and Stella appreciated the responsibility inherent in being a modern-day practitioner of a noble tradition. With little formal training in draftsmanship, except for his fervent study of Old Master drawings, he embraced the medium. He remains one of the most inspired and accomplished practitioners of metalpoint drawing in modern times. Although he scrutinized fifteenth- and sixteenth-century models, Stella never simply copied. His metalpoint drawings are always his own studies from life. He was deeply affected by the expressive faces of old men, which by their deep-cut, linear character seemed to him evocative drawings in and of themselves, works bearing the impress of the hand of time. He drew them repeatedly and with special reverence. "My preference was going to curious types," he said of these subjects, "revealing with the unrestrained eloquence of their marks, the crude story of their life."[2]

PJ

1. Joseph Stella, "Confession," undated ms., as translated from the Italian, in Barbara Haskell, *Joseph Stella*, exh. cat. (New York: Harry N. Abrams for the Whitney Museum of American Art, 1994), 220.
2. Joseph Stella, "Autobiographical Notes," 1946, quoted in Haskell, *Stella*, 211.

Joseph Stella

JOHN SLOAN
1871–1951

On the Roof, 1910

Monotype on wove, cream paper; image: 8⅝ × 5¾ in. (22 × 14.6 cm);
sheet: 11⅜ × 8⅜ in. (28.9 × 21.3 cm)

Signed lower right: *John Sloan*

(Object reproduced at actual size)

1982.48

Born in Lock Haven, Pennsylvania, John Sloan studied at the Pennsylvania Academy of the Fine Arts in Philadelphia from 1892 to 1894. He absorbed the intense realism of Thomas Eakins [q.v.] via his instructor Thomas Anshutz and became a successful artist-journalist. Sloan eventually joined a circle of young artists who were inspired by the painter Robert Henri (1865–1929) to render scenes of city life. He followed Henri to New York City in 1904 and stayed there until the end of his life, painting lively genre scenes of urban dwellers and their often seamy lives. The art establishment dismissed Sloan and the Henri followers because their subject matter, dark palette, and bold painting style ran counter to impressionist tastes; they were later collectively referred to as the Ashcan School. In 1908 Sloan and seven other artists—called The Eight—participated in an important exhibition at the Macbeth Gallery to protest the conservatism of the National Academy of Design. Although he was aligned with young renegade realists and was politically active, even working for the socialist journal The Masses *from 1912 to 1916, Sloan never directly conveyed social criticism through his painting. He was an influential teacher during his sixteen years at the Art Students League, from 1916 to 1932, and through his book* Gist of Art, *published in 1939.*

THE INHABITANTS OF NEW YORK CITY'S LOWER EAST SIDE served as a continuous cast of characters for John Sloan's paintings and prints. Here, two women take advantage of the breezes that cool a tenement rooftop to dry their hair. The robust woman dominates the scene, planting her feet precariously yet defiantly on the very edge of the roof, while the second woman perches on the ledge beside her. Sloan's rapid and sketchy technique, an inherent characteristic of the monotype process, aptly captured the spontaneous spirit of the scene.

The monotype is produced by applying paint onto a smooth printing surface and then exerting pressure to transfer the image to a sheet of paper. Sloan made only about two dozen monotypes, all in the early part of his career. The palette here, as in his other monotypes, is largely monochromatic—a reddish brown with a few ochre accents. After creating the image's primary forms, he swiftly wiped away selected areas, adding definition and highlights by scratching in animated details, such as the shutters on the building to the right and the ledge beneath the standing woman's feet.

Sloan often took as his subject the simple, unabashed pleasures of urban dwellers, particularly immigrants, whose numbers swelled around the turn of the century. In *On the Roof*, the artist commends their ability to contend with difficult circumstances, in this case a lack of privacy due to cramped living spaces. Rooftops offered an escape and were often the site of everyday pursuits for those in search of a cooler night's sleep or a place to hang their laundry. Although Sloan did not intend his work to be political, social reformers of the day hailed him for his ability to capture essential truths about "the other half" by illuminating its humanity.

JM

69

ARTHUR G. DOVE
1880–1946

Team of Horses, 1911 or 1912

Pastel on composition board mounted to plywood, 18⅛ × 21½ in. (46 × 54.6 cm)

Signed lower right: *Dove*

1984.29

Alfred Stieglitz [q.v.], the champion of American modernism, nurtured Arthur Dove's career by providing crucial early support. Born in up-state New York, Dove had his first one-person exhibition in 1912 at Stieglitz's Manhattan gallery, 291, one of many seminal modernist ex-hibitions in which he participated. In 1921 Dove left his wife for fellow artist Helen (Reds) Torr, whom he would marry eleven years later. They made their home on Long Island Sound in a forty-two-foot-long yawl, the Mona*. In the mid-1920s, Dove established an enduring rela-tionship with the collector Duncan Phillips, who provided him with crucial financial backing. After living for a time in Geneva, New York, the artist's childhood home, Dove and Torr moved in 1938 to Huntington, Long Island. Ill health gradually slowed his artistic activities, and he died in 1946.*

MANY AMERICAN AVANT-GARDE ARTISTS working after the turn of the cen-tury made their most innovative statements in media other than traditional oil painting. *Team of Horses* was one of the first artworks to reflect this search for original expression. The drawing belongs to an extraordinary series of ten pas-tels, dating from 1911 to 1912, that would eventually become known as "The Ten Commandments." Exhibited in 1912 at Alfred Stieglitz's 291 gallery in New York City, these works launched Arthur Dove's reputation as a radical modernist.

Dove's choice of imagery and technique in this drawing reveals his progressive attitude. At the time he made it, he was living in Westport, Connecticut, trying to support his young family through farming and com-mercial illustrating. In *Team of Horses*, he expressed his affinity for nature's creative forces, forms, and colors in a unique and highly subjective composi-tion that challenges the boundaries of the canvas. The piece was untitled when exhibited, but when one critic noted how its curvilinear and sawtooth shapes suggested the manes of horses galloping uphill, it received its apt title.

Dove used pastel in a novel way: applying the medium vigorously, often in dense layers, he roughed up the fragile surface of compressed layers of paper. His experimentation with bold forms, a subdued yet rich palette, and textural variety coalesce in a work that, along with the other pastels, played a decisive role in the history of twentieth-century American art.

JM

STUART DAVIS
1892–1964

Chinatown, 1912

Oil on canvas, 37 × 30¼ in. (94 × 76.8 cm)

Signed and dated lower right: STUART DAVIS —1912 —

Purchase with assistance from the Council of the Amon Carter Museum

1999.7

Stuart Davis was born into an artistic Philadelphia family. His father, Edward Wyatt Davis, was art director of the Philadelphia Press; *his mother, Helen Stuart Foulke Davis, was a sculptor. Among his father's friends were the artists Robert Henri (1865–1929) and John Sloan [q.v.], who both eventually settled in New York City. In 1910, before he had finished high school, Davis followed them to study with Henri, one of the leading art teachers of the day. The five watercolors Davis exhibited in the Armory Show in 1913 reflect the influence of Henri and his school of realism, as do the illustrations he contributed to the socialist magazine* The Masses *between 1913 and 1916. Throughout the 1910s, Davis avidly experimented with various modern painting styles, including postimpressionism and cubism. During World War I he served as a cartographer for the U.S. Army Intelligence department.*

STUART DAVIS MOVED TO NEW YORK CITY as a teenager to join the circle of realist artists who were to become known as the Ashcan School. He quickly assimilated the teachings of the group's spirited leader, Robert Henri, who encouraged his followers to paint honest appraisals of contemporary life. In *Chinatown*, Davis depicted the seamy underpinnings of a neighborhood in Lower Manhattan.

Davis' signature use of ironic humor and the written word make a prescient appearance in this painting. The pidgin English on the storefront enterprise, "Sun Yet Pleasure," offers a clue to the work's subtle narrative: according to contemporary convention, a woman walking alone was a prostitute. The cat stretching out on the iron railing reinforces this reading, the word *cat* being a slang reference to a sexually promiscuous woman. Davis' attraction to social criticism reflected his association with the artists and writers, among them Max Eastman and Louis Untermeyer, who founded and contributed to the socialist magazine *The Masses* (1911–17). United in their sympathetic attitude toward the downtrodden, they perceived prostitutes to be victims of the nation's economic problems.

Chinatown reverberates with the expressive brushwork and dramatic light-and-dark contrasts of Davis' artistic mentors among the Henri circle. The work also foreshadows the young artist's subsequent renunciation of representation. Even within this subdued palette, there are portents of Davis' flamboyant future color choices in the flashes of red on the woman's cheeks and lips and in the abstract splashes of bright color around the doorway and storefront window.

JM

JOHN MARIN
1870–1953

Woolworth Building, No. 1, 1913

Etching on wove, cream paper; plate: 11⅞ × 9½ in. (30.2 × 24.1 cm); sheet: 14⅝ × 11⅞ in. (37.1 × 30.2 cm)

Signed, dated, and inscribed lower right, in plate: *Woolworth-1 Marin-13*

1985.296

Born in Rutherford, New Jersey, John Marin grew up across the Hudson River from New York City. Although he initially studied to be an architect, Marin enrolled at the Pennsylvania Academy of the Fine Arts in 1899. His earliest works were a series of etchings depicting European street scenes in the popular, conservative style of architectural etching. In Paris in 1909 he befriended Alfred Stieglitz [q.v.], who would actively promote his work for the next forty years. Around 1910 he undertook a series of fluid watercolors of the Austrian Tyrol, which were his most spontaneous statements to date. But the first indications that Marin's innovative handling of form and technique would earn him a place among America's great modernists was a series of watercolors, oils, and prints executed from 1911 to 1913. Depicting New York City's icons and populace in frenzied, fragmented views, these pieces were among the earliest modernist works in America. Marin favored watercolor for the rest of his career, and his inspired use of it greatly elevated the status of this medium.

JOHN MARIN CREATED *Woolworth Building, No. 1* the same year that the new structure, designed by Cass Gilbert (1859–1934), became the world's tallest building—a distinction it held until 1929. Even before its completion, the artist recognized the structure as a twentieth-century icon and began drawing it incessantly. Here, Marin sets the skyscraper—a symbol of America's prewar optimism and the advent of new technologies—within its chaotic urban environs. That Frank Woolworth built the skyscraper as the headquarters for his variety-store chain only underscored the potential in the United States for commercial enterprise.

Marin shows the Woolworth Building dominating its site, towering over nineteenth-century buildings and a few withered trees. An extraordinary novelty at the time, the edifice offered a dizzying perspective of a vast area. Visitors touted the "indescribable" view from the top: "[It] will give you something really interesting to talk about for the rest of your days," wrote one.[1] Marin conveyed the structure's wondrous quality by fusing all the pictorial elements in an animated dance. His manipulation of a thin film of ink on the printing plate, combined with delicate and lively etched lines, reinforced the feeling of overwhelming vertigo and boundless energy and expressed the artist's subjective reaction to the sight of a monumental structure towering above all else.

JM

1. Henry Collins Brown, *New York of Today* (New York: Old Colony Press, 1917), 265.

Woolworth. I Marin. 13

**MORTON LIVINGSTON
SCHAMBERG**
1881–1918

Figure, 1913

Oil on canvas, 32¼ × 26⅛ in. (81.9 × 66.4 cm)

Signed and dated upper right: *Schamberg / 1913*

1984.16

Morton Livingston Schamberg was one of the most gifted members of the Philadelphia avant-garde during the 1910s. Born and raised there, he earned a degree in architecture from the University of Pennsylvania. Following summer art classes abroad with William Merritt Chase [q.v.], Schamberg continued studying with this influential teacher at the Pennsylvania Academy of the Fine Arts. His friends at the academy, from which Schamberg graduated in 1906, included Charles Sheeler [q.v.] and Walter Pach (1883–1958), artists who would figure prominently in American modernism. A 1908 trip to Paris, where he studied the work of leading French avant-garde artists, convinced him to follow a modernist program. After Schamberg returned to Philadelphia, his work moved from the bright colors and abstract landscapes of the French fauves to a more innovative and structured cubism. Among the artist's other interests were photography and mechanical imagery, which he explored in a striking series of pastel drawings. Schamberg's premature death in the influenza epidemic of 1918 ended what surely would have been a pioneering artistic career.

WHEN MORTON LIVINGSTON SCHAMBERG SAW THE WORK of the European modernists on exhibition in Paris and New York, he was inspired to investigate the unconventional spatial construction and palette of avant-garde painting. In 1913 he began a series of oils based on the abstract analysis of a figure in space. *Figure* presents an innovative series of interlocking planes that describe the shape of a seated figure in profile.

At the top of the canvas, an oval head placed slightly left of center and comprised primarily of red and green elements directs the eye into the sweeping arc of the figure's back, extending down the right side of the canvas. A semicircular chain of red, yellow, and orange segments beneath the head tapers into an orange triangle, alluding to an arm and a hand. Schamberg employed the same triad of colors to designate the figure's other corporeal shapes; undulating forms evoke the rounded volumes of calf, thigh, and buttocks. In contrast to the colors Schamberg employed for the major anatomical divisions, blue and green fill the voids around the figure. Intense hues of primary and secondary colors applied unevenly result in both dense and thin passages and contribute a degree of three-dimensionality that counteracts the flat surface of the canvas. Such overt abstraction puzzled most Americans in 1913, yet art aficionados heralded Schamberg as one of the most promising young members of the avant-garde.

JM

PAUL MANSHIP
1885–1966

Indian Hunter and Pronghorn Antelope, modeled 1914;
cast 1915

Bronze, (Indian) h: 13 in. (33 cm); w: 10⅛ in. (25.7 cm); d: 8¼ in. (21 cm); (antelope) h: 12 in. (30.5 cm); w: 10⅛ in. (25.7 cm); d: 8 in. (20.3 cm)

Inscribed on *Indian Hunter* at top of base: ©.*1914. / .PAUL MANSHIP*; at proper left side of base: *GORHAM CO. FOUNDERS QAFE GFC*; inscribed on *Pronghorn Antelope* at top of base: ©.*1914. / .PAUL MANSHIP*; at proper left side of base: *GORHAM CO. FOUNDERS QAFE GFC*

Ruth Carter Stevenson Acquisitions Endowment

1997.3.A–B

Born in St. Paul, Minnesota, Paul Manship went abroad in 1909 as a recipient of the prestigious Prix de Rome. He was already adept at the dominant French mode of boldly modeled, highly expressive sculpture, epitomized by the bronzes of Auguste Rodin (1840–1917). A dynamic naturalism had prevailed in American sculpture from the time when the French-trained Augustus Saint-Gaudens [q.v.] and Daniel Chester French (1850–1931) had popularized it in the 1880s. Manship had studied with two Beaux-Arts style adherents, Solon Borglum (1868–1922) and Isidore Konti (1862–1938). But in Greece and Rome, he found a vitality in classicism that was the antithesis of Rodin's freely modeled forms. Back in the United States in 1913, he was immediately recognized as a daring talent, and his graceful, refined figural works, emulating the elegant sculptures of the archaic Greeks, proved to be a sensation. Admired for his decorative sense, Manship was in demand as an architectural sculptor. He created massive public works, such as the great Prometheus *(1933–38) in New York's Rockefeller Center, as well as garden figures and small cabinet pieces. Two years before his death in New York, he completed a statue of Theodore Roosevelt in Florence, Italy. The work was moved to Washington, D.C., four months after he died.*

"I AM AT PRESENT QUITE CRAZY ABOUT EARLY GREEK ART," Paul Manship wrote to his friend the sculptor Isidore Konti in the spring of 1912.[1] Shortly thereafter he made his first visit to Greece, where he absorbed the highly graphic forms of early black-figure vase painting and archaic Greek sculpture. He loved the decorative quality of early Greek art, "that power of design—that feeling for structure in line."[2] Simplicity and linear vitality became the hallmarks of Manship's art and also perfectly conveyed the modern spirit of the Machine Age. The decorative quality he admired in archaic Greek art—and in ancient Egyptian, Assyrian, and Asian sculpture as well—flowered in America in architecture and design in the 1920s as art deco.

Manship created *Indian Hunter and Pronghorn Antelope* soon after returning to the United States from his studies at the American Academy in Rome. His initial cast of the two-part piece was one of the works that successfully launched him in this country, establishing him as a bold American talent who had broken free from the prevailing Rodin-inspired style of freely modeled, impressionistic sculpture. Created to stand in profile at either end of a fireplace mantel, these solid, stylized figures almost seem to have sprung from a black-figure vase painting, although the subject matter is a distinctly American version of an ancient theme—the hunt. Like the narrative that unfolds around a Greek vessel, the action of the hunt is played out here across an expanse of space. The Indian hunter, his arms still taut, has just released his arrow. We follow it across the void between the two sculptures to the flank of the antelope, which rears backward in agony, creating, ironically, an elegant arabesque.

PJ

1. Manship to Konti, 1912, quoted in Susan Rather, *Archaism, Modernism, and the Art of Paul Manship* (Austin: University of Texas Press, 1993), 34.
2. Manship, "The Decorative Value of Greek Sculpture," a lecture delivered at the American Academy in Rome, May 1912, quoted in Rather, *Archaism*, 183–84.

KARL STRUSS
1886–1981

The Avenue—Dusk, 1914–15

Platinum print, 12⅛ × 9⁵⁄₁₆ in. (30.8 × 23.7 cm)

Signed, dated, and inscribed, lower left: *Karl Struss 1915*; on mount, lower left: *1914*; on mount, lower right: *Karl Struss.*

Copyright 1983, Amon Carter Museum, Fort Worth, Texas

P1983.23.92

Karl Struss studied photography with Clarence H. White (1871–1925) at Teachers College, Columbia University, from 1908 to 1912. So impressed was Alfred Stieglitz [q.v.] by the richness of Struss' hand-coated platinum prints that he included twelve of his images in the landmark International Exhibition of Pictorial Photography *at the Albright Art Gallery in Buffalo in 1910. In 1912 Struss became the last artist invited to join the Photo-Secession; eight photogravures of his work were featured in Stieglitz's journal* Camera Work *that same year. Although Struss favored the soft-focus pictorial style, his work prior to World War I anticipated the modernist aesthetic later championed by Stieglitz and Paul Strand [q.v.]. His images of New York, most of them made from 1908 to 1916, are considered groundbreaking. After serving in the U.S. Army from 1917 to 1919, Struss went west to Hollywood, where he was first hired by Cecil B. DeMille. His pictorial talents placed him at the forefront of motion-picture cinematography. He and Charles Rosher shared the first Academy Award for cinematography for their work on the film* Sunrise *(1927). In 1983 the Amon Carter Museum acquired his photographic archives.*

A NATIVE OF NEW YORK CITY, Karl Struss witnessed the transformation of Manhattan from a mercantile and industrial center into the archetypal modern city and the hub of international commerce. Fascinated by this evolution, he photographed street scenes and architectural highlights that symbolized the city's dynamism. To convey the magical nature of midtown Fifth Avenue, he photographed it at twilight, when the city's crowds were scurrying to their evening destinations.

Struss made this photograph from the top of a double-decker bus, near Fiftieth Street, to gain a vantage point above the bustling traffic. Looking south into the oncoming automobiles, he selected for his composition an area distinguished by exclusive shops and prestigious men's clubs. On the right, beyond the spire of the Collegiate Dutch Reformed Church on the corner of West Forty-eighth Street, are the Century Association, the Harvard Club, and the New York Yacht Club. On the left are the Charles Scribner's Sons bookstore and the Windsor Arcade, filled with jewelry and dry-goods shops.

The dark tones here challenged Struss' remarkable printing skills in the development processes favored by the pictorial photographers. He frequently used multiple coatings and exposures to create prints so dark that it is difficult to discern details from the shadows. By printing to emphasize the single line of illuminated streetlights, Struss transformed it into an elegant necklace for the city's evening attire.

BMC

CHILDE HASSAM
1859–1935

Flags on the Waldorf, 1916

Oil on canvas, 36¼ × 30¼ in. (92.1 × 76.8 cm)

Signed and dated lower left: *Childe Hassam 1916*

1985.301

When Childe Hassam began painting urban street scenes in the 1880s, early in his career, he was one of the few American artists drawn to such a subject. He first studied and exhibited in his native Boston, but in 1886 he went to Paris and discovered that city's impressionist painters. Back in New York City in 1890, he allied himself with the most progressive artists of the day. He painted urban scenes in both watercolor and oil. Hassam also embarked on a series of lyrical studies of the garden of his friend the poet Celia Thaxter (1835–1894) on Appledore, one of the Isles of Shoals off the Maine-New Hampshire coast. He embraced open-air painting and traveled to other light-filled picturesque spots as well, including Old Lyme and Cos Cob in Connecticut and East Hampton on Long Island, where he built a home in 1903. By the time of his death in 1935, Hassam's impressionist style was no longer modern, but during his long and illustrious career, he received nearly every honor awarded an American artist on both sides of the Atlantic.

IN AN EXTENSIVE SERIES OF PAINTINGS, which ultimately numbered more than thirty canvases, Childe Hassam recorded the changing patriotic display along Fifth Avenue during World War I, when New York City regularly flew the flags of the allied nations, the armed services, and the American Red Cross. For the artist, these colorful displays enhanced the kaleidoscopic vitality of the avenue, which he captured on canvas in his broken brushwork as few impressionist painters in America could.

Always sensitive to qualities of light and atmosphere, Hassam employed the flag as Monet did the haystack—as a constant in an otherwise changing scene, from season to season. Here, the profusion of American flags in the dim light of a wet late afternoon adds an elegiac air to the scene. So closely keyed were Hassam's flag paintings to the public mood, and so effective was his representation of America's war spirit, that a committee of prominent New Yorkers sought to raise funds to acquire the group as a permanent war memorial. Seeing these paintings, America's returning soldiers might "absorb their atmosphere and feel that we were indeed with them, heart and soul, during the conflict," one supporter believed.[1] "Apart from the artistic interest of the collection," another enthusiast wrote of the series, "it forms an important record of a period as picturesque and beautiful in its commemorations as it was hideous and cruel in its destruction."[2]

PJ

1. *Patriotic Street Scenes by Childe Hassam and Verdun Church Relics* (New York: Parish House, Church of the Ascension, 1919), n.p.
2. "November Exhibition in Great Variety—Art at Home and Abroad," *New York Times*, November 17, 1918.

B. J. O. Nordfeldt
1878–1955

Fisherman's Family, 1916

Woodcut on wove, off-white paper; image: 12 × 11 in. (30.5 × 27.9 cm); sheet: 14 × 13 in. (35.6 × 33 cm)

Signed and inscribed, lower center: *Nordfeldt imp*; lower left: *The Fisherman's family*; lower right: *no 18*

1987.82

Bror Julius Olsson Nordfeldt immigrated to Chicago from his native Sweden in 1891. After studying wood-block printing in England in 1900, he began making prints and exhibiting them at various Chicago venues. Nordfeldt earned his living, however, producing etchings to illustrate popular periodicals. In 1915 he began spending winters in New York City and summers in Provincetown, Massachusetts. He was a founding member of the Provincetown Players, a group of writers and artists committed to staging new and experimental plays—by Eugene O'Neill and Edna St. Vincent Millay, among others—both locally and in New York's Greenwich Village. During his summers in Provincetown, Nordfeldt developed his signature method for making multicolored prints from a single block. In 1919 he settled in New Mexico, where he concentrated on painting landscapes, portraits, and still lifes. During the 1930s and 1940s the artist taught in Minneapolis, Wichita, and Austin, Texas. In 1937 he moved to Lambertville, New Jersey. Nordfeldt died of a heart attack in Henderson, Texas, while returning from a trip to Mexico.

BETWEEN 1915 AND 1918, B. J. O. Nordfeldt spent his summers in the artists' colony and fishing village of Provincetown, Massachusetts. This picturesque coastal town was a seasonal magnet for writers and artists who were prevented from traveling abroad by the outbreak of World War I. Mingling with the local Portuguese fishermen and their families, Nordfeldt and his fellow artists found Provincetown a colorful and productive setting.

The white lines separating the compositional elements in *Fisherman's Family* denote Nordfeldt's innovative printmaking technique, known as the single-block, white-line woodcut method. Unlike the traditional and more labor-intensive technique whereby the artist carved a separate woodblock for each color, Nordfeldt incised the entire image onto a single block. The slightly embossed white lines that resulted from hand pressing a sheet of wet paper against the block reinforced the composition's abstract quality.

As seen in the fisherman's light-blue jacket, Nordfeldt created painterly effects by applying watercolor to the woodblock with a brush. A palette of exquisite pastel hues and the patterns on the skirt of the fisherman's wife and on his daughter's frock enhance the print's visual appeal. Nordfeldt sets the figures against a backdrop of quaint structures; the two women wearing shawls suggest the European origins of the village's year-round inhabitants. His novel printmaking technique proved to be popular, and his protégés, among them Blanche Lazzell [q.v], continued working in the white-line technique after he had abandoned it in favor of other artistic media.

JM

PAUL STRAND
1890–1976

From the Viaduct, 125th Street, New York, 1916

Platinum print, 9¹⁵⁄₁₆ × 13 in. (25.2 × 33 cm)

Signed, dated, and inscribed on reverse, upper center: *Paul Strand / New York 1916*

Copyright 1981, Aperture Foundation, Inc., Paul Strand Archive

P1983.17

Paul Strand is revered as an innovative photographer and a master of his craft. In the mid-1910s, he demonstrated how cubist-inspired composition could effectively capture the alienation of modern urban life. A native New Yorker, he learned photography in high school from the socially conscious photographer Lewis Hine [q.v.]. He absorbed the modern-art aesthetic by frequently visiting Alfred Stieglitz's [q.v.] influential modernist gallery, 291. In 1915 and 1916 Strand won widespread acclaim with his revolutionary portraits of New York street life, and in 1920 he collaborated with the painter-photographer Charles Sheeler [q.v.] to create the first American avant-garde film, Manhatta. Over the next two decades, Strand split his time between still photography and cinematography, photographing in New York, New England, the American Southwest, and Mexico, and working on newsreel, documentary, and feature films. These included the Mexican feature Redes (1934), Pare Lorentz's The Plough That Broke the Plains (1936), and Native Land (1941), a drama based on actual incidents and testimony that had been amassed by a Congressional committee investigating union activities. He and writer Nancy Newhall began the book Time in New England in 1945. (The book was published in 1950.) That same year the Museum of Modern Art mounted a retrospective exhibition of his work, the first time it accorded a photographer this honor. In 1950, uncomfortable with the intensely anticommunist climate then prevailing in the United States, Strand left the country. He settled in France, where he lived until his death in 1976, producing a series of innovative photograph-and-textbook portraits of rural France, Italy, the Hebrides, Egypt, and Ghana.

PAUL STRAND REVOLUTIONIZED PHOTOGRAPHY with images such as this view of Upper Manhattan from the viaduct of an elevated train. Shot the year before the United States entered World War I, this and the other photographs he made around this time captured the unalloyed power of the city. Through his lens, New York was a harsh composite of gigantic architecture and endless pavement—an oversized stage upon which hapless humans were shackled to their mundane workaday lives. What further distinguished Strand's vision was his keen focus on space. Composition was the key. By piecing his images together in the delicate balance of an innovatively flattened space, Strand employed cubism's strategies to inform and strengthen the emotional content of his work.

When Alfred Stieglitz, the impresario of American modernist art, saw Strand's mid-1910s photographs, including this print, he was overjoyed. Here was the vision he had sought for years, both in his own work and among other photographers. Calling them "the direct expression of today," Stieglitz immediately exhibited the photographs in his 291 gallery.[1] Strand's model served as photography's answer to the challenge of modernism.

JR

1. Alfred Stieglitz, "Our Illustrations," *Camera Work*, nos. 49–50 (June 1917): 36.

GEORGE BELLOWS
1882–1925

A Stag at Sharkey's, 1917

Lithograph on wove, cream paper; plate: 8¹¹⁄₁₆ × 24 in. (22 × 61 cm); sheet: 21⅞ × 26¾ in. (55.6 × 68 cm)

Signed and inscribed, lower right: *Geo Bellows*; lower center: *A Stag at Sharkey's*; lower left: *No 37*; lower center, on stone: *Geo Bellows*

1983.23

George Bellows enjoyed considerable professional success during his brief life. A native of Columbus, Ohio, he withdrew from Ohio State University in 1904 to study art in New York. There he fell in with the group of artists, collectively called the Ashcan School, who followed the teachings of Robert Henri (1865–1929). By his late twenties, Bellows had already developed a reputation for his energetically painted scenes of New York life, which seemed to capture the dynamics of the modern era. His lithographs, begun in 1916, evolved from the subject matter and style of illustrations he made for the socialist magazine The Masses. *While some lithographs touched on social issues of the day, such as evangelicalism and the German invasion of Belgium during World War I, others were more benign images of his beloved family and friends. For the last four years of his life, Bellows settled into a routine of painting at his Manhattan home during the winter and making lithographs in Woodstock, New York, in the summer. He died in New York City at age forty-two of complications from a ruptured appendix. Shortly after his death, Bellows was honored with a memorial exhibition at the Metropolitan Museum of Art.*

GEORGE BELLOWS DEFTLY CAPTURED a broad range of themes drawn from everyday life in New York City, but his depictions of prizefighting are his most famous. He based this lithograph on his 1909 oil painting of a fight at Sharkey's Athletic Club (Cleveland Museum of Art), a saloon that surreptitiously doubled as a boxing arena. After New York State outlawed public bouts in 1900, prizefights became an exciting, albeit forbidden, pastime of the urban underworld.

In *A Stag at Sharkey's* Bellows adroitly summarized one of the crowded and seedy backroom bouts that managed to circumvent the law. Eager men (hence the "stag" of the title) crowd around the ring; the balding individual to the right of the referee may well represent one of the regulars—the artist himself. The lithograph's dramatic light and dark contrasts and powerful triangular composition capture the highly charged scene, dominated by two fighters of apparently considerable physical power. Their individual identities obscured, the two men are locked in battle as their heads and fists collide. Bellows' ability to translate a large oil painting into a much smaller black-and-white format demonstrates his keen understanding of the properties of lithography. Relatively new to American artists at this time, lithography was a complex and challenging medium; it required a working knowledge of chemistry to fix the image successfully onto the lithographic stone, from which the print was then pulled.

JM

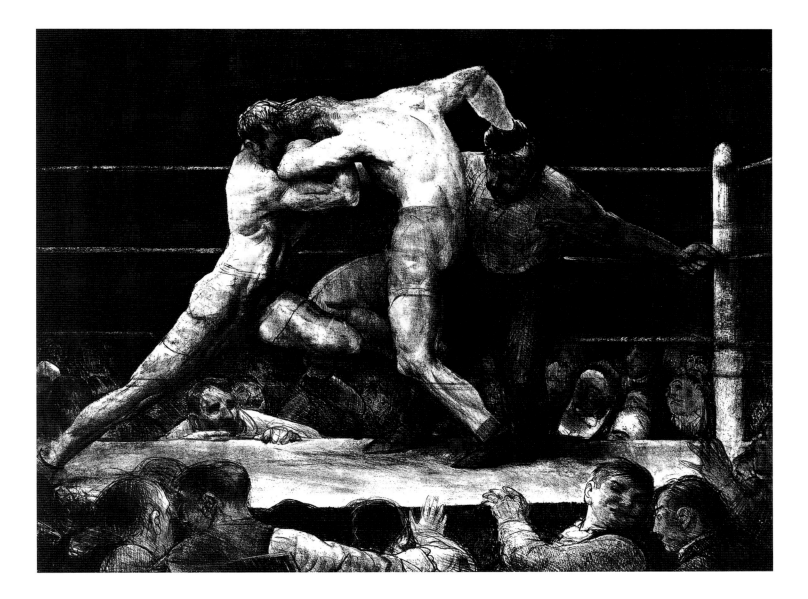

GEORGIA O'KEEFFE
1887–1986

Light Coming on the Plains No. I, 1917

Watercolor on wove, beige paper [newsprint], 11⅞ × 8⅞ in. (30.2 × 22.5 cm)

Dated and inscribed on [removed] label: *Light Coming on the Plains No. I / 1917 / Water Color on Paper*

1966.30

Born on a dairy farm near Sun Prairie, Wisconsin, Georgia O'Keeffe began receiving art instruction when she was a child. Eventually, she would study at several distinguished art schools, including the School of the Art Institute of Chicago; the Art Students League in New York City, under William Merritt Chase [q.v.]; and Teachers College, Columbia University, under Arthur Wesley Dow [q.v.]. O'Keeffe herself began teaching art in 1911, obtaining appointments at Chatham Episcopal Institute in Chatham, Virginia; the University of Virginia, Charlottesville; and Columbia College in Columbia, South Carolina. While in South Carolina, O'Keeffe had an epiphany that transformed her artistic method; rather than emulate her teachers' work, she would express through art her most private sensations. The result was her seminal series of abstract charcoal drawings, which her former classmate Anita Pollitzer showed to Alfred Stieglitz [q.v.]; he exhibited some of them at his Manhattan gallery, 291, in 1916. That same year O'Keeffe took a teaching position at West Texas State Normal College in Canyon, Texas.

WHILE TEACHING ART at West Texas State Normal College in Canyon, Texas, from 1916 to 1918, Georgia O'Keeffe made a series of watercolors reflecting her awe at the immensity of the region's expansive vistas and seemingly endless skies. Her walks into the countryside provided a welcome reprieve from the demands of teaching and the rebuffs of the townspeople, who found the strong-willed artist's behavior and dress eccentric.

During these restorative walks, O'Keeffe developed a special fondness for the deeper and more intense nocturnal colors, particularly at the transitional moments of daybreak and sunset. In a series of vivid and fluid watercolors, including the three in the Amon Carter Museum's collection entitled *Light Coming on the Plains*, the artist worked the motif repeatedly until she felt that the image fully captured her emotional response. She favored the medium of watercolor because of its inherent spontaneity and immediacy, and her control of it indicates a sophisticated and innovative mastery. Refraining from first sketching out her design in graphite, she allowed the fluidity of the pure medium to suggest the final design. O'Keeffe captured a monumental landscape in this simple configuration, fusing blue and green pigments in almost indistinct tonal gradations that simulate the pulsating effect of light on the horizon of the Texas Panhandle.

JM

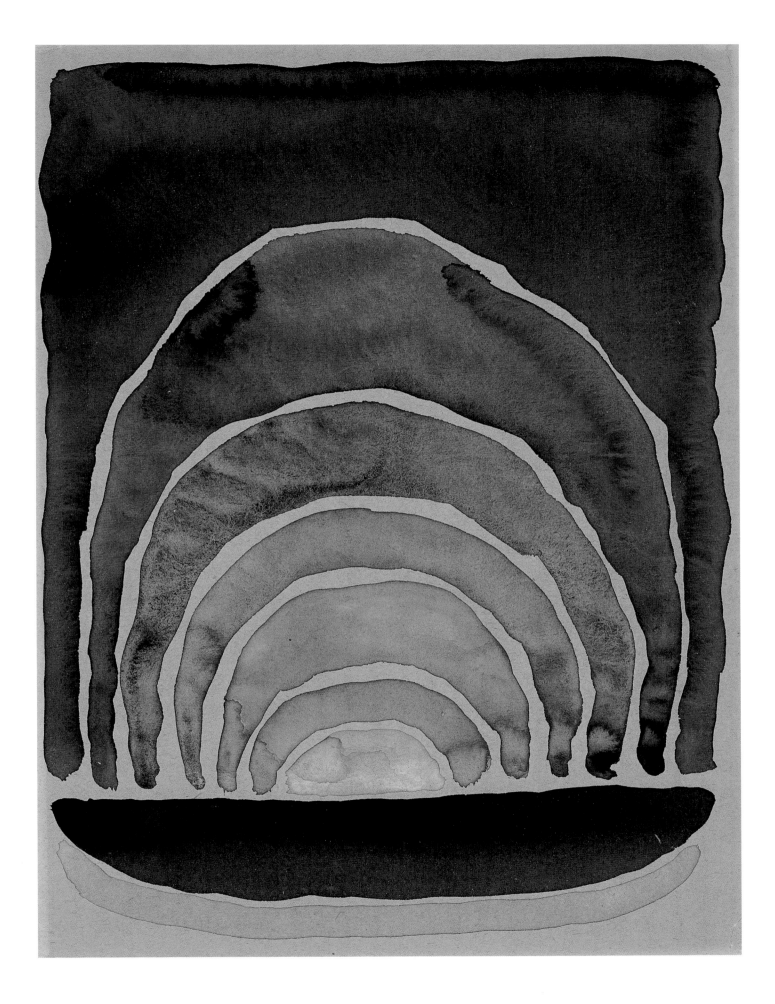

GEORGIA O'KEEFFE
1887–1986

Series I – No. 1, 1918

Oil on composition board, 19¾ × 16 in. (50.2 × 40.6 cm)

Purchase with assistance from the Anne Burnett Tandy Accessions Fund

1995.8

Georgia O'Keeffe and Alfred Stieglitz [q.v.], who was married at the time, began an affair upon O'Keeffe's return from Texas to New York City in 1918. For the next few years, their careers were closely aligned. Stieglitz, who had given O'Keeffe her first solo exhibition at his 291 gallery the previous year, made numerous photographs of her, including a famous set of nude studies. At the same time, having worked extensively in watercolor in Texas, O'Keeffe returned to the oil medium in a group of deeply colored abstractions that echo the intensity of Stieglitz's photographs. She began spending part of each year in Lake George, New York, the summer residence of Stieglitz's family, where she painted the local landscape. In 1920 she also began spending time in York, Maine; its more isolated environment better suited her independent spirit.

GEORGIA O'KEEFFE PAINTED *Series I – No. 1*, an outstanding example of her sensuous investigation of pure form and color, shortly after returning east following a year-and-a-half teaching assignment in the Texas Panhandle. In New York City she fell in love with Alfred Stieglitz, the preeminent promoter of modern art in America, who was nearly twenty-four years her senior. At the time she executed this painting, Stieglitz (who would marry O'Keeffe in 1924) depicted her in a famous series of photographs that share a similar fascination with abstract form and sensuality.

Series I – No. 1, one of ten oils dating from 1918 to 1920, marks her initial efforts at combining the tactility and color of oil paint with the abstract forms she had earlier explored in charcoal and watercolor. The organic, unfurling shape at center, surrounded by patches and arcs of swirling coral, magenta, and turquoise, seems a purely nonrepresentational study of form. But O'Keeffe viewed the creative symbiosis of such elements as the truest expression of herself. "The abstraction," she wrote, "is often the most definite form for the intangible thing in myself that I can only clarify in paint."[1]

JM

1. Georgia O'Keeffe, *Georgia O'Keeffe* (New York: Viking Press, 1976), n.p.

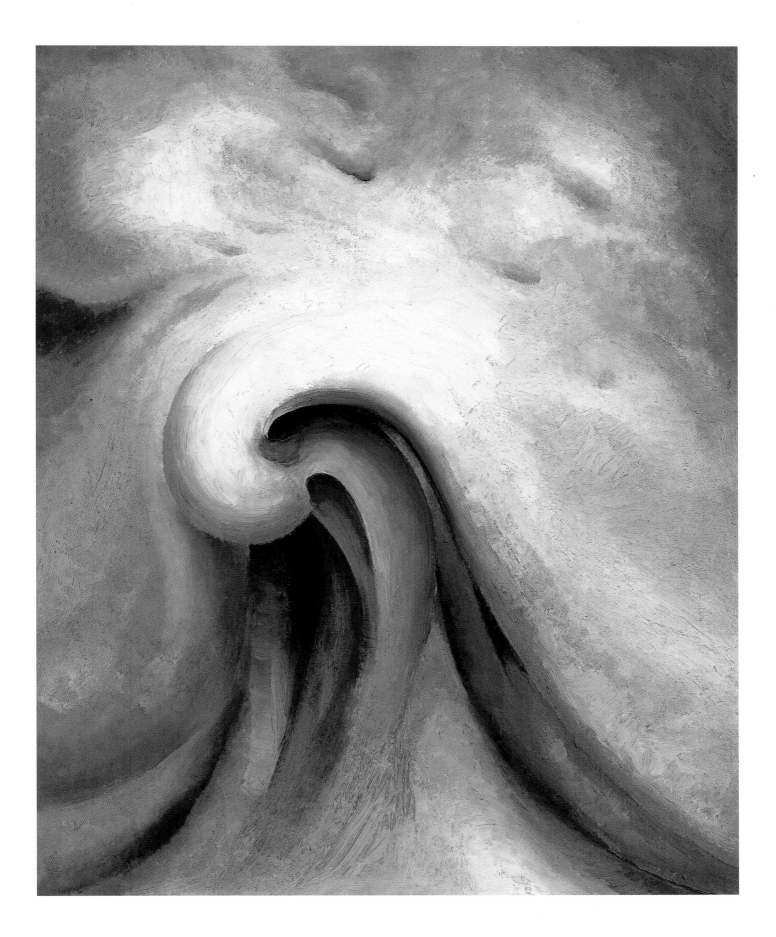

STUART DAVIS
1892–1964

Self-Portrait, 1919

Oil on canvas, 22¼ × 18¼ in. (56.5 × 46.4 cm)

Signed, dated, and inscribed on reverse: *TIOGA, PA. 1919 / STUART / DAVIS / SELF PORTRAIT*

1975.29

Stuart Davis grew up in a lively artistic house-hold in Philadelphia. His father, an art director for the Philadelphia Press, *knew other artist-journalists, including Robert Henri (1865–1929) and John Sloan [q.v.], and his mother was a sculptor. In 1910, before he had finished high school, Davis followed Henri to New York to study painting. Like his mentor, he initially focused on the street life around him. Remarkably, Davis saw five of his watercolors exhibited in the 1913 New York Armory Show, all of them Ashcan School subjects in the manner of Henri and his circle of realist painters. That same year, Davis also began making illustrations for the socialist magazine* The Masses, *although he would eventually reject conventional pictorial and narrative modes of expression. The Armory Show introduced Davis to European modern art, and in the years following that landmark event, he began experimenting with the bold colors and brushwork of the postimpressionists and the compositional devices of the cubists. Although Davis' period of experimentation was briefly interrupted by his service with the U.S. Army Intelligence department during World War I, he resumed his quest for innovation after the war and continued it for the next decade.*

STUART DAVIS' GAUNT VISAGE STARES DISARMINGLY from the canvas in this frank self-appraisal. He presents himself at age twenty-six with disheveled hair and a surreal yellow pallor accented with jarring touches of green and red. Contributing to this intense and restless presentation is the framed, brown-red rectangle hanging slightly askew in relation to the edges of the actual painting.

The pronounced psychological content of this work signals Davis' break with conventional artistic traditions, a process begun in 1913 when he discovered the expressive paintings of avant-garde Europeans. That year, New York's famed *International Exhibition of Modern Art*, better known as the Armory Show, gave the work of artists such as Vincent van Gogh (1853–1890) and Paul Gauguin (1848–1903) its first major showcase in the United States. This first-hand exposure powerfully affected many young American artists, including Davis, who resolved that he "would quite definitely have to become a 'modern' artist."[1]

For several years following the Armory Show, Davis experimented with a range of modern styles, all characterized by a vibrant palette, expressive brushwork, and abstract simplifications of form. By 1919, however, when he executed *Self-Portrait*, he had stopped merely emulating the modernists and had developed his own style. While the portrait stands as a testament to the European artists who had fostered Davis' distinctive approach, it marks his departure from their example in favor of more personal abstractions. Unifying his internal and external states, *Self-Portrait* presents the restless psyche of an artistic contender whose youthful energies portend a long, creative career.

JM

1. Stuart Davis, "Autobiography," 1945, quoted in Diane Kelder, ed., *Stuart Davis* (New York: Praeger, 1971), 24.

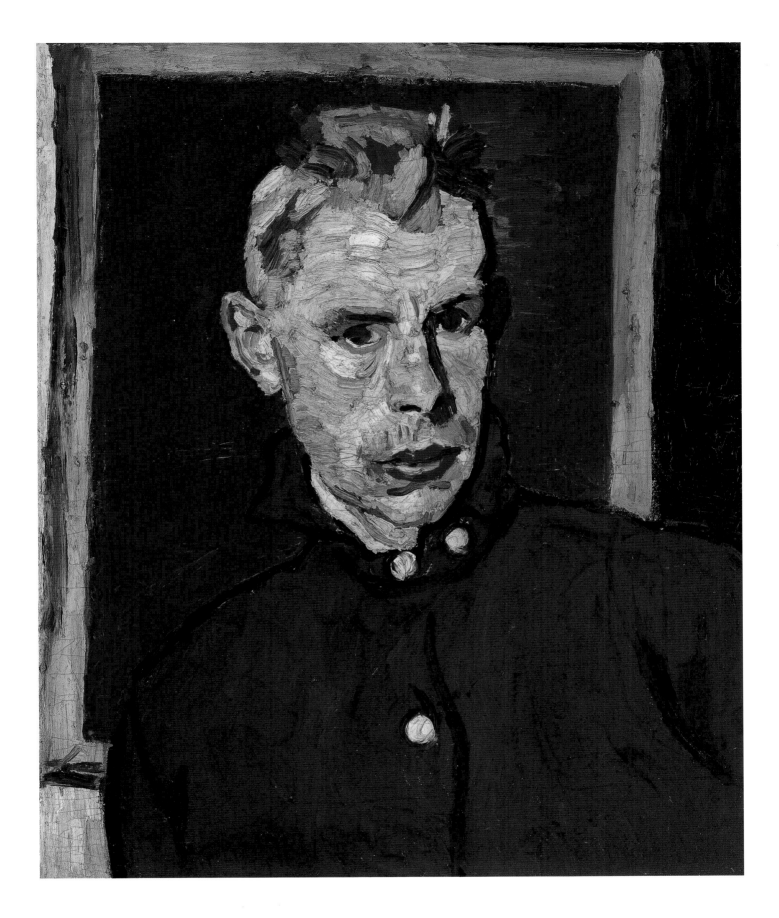

ELIE NADELMAN
1882–1946

Chef d'Orchestre, ca. 1919

Cherrywood, stained and gessoed, h: 38½ in. (97.8 cm); w: 22 in. (55. 9 cm); d: 11 in. (27.9 cm)

Partial gift of the Anne Burnett and Charles Tandy Foundation

1988.33

Born in Warsaw, Elie Nadelman was already a successful modern sculptor in Paris before he moved to the United States in 1914. His elegant figural works, which drew upon the simple forms of classical antiquity, had been acquired by the American collector Leo Stein, who introduced Nadelman to Pablo Picasso (1881– 1973). In 1913 the American artist Arthur B. Davies (1862–1928) selected one of Nadelman's figures and twelve of his drawings for inclusion in the pathbreaking Armory Show of modern art in New York City. The following year, an American patron, Helena Rubinstein, made possible Nadelman's move to New York. Nadelman and his wealthy wife spent lavishly to build their folk art collection, which they housed at their expansive estate, Alderbrook, in Riverdale, New York, and in their Manhattan townhouse. But with the October 1929 stock market crash and subsequent Great Depression, Nadelman was forced to sell his collection. He retreated to Riverdale, where he remained a recluse until his death in 1946. His friend the ballet impresario Lincoln Kirstein revived Nadelman's reputation by organizing a retrospective of his work at the Museum of Modern Art in 1948.

THIS FORMALLY ATTIRED CONDUCTOR, gesturing to his unseen orchestra, personifies both the sophistication of high culture and a rough-hewn provincialism. The influences of classical and folk sculpture are equally evident in this figure, one in a series of innovative cherrywood pieces Elie Nadelman made after he moved to the United States from his native Poland at the outbreak of World War I. The artist defines *Chef d'Orchestre* through a series of rhythmical lines, emphasizing gesture and expressive silhouette over detail. The resulting abstract and lyrical arabesque was intended to be a violin soloist until the sculptor decided the addition of the instrument upset the overall balance of the piece.

Nadelman had long admired the expressive and simplified forms of folk art in his native country and in the United States, where he became one of the first devoted collectors of such art. It was this personal collection, including dolls and advertising mannequins, that inspired his series of attenuated and streamlined figural wood sculptures. The treatment of the raw materials also indicates his partiality to folk art, as seen in the individual tool marks scattered across the sculpture and in the unevenly applied gesso defining the conductor's head and white vest. Drawn to subjects from contemporary American life, particularly the popular arts of dance, circus, theater, and the concert stage, Nadelman imparted to his figures an urbane gentility, coupled with allusions to the country's vernacular folk customs. As such, *Chef d'Orchestre* provides an entrancing reflection of American culture as it entered the Roaring Twenties.

JM

JOSEPH STELLA
1877–1946

84

Peonies, ca. 1919

Metalpoint and crayon on prepared paper, 23⅛ × 18⅝ in. (58.7 × 47.3 cm)

Signed lower center: *Joseph Stella*

Gift of Ruth Carter Stevenson

1986.22

Around 1919, as he continued to celebrate New York's bridges, skyscrapers, and lights in dynamic, almost abstract paintings, Joseph Stella responded to powerful memories of his homeland in the southern Apennines, west of Naples. He seemed to seek peace from urban tumult by reclaiming some of the joy he remembered having felt in an earthly paradise of brilliant sunshine, limitless blue vistas, and lush green hills. He painted these elements in rich symbolist canvases. But he also increasingly focused upon the small wonders of nature—the world contained in a single flower or tiny bird. He proclaimed this sudden change of focus as the dawn of a new age in his art and his life, and he never again returned to the urban images that had once captivated him. Throughout his career, he explored themes ranging from the symbolic to the commonplace. Stella died seven months after a solo exhibition of his work was presented at the Egan Gallery in New York.

"MY DEVOUT WISH: that my every working day might begin and end—as a good omen—with the light, gay painting of a flower," wrote Joseph Stella of his increasingly mystical absorption in nature.[1] The meticulously rendered, almost worshipful studies of delicate flowers, birds, and butterflies that he repeatedly drew in silverpoint and wax crayon were his means of paying tribute for the gifts of the natural world.

The traces of silver laid down with the drawing stylus sit up on the coated surface of the paper, so that Stella's peonies seem to hover above the ground, almost coming to life. He has touched each bloom lightly with yellow, further enhancing the illusion of a living flower. Yet in silverpoint, the peonies are faint, even elusive, their beauty almost palpably transitory. The effect of the bending blossom, which will soon wither and die, is meditative, even elegiac. Presented in splendid isolation on the page, these specimens are devoid of any context, and the spare composition suggests a surreal or dreamlike realm. In this, Stella's drawing is unmistakably modern, worlds apart from either scientific illustration or the elaborate, sentimentalized arrangements of the Victorian flower painters. Stella was the rare artist who used drawing not just as an occasional technical exercise or as an adjunct to painting but also as a powerful, expressive vehicle in its own right. The extensive body of silverpoint and goldpoint drawings in his work identifies him as an artist of discipline and virtuosity. But in these delicate botanical drawings we can also keenly feel the artist's deep spirituality, his quiet but all-consuming passion for the natural world.

PJ

1. Joseph Stella, "Thoughts II," undated ms., translated from the Italian, in Barbara Haskell, *Joseph Stella*, exh. cat. (New York: Harry N. Abrams for the Whitney Museum of American Art, 1994), 220.

Joseph Stella

LEWIS W. HINE
1874–1940

Steamfitter, 1921

Gelatin silver print, 16⅝ × 12³⁄₁₆ in. (42.2 × 31 cm)

P1981.80.3

Born and raised in Oshkosh, Wisconsin, Lewis W. Hine studied sociology and education at the University of Chicago, New York University, and Columbia University. A self-taught photographer, he deployed his camera to expose society's ills. In 1904 he began photographing new arrivals at Ellis Island, putting a sympathetic human face on the immigrant experience. Beginning in 1907 Hine became an investigator and photographer for the National Child Labor Committee; often working surreptitiously, he took pictures of children in factories and fields, from Maine to Texas, that were instrumental in the passage of the first child-labor laws. In 1918 wartime work with the American Red Cross took him to Europe, where he photographed refugees from Serbia and Italy. He returned to the United States the next year with a new goal of documenting labor from a more uplifting perspective. In 1930 construction began on the Empire State Building. Hine's images of the project, which were among his most dramatic, were published in his book Men at Work *(1932). Through the mid-1930s Hine photographed for various government agencies, including the Rural Electrification Agency, the Tennessee Valley Authority, and the Works Progress Administration. The year before he died, the Photo League organized a retrospective of his work. But not until the 1970s did his imagery regain recognition.*

LEWIS HINE'S ICONIC PHOTOGRAPH OF A MECHANIC working in a Pennsylvania power plant represents a major turning point in the artist's philosophy. Although his previous photographs of immigrants and child labor had portrayed working people, he depicted them as exploited and dehumanized. Hine's post–World War I series of "work portraits," however, depicted the worker as a noble contributor to industry who is worthy of celebration.

A slight variant of this photograph appeared in the December 31, 1921, issue of the reform journal *Survey Graphic*, as the lead image of a portfolio entitled "Powermakers: Work Portraits by Lewis W. Hine." The photographs function as visual allegories, depicting the workers as heroic symbols; the captions allude to pre-industrial crafts and serve to confer the kind of respect accorded more traditional occupations. Emphasizing the skill required to control the machines, Hine likened the mechanics to those who care for horses, calling them "the trainers of ten thousand horse-power."[1]

With this image and its portfolio companions, Hine redefined his role from that of a social-issues photographer to that of an interpretive photographer. In doing so, he documented scenes in a more positive manner, while simultaneously composing more pictorial photographs.

BMC

1. Lewis W. Hine, "Powermakers: Work Portraits by Lewis W. Hine," *Survey Graphic* 47 (December 31, 1921): 511.

PAUL OUTERBRIDGE, JR.
1896–1958

H. O. Box, 1922

Platinum print, 4⁷⁄₁₆ × 3⁵⁄₁₆ in. (11.3 × 8.4 cm)

Signed and dated lower right on mount: *Paul Outerbridge, Jr. 1922*

Copyright 1997, Estate of Paul Outerbridge, Jr., Courtesy of G. Ray Hawkins

(Object reproduced at actual size)

P1996.16

Born in New York City, Paul Outerbridge, Jr., studied drawing at the Art Students League in 1915 and then worked as a freelance illustrator until 1921, when he entered the Clarence White School of Photography. There he learned both the modernist philosophy of the cubist painter Max Weber (1881–1961) and the commercial potential of photography. From the beginning, Outerbridge's photographs demonstrated great technical skill and abstract composition and included "ready-made" objects as subject matter. He began working for Vogue *in 1922. In 1925 commercial assignments took him to Paris, where his friend the photographer Man Ray (1890–1976) introduced him to Georges Braque (1882–1963), Marcel Duchamp (1887–1968), Francis Picabia (1879–1953), and Pablo Picasso (1881–1973). Returning to New York in 1929, he perfected the tricolor carbro-print process in layouts for such magazines as* House Beautiful, McCall's, *and* Vogue. *Although he created a series of erotic carbro-print images during the 1930s, he never strayed from the still life, detailing his ideas and techniques in the seminal book* Photographing in Color *(1940).*

THE 1920S WAS THE FIRST DECADE during which more Americans lived in cities than in rural areas; it also was the period when automobiles began commanding the roads and silent movies gave way to sound. The relatively new notion of buying on credit, in tandem with the more prosperous economy then emerging, spurred the development of a consumer culture. Now the middle class could acquire—if not necessarily afford—material goods previously available only to the wealthy. Advertisers reflected these changes by aggressively incorporating more seductive imagery and modernist designs into their work.

Paul Outerbridge was a key player in that trend. With photographs such as *H. O. Box*, he helped redefine the standards of commercial product illustration. This striking image is one of his earliest and most spectacular successes. Although the photo ostensibly presents an ordinary box of oats, the artist's theatrical lighting and angled perspective lend to the subject a dark and mysteriously attractive quality, while at the same time transforming it into a scene out of the distorted world of Dr. Caligari. With the container lit from below so that only the top third is showing, the box becomes a mere flash of light floating within a darkened landscape of interlocking geometric forms. Further blurring the boundary between commerce and art, Outerbridge printed this image on expensive platinum paper, giving the work a luminous glow and monumentality that belie its small size.

JR

ALFRED STIEGLITZ
1864–1946

Music—A Sequence of Ten Cloud Photographs, No. I, 1922

Palladium print, 7⁹⁄₁₆ × 9½ in. (19.2 × 24.1 cm)

Copyright the Georgia O'Keeffe Foundation

P1998.70

Born in Hoboken, New Jersey, Alfred Stieglitz made his first informal photographs while studying engineering and photochemistry in Berlin in 1883. He returned to New York City in 1890, committed to photography and its vast creative potential. In 1897 he became founding editor of the journal Camera Notes. *Five years later, Stieglitz and other pictorialist photographers, among them Clarence H. White (1871–1925) and Edward Steichen (1879–1973), formed the Photo-Secession—a group dedicated to photography as an art form. Stieglitz reproduced photogravures of the group's work in his influential quarterly,* Camera Work *(1903–17), a journal with worldwide distribution. Concurrently, he promoted modern American painting, sculpture, and photography at his gallery 291, which from 1905 to 1917 was the venue for many groundbreaking exhibitions. Stieglitz organized the* International Exhibition of Pictorial Photography, *held at the Albright Art Gallery in Buffalo in 1910; it represented the high point of the Photo-Secession. Thereafter, Stieglitz turned from pictorial to straight photography, creating from 1917 to 1929 eloquent city views, landscapes, and portraits. A major retrospective of his work, held at his gallery An American Place in 1932, paid homage to his four decades as a photographer and sought to reflect the breadth of his influence. Stieglitz made his last images at Lake George in 1937.*

WHEN ALFRED STIEGLITZ CREATED THIS DRAMATIC VIEW of dense storm clouds breaking across a ridge near his Lake George, New York, summer home, he had been working for thirty years to prove the artistic potential of photography, both by example and by celebrating the work of such photographers as Gertrude Käsebier (1852–1934), George Seeley [q.v.], and Paul Strand [q.v.]. He had introduced modern art to Americans through his editorship of several periodicals and management of a New York City gallery, and he had nurtured the careers of such important young American artists as Arthur Dove [q.v.], John Marin [q.v], and Georgia O'Keeffe [q.v.].

This arresting image, however, recalls the dramatic mid-nineteenth-century storm paintings of Thomas Cole [q.v.] and Frederic Edwin Church [q.v.]. Mirroring a common motif of those earlier works, the clapboard house is enveloped by a dense, forbidding wilderness. Like his predecessors, Stieglitz recorded a turbulent sky pierced with sunlight, and while the scene might not carry the same Edenic metaphor, its break of light delivers an emotional charge.

Stieglitz had photographed clouds intermittently throughout his career, drawn by the challenge of capturing extremes of light and darkness. Indeed, by 1922 the subject had become a popular motif among amateur photographers. Yet in creating *Music, No. I,* he sought to transcend pure transcription. He told O'Keeffe that his goal was to convey "his philosophy of life."[1] Avidly photographing clouds during the late summer and early fall of 1922, he created what he called "equivalents" of his "most profound life experience."[2] Stieglitz was launching into an extended photographic study of the metaphorical qualities of clouds that would preoccupy him for ten years and fundamentally influence a number of photographers, including Edward Weston (1886–1958) and Minor White (1908–1976). He then assembled sequences of the best of these cloud images to reflect the emotional ebb and flow of symphonies. *Music, No. I* is the opening image of his first cloud sequence.

JR

1. Richard Whelan, *Alfred Stieglitz: A Biography* (New York: Little Brown, 1995), 431.
2. Dorothy Norman, *Alfred Stieglitz: An American Seer* (New York: Random House, 1973), 144.

CHARLES DEMUTH
1883–1935

Cineraria, 1923

Watercolor and graphite on wove, off-white paper, 10 × 14 in. (25.4 × 35.6 cm)

Signed and dated at center: *C. Demuth- / 1923 / Lancas / ter.*

Purchase with funds provided by Nenetta Burton Carter

1981.2

Born in Lancaster, Pennsylvania, Charles Demuth studied in Philadelphia at the Drexel Institute and the Pennsylvania Academy of the Fine Arts. Although he valued the rigorous figure drawing of his academy instructor Thomas Anshutz, he never adopted the realism that many of his fellow students embraced. Instead, he was inspired by the late watercolors of the French modernist Paul Cézanne (1839–1906). From the beginning, Demuth favored watercolor as a medium perfectly suited to his fascination with simple, fluid forms and prismatic light. His first exhibition, at the Daniel Gallery in New York City in 1914, was a show of watercolors. Over the next eight years, he documented his life in watercolor—summers in Provincetown and Gloucester, Massachusetts; a winter in Bermuda; and periodic stays in Greenwich Village. He also painted watercolor still lifes as explorations of pure color effects. When he returned home to Lancaster in 1922, his travels and activity curtailed by debilitating diabetes, the planar structure of his works became increasingly complex. Demuth's spare watercolors placed him squarely within the artistic vanguard, and they were admired and exhibited by Alfred Stieglitz [q.v.]. However, their delicate beauty went largely unappreciated by critics during the artist's lifetime.

"I'VE ONLY PAINTED IN WATERCOLOR," Demuth wrote to Alfred Stieglitz in September 1923, describing his recent work. "The strain is greater, but I don't have to return and fuss if it goes bad as one always does in oil and tempera."[1] He was back at the old family home in Lancaster, Pennsylvania, working in the small studio he had earlier made for himself in an upstairs bedroom overlooking his mother's flower garden. Although he was weak from his struggle with diabetes, Demuth's intellectual energy surged as he pushed his work in watercolor to new levels of color and compositional complexity. His fascination with unconventional viewpoints and the intricacies of faceted daylight and planar space, which had characterized his earlier architectural studies, was now brought to bear on the unprepossessing tabletop still life.

The most obvious compositional device in this elaborate painting of potted cineraria is the vibrant pattern of color. As the picture comes into focus, however, the artist's compositional skills and his careful control of transparent watercolor to achieve clarity and crispness become apparent. The sprightly cineraria stand out as brilliant white against the light blue-gray tones that Demuth has laid down beside them to create depth, atmosphere, and delicate shadows. Carefully modulated patches of gray and green form the ample leaves of the cineraria twisting in space. Distance is indicated by clearly delineated planes that direct the eyes around the central backdrop, passing over the flowerpot half hidden there, to the edge of the table and on into the far corner of the room. *Cineraria* is more than a study of flowers: working within a confined physical space, Demuth has managed to present an intricate, almost architecturally structured world.

PJ

1. Demuth to Stieglitz, September 1923, quoted in Barbara Haskell, *Charles Demuth*, exh. cat. (New York: Harry N. Abrams for the Whitney Museum of American Art, 1987), 141.

ROBERT LAURENT
1890–1970

Plant Form, ca. 1924–28

Stained fruitwood, h: 32 in. (81.3 cm); w: 5¾ in. (14.6 cm); d: 5¾ in. (14.6 cm)

Purchase with funds provided by the Council of the Amon Carter Museum

1989.1

Born in an artists' colony in Concarneau, France, Robert Laurent came to America as a protégé of the Brooklyn sculptor Hamilton Easter Field (1873–1922), a well-connected figure within the country's modern art circles. Field mentored the young artist and supervised his studies, and when Laurent became interested in sculpture after working as an art dealer's assistant in Paris, Field took him to London and Rome to study ancient models as well as innovative modern work. Back in the United States, Field introduced Laurent to his influential friends—among them Marsden Hartley [q.v.] and Alfred Stieglitz [q.v.]—and the two established an artists' colony in Ogunquit, Maine, their favorite summer place. Inspired by traditional American forms of wood carving he saw in New England and by European abstract art, Laurent developed an original style of direct carving in wood and stone. His organic forms recalled such innovators as Constantin Brancusi (1876–1957) in addition to simply carved folk art. His first significant exhibition—in 1915 at the Daniel Gallery in New York City—was an immediate success, and other important New York exhibitions followed. In 1941 Laurent took a teaching post at Indiana University. He also continued teaching at the Ogunquit colony. He remained productive as a sculptor and teacher until his death in 1970.

ROBERT LAURENT, one of the first American artists to produce direct-carved abstract sculpture, created *Plant Form* from a solid block of fruitwood. The sculpture swells from a simple base into a duet of organic, vertical forms that the artist partially colored in green. A contrasting gold stain distinguishes an emerging shape within the larger of the two forms, which suggests a budding flower. *Plant Form* is one of a small group of abstract wood sculptures Laurent produced in the mid-1920s, at the same time Georgia O'Keeffe [q.v.] also was exploring sensual and broadly rendered natural forms.

Like other modernists, such as Elie Nadelman [q.v], Laurent derived inspiration from his personal collection of American folk art. The indigenous styles and techniques that characterized these objects prompted Laurent to champion direct carving, as opposed to modeling and casting. He especially advocated the fine points of craftsmanship, such as allowing the wood grain to show through the colored stains. To Laurent and others, folk art seemed intuitive and therefore closer to modernism's emphasis on subjective, rather than objective, reality.

Laurent believed above all that the raw material itself should determine the ultimate form a piece would take: "I do not especially enjoy modeling in clay," he said. "I prefer a material more resistant. . . . Generally, I start cutting without a preconceived idea—it keeps me more alert and open to surprises that always develop."[1] The result, as seen in *Plant Form,* was a direct response to the essence of the natural world.

JM

1. Quoted in Peter V. Moak, *The Robert Laurent Memorial Exhibition,* exh. cat. (Durham: University of New Hampshire, 1972), 18.

GEORGIA O'KEEFFE
1887–1986

Red Cannas, 1927

Oil on canvas, 36⅛ × 30⅛ in. (91.8 × 76.5 cm)

Signed, dated, and inscribed, on stretcher: *Georgia O'Keeffe—1927—Red Cannas*; on reverse: *Georgia O'Keeffe/1927*

1986.11

In 1924 Georgia O'Keeffe married Alfred Stieglitz [q.v.], who promoted her work through major solo exhibitions nearly every year of that decade. During this period, she focused on urban architectural landmarks, magnified flowers, and fruit still lifes. Her boldly colored flowers—red cannas, white and yellow calla lilies, and black irises—caused a sensation in New York City. Critics often ascribed sexual content to their sensual forms and saw her work as the ultimate expression of the female psyche. O'Keeffe strongly objected to such Freudian readings of her flowers, saying that others should not project their own interpretations onto her highly personal imagery.

O'KEEFFE'S STILL LIFES DESCRIBE a deeply personal sensory experience, an absorption in the object at hand. Moreover, for her these objects had associations with people and places—apples from the orchard at the Stieglitz family house at Lake George in the Adirondacks, dead leaves gathered there in the autumn, or the vibrant cannas from her Lake George flower garden.

In painting outsized studies of these botanical elements, O'Keeffe celebrated the dynamic color patterns found in nature. At the same time, she revealed a touching emotional attachment to these objects. She often created these paintings in the fall, when she and Alfred Stieglitz were away from Manhattan and alone together at the lake house. The works suggest joy and the pure sensual pleasure she found in paint, in color, in nature, and in her bucolic life there with Stieglitz.

O'Keeffe's flower studies are among her signature works. She explained her motivation to paint them this way:

> Everyone has many associations with a flower. You put out your hand to touch it, or lean forward to smell it, or maybe touch it with your lips almost without thinking, to give it to someone to please them. But one rarely takes the time to really see a flower. I have painted what each flower is to me and I have painted it big enough so that others would see what I see.[1]

PJ

1. Georgia O'Keeffe, statement in *Fifty Recent Paintings by Georgia O'Keeffe*, catalogue of an exhibition at Stieglitz's *The Intimate Gallery*, 1926, quoted in Barbara Buhler Lynes, *Georgia O'Keeffe: Catalogue Raisonné*, 2 vols. (New Haven and London: Yale University Press for the National Gallery of Art, Washington, D.C., and the Georgia O'Keeffe Foundation, Abiquiu, N.M., 1999), 2: 1098.

CHARLES SHEELER
1883–1965

Ford Plant—Detroit [Bleeder Stacks], 1927

Gelatin silver print, 9½ × 7⁹⁄₁₆ in. (24.1 × 19.2 cm)

Signed and inscribed on reverse, upper center: *Ford Plant—Detroit photo by Charles Sheeler*

(Object reproduced at actual size)

P1980.22.4

Born in Philadelphia, Charles Sheeler was seventeen when he was accepted into the Pennsylvania Academy of the Fine Arts. There, he studied painting with William Merritt Chase [q.v.] and met Morton L. Schamberg [q.v.], who would become his friend. A trip to Europe in 1908 had a profound impact on Sheeler: he absorbed the works of Georges Braque (1882– 1963), Henri Matisse (1869–1954), and Pablo Picasso (1881–1973) and returned to Philadelphia a modernist. In 1910, while pursuing painting, Sheeler took up photography to generate income, specializing in architectural images. At this time he began creating clean, geometric drawings, paintings, and photographs of barns and farmhouses in Bucks County, Pennsylvania, helping establish a style that became known as "precisionism." Influenced by the photographers Alfred Stieglitz [q.v.] and Paul Strand [q.v.], Sheeler moved to New York City in 1919. The next year he collaborated with Strand on the experimental seven-minute film Manhatta*. For three years, beginning in 1926, Sheeler was on the staff at Condé Nast publications, making photographs for* Vogue *and* Vanity Fair*. His 1927 documentation of the Ford Motor Company's River Rouge plant won him national acclaim as a photographer of the Machine Age. After 1932 Sheeler made photographs mainly as preparatory studies for his paintings and drawings; beginning in the mid-1940s, he focused exclusively on painting. A 1954 retrospective exhibition at the University of California, Los Angeles, demonstrated the symbiotic relationship of all his works.*

IN 1927, AS THE FORD MOTOR COMPANY prepared to release the Model A for the first time, the company moved its massive, automated assembly-line operation from Highland Park, Michigan, to its River Rouge steel plant, bringing all phases of production onto one site and making River Rouge the world's largest industrial complex. To help publicize the facility, Ford commissioned Charles Sheeler to photograph it. This assignment represented a major turning point for Sheeler, who subsequently adopted American industry as one of his primary subjects.

Sheeler spent six weeks at the Ford plant, where he found himself drawn to the huge geometric forms of the steel-production architecture and machinery. These structures had been designed solely for functionality, but their inadvertently abstract designs and purity of form captivated Sheeler. Walking along a raised catwalk, he found a vantage point beneath these imposing bleeder stacks, where excess gas was released from the immense blast furnaces below. Although the artist included no evidence of people in his various depictions of the plant, a contemporary critic discussed them in human terms, praising Sheeler for articulating "the very soul of steel in a series of the truest portraits of our times."[1]

BMC

1. Samuel M. Kootz, "Ford Plant Photos of Charles Sheeler," *Creative Art* 8 (April 1931): 266.

STUART DAVIS
1892–1964

Egg Beater No. 2, 1928

Oil on canvas, 29⅛ × 36 in. (74 × 91.4 cm)

Signed and inscribed, upper right: *STUART DAVIS*; on reverse on label,
EGG—BEATER / NO. 2 / Stuart Davis

1996.9

Stuart Davis was born into an artistic Philadelphia family. He dropped out of high school and moved to New York City in 1910. Three years later, five of his watercolors were exhibited in the Armory Show. As he matured artistically during the 1920s, his career gathered momentum. In 1926 Gertrude Vanderbilt Whitney and Juliana Force gave him a one-person exhibition at the Whitney Studio Club, a leading Manhattan showcase for new talent. In 1928 the Valentine Gallery in New York featured Davis' seminal Egg Beater series, and when Force purchased two of his oils the same year, he had enough money to travel to Paris. He lived there for a year and met one of the leading French modernists, Fernand Léger (1881–1955), who admired the Egg Beater paintings and whose work had influenced Davis. Along with other American artists, Davis learned lithographic technique at the Atelier Désjobert and produced eleven prints devoted to Paris street subjects. Once back in the United States, he maintained his interest in Parisian imagery, combining it with American themes in both lithographs and paintings.

DURING THE 1920S DAVIS PURSUED A SOPHISTICATED APPROACH to painting that involved the reordering of pictorial space. In the Egg Beater series of four related works, executed in 1927 and 1928, he used ordinary household objects as his points of reference: an electric fan, a rubber glove, and an eggbeater, all affixed to a table. As he worked on the series, to which he devoted himself exclusively for a year, Davis allowed the objects themselves to suggest inventive color and space associations. This approach would become the cornerstone of his artistic method. "It was from the eggbeater that the pictures took their impulse," he later said. "Their subject is an invented series of planes which was interesting. . . . I got away from naturalistic forms. I invented the geometrical elements."[1]

Davis obscures any identifiable forms in *Egg Beater No. 2*, although close scrutiny reveals provocative allusions to his subjects. The broadly spaced linear elements suggest the open wires of an eggbeater; the rounded shapes at the lower right, the fingers of a glove; the brown teardrop poised in the center of the canvas, the blade of an electric fan; and the notched blue form, the serrated edge of a rotary eggbeater's drive wheel. A boxlike setting with four receding walls implies a three-dimensional enclosure for the distinctive shapes and colors, yet the parallelogram that spans the canvas from corner to corner simultaneously negates that illusion. Such components mark the Egg Beater series as Davis' first truly abstract paintings.

JM

1. Stuart Davis, interview with James Johnson Sweeney, *Stuart Davis*, exh. cat. (New York: Museum of Modern Art, 1945), 17; quoted in Diane Kelder, ed., *Stuart Davis* (New York: Praeger, 1971), 7.

LOUIS LOZOWICK
1892–1973

Still Life #2, 1929

Lithograph on wove, buff paper; image: 10⅜ × 13¼ in. (26.4 × 33.7 cm); sheet: 13½ × 17¼ in. (34.3 × 43.8 cm)

Signed and dated, lower left, on stone: *LL* [monogram]; lower right: *LOUIS LOZOWICK '29*

1983.76

Louis Lozowick's work was informed by his firsthand exposure to modernism in the international arena. Born in the Ukraine, he studied at the Kiev Art Institute before moving to Newark, New Jersey, to join his brother in 1906. He took classes at the National Academy of Design in New York City and completed his undergraduate work at Ohio State University in 1918. During the 1920s, Lozowick traveled to Paris, Berlin, and Moscow, where he met many of the leading artists and theorists of the avant-garde. Back in New York, he became an advocate for modern art through writings, lectures, and his artwork, which focused on lithography but also included stage sets, oil paintings, and abstract ink drawings. Through his book Modern Russian Art *(1925), Lozowick introduced Russian constructivism and suprematism to America. A left-wing political activist, he was sympathetic toward the American laborer; during the 1930s, he often portrayed workers within the urban landscape. That decade also saw his employment by the Works Progress Administration and a stylistic shift toward realism. In 1945 he moved to South Orange, New Jersey, where he lived until his death in 1973.*

LOUIS LOZOWICK'S *Still Life #2*, a lithograph depicting everyday objects, is a technical tour de force of precise shapes, patterns, tones, and textures. The image reveals the printmaker's mastery of the range of effects attainable through the lithographic process. Soft gray tones indicate transparent liquid in a coffee cup while, at the other end of the spectrum, the alternating squares of the checked tablecloth are rendered in rich, velvety black. Lozowick also used the blank paper to great effect in his rendering of the crisp interior of a cut apple and a folded cloth napkin. The grain imparted by the lithographic stone also delighted the artist, who exploited its singular character in numerous other works.

Ostensibly a simple still life, this print, in fact, embodies Lozowick's idea that art should reflect the underlying order of American life in the modern age. His visual vocabulary involved the creation of solid geometric forms within compact compositions. He believed that lithography was ideally suited to the expression of modern form, and he maintained that the artist should "make his work clear in its intention, convincing in its reality, inevitable in its logic."[1]

Although the human presence is only implied in Lozowick's rather impersonal imagery of grain silos, skyscrapers, construction sites, and bridges, the presence of man is always palpable. In this print, the long shadow of a coffeepot indicates activity beyond the visible boundaries. Lozowick further heightens the sense of verisimilitude by employing the unusual bird's-eye perspective of an individual seated at the table, looking down on the coffee cup and fruit.

JM

1. Louis Lozowick, "The Americanization of Art," 1927, quoted in Virginia Hagelstein Marquardt, ed., *Survivor from a Dead Age: The Memoirs of Louis Lozowick* (Washington, D.C., and London: Smithsonian Institution Press, 1997), 282.

LOUIS LOZOWICK '29

JOHN MARIN
1870–1953

Taos Canyon, New Mexico, 1930

Watercolor and charcoal on wove, off-white paper, 15½ × 21 in. (39.4 × 53.3 cm)

Signed and dated lower right: *Marin 30*

1965.5

Born in Rutherford, New Jersey, John Marin initially studied to be an architect but, in 1899, enrolled at the Pennsylvania Academy of the Fine Arts in Philadelphia. In 1911 he began a series of watercolors, oils, and prints that would earn him a place among America's great early modernists. Marin's habit was to work during the winter in his Cliffside Park, New Jersey, studio then spend the rest of the year traveling and painting in various landscapes, primarily along the East Coast. Among his favorite painting destinations was the rocky coast of Maine; he spent each summer from 1933 to 1953 in the town of Cape Split. Marin's friend Alfred Stieglitz [q.v.] ensured that the artist's work was shown in various New York galleries. Marin also saw his works exhibited and acquired by such institutions as the Saint Louis Art Museum, the Metropolitan Museum of Art, and the National Gallery of Art.

IN 1929 THE ART PATRON MABEL DODGE LUHAN invited John Marin to visit her in the remote town of Taos, New Mexico. Marin, then in his fifties and living in Cliffside Park, New Jersey, sojourned happily there that summer and the following one, engaging in two of his favorite activities: trout fishing and watercolor painting—sometimes doing both on the same outing.

One of the twentieth-century's masters of watercolor, Marin soon devised innovative methods to express his response to the unfamiliar surroundings. Driving along the dirt roads outside Taos, he was overwhelmed by the vast landscape vistas and the intensity of the sunlight. He expressed the environment's raw spirituality in a letter to his mentor, Alfred Stieglitz: "The *One* who made this country, this big level seeming desert table land cut out slices. They are the canyons. Then here and there he put mountains atop. Astanding [*sic*] here you can see six or seven thunder storms going on at the same time."[1]

Marin painted *Taos Canyon, New Mexico* on one such excursion, probably above San Cristobal Valley looking down onto the vast plain below. The distinctive arid landscape informed Marin's palette of aqua, terra-cotta, and brown. Using jagged and angular abbreviations of form, he deftly captured the essential elements of the distant view—mountains, sky, scrubs, and small buildings—in a schematic yet descriptive manner. He created a lively interplay of paper and pigment by leaving some passages free of color and sweeping a dry brush across the heavy wove paper so as not to cover it completely, thereby lending the work a vibrant luminosity. Marin enclosed the image in an internal framing element—his favorite compositional device—and took the illusion a step further by painting a frame around the sheet itself, directly onto the mounting paper. The inclusion of this motif clearly underscores the personal perspective of an East Coast artist who found a fresh store of inspiration in the landscape of the Southwest.

JM

1. John Marin, Taos, to Alfred Stieglitz, July 21, 1929, quoted in Ruth E. Fine, *John Marin*, exh. cat. (Washington, D.C.: National Gallery of Art; and New York: Abbeville Press, 1990), 220.

GEORGIA O'KEEFFE
1887–1986

Ranchos Church, New Mexico, 1930/31

Oil on canvas, 24 × 36 in. (61 × 91.4 cm)

1971.16

By the late 1920s, Georgia O'Keeffe longed for a return to the liberating spaces of the vast western landscape. Her visit to Taos during the summer of 1929 marked the first of many sojourns in New Mexico. Much of the imagery she produced for the rest of her life would center on the Southwest. She found inspiration in the region's Native American culture and in its austerely beautiful landscape. The artist made regular trips back to New York City to see her husband, Alfred Stieglitz [q.v.], who, despite declining health, continued exhibiting and championing her work until he died in 1946. Around that time, she established roots in the village of Abiquiu, moving there for good in 1949. Beginning in the late 1960s, O'Keeffe's work attained nationwide popularity. She received many honors, and major museums around the country accorded her retrospective exhibitions. In 1984 ill health forced her to leave her beloved rural Abiquiu home for Santa Fe, where she died two years later.

LIKE ALL VISITORS TO TAOS, Georgia O'Keeffe was taken with Ranchos de Taos Church, pronouncing it "one of the most beautiful buildings left in the United States by the early Spaniards."[1] Yet as she demonstrates in this painting, that beauty is unconventional and is made manifest in the building's striking simplicity, unpretentiousness, and mystery. O'Keeffe fixed on the aged structure as something revelatory in the unfamiliar terrain of the Southwest. She made her first extended visit to New Mexico in 1929, and she returned every year thereafter, eventually settling permanently in Abiquiu.

O'Keeffe's first two summers in Taos brought forth a succession of large and closely cropped studies of the famous church's unadorned angular apse, with its massive blocky buttresses. She delighted in these distinctive sculptural elements, so artful in the way they capture light and shadow and, ironically, so modern. She presents the church as an ageless earth-form rising out of the desert, an icon of immense scale and significance. O'Keeffe has managed here to convey the look of the New Mexico landscape, the singularity of the region's culture, and her own joy at finding things new, confounding, and fascinating in the vast Southwest.

PJ

1. Georgia O'Keeffe, *Georgia O'Keeffe* (New York: Viking Press, 1976), n.p., quoted in Sandra D'Emilo, *Spirit and Vision: Images of Ranchos de Taos Church* (Santa Fe: Museum of New Mexico Press, 1987), 15.

JOHN B. FLANNAGAN
1895–1942

Goat, 1930–31

Granite, h: 8½ in. (21.6 cm); w: 19¼ in. (48.9 cm); d: 9 in. (22.9 cm)

Ruth Carter Johnson Fund Purchase

1982.37

John B. Flannagan's life was shaped by intense poverty and his own self-effacing, self-doubting nature. Born in Fargo, North Dakota, in 1895, he was placed in an orphanage at age five when his mother, left destitute after his father's death, could not afford to raise her children. He managed to study art briefly at the Minneapolis Institute of Arts before the United States entered World War I, then enlisted in the service. In 1922, living on the streets of New York City, he was befriended by the painter Arthur B. Davies (1862–1928), whose encouragement and financial support led Flannagan to take up sculpting. Although he found representation at the prominent Weyhe Gallery, his work in stone was slow and difficult, and he required a monthly stipend from his dealer just to get by. He suffered long bouts of depression brought on by the strain of his labors. In 1939 a car hit him, and he sustained brain injuries from which he did not recover. Flannagan committed suicide in January 1942, two months before the opening of his first retrospective exhibition at New York's Buchholz Gallery.

FOR JOHN FLANNAGAN, stone was a living substance, possessing the character of even the most delicate creatures and needing only the knowing hand of the carver to reveal its underlying form. He saw "with the vividness of a hallucination," he said, and could transform stone into a newborn child, a tightly compact sleeping cat, the round mass of a lumbering elephant, or, as in this work, into a fragile kid goat.[1]

Flannagan preferred to work in weathered fieldstone, choosing it initially because he could not afford quarried granite or marble but soon prizing it for its raw beauty. "I would like my sculpture to appear as rocks, left quite untouched and natural," he wrote his friend Carl Zigrosser of the Weyhe Gallery in New York City, "and, as you have said, inevitable."[2]

Flannagan regarded himself merely as the intermediary in a natural process of regeneration of form. He even wished that his carvings might stand not as modern artistic statements but rather as the kind of unpretentious and solemn tributes to nature that had been made by earliest man or left on earth by ancient civilizations. In keeping with this desire, he rarely even signed his works, allowing them to attain the aura of anonymous devotional objects.

In March 1930, with the help of his dealer, Erhard Weyhe, Flannagan left New York for an extended stay in Connemara, on the rocky peninsula between Galway and Clew Bay in northwestern Ireland. There he found much needed rejuvenation. "These hills are a sculptor's dream—or nightmare—I still don't know which," he wrote to Zigrosser in his first weeks there. "Stone—stone—green—white—black marble—granites including my black. None of it being quarried—you find it in the fields and fences. . . . I find there is still something eager left in me . . . feel more intensely just one steady abiding purpose such as it is—to make images out of rock." In this rural setting, he reconnected with subjects he held dear. "If there is anywhere an animal's country, this is surely it," Flannagan continued enthusiastically in a subsequent letter to Zigrosser. "In the mountains where there isn't stone there are sheep. I'll warn you—you're bound to get from me at least one Connemara Ram."[3] Indeed, sheep and goats were among the menagerie of animals he carved in Ireland that year, each one worked in primordial rock and evoking an ancient Celtic simplicity.

PJ

1. Flannagan to Zigrosser, n.d., quoted in Carl Zigrosser, "John B. Flannagan," in *The Sculpture of John B. Flannagan*, exh. cat. (New York: Museum of Modern Art, 1942), 10.
2. Ibid., 9.
3. Flannagan, Clifden, Ireland, to Zigrosser, June 22, 1930, reprinted in *Letters of John B. Flannagan* (New York: Curt Valentin, 1942), 22–23.

STUART DAVIS
1892–1964

Barber Shop Chord, 1931

Lithograph on wove, buff paper; plate: 13⅞ × 19 in. (35.2 × 48.3 cm); sheet: 20 × 25⅞ in. (50.8 × 65.7 cm)

Signed and inscribed, lower left, on stone: *STUART DAVIS*; lower left: *1 / 25*; lower right: *Stuart Davis*

Copyright Estate of Stuart Davis/Licensed by VAGA, New York, NY

1984.77

Stuart Davis left his native Philadelphia in 1910 to follow the painter Robert Henri (1865–1929) to New York City. Remarkably, three years later, he saw five of his watercolors included in the landmark Armory Show of modern art. He experimented with modern styles through the 1920s and realized increasing success. In 1926 Gertrude Vanderbilt Whitney and Juliana Force featured his paintings in a solo show at the Whitney Studio Club, their showcase for new talent. Sales of paintings in 1928 made possible a trip to Paris, his home for the next year. There he befriended other painters working in an abstract mode, including Fernand Léger (1881–1955), whose colorful, graphic painting style was akin to Davis' own. Like other American artists then in Paris, Davis was introduced to lithography at the Atelier Désjobert and created eleven prints focused on Paris street life. After returning home, he retained his interest in Parisian imagery, blending it with distinctly American motifs.

DURING HIS 1928–29 STAY IN PARIS, Stuart Davis focused on everyday objects, such as signs, café facades, and decorative ironwork, to evoke that singular city. Like many of his contemporaries, Davis also sought a new visual language to express America's unique character. Upon his return from Europe, the artist evolved an array of imagery to describe his primary places of residence, New York City and Gloucester, Massachusetts.

Davis' fondness for Gloucester, a coastal fishing town where he spent many summers, is conveyed in *Barber Shop Chord*. He depicts an abundance of resonant forms: masts and boat rigging, a sign reading "FISH__G," a stop sign, a café, a lamppost, and a fire hydrant. The conical structure represented at left was a sixty-foot-tall natural-gas tank, one of two located along the town's waterfront. Over these forms Davis incongruously superimposed a vertical figure that dominates the composition; its biomorphic shape echoes the dreamlike quality of surrealist art to which Davis was probably exposed in Paris. A striped barbershop pole has leapt from its perch to merge with the outsized figure, adding another witty element to the richly patterned image. The print's scintillating use of deep blacks and pure whites demonstrates Davis' command of the complicated lithographic process, which he had first explored in Paris.

JM

CHARLES DEMUTH
1883–1935

Chimney and Water Tower, 1931

Oil on composition board, 30 × 24 in. (76.2 × 61 cm)

Signed and dated lower right: *C. D. '31*

1995.9

Charles Demuth was deeply attached to his hometown of Lancaster, Pennsylvania. He found solace there as he struggled with the diabetes that ultimately killed him. The city was a source of artistic inspiration, too, and Demuth produced some of his most celebrated works there. He had left home to study in Philadelphia, first at the Drexel Institute and then at the Pennsylvania Academy of the Fine Arts. Captivated by modern European art, he went next to Paris and absorbed the new ideas of the artists and writers who associated with his friend Gertrude Stein (1874–1946). Returning to New York City, Demuth had his first exhibition at the Daniel Gallery there in 1914. He soon joined the circle of young artists regularly featured at Alfred Stieglitz's [q.v.] gallery An American Place. Fascinated with unconventional viewpoints and formal structure, he was drawn to architectural subjects, especially views in Lancaster, and painted them throughout his career. In his studies of the city's church steeples, water towers, and grain elevators, Demuth showed a modern analytical approach to form, color, and light. But these works conveyed as well his abiding emotional ties to his native city.

DURING THE LATE 1920S, Demuth embarked on a series of canvases focused on the architecture of his hometown, Lancaster, Pennsylvania. Although his ties to the New York City art world were strong, he was repeatedly drawn to Lancaster as a source of imagery for his oils and watercolors.

In *Chimney and Water Tower*, Demuth depicted the austere smokestack and water tower that rose above the Armstrong Cork Company, an important local plant where linoleum was produced. Painting in steel gray and blue with passages of deep red, Demuth presented a carefully controlled visual essay involving lines, planes, and angles. He raised his line of sight above street level to accentuate the factory's main components, stripping away the mélange of industrial detail to emphasize its monumental forms. The artist rendered his rigid underlying scheme of semicircular, diagonal, vertical, and horizontal elements through methodically ruled graphite lines, visible throughout; he drew these on the canvas before applying layers of opaque paint. Demuth varied the resulting abstracted fields of color by imparting subtle patterns with his brush, as seen in the overcast sky, which is further defined with a horizontal swathe of white paint. Although few critics at the time were receptive to the stark beauty of such nontraditional subject matter, Demuth held fast to evoke in his work a strongly personal sense of place, expressed through an elegant and masterful composition.

JM

CHARLES SHEELER
1883–1965

Industrial Architecture, 1931

Conté crayon and graphite on wove, off-white paper mounted to board,
14¼ × 10⅛ in. (36.2 × 25.7 cm)

Signed and dated lower right: *Sheeler 1931*

1990.38

Born in Philadelphia, Charles Sheeler stud-ied at the School of Industrial Design there from 1900 to 1903 before enrolling at the Pennsylvania Academy of the Fine Arts. He em-braced European modern art and in 1908 trav-eled to the Continent with his friend the abstract painter Morton L. Schamberg [q.v.]. In New York's Armory Show of 1913, he exhib-ited Cézanne-inspired landscapes and still lifes. But thereafter he was increasingly drawn to ab-stract qualities inherent in familiar objects and structures, painting the innate geometry of a Shaker chair, a Bucks County barn, or exam-ples of America's new industrial architecture. He took up commercial photography around 1910 and became a respected specialist in architectural subjects. His important 1927 commission to photograph the Ford Motor Company's River Rouge Plant led to a series of drawings and paintings that demonstrate how deftly he managed to merge photography and painting over the course of his career. Sheeler applied the abstract-design principles of mod-ern painting to his photographs, while impart-ing the precision of the camera to his paintings and graphic work. He became affiliated with Edith Halpert's vanguard Downtown Gallery in 1931 and was accorded a retrospective exhi-bition at the Museum of Modern Art in New York in 1939.

THE FLAWLESS CONFIGURATION OF THIS DRAWING illustrates the aesthet-ics that unexpectedly underlay America's heavy industry in the 1920s. For six weeks in 1927, Charles Sheeler photographed the Ford Motor Company's River Rouge Plant outside Detroit for an advertising campaign introducing the new Model A. The result was a fresh body of photographs that would con-tinue resonating with the artist when, a few years later, he produced a series of paintings and drawings based on the River Rouge project.

Industrial Architecture is a nearly identical conté-crayon translation of one of Sheeler's photographs of the plant. He preferred the precise detail offered by photography to sketches done on site: "Having this information," he wrote, "I am as free to select that which I need as I am in the presence of the subject in nature."[1] In this drawing, the artist successfully adapted aspects of photography's distinctive character: the varying intensities of tonal con-trasts, cropping, incisive shapes and patterns, and the immediacy of a dra-matic perspective.

Sheeler's image is rigid and calculated, yet it implies the actual bustling nature of Ford's enterprise through the prominent placement of four massive converging and crisscrossing shapes. Cutting diagonally across the composi-tion at top and bottom are conveyors, part of the complex network for moving coal in and out of the large structure known as the Pulverizer Building. To the left is the crane that unloaded the coal for transfer to railroad cars on the over-head track shown beneath it. Despite the notable dearth of action—Sheeler chose to limit movement to the man wearing a hat, barely perceptible in the lower-left corner—these monumental forms sustain the image of a plant with fifty-three thousand machines and seventy-five thousand employees. Remark-ably, even on this diminutive scale and depicting a quiet moment, Sheeler captures the massive plant's energy, efficiency, and majesty.

JM

1. Papers of Charles Sheeler, Archives of American Art, Smithsonian Institution, Washington, D.C., NSh-1, frames 112–13, quoted in Mary Jane Jacob and Linda Downs, *The Rouge: The Image of Industry in the Art of Charles Sheeler and Diego Rivera*, exh. cat. (Detroit: Detroit Institute of Arts, 1978), 15.

DAVID SMITH
1906–1965

Untitled [Bolton Landing Tableau], 1932

Gelatin silver print with applied varnish, 7⅛ × 10¹⁄₁₆ in. (18.1 × 25.6 cm)

Copyright Estate of David Smith/Licensed by VAGA, New York, NY

P2000.14

Born in Decatur, Indiana, David Smith studied at New York City's Art Students League in 1927 and 1928 with the artists John Sloan [q.v.] and Jan Matulka (1890–1972). He considered his works to be "difficult" and believed that taking photographs of them helped make them accessible. Smith most often photographed his works in natural surroundings, sometimes in snow or silhouetted against the sky; by the end of World War II, no work left his studio without being photographed. Smith also effectively used the medium as a marketing tool, producing in 1948 a small, handmade catalogue, Selections of Recent Work: 1947–1948. *In 1950 he used part of a Guggenheim Fellowship he received that year to purchase large-format camera equipment, and he subsequently made photographs of more than a hundred of his works dating back to 1933. Smith's early photographs remained unknown until recently.*

DURING A NINE-MONTH STAY IN THE VIRGIN ISLANDS in 1931–32, David Smith gathered unusual shells, bones, and bits of coral, arranging them on the beach in quasi-narrative figural patterns or displays evocative of ancient architectural ruins. He then photographed the constructions. He brought some of these objects home with him in June 1932, taking them to his summer studio in Bolton Landing, above Lake George's western shore. Although he was then still calling himself a painter, these constructions and the photographs made of them showed that he was working out ideas about space, texture, relationship, and balance that would lead him to become one of this country's preeminent modernist sculptors.

Untitled [Bolton Landing Tableau] is a prime example of this interaction between sculpture and photography. Although at first the image appears to be a shallowly focused assemblage of coral, shells, wood, and iron, it is much more. By painting in clouds and selectively applying a varnish, Smith transcended the standard, purist photographic aesthetic of the day to create something akin to the surrealist landscapes of the painter Yves Tanguy (1900–1955). All sense of scale is lost. The disparate objects look monumental, even as they seem, paradoxically, to be weightless. The result is a delicate balance of space and nonhierarchical form that soon would become the hallmark of Smith's sculpture.

By the mid-1930s, as his sculptural vision became more assured, Smith gave up this kind of experimental photography. He thought enough of these works, however, to send them to László Moholy-Nagy (1895–1946) in 1939, two years after the Hungarian artist arrived in the United States to open an American version of the Bauhaus in Chicago. Moholy-Nagy was so impressed with the prints that he asked to keep them for use in his teaching.[1]

JR

1. Joan Pachner, "David Smith's Photographs," in David Smith, *David Smith Photographs, 1931–1965*, exh. cat. (New York: Matthew Marks Gallery; and San Francisco: Fraenkel Gallery, 1998), 110.

BLANCHE LAZZELL
1878–1956

The Monongahela at Morgantown, 1935

Woodcut on laid, cream paper; image: 12 × 14 in. (30.5 × 35.6 cm); sheet: 15½ × 18⅛ in. (39.4 × 46 cm)

Signed, dated, and inscribed in image, lower center: *Blanche Lazzell—1935*; lower right: *The Monongahela at Morgantown. 1935*; signed, dated, and inscribed in bottom margin, lower left: *The Monongahela at Morgantown*; lower right: *Blanche Lazzell—1935—*

1985.287

Born in rural West Virginia, Blanche Lazzell was an unlikely candidate to become a pioneering American modernist. She studied drawing, painting, and art history before honing her painting skills under William Merritt Chase [q.v.] at the Art Students League in New York City. She lived in Europe from 1912 to 1914, studying at the Académie Moderne in Paris. The next year she settled in the artists' colony of Provincetown on Cape Cod. There, she met other American artists just back from study abroad, several of whom had been experimenting with traditional Japanese color wood-block printing. B. J. O. Nordfeldt [q.v.] became the most influential of these printmakers when he hit upon a single-block technique for making multicolor prints and passed it along to Lazzell and others. The boldly patterned white-line prints these graphic artists produced were acclaimed as highly original modernist expressions from the moment they were first shown at the Detroit Institute of Arts in 1919. From that point forward, Lazzell exhibited her prints nationally and internationally, and when she died in 1956 she was recognized as a forerunner of American modernism.

ALTHOUGH BLANCHE LAZZELL IS MOST CLOSELY ASSOCIATED with the artists' colony of Provincetown, Massachusetts, on Cape Cod, where she lived and worked from 1915 onward, she returned on occasion to her family home near Morgantown, West Virginia, on the Monongahela River. Lazzell made colorful views of the landscape there, working almost exclusively in color woodcut. Her Provincetown friend B. J. O. Nordfeldt taught her the innovative technique of creating multicolor prints from a single, carved woodblock. This involved compartmentalizing each element of the woodcut design and isolating it from adjacent forms by an incised line, thereby making it possible to ink components individually. The incised border around each shape produces a white line when the variously inked block is printed. The resulting image is, as seen here, a bold pattern of color shapes and an emphatically linear design.

In 1934, with support from the federal government's Public Works of Art Project, Lazzell returned to Morgantown to make art. The rather harsh setting, punctuated by the smokestacks of the local glass factories, stood in striking contrast to the rustic fishing huts and unspoiled natural beauty of Cape Cod. But Lazzell found it compelling nonetheless. For her, the high steep hills, strong S-curve of the river, and rows of simple, boxy, pitch-roofed buildings, regimentally descending to the river's edge, all fell naturally into a dynamic, decorative pattern. The place suited Lazzell's keen sense of design, and she produced several woodcut prints inspired by the vistas afforded from the hilltops above town. The highly reductive composition and sparkling color pattern of this work vividly capture the unmistakable look of Morgantown.

PJ

The Monongahela at Morgan Town Blanche Lazzell – 1935

LOUISE NEVELSON
1899–1988

[Untitled], ca. 1935

Painted plaster, h: 11½ in. (29.2 cm); w: 21 in. (53.3 cm); d: 12½ in. (31.8 cm)

Copyright 2000, Estate of Louise Nevelson/Artists Rights Society (ARS), New York

1998.144

Louise Nevelson emigrated with her family from Kiev to Rockland, Maine, in 1905. Her father established a construction business and ran a lumberyard. After she married and moved to New York City, Nevelson studied painting, drawing, drama, and dance, taking classes at the Art Students League and with the painter Hans Hofmann (1880–1966) in New York and Munich. Her work in 1933 with the Mexican artist Diego Rivera (1886–1957) on his murals at the New Workers' School in New York may have prompted her to work on a large scale. During the 1930s, she focused on relatively small-scale wood, terra-cotta, and clay sculptures. Her blocklike figures from this time reflect her interest in cubism and ancient Mesoamerican art. In 1937 the struggling artist found crucial employment with the Federal Arts Project of the Works Progress Administration.

THIS SCULPTURE OF A KNEELING DANCER is among Louise Nevelson's earliest works. Between 1932 and 1941—a period of dislocation, depression, and introspection for the artist—she made a series of figural pieces that bore clear autobiographical associations. Nevelson's family emigrated from Russia to Rockland, Maine, when she was six years old. Although she intended to study art seriously after high school, her plan was set aside when she married Charles Nevelson, a shipping merchant, and, in 1920, moved to New York City. The traditional domestic role did not suit Nevelson; she and her husband separated several years after she enrolled at the Art Students League in New York in 1929. Financial struggles ensued, forcing her and her young son to move from one rooming house to another.

During these hard years, Nevelson studied modern dance and movement and thereby became fascinated with the nude female form. As she practiced dance, she was drawn to the idea of capturing three-dimensional movement through sculptural form. "Modern dance certainly makes you aware of movement," she later said, "and that *moving* from the center of the being is where we generate and create our own energy. . . . I became aware of every fiber, and it freed me."[1]

She transmitted that liberating awareness in this untitled work. The figure of the dancer changes dramatically as one moves around it, for Nevelson strove to make each angle equally expressive. She broadly articulated the arms and hands that encircle the dancer as she seems to bow in a self-embrace. The momentary nature of this gesture counteracts the solid mass of the object, as do the expressive ways that Nevelson plays the primary corporeal forms against each other. Adding to this sense of fluidity is the network of abstract lines Nevelson incised over the surface of the piece. The capacity for self-expression displayed here helped propel her into becoming one of the twentieth century's most noted sculptors.

JM

1. Quoted in Diana MacKown, *Dawns + Dusks: Louise Nevelson, Taped Conversations with Diana MacKown* (New York: Charles Scribner's Sons, 1976), 65–66.

103

MABEL DWIGHT
1876–1955

Queer Fish, 1936

Lithograph on wove, off-white paper; plate: 10⅝ × 13 in. (27 × 33 cm);
sheet: 13⅝ × 17⅞ in. (34.6 × 45.4 cm)

Signed lower right: *Mabel Dwight*

1997.10.21

Born Mabel Jacque Williamson in Cincinnati, the artist took the surname Dwight in 1921 for reasons unknown. That was the year she emerged as an artist after nearly two decades of immersion in left-wing politics and in the career of her husband, the painter and etcher Eugene Higgins (1874–1958). She had studied art at the Mark Hopkins Institute in San Francisco in 1897, an experience, she later recalled, that was mainly memorable for having introduced her to socialism. She traveled in Egypt and the Far East, returning in 1903 to settle in the bohemian environment of New York's Greenwich Village, where she met and married Higgins. Their relationship deteriorated, however, and they separated in 1917. The next year, she became associated with Gertrude Vanderbilt Whitney's newly founded Whitney Studio Club, taking part in life-drawing sessions and enjoying the camaraderie of other artists there. She and Higgins were divorced in 1921. Five years later, at age fifty-one, she went to Paris and took up lithography, the medium that would define her career. She returned to the United States in 1927; her first solo exhibition, in New York in 1928, was made up of lithographs satirizing contemporary life. From 1935 to 1939, she produced numerous prints under the auspices of the Works Progress Administration's Federal Arts Project. After 1941 her health declined, and she focused on writing her autobiography, which was never published. She died in 1955 following a stroke.

IN SEARCH OF SUBJECTS for her gently satirical views of human nature, Mabel Dwight frequented the New York Aquarium in Battery Park. Second in the world in size and first in variety and number of specimens, the aquarium—which was torn down in 1941—had an average of seven thousand daily visitors. It provided Dwight with a myriad of candid moments.

Queer Fish, a print relaying one of Dwight's favorite experiences at the aquarium, reflects her perceptive and sympathetic assessment of the human condition:

It is dark under the balcony and the people are silhouetted black against the lighted tanks. . . . Sometimes it's very funny. People twist themselves into grotesque shapes as they lean on the rather low railing; posteriors loom large and long legs get tangled. One day I saw a huge Grouper fish and a fat man trying to outstare each other; it was a psychological moment. The fish's mouth was open and his telescopic eyes focused intently. The man, startled by the sudden apparition, hid his hat behind him and dropped his jaw, also; they hypnotized each other for a moment—then both swam away. Queer Fish![1]

Dwight expressed her amusement at this momentary exchange of bewildered glances through her subtle exaggeration of the two protagonists' forms and expressions. She also drew upon the rich range of darks and lights attainable through lithography, the only print process in which she worked. Seeking to make her art accessible to a broad audience, Dwight produced her lithographs in large editions. A charmingly comic image, *Queer Fish* proved to be her most popular print.

JM

1. Mabel Dwight, unpublished autobiography, pp. 21–22, quoted in Susan Barnes Robinson and John Pirog, *Mabel Dwight: A Catalogue Raisonné of the Lithographs* (Washington, D.C., and London: Smithsonian Institution Press, 1997), 117.

230

WALKER EVANS
1903–1975

Penny Picture Display, Savannah, 1936

Gelatin silver print, 8½ × 6¾ in. (21.6 × 17.1 cm)

(Object reproduced at actual size)

P1987.4.1

A native of St. Louis, Walker Evans spent two years in Europe before settling in New York City in 1928. Inspired by the proto-modernist French poet Charles Baudelaire (1821–1867), he used his camera to record the commonplace in contemporary life. From 1935 to 1937 he photographed for the Farm Security Administration. For three weeks in 1936, Evans took a break from his government work to travel through Alabama with the writer James Agee (1909–1955). Fortune magazine had assigned them to produce an article about tenant cotton farmers there. Although the article was never published, their collaboration led to the 1941 book Let Us Now Praise Famous Men. *The images, grouped at the front of the book, constitute Evans' masterpiece. They established his place in twentieth-century photography and would influence many artists, from Robert Frank [q.v.] to William Christenberry (b. 1936). In 1938 Evans was accorded a solo exhibition at the Museum of Modern Art in New York; his book* American Photographs *was issued to accompany the show. That year, he also began a series of clandestine and provocative photographs taken in the New York subway. In 1940 he received a Guggenheim Fellowship to complete the project; the pictures were published in 1966 in the book* Many Are Called. *From 1945 to 1965, Evans worked for* Fortune, *first as a staff photographer and eventually as an associate editor. In 1971 John Szarkowski, curator of photography at the Museum of Modern Art, assembled a major retrospective and monograph documenting Evans' decisive contribution to American photography.*

WALKER EVANS' SELF-DEFINED "LYRIC DOCUMENTARY" STYLE made both the artist and the camera seem transparent and brought the subject to the forefront. The photographer turned away from symbolic and psychological forms of the medium, preferring the archivist's mission to record and classify. Combining this zeal for straight realism with an aesthetic attraction to harmony and repetition, Evans delicately walked a fine line between documentary and art in a way that helped redefine American photography.

This depiction of a commonplace photographer's window display has become one of Evans' most recognizable comments on the American experience. He discovered this scene while photographing for the Farm Security Administration (FSA) from 1935 to 1937, his most productive period. Although the FSA was a program created under the auspices of Franklin D. Roosevelt's New Deal, Evans steadfastly rejected the notion of attaching politics to the work. "This is pure record," he asserted, "not propaganda."[1]

Evans was probably attracted to this window display as an example of a vernacular advertisement. However, it also stands as an inventory of this Savannah business' patrons in the depths of the Great Depression. In the common style of studio portraiture, the individuals all wear their best clothes and present a polished appearance, in essence "putting their best face forward." Likewise, the photographer displays the best of the studio's work in the window, advertising the general status of the customers. By focusing tightly on the gridded pattern, Evans created a composite portrait of the American public's self-image.

BMC

1. Memorandum draft, quoted in Walker Evans, *Walker Evans at Work* (New York: Harper and Row, 1982), 112.

PETER SEKAER
1901–1950

Interior, Nashville, ca. 1938–40

Gelatin silver print, 6¾ × 9½ in. (17.1 × 24.1 cm)

Copyright Estate of Peter Sekaer

P1999.4

Born in Copenhagen, Peter Sekaer arrived in New York City in 1918. Financial success as a master sign painter allowed him to study at the Art Students League, where he met the artist Ben Shahn [q.v.]. Shahn introduced him to Walker Evans [q.v.]. As his commitment to photography grew, Sekaer became especially drawn to the work of Jacob Riis (1849–1914). In 1934 he studied with Berenice Abbott (1898– 1991), and two years later, with camera in hand, he spent two months crisscrossing the South with Evans. Sekaer's first professional position was with the Rural Electrification Administration, for which he documented the hardships of people living without electricity. His photographs appeared in the Museum of Modern Art's 1941 exhibition Image of Freedom. *During World War II Sekaer worked for the American Red Cross and the Office of War Information but chafed at having to produce propagandistic imagery. He ceased working for the government when the war ended, accepting commercial assignments from various magazines and corporations until his death in 1950.*

ALTHOUGH PETER SEKAER ALWAYS WANTED TO BE CALLED a photographer and not an artist, this compelling composition belies that assertion. *Interior, Nashville* transforms his documentation of slum life into an intense psychological confrontation. By standing above and in front of the two women (perhaps a mother and her daughter) and shooting down while theatrically lighting them from below, the photographer seems to float, almost ghostlike, before them. Yet by gazing sharply back into the camera, the two women deflect any notion of his superiority. Their looming, jet-black shadows, the firelight spilling out from the edge of the stove, and the two brilliantly lit stove panels compound the unnerving energy within this dark, dilapidated kitchen.

Although little known today, Sekaer belonged to a vanguard of young artists intent on recording the reality of American life in the early 1930s. In the late 1920s he abandoned a successful commercial career to pursue photographic studies in New York City, first at the Art Students League and next under Berenice Abbott at the New School for Social Research. He then became a darkroom and studio assistant to Walker Evans, traveling and photographing with him on his November 1935 visit to western Pennsylvania and on his pivotal tour of the South in the spring of 1936.

Several months later, Sekaer took a job with the Rural Electrification Administration (REA). Shortly before he made this photograph, the REA lent him to the United States Housing Authority; his mandate was to document slums in twenty American cities that had just accepted federal funds to build public housing. The three-room apartment in Nashville, Tennessee, that these women inhabited was home to ten people.

JR

STUART DAVIS
1892–1964

Bass Rocks No. 2, 1939

Oil on canvas, 33 × 43 in. (83.8 × 109.2 cm)

Signed and dated lower right: *STUART DAVIS '39*

Acquisition made possible by a generous gift from Nancy Lee and Perry R. Bass

1997.142

An erudite and prolific writer on art, Stuart Davis also was one of the most respected painters of his time. During the 1930s, along with many other artists struggling for steady income, he joined the Federal Arts Project under the auspices of the Works Progress Administration. He also was a leading activist on behalf of artists whose causes ranged from protesting government policies to protecting the right of self-expression, regardless of pictorial language. In 1939, a year after marrying his second wife, Roselle Springer, Davis executed a mural, The History of Communications, *for the New York World's Fair. In 1940 he began teaching at the New School for Social Research in New York City and, thereafter, refocused his energies on his own work. A retrospective exhibition of his work was mounted at the Museum of Modern Art in 1945. During the 1950s he completed several major mural projects. Represented in international exhibitions and the recipient of numerous awards, Davis produced major works up to the time of his death from a stroke in 1964.*

THE BRILLIANT, SYNCOPATED FORMS OF *Bass Rocks No. 2* typify the delicate equilibrium Stuart Davis maintained between abstraction and realism. The painting refers to a rugged section of coast near Gloucester, Massachusetts, where, beginning in the summer of 1915, the artist and his family enjoyed the stimulation and conviviality of an artistic and literary atmosphere.

In this painting, Davis reduces nature's three dimensions to abstract equivalents: blue, orange, red, and black planes overlaid with a network of colorful, animated lines. Recognizable forms materialize upon scrutiny. The coastline's massive granite boulders become the craggy contours in the foreground and left portion of the composition, while serpentine lines in the solitary aqua passage suggest waves rushing toward the shore. Nearby, the only two signs of humanity—a red-and-black icon suggesting a human figure and a rectilinear shape denoting a small structure—straddle the adjacent yellow horizontal shoreline. The painting captures the essence of Davis' sensations rather than literally depicting the site: "Naturally it was not my purpose to reproduce the optical appearance of this scene," he later wrote. "What I wanted to do was to make a picture that would recall my exhilaration in contemplating it. . . . the brilliance of light, the dynamics of the rock formations, the entirely different dynamics of the sea, etc., were transmuted into an analagous [*sic*] dynamics of spaces and color."[1]

JM

1. Quoted in Jane Comstock, "Stuart Davis: Bass Rocks #1," in Novelene Ross, *Toward an American Identity: Selections from the Wichita Art Museum Collection of American Art* (Wichita, Kans.: Wichita Art Museum, 1997), 122.

GRANT WOOD
1891–1942

Parson Weems' Fable, 1939

Oil on canvas, 38⅜ × 50⅛ in. (97.5 × 127.3 cm)

Signed and dated lower right: *GRANT WOOD / 1939*; inscribed on artist's painted frame: *PARSON WEEMS' FABLE*

1970.43

Grant Wood's decision to live and work in his native Iowa constituted his revolt against urban art centers and modern art theory. Born near Anamosa, he received early art training in Minneapolis and Chicago and taught school in Cedar Rapids before pursuing his artistic aspirations in Europe during the 1920s. His decision to paint midwestern scenes came as something of an epiphany at the end of that decade. Wood's American Gothic *(1930, Art Institute of Chicago) proved to be a public sensation—representing both an audacious rejection of modern European influences and the artist's unapologetic embrace of a populist art depicting American subjects in a realistic, accessible style. He painted with humor and a satirical bent, emerging as a severe critic of the conservatism that pervaded rural communities. A strong advocate for a "regionalist" art, he perpetuated this conviction in the artists' colony that he established in Stone City, Iowa. When he died in 1942, the appeal of such regionalism was waning: the country had just entered World War II and faced the shattering political, social, and cultural changes that international conflict entails.*

GRANT WOOD IS REGARDED AS A PAINTER of the contemporary midwestern scene. But in truth it was memories of his Iowa childhood that fueled his artistic imagination, not the rural landscape of the 1930s. His paintings are filled with a young boy's impressions: recollections of a stern father, or of his flinty Victorian aunts, or of the poems and stories his mother read to him, such as Henry Wadsworth Longfellow's "Paul Revere's Ride" (1861; included in *Tales of a Wayside Inn*, 1863) and Parson Mason Locke Weems' *The Life of George Washington* (1800). These were fitting subjects for art because they represented common experiences for many Americans in the 1930s. Wood embraced them as he dedicated himself to encouraging a robust national art that was distinct in style and content from European art.

Victorian-era children were raised on Parson Weems' moral fable of Washington and the cherry tree, a fictional tale that was nevertheless recounted in schoolrooms, generation after generation, and accepted by American children as historical truth. Confronted by his father, who found the tree chopped down and inquired of his son if he was to blame, the boy Washington, Weems tells us, courageously admitted, "I can't tell a lie, Pa, you know I can't tell a lie; I did cut it with my hatchet."[1] Wood shows Weems the dramatist, raising the curtain on his highly theatrical footnote to American history. The "Father of Our Country" appears at center stage, sporting, even as a youth, the head of Washington as elder statesman—the head that Gilbert Stuart (1755–1828) created in his ubiquitous "Athenaeum" portrait of 1796. This is, after all, the visage that defines George Washington in the American imagination.

"He said he hoped the painting would help reawaken interest in the cherry tree and other bits of American folklore too good to lose," Wood's sister recalled of her brother's intentions in painting *Parson Weems' Fable*.[2] Particularly in 1939 this seemed to Wood a vital subject, one of many such colorful myths and traditions that might remind Americans of a common heritage and thus brace them amid the social, political, and economic upheaval of modern times.

PJ

1. Mason Locke Weems, *The Life of George Washington*, with an introduction by Marcus Cunliffe (1800; repr. Cambridge: Harvard University Press, 1962), 12.
2. Nan Wood Graham with John Zug and Julie Jensen McDonald, *My Brother, Grant Wood* (Iowa City: State Historical Society of Iowa, 1993), 156.

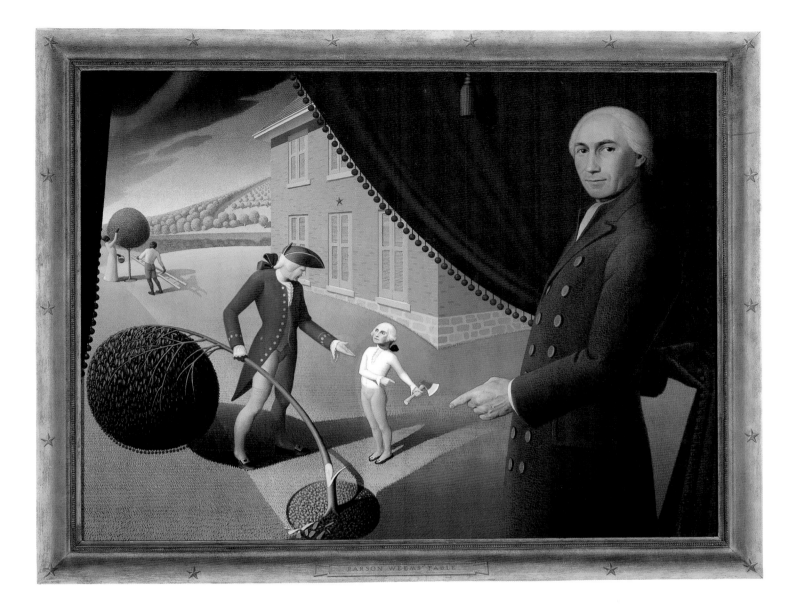

NELL DORR
1893–1988

Nursing Mother, 1940; printed ca. 1954–64

Gelatin silver print, mounted on Masonite, 19⅝ × 15⅝ in. (49.8 × 39.7 cm)

Copyright 1990, Amon Carter Museum, Fort Worth, Texas, Gift of the Estate of Nell Dorr

P1990.45.41

Born in Cleveland, Nell Dorr learned photography from her father, John Becker, who was a photographer for the B&O Railroad. She began her career in Florida in the 1920s, making studio portraits and photographing for Gondolier, *a Miami resort magazine. In 1932 Dorr, now divorced from her first husband, and her children moved to New York City, where she established a portrait studio. In 1933 she had a solo exhibition at the Delphic Gallery there, and one year later married the scientist John V. N. Dorr. Her first book,* In a Blue Moon *(1930), featured photographs she made in Florida. Her most successful volume,* Mother and Child *(1954), included photographs from the 1940s of her daughters, friends, and their children. In 1955 Edward Steichen (1879–1973) included three of her works in his landmark exhibition* The Family of Man. *She published two other books,* The Bare Feet *(1962) and* Of Night and Day *(1968). Along with such photographers as Carlotta Corpron [q.v.], Laura Gilpin [q.v.], and Barbara Morgan (1900–1992), Dorr was featured in* Recollections: Ten Women of Photography *(1979), a touring exhibition organized by the International Center of Photography, New York. In 1990 the Amon Carter Museum became the repository of the Nell Dorr Archives.*

IN 1940, SHORTLY AFTER the children's book illustrator Tasha Tudor (b. 1915) gave birth to her first child, Bethany, she wrote to her close friend Nell Dorr, encouraging her to come meet her godchild. "What joy it is to nurse her! . . . Isn't it delicious to feel their little bodies up against one and their face buried in one's breast, just drinking in nourishment!"[1] Dorr had three daughters of her own and empathized with Tudor's delight in new motherhood, so she decided to document this intimate moment.

In the early 1940s Dorr continued photographing Tudor and her children, along with her own three daughters and six grandchildren. While Dorr's husband served in the armed forces during World War II, she and her children lived in rural New Hampshire, secluded from the cares of the outside world. Tudor often visited her there, and the women reared their children in a protected environment, emulating a nineteenth-century style of living without electricity and indoor plumbing. In 1954, after one of her daughters died, Dorr published her best-known book, *Mother and Child*.

The following year, the Museum of Modern Art in New York presented the photographic exhibition *The Family of Man*, which recognized and celebrated the universality of human experience. The photographer and curator Edward Steichen included this image in the exhibition and in the subsequent best-selling book of the same title. Given a full-page reproduction, the image was accompanied by a quote from Euripides: "And shall not loveliness be loved forever?"

BMC

1. Tasha Tudor to Nell Dorr, August 12, 1940, Nell Dorr Archives, Amon Carter Museum.

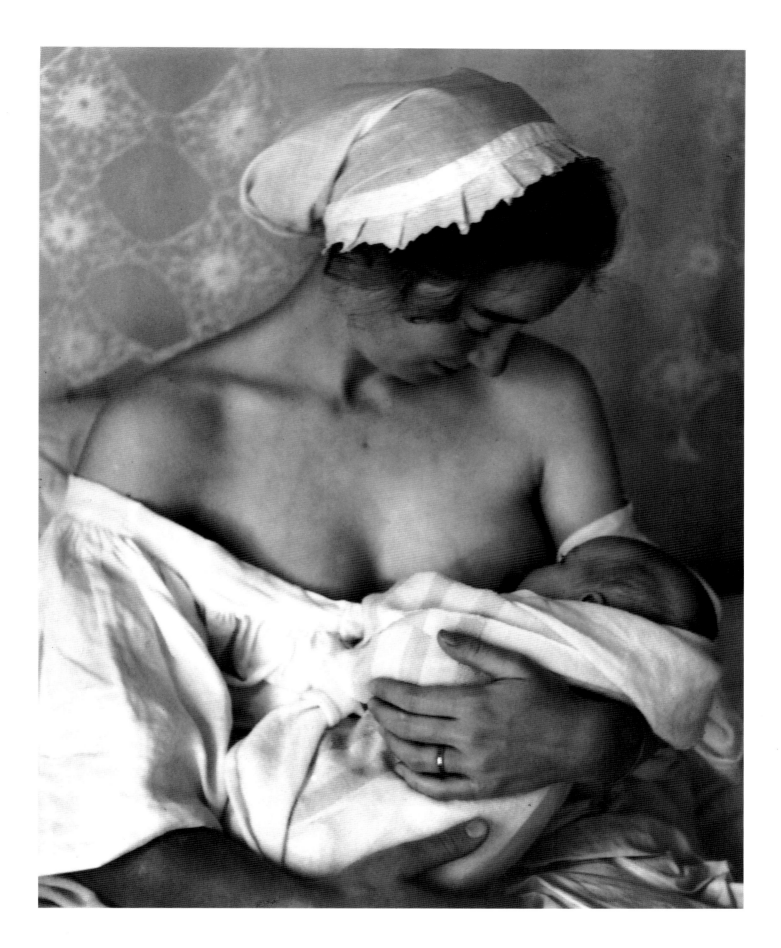

WILLIAM H. JOHNSON
1901–1970

Breakdown, ca. 1940

Modified screenprint on wove, cream paper, 14⅞ × 17⅞ in. (37.8 × 45.4 cm)

Purchase with funds provided by the Council of the Amon Carter Museum

1997.4.A

Born to a poor family in South Carolina, William H. Johnson made his way in 1918 to New York City, where, while working at odd jobs, he took classes at the National Academy of Design. In the late 1920s he was painting in France when he met the Danish weaver Holcha Krake (1885–1944), whom he married in 1930. They settled in Kerteminde, Denmark, where Johnson enjoyed his first success as a painter, producing landscapes and city views in a modern, expressionistic style. In 1938 Johnson and his wife moved to New York. The next year, he found employment with the Federal Arts Project of the Works Progress Administration, working for the agency until 1943, the year Congress closed it. Influenced by the movement to celebrate African-American heritage, Johnson began drawing subjects from southern religious and rural life as well as depicting African-American soldiers in World War II. After his wife died in 1944, Johnson's mental health deteriorated. In 1947 he was admitted to Long Island's Central Islip State Hospital, where he remained for the last two decades of his life, never to work again. His fame grew steadily, however, and during the 1960s the National Collection of Fine Arts (today the Smithsonian American Art Museum) acquired more than a thousand of his works, distributing many of them to black colleges and museums.

WILLIAM H. JOHNSON'S VIEW OF BLACK CULTURE was often tinged with nostalgia for the rural South that he and many other African-Americans had forsaken when they migrated north in the early twentieth century. *Breakdown* records memories of Johnson's birthplace in rural South Carolina, where a couple's antiquated auto, apparently laden with all their earthly goods, has broken down. While the man, represented only by his legs and bare feet, attends to mechanical necessities, his female companion kneels before a road-side campfire. Their resiliency despite their predicament, the sanctity of the family unit, and their religious fortitude as suggested by the woman's genu-flecting posture all had parallels in contemporary African-American literature.

Johnson taught at the Harlem Community Art Center, where he was exposed to the latest advances in printmaking processes. Around 1940 he began making screenprints, a process then new to artists, by pressing thick, opaque ink through a mesh screen. The vibrant colors and vivid details, such as the multihued jalopy and the exaggerated spiked heels on the woman's shoes, reflect the influence of the comic strips Johnson loved as a child. He worked in extremely modest conditions and often reused paper; the other side of the sheet on which *Breakdown* was printed has a finished image depicting two female figures.

JM

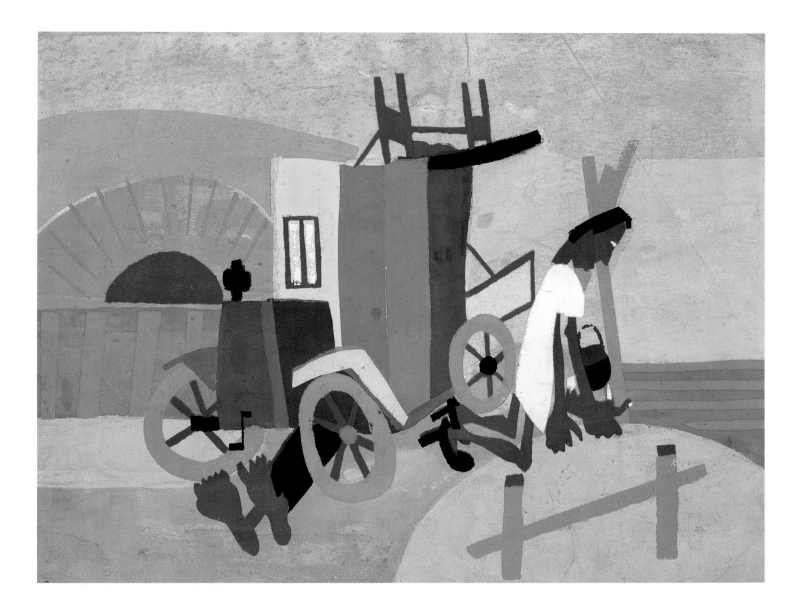

EDWARD A. WILSON
1886–1970

The Propeller, ca. 1941

Lithograph on wove, off-white paper; plate: 9 × 13 in. (22.9 × 33 cm);
sheet: 11⅜ × 16 in. (28.9 × 40.6 cm)

Signed, dated,[1] and inscribed, lower left: *'The Propeller';* lower center:
To Stow Wengenroth; lower right: *Edward Wilson / '43*

1998.140

Edward A. Wilson was born in Glasgow. His father, who was in the shipping business, moved the family to Rotterdam and then to Chicago, where Wilson lived for seventeen years. He studied at the Art Institute there, apprenticed in engraving and printing firms in both Chicago and New York City, and designed posters and travel brochures. As early as 1921 Wilson was making the book illustrations on which his artistic fame is based; in all, he contributed illustrations to more than sixty volumes. His accessible, romantic style reflects the influence of two years' study with the popular writer and illustrator Howard Pyle (1853–1911) in Wilmington, Delaware. After he started a family, Wilson settled in Truro, Massachusetts, and supplemented his income as a book illustrator by producing lithographs for various advertising campaigns. He died in Dobbs Ferry, New York.

IN THIS POWERFUL GRAPHIC HOMAGE to American labor and industry, the illustrator and printmaker Edward A. Wilson effectively rendered the monumental arcing forms of a ship's propeller. Wilson was drawn to nautical subjects that had fascinated him since childhood in his native Glasgow. As a successful book illustrator, he gravitated toward maritime stories, providing illustrations for such literary classics as *Two Years before the Mast* (1930) and *Treasure Island* (1941).

Wilson generally used the woodblock technique for his book illustrations, but in *The Propeller* he took full advantage of the nuanced shading and intensities of black and white achievable in lithography. Combining the artist's interest in geometric forms with a high degree of realism, the composition is enlivened through the curving shapes of the massive blades, grinding wheels, and workers' masks. The activity depicted—smoothing the blades of a ship's propeller with air-powered grinders—is the focus of the image, not the two individuals; their faces are concealed, their identities secondary to their collaborative effort.

Wilson was among many artists of the 1930s and 1940s to honor common laborers through heroic images that, during World War II, focused on their crucial contribution to the military-industrial effort. Wilson made other lithographs on commission during the 1940s that celebrated American industrial ingenuity, including advertisements for such enterprises as an airline, a pipe-and-foundry company, and a chemical plant. *The Propeller* conveys the sense of poetry that the artist found in American technology and the challenging life of the American laborer.

JM

1. Wilson probably dated the lithographs as he printed them over a period of years. Although the Amon Carter Museum's impression is dated 1943, the print probably was created in 1941, based on an inscription on the impression owned by the Library of Congress.

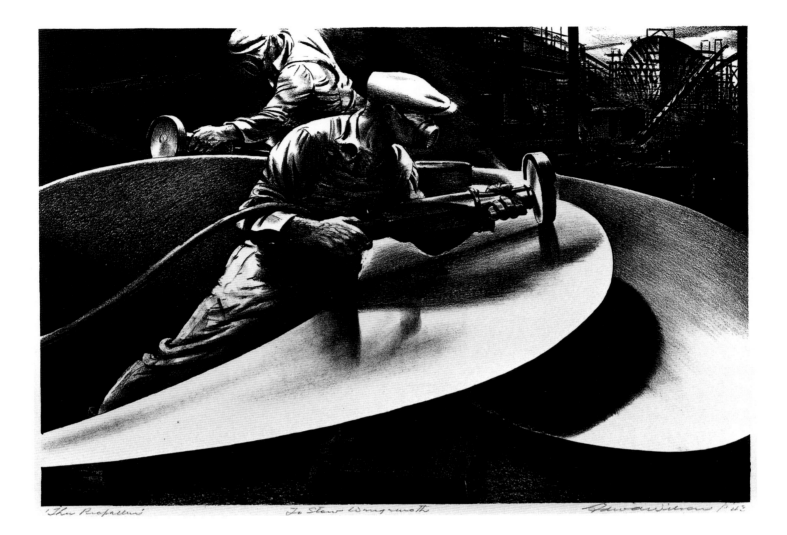

'The Propeller' To Stan Wingrowth Edward Wilson P 42

ALEXANDER CALDER
1898–1976

[Untitled], ca. 1942

Painted aluminum sheet, steel sheet, and steel wire, h: 58 in. (147.3 cm); w: 72 in. (182.9 cm); d: 45 in. (114.3 cm)

Signed on blue element: *CA*

Copyright 2000, Estate of Alexander Calder/Artists Rights Society (ARS), New York

1999.6

Alexander Calder was seemingly destined to become a sculptor: born in Philadelphia, he was named for his father and grandfather, both distinguished sculptors themselves. He first studied mechanical engineering. Subsequent training under the painter John Sloan [q.v.] at the Art Students League in New York City prepared him for employment as an artist-journalist and illustrator in the early 1920s. In 1926 he made his first trip to Paris, where he associated with some of the leading European modern artists. During a 1930 visit to the Paris studio of Piet Mondrian (1872–1944), Calder was awakened to the possibilities of simple kinetic abstractions, the three-dimensional equivalent of Mondrian's gridlike paintings in primary colors. He proceeded to invent the mobile, and over the next decades developed it into increasingly complex and lyrical structures that evoked elaborate ballets of biomorphic and geometric forms or the intricate movements of birds or schools of fish. By the 1950s he had pushed the painted construction to greater scale and mass, creating sheet-metal stabiles, which won him numerous commissions for public sculpture. By the time of his death in 1976, Calder was one of the nation's most popular and revered artists.

ONE OF THE MOST IMPORTANT AMERICAN SCULPTORS of the twentieth century, Alexander Calder invented new forms and materials for his work while incorporating within it the concepts of space, time, and motion. In 1942, around the time he made this piece, he defined the mobile as a type of abstract sculpture that moved by mechanical or other means. He likened his early moving sculptures to planetary systems, whose separate elements rotated in overlapping orbits, resulting in ever-changing relationships. He was fond of saying that the movement in these mobiles was akin to the choreography of a ballet.

During the 1930s some of Calder's abstract sculptures were motorized assemblages of shapes in primary colors that had articulated joints to allow certain parts to move freely into new positions. By 1940, however, he was no longer using cranks and motors to generate movement but was instead seeking a delicate balance that would produce unpredictable, more random motion. To achieve this balance, he developed a system of differently sized armatures made of three gauges of wire and two types of sheet metal (aluminum and steel). In these works, some of the elements float parallel to the floor, while others are suspended perpendicular to it. The mobile seen here has a whimsical, wondrously balanced array of variously shaped and colored elements that are suspended from five main arms of colored wire. Its balance is so carefully conceived that the slightest breath of air on one of the small elements can set the entire array moving ever so subtly.

RS

JACOB LAWRENCE
1917–2000

There are many churches in Harlem. The people are very religious. [Church of God], 1943

Transparent and opaque watercolor on wove, buff paper, 15½ × 22½ in. (39.4 × 57.2 cm)

Signed and dated upper left: *J. Lawrence 43*

Copyright 1943, Jacob Lawrence

1987.94

Born in Atlantic City, New Jersey, and raised in Boston and Philadelphia, Jacob Lawrence settled with his family in New York's Harlem around 1930, in the Great Depression years following the celebrated Harlem Renaissance of the 1920s. He began his art training in 1932, under the painter Charles Alston, at the Harlem Art Workshop in the 135th Street Public Library. Inspired by the library's Schomberg collection of materials on black history and culture, he decided to paint not just scenes of contemporary Harlem but also extended narratives drawn from African-American history. Between 1937 and 1943 Lawrence created a series of paintings recounting the lives of the eighteenth-century Haitian revolutionary Toussaint L'Ouverture and the nineteenth-century black abolitionists Frederick Douglass and Harriet Tubman, as well as the migration of African-Americans from the South to the North. The Migration Series—some sixty works in all, produced in 1940 and 1941—was shown at New York's vanguard Downtown Gallery in 1941, when the artist was only twenty-four; three years later it was shown at the Museum of Modern Art. In 1946 he taught at the innovative Black Mountain College in North Carolina, the first of many teaching posts he would hold. In 1971 he accepted a permanent teaching position at the University of Washington and moved to Seattle, where he enjoyed increasing national and international acclaim during the last decades of his life.

THIS WORK IS ONE IN A SERIES OF THIRTY PAINTINGS Jacob Lawrence created to describe everyday life in Harlem, where he lived as a young man during the Great Depression. The artist evoked a strong sense of place in his depictions of this African-American enclave, whose citizens, many from the South, settled in New York City during the early part of the century. The bright colors and angular patterns in this work form an animated vignette, set within a flat, stagelike setting. A woman walking along the sidewalk carries groceries in a bag whose vivid colors are echoed in the facade of the "storefront church" she passes.

During the 1930s and 1940s almost every Harlem block included churches such as this one. They provided a haven for the poorest and least educated, who suffered from overcrowding, malnutrition, and disease. Their ministers preached a form of fundamentalism, emphasizing both the terror and joy of divine retribution. The liveliness of this scene reflects the vigorous cultural community that thrived in Harlem and nourished Lawrence as a young artist. He acknowledged his profound debt to the older black artists who taught at the Harlem Art Workshop and at the Harlem Community Art Center, both of which provided free art instruction to neighborhood residents.

JM

BEN SHAHN
1898–1969

World's Greatest Comics, 1946

Tempera on panel, 35 × 48 in. (88.9 × 121.9 cm)

Signed and dated lower right: *Ben Shahn* © *1946*

1974.24

Ben Shahn's art reflects his immigrant experience and the unflagging concern for social justice that was his family's heritage. Born in Lithuania, he was uprooted when the czarist authorities accused his father of engaging in revolutionary activity. Settling with his family in New York City in 1906, the young Shahn sought solace from the traumatic experiences of his childhood by turning inward to art and books. He studied drawing at both the Art Students League and the National Academy of Design in New York. But it was his encounter with the art of Paul Klee (1879–1940), Henri Matisse (1869–1954), and Pablo Picasso (1881–1973), while studying in Paris in 1925, that most profoundly influenced his painting. He adopted modernist design principles, working in simple, bold lines and flat colors, but he dedicated himself to addressing political and social themes. He painted powerful images of individuals who, for him and many others, were symbols of injustice: the French Captain Alfred Dreyfus (1859–1935), emblem of anti-Semitism; the Italian-born laborers Nicola Sacco and Bartolomeo Vanzetti, anarchists executed in Boston in 1927; and the San Francisco labor leader and convicted terrorist Tom Mooney (1882–1942). Influenced by his friend Walker Evans [q.v.], he photographed agricultural workers for the Farm Security Administration from 1935 to 1938. He also made forceful graphic works to illustrate such magazines as Time *and* Fortune. *Only days before his death, while lying in a hospital bed, he signed one hundred copies of his print of the recently assassinated Martin Luther King, Jr. to be sold for charity.*

"FOR ME, [A CHANGE] HAD BEGUN during the late thirties when I worked in the Resettlement Administration," Shahn wrote of the turn he took in his art and political thinking:

I had then crossed and recrossed many sections of the country and had come to know well so many people of all kinds of belief and temperament which they maintained with a transcendent indifference to their lot in life. Theories had melted before such experience. My own painting then had turned from what is called "social realism" into a sort of personal realism.[1]

Previously, Shahn's art had pointedly reflected his socialist ideals. But his experiences in the 1930s revealed to him a more human, less theoretical side of American society. He distilled the many individual stories of trial and survival that he absorbed from displaced people into images that express the resilience of the human spirit. Inevitably, he drew upon the circumstances of his own boyhood, picturing the despair and isolation he felt when he immigrated from his home in rural Lithuania to the bleak confines of Brooklyn. *World's Greatest Comics* seems autobiographical. In this desolate playground bounded by a barren tenement, two lone boys are absorbed in their comics. A child's imagination, Shahn reminds us, is capable of transcending even the most dispiriting circumstances.

PJ

1. Ben Shahn, "The Biography of a Painting," 1957, quoted in Stephen Polcari, "Ben Shahn and Postwar American Art: Shared Visions," in Susan Chevlowe et al., *Common Man/Mythic Vision: The Paintings of Ben Shahn*, exh. cat. (Princeton, N.J.: Princeton University Press for the Jewish Museum, New York, 1998), 70.

LAURA GILPIN
1891–1979

White Sands #3, New Mexico, 1947

Gelatin silver print, 7½ × 9½ in. (19 × 24.1 cm)

Signed and dated on old mount, lower right: *Laura Gilpin / 1945* [*sic*]

Copyright 1979, Amon Carter Museum, Fort Worth, Texas, Gift of the artist

P1979.95.49

A native of Colorado Springs, Laura Gilpin studied at the Clarence White School of Photography in New York City from 1916 to 1917. Her early images were strongly pictorial, reflecting White's influence. After her studies, Gilpin returned to her hometown, where over the next twenty years she established a thriving portrait studio and publishing company. In the 1930s her work moved from a soft-focus approach to a more objective, straightforward perspective. With the onset of World War II, her business declined, and she took a job as photographer for the Boeing Aircraft Corporation. After the war she moved to Santa Fe, New Mexico. Gilpin had an abiding interest in the Navajo culture, and she photographed the Navajo and the southwestern landscape for the rest of her career. Also a skilled writer and designer, she published several books, including The Rio Grande: River of Destiny (1949) *and* The Enduring Navaho (1968). *In the 1970s she received a Guggenheim Fellowship, was given an honorary doctorate from the University of New Mexico, and was included in two major exhibitions surveying the work of women photographers. A retrospective of her photographs toured in 1978. The Laura Gilpin Archives reside at the Amon Carter Museum, which mounted a major exhibition of her work and published the accompanying catalogue,* Laura Gilpin: An Enduring Grace, *in 1986.*

AFTER WORKING AS THE BOEING AIRCRAFT CORPORATION's company photographer during World War II, Laura Gilpin, who considered herself primarily a landscape photographer, was anxious to return to the outdoors. From 1945 to 1947 she did just that, traveling more than twenty-seven thousand miles to document the Rio Grande River from its source in the Rocky Mountains of Colorado to its mouth in the Gulf of Mexico; she photographed the land it traversed and the people who lived there. The Southwest was a perfect subject for Gilpin. "Here is the country where photography should really come into its own, for here, the land is 'drawn with light,'" she wrote. "It is light, the strong, clear sunlight, and illuminated shadows, that mark the contour of the land, giving it its form and meaning."[1]

While photographing the Rio Grande's middle section, Gilpin visited White Sands, a large deposit of gypsum sand in New Mexico's Tularosa Basin. Faced with the challenge of producing a striking design while characterizing the unique nature of the fine white sand, she researched the geological history of the area, the wind direction, and the rate of the dunes' movements. Gilpin made this photograph when the sun was low in the sky, creating strong shadows that demarcate the sand's ripples. During a period of calm, she used the smallest aperture on her eight-by-ten-inch camera and took a long exposure, capturing the sharpest focus possible, from the foreground to the tip of the dune.

Besides placing this image in the Rio Grande exhibition and accompanying publication, Gilpin included it in her last exhibition, a 1978 touring retrospective that came to the Amon Carter Museum with the bequest of her entire photographic archives.

BMC

1. Laura Gilpin, draft of an article, ca. 1949, submitted to *U.S. Camera* and *Travel* but not published, Laura Gilpin Archives, Amon Carter Museum.

CARLOTTA CORPRON
1901–1988

Eggs Encircled, 1948; printed ca. 1948

Gelatin silver print, 9⁹⁄₁₆ × 7¹³⁄₁₆ in. (24.3 × 19.8 cm)

Signed and inscribed on reverse, center: *Carlotta M. Corpron Eggs Encircled*

Copyright 1988, Amon Carter Museum, Fort Worth, Texas, Gift of the artist

P1987.5.3

Born in Blue Earth, Minnesota, Carlotta Corpron studied art education at Michigan State Normal College and received her M.A. from Teachers College, Columbia University, in 1926. She worked primarily as an art educator, pursuing photography for only about ten years, in the 1940s. She taught at the Woman's College of Alabama in Montgomery (renamed Huntingdon College in 1935) and at the University of Cincinnati before moving to Denton, Texas, in 1935 to teach design at Texas Woman's University. Fascinated by light as a formal design element, Corpron taught a light workshop while assisting visiting photography professor László Moholy-Nagy (1895–1946) in 1942. Two years later the renowned abstract photographer Gyorgy Kepes (b. 1906) arrived to teach at North Texas State University; Corpron's informal work with him would lead her to declare Kepes her sole influence. Besides several solo exhibitions, including one at the Dallas Museum of Fine Arts (now the Dallas Museum of Art) in 1948 and another at the Art Institute of Chicago in 1953, Corpron participated in the Museum of Modern Art's seminal 1951 exhibition, Abstraction in Photography. *After 1955 she was physically unable to meet the demands of darkroom labor and focused instead on teaching until retiring in 1968. The Amon Carter Museum maintains the Carlotta Corpron Archives.*

"ALL OF A SUDDEN THE EGGS BEGAN TO DO AMAZING THINGS," Carlotta Corpron wrote about a session in which she photographed a cluster of eggs reflected in a ferrotype plate. "They stood on end and cast shadows and became distorted into very strange forms."[1] She was so intrigued that she made more than thirty negatives of egg compositions on that one day.

Throughout the 1940s Corpron explored the design properties of light. She always let the vicissitudes of natural illumination determine the direction of her experimentation, then worked creatively and intuitively to translate them. Her final experimental series of that decade grew out of a single moment when she saw how light coming through a set of venetian blinds and shining onto plastic sheeting created fluid patterns of luminescence. To create this image, Corpron combined two negatives in the darkroom, one from her egg compositions and one from the fluid-light series. The lines of light seem to replicate the ovoid shapes here, making the eggs swirl in dizzying motion. At the time, Corpron was one of but a few photographers in the country specializing in abstraction. She included a print of this image in her 1948 solo exhibition at the Dallas Museum of Fine Arts and then in another one-artist show at the Art Institute of Chicago in 1953.

BMC

1. Carlotta Corpron, artist's statement, Texas Woman's University archives, quoted in Martha A. Sandweiss, *Carlotta Corpron, Designer with Light*, exh. cat. (Austin: University of Texas Press, 1980), 15.

GORDON PARKS
B. 1912

Red Jackson, 1948; printed before 1962

Gelatin silver print, 12⅜ × 9½ in. (31.4 × 24.1 cm)

Copyright 1948, Gordon Parks

P1998.32

The self-taught photographer Gordon Parks was born in Fort Scott, Kansas, and eventually settled in Chicago. His photographs of ghetto life on that city's South Side won him a Julius Rosenwald Fellowship in 1941. The fellowship enabled him to move to Washington, D.C., where he served as an unpaid intern for Roy Stryker's Farm Security Administration photography unit. Subsequently, he worked for the Office of War Information and the Standard Oil Company. Parks is renowned for the photo essays to which he contributed during his tenure at Life *magazine from 1948 to 1961. Beginning in 1962 he freelanced for* Glamour *and* Vogue *magazines as a fashion photographer. Parks also has proven to be an adept poet, memoirist, composer, and film director. His biggest cinematic successes have been* The Learning Tree *(1969), based on his 1962 autobiographical novel, and* Shaft, *a major hit of 1971. He has been the recipient of numerous honorary degrees, and President Ronald Reagan awarded him the National Medal of Arts in 1988 for his contribution to America's cultural life. In 1997 a major retrospective,* Half Past Autumn: The Art of Gordon Parks, *began touring the country. Now in his late eighties, he continues to be a prolific, multifaceted artist.*

SEVENTEEN-YEAR-OLD RED JACKSON, leader of the Midtowners, a Harlem gang, allowed *Life* photographer Gordon Parks to document the group's activities for a feature in the magazine. Parks knew that many of Harlem's young men had died in gang wars, and he hoped that his photographs might turn some youths away from killing each other. For four weeks Parks accompanied Jackson wherever he went, photographing the gang during peaceful times and during rumbles. One day, after visiting a funeral parlor to view the body of a slain "war lord," members of the rival gang who had murdered him chased Jackson's group, along with Parks, into a vacant house. Fleeing to the second floor, Jackson knocked out a window, reached for his .38 pistol, and prepared to shoot. But approaching police cars chased the other gang away, and violence was narrowly averted.

Parks' photograph, made during the tense moments when Jackson peered through the broken glass, was the lead image of the nineteen included in the November 1, 1948, *Life* story. By framing the image so the irregular cracked glass divides the view of the building across the street, Parks echoed the clouded, fractured life of his subject. He printed it dark to accentuate the dim streetlight highlighting Jackson's strong profile and making the dirty glass glow, further emphasizing the young man's bleak world.

BMC

AARON SISKIND

1903–1991

North Carolina 9, 1951

Gelatin silver print, 10⁷⁄₁₆ × 13³⁄₁₆ in. (26.5 × 33.5 cm)

Signed, dated, and inscribed lower left: *North Carolina 9 1951*; lower right: *Aaron Siskind*

Copyright Aaron Siskind Foundation, Courtesy of Robert Mann Gallery

P1997.42

New York City native Aaron Siskind became active in the reform-conscious Photo League in 1936, inspiring and contributing to several important photo series, including The Harlem Document *(1940). Beginning in 1943 Siskind's images turned increasingly symbolic and abstract, often incorporating found objects from Martha's Vineyard and Gloucester, Massachusetts, where he did most of his work. The Charles Egan Gallery in New York regularly exhibited his photographs, and the Museum of Modern Art curator Edward Steichen (1879–1973) included Siskind in his important 1951 exhibition* Abstraction in Photography. *Siskind was the only photographer who belonged to the group of New York City abstract expressionist painters known as "The Club." At the invitation of the photographer Harry Callahan (1912–1999), he joined the faculty at the Institute of Design in Chicago, becoming head of its photography department in 1961. Two years later, he became a founding member of the Society for Photographic Education, and in 1966 he received a Guggenheim Fellowship. From 1971 to 1976 Siskind taught photography at the Rhode Island School of Design.*

DURING THE SUMMER OF 1951, Aaron Siskind taught at Black Mountain College, the innovative, Bauhaus-inspired art school nestled in the Appalachian Mountains of North Carolina. He met and became friends with such emerging artists as Robert Rauschenberg (b. 1925) and Cy Twombly (b. 1929)—both Black Mountain students at the time—and it was there also that he made *North Carolina 9*.

An unusual image in Siskind's oeuvre, this photograph suggests the black sweeps of paint being created at the time by his friend and fellow Black Mountain teacher Robert Motherwell (1915–1991). But the hazy view through the window is both ambiguous and paradoxical. The flaking paint strewn across the surface suggests a confining wall as well as an empty space. The line that waves across the upper third of the window mirrors the indistinct ridgeline on the horizon. Reflecting the enthusiasm of the Black Mountain school for interdisciplinary experimentation, the image seems to be part photograph, part painting.

Photography critics at the time derided Siskind's photographs because they fit neither documentary nor modernist definitions. Yet painters such as Motherwell, Franz Kline (1910–1962), and Twombly supported his work. The artist and writer Elaine de Kooning (1920–1989) termed Siskind "a painter's photographer," suggesting that his work was more closely related to contemporary painting than to current photography.[1] Like many painters then emerging, Siskind was building his art on expressionist gesture. As the critic Harold Rosenberg astutely remarked in a 1959 essay: "Instead of scenes that seem like paintings, Siskind's pictures *are* paintings as they appear on the printed page—which is where people today see most of the paintings that they see. They are reproductions, though reproductions that have no originals."[2]

JR

1. Elaine de Kooning, "The Photographs of Aaron Siskind," exhibition panel, Egan Gallery, New York, 1951, quoted in Deborah Martin Kao and Charles A. Meyer, eds., *Aaron Siskind: Toward a Personal Vision, 1935–1955*, exh. cat. (Chestnut Hill, Mass.: Boston College Museum of Art, 1994), 59.
2. Harold Rosenberg, "Evidences," in *Aaron Siskind: Photographs* (New York: Horizon Press, 1959), n.p.

ROBERT FRANK
B. 1924

Hoover Dam, Nevada, 1955; printed 1978

Gelatin silver print, 13⅜ × 9⅛ in. (34 × 23.2 cm)

Signed, dated, and inscribed, lower left: *US 1956* [*sic*]; lower right: *R. Frank.*

Copyright Robert Frank, Courtesy Pace/MacGill Gallery, New York

P1990.24

In 1947 Robert Frank emigrated from Switzerland to the United States and began working as a fashion photographer. Encouraged by his friend Walker Evans [q.v.], he applied for and received a Guggenheim Fellowship in 1955 to photograph throughout his adoptive country. The resulting body of work was initially published in France as Les Américains *in 1958 and released in the United States as* The Americans *a year later. The work provoked harsh criticism for its unusual visual perspective and because it portrayed the tragic underside of American culture; the volume served as a de facto counterpoint to Edward Steichen's generally upbeat, widely popular* Family of Man *exhibition at the Museum of Modern Art in 1955. Despite this negative reception, Frank's grainy, sometimes off-kilter photographs and highly personalized approach exerted an enormous influence on a subsequent generation of photographers. His interest in how images interconnect eventually led him to film, and he continues to work in both media. In 1959 Frank completed* Pull My Daisy *(narrated by Jack Kerouac and based on his play* The Beat Generation*), the first of more than twenty films and videos to his credit. He also has authored or been the subject of numerous books, including* The Lines in My Hand *(1972) and* Robert Frank: Moving Out *(1994).*

ONE OF THIS COUNTRY'S GREATEST ENGINEERING FEATS, Hoover Dam captured the imagination of Americans even before its completion (as Boulder Dam) in 1936. Today, it draws an estimated eight hundred thousand visitors annually. Most tourists and photographers have naturally preoccupied themselves with the dam's massive scale, focusing on its 726-foot-high concrete retaining wall. But when Robert Frank visited the site in 1955, he made it a symbol of Americans' grand vision of the West—a space where humanity's compulsion to harness and control nature assumed enormous proportions. Frank was touring the country with the support of a Guggenheim Fellowship when he made this photograph. His goal, he had written in his fellowship application, was to construct "a broad, voluminous picture record of things American, past and present. . . . What I have in mind, then, is observation and record of what one naturalized American finds to see in the United States that signifies the kind of civilization born here and spreading elsewhere."[1]

Today, we readily recognize the absurdity of a postcard celebrating the mushroom cloud of an atomic-bomb explosion, and we can appreciate the irony of a display rack juxtaposing cards of the Grand Canyon, Hoover Dam, and the bomb. Frank's genius, however, was to point out this disjunction at a time when most Americans blindly celebrated the coexistence of these three great symbols of the West. Centered on a tiny American flag, the image alludes both to American Cold War patriotism and Frank's own foreign birth. Here is a landscape where the only views of the land take the form of cheap depictions created to meet tourist expectations.

Just as his friend Walker Evans had summed up the 1930s in his seminal book *American Photographs* (1938), Frank was looking within and beyond the obvious to capture the temper of the 1950s. This photograph was part of the visual reservoir he tapped to create his radical and important book *The Americans*, published in the United States in 1959.

JR

1. Robert Frank, "Guggenheim Application," quoted in Anne W. Tucker and Philip Brookman, eds., *Robert Frank: New York to Nova Scotia*, exh. cat. (Houston: Museum of Fine Arts, Houston; and New York: New York Graphic Society, 1986), 20.

LOUISE NEVELSON
1899–1988

Lunar Landscape, 1959–60

Painted wood, h: 86 in. (218.4 cm); w: 49 in. (124 cm); d: 14 in. (35.6 cm)

Signed and dated on sculpture in three places: *NEVELSON 1959*; on sculpture in three other places: *NEVELSON 1960*

Ruth Carter Stevenson Acquisitions Endowment

1999.3.A–J

Louise Nevelson, one of this nation's unique and best-known sculptors, began showing her work regularly in the early 1940s at the Nierendorf Gallery in New York City. It was there in 1942 that she introduced works incorporating found objects, and two years later she exhibited her first abstract wood sculptures at the gallery. But after owner Karl Nierendorf's death in 1948, Nevelson's output waned dramatically. She would not resume her creative output until 1955, when she produced a series of black geometric assemblages from odd pieces of wood gathered near her Manhattan apartment. Over the next three years she was accorded three solo exhibitions at New York's Grand Central Modern Gallery, and in 1956 the Whitney Museum of American Art became the first major institution to acquire one of her works. Between 1958 and 1962 Nevelson showed her large-scale wall reliefs at the prestigious Martha Jackson Gallery in New York; they met with critical acclaim. The Whitney mounted a Nevelson retrospective in 1967, and in 1978 Boston University awarded her an honorary degree. By the time of her death in 1988, she had become an iconic figure in American art.

NEVELSON BEGAN HER RENOWNED SERIES OF WALL RELIEFS in 1958 when she started scavenging odd pieces of wood, such as architectural ornaments and other discarded items, from the streets around her New York City studio. She placed these irregular and often rough pieces into crates and boxes, stacking them one atop another in unified, gridlike arrangements and then painting them black.

Lunar Landscape stands as a prime example of her wall reliefs, lacking a single focal point but conveying a powerful combination of lyricism, enigma, and splendor. Recognizable objects lose their identities when Nevelson strips them of their original contexts by selecting only tantalizing fragments, painting them black, and arranging them by form, not function. Inevitably, suggestive associations emerge. The black discs, for example, suggest the lunar orb, which carried strong mystical connotations for the artist and is alluded to in the title of the work. Nevelson evoked America's colonial history by including a turned bedpost and the curved seat of a dilapidated Windsor chair. Shadows and light interact with an array of irregular forms, such as protruding nails and a narrow, vertical, hinged box containing a juggling pin. Nevelson's bold, ingenious wall reliefs mark her artistic breakthrough.

JM

ELIOT PORTER
1901–1990

Sunrise on River, Navajo Creek, Glen Canyon, Utah, August 27, 1961, 1961

Dye transfer print, 10¼ × 8½ in. (26 × 21.6 cm)

Signed on mount, lower right: *Eliot Porter*

Copyright 1990, Amon Carter Museum, Fort Worth, Texas, Bequest of Eliot Porter

P1990.51.4998.1

Born in Winnetka, Illinois, Eliot Porter spent his boyhood summers on a family-owned island off the coast of Maine, where he developed a deep love of nature. Although he earned a medical degree from Harvard in 1929 and conducted research in biochemistry for several years, he was, above all, a devoted photographer. After Alfred Stieglitz [q.v.] organized an exhibition of Porter's work at his An American Place gallery in 1938, Porter turned exclusively to photography. He had a lifelong passion for birds, photographing them first in black-and-white and then in color; the results not only made him a master of the dye-transfer process, but they also garnered him a Guggenheim Fellowship in 1941. World War II interrupted Porter's work and funding, but the fellowship was renewed in 1946, the same year he moved to New Mexico. By 1950 Porter had started making color photographs of myriad natural subjects, often in close-up. His first book, In Wildness Is the Preservation of the World *(1962), united his brilliant color images of nature with quotations from the writings of Henry David Thoreau. Published by the Sierra Club, it outlined his philosophy of nature and elicited international acclaim. Building on that book's popularity, Porter spent the next quarter-century traveling to and photographing ecologically and historically significant places worldwide. The resulting twenty-five books established an influential model for color nature photography. In 1979 his work was the focus of the first color-photography exhibition ever mounted at the Metropolitan Museum of Art in New York. He bequeathed his extensive archives to the Amon Carter Museum.*

IN LATE SUMMER 1960 ELIOT PORTER'S FRIEND the writer-poet Spud Johnson invited him to go rafting down the Colorado River through Glen Canyon. Porter had never rafted the Colorado and had hardly heard of Glen Canyon, but he accepted the offer because he was curious about the geology of the area. He was so intrigued by the site and its fate that he visited repeatedly over the next several years, making the photographs that would be winnowed down into one of his most influential books.

Construction on the Glen Canyon Dam had already begun when Johnson approached Porter. The dam gates were scheduled to be closed in early 1963, and the U.S. Bureau of Reclamation was trumpeting the production of extensive electrical energy and the tourism that would result from the creation of Lake Powell. Even though his brother-in-law was the bureau's commissioner, Porter was appalled at the prospect of sacrificing such extraordinary natural beauty.

Porter had been making color photographs of nature for almost twenty years before he visited Glen Canyon. But the landscape was so different from anything he had yet seen that he found it difficult to comprehend during his first trip. "It was so monumental and so complex," he later wrote, "that I could not focus on any of its features without experiencing a confusing sensation of losing contact with the whole canyon."[1] To capture the spirit of the place, Porter had to alter his photographic style radically. He previously had focused on documenting his subjects (plants, rocks, birds) within their environment, but here he brought composition, color, and texture to the fore. Recognizing how the canyon's reflected light distorted color in magical ways, he began, much like a painter, to make color an expressive tool in its own right. Echoing the intimate quality of the canyon space, he almost never included sky in his images, except as reflected in water. He even made a point of composing semiabstract patterns of light, color, and form. *Sunrise on River, Navajo Creek* is one of the most striking examples of these combinations.

The Sierra Club published Porter's book *The Place No One Knew: Glen Canyon on the Colorado* in 1963 as part of its renowned Exhibit Format series. Porter's elegy to the canyon was so powerful that it encouraged the federal government to rethink and eventually terminate its policy of extensive, large-scale damming of western rivers.

JR

1. Eliot Porter, *Eliot Porter*, exh. cat. (Boston: Little, Brown and Company for New York Graphic Society Books in association with the Amon Carter Museum, 1987), 47.

STUART DAVIS
1892–1964

Blips and Ifs, 1963–64

Oil on canvas, 71⅛ × 53⅛ in. (180.7 × 134.9 cm)

Signed upper center: *Stuart Davis*

Acquisition in memory of John de Menil, Trustee, Amon Carter Museum, 1961–1969

1967.195

Through a long career, Stuart Davis distinguished himself as a painter, printmaker, critic, teacher, and muralist, his various interests reflecting the ease with which he responded to the dramatic social, political, and artistic changes he witnessed during fifty years of creative activity. He first worked in New York City as a follower of the realist painter Robert Henri (1865–1929), creating scenes of seamy street life and satirical illustrations for the socialist magazine The Masses. *Affected by the Armory Show of 1913, he embraced European modernist movements—post-impressionism and cubism. In Paris in 1928–29, he learned lithography and further developed his highly graphic pictorial style. During the 1930s he worked in the government-sponsored art programs of the New Deal and devoted much of his energy to defending the country's artistic vanguard. When American artists turned enthusiastically to mural painting, Davis did too, creating* The History of Communications *for the 1939–40 New York World's Fair and other mural projects through the 1950s. He began teaching at the New School for Social Research in New York City in 1940. Five years later he was accorded a retrospective exhibition at the Museum of Modern Art. He remained active until his death in 1964.*

STUART DAVIS' PASSION FOR CONTEMPORARY URBAN LIFE extended from his early street scenes made in the 1910s to *Blips and Ifs*, a painting he completed shortly before his death. The largest of the six Davis paintings in the Amon Carter Museum's collection, this work marks the culmination of the long, productive, and highly inventive career of one of America's great twentieth-century artists.

Believing that "Modern Art has met the dynamics of contemporary subject matter on its own terms," Davis evoked the spirit of the prevailing culture through bright colors, interlocking forms, and seemingly arbitrary combinations of words and word fragments.[1] For him, words served primarily as compositional elements but carried associative meanings, too. In *Blips and Ifs*, "Pa," a fragment of the word "pad," and "tight" echo contemporary slang. "Compl," a fragment of "complete," refers to the act of making art in which the emotional and associative impact supersedes literal representation. The title of the painting suggests radar terminology—the "blips" found on a radar screen and radar's intermediate frequencies, or "ifs." Davis even integrates his signature into the lively composition.

The work's rhythmic energy embodies Davis' love of American popular culture—particularly, in his words, "le hot jazz." Although his sensual response to life in New York City is simultaneously visceral and calculated, he expresses here his appreciation for American culture in a splendid, unified whole.

JM

1. Stuart Davis, "Autobiography," in *Stuart Davis*, ed. Diane Kelder (New York: Praeger, 1971), 30.

ROBERT ADAMS
B. 1937

Berthoud, Colorado, 1976; printed 1989

Gelatin silver print, 15 × 15 in. (38.1 × 38.1 cm)

Signed and dated on reverse, lower right: *Robert Adams 1989*

Copyright 1985, Robert Adams, Courtesy Fraenkel Gallery, San Francisco

P1998.58

Born in Orange, New Jersey, Robert Adams earned a Ph.D. in English from the University of Southern California in Los Angeles. While teaching English at Colorado College in Colorado Springs from 1962 to 1970, he studied photography, working on technique with the documentary photographer Myron Wood in 1964. Soon he was documenting his singular relationship to contemporary landscapes. Encouraged by the photography curator John Szarkowski, Adams committed himself to photography in 1969. Four years later he received both Guggenheim and National Endowment for the Arts Fellowships. Influenced by Ansel Adams (1902–1984, no relation) and the work of the nineteenth-century photographer Timothy O'Sullivan [q.v.], Adams expanded the western landscape tradition, developing a distinctive aesthetic that fosters an awareness of humanity's relationship to the land. His book Denver *was published in 1974, followed three years later by* The New West. *These volumes, along with his representation in the 1975 touring exhibition* New Topographics: Photographs of a Man-Altered Landscape, *confirmed his place among the leading landscape photographers of his time. He received the Charles Pratt Memorial Award in 1987, and in 1989 his work was the subject of a major retrospective at the Philadelphia Museum of Art.*

THE OPPRESSIVE DAYTIME HEAT HAS FINALLY LIFTED, and windows are opened to the cool of the evening. It is time to walk off dinner with a stroll through the neighborhood. There are reassuring sounds of children playing in the distance, low-pitched voices on porches, sprinklers rhythmically dousing lawns and pavement. Robert Adams has delivered an image of soothing familiarity, one that evokes Thornton Wilder's play *Our Town* (1938) and other such paeans to small-town America.

He also has challenged convention. This is not the West of lore, land of hard-bitten cowboys, noble Indians, pioneering farmers, and vast treeless spaces; it seems more like New England than north-central Colorado. Convention also requires that photographers create prints that hold detail across the spectrum from dark to light. Instead, Adams relishes the blackness of night and the dreamlike filigree of shadows across clapboard—all the better to capture the aura of the streetlight and be drawn in through the plant-filled window.

Adams is an influential artist who has helped shift the focus of landscape photography away from the majestic, crystalline views of Ansel Adams toward quieter, personal visions of a more accessible world. Thoughtfully regarding what most people pass by, he reveals the remarkable in the modest, even the banal, and finds a regenerative grace in unexpected places. In doing so, he has helped reinvigorate landscape photography, establishing a model by which many photographers working today measure their own efforts to question and comment on how we live.

JR

LINDA CONNOR
B. 1944

Great Gallery, Horseshoe Canyon, Utah, 1982

Gelatin silver print, 10 × 8 in. (25.4 × 20.3 cm)

Signed lower left: *Linda S. Connor*

Copyright Linda Connor, Purchase through exchange

P1999.3.48

Born in New York City, Linda Connor studied photography with Harry Callahan (1912–1999) from 1962 to 1966 at the Rhode Island School of Design in Providence; she continued her studies with Aaron Siskind [q.v.] at the Institute of Design in Chicago. She began her teaching career in 1969 at the San Francisco Art Institute. Her deep admiration for the photographs of Walker Evans [q.v.] is evident in the formal structure inherent in her work, which explores the relationships among nature, civilization, and spirituality. Her first book, Solos (1979), was comprised of soft-focus images. Thereafter, she turned to straight photography, using a view camera, making contact prints on printing-out paper, and then goldtoning them to achieve a warm effect. Connor has received numerous awards, including National Endowment for the Arts Fellowships in 1976 and 1988, a Guggenheim Fellowship in 1979, and the Charles Pratt Memorial Award in 1988. Her books include Spiral Journey *(1990), published in conjunction with her first major solo exhibition at the Museum of Contemporary Photography, Chicago;* Luminance *(1994); and* On the Music of the Spheres *(1996).*

LINDA CONNOR DROVE SIXTY-FIVE MILES DOWN A DIRT ROAD, then hiked four miles down a trail that descends seven hundred feet to document this pictograph of mummy-shaped figures known as the Holy Ghost panel. She was one of a group of five photographers who, in an effort to rediscover the spiritual in the contemporary landscape, produced images of rock art in the early 1980s. The project resulted in the publication *Marks in Place: Contemporary Responses to Prehistoric Rock Art* (1988).

The pictographs in Horseshoe Canyon's Great Gallery are among the finest examples of paintings executed in the so-called Barrier Canyon style, which is defined by dark, tapered, anthropomorphic figures. Anthropologists generally believe that an ancient hunting-and-gathering people, living about A.D. 500 in the vicinity of what is now southern Utah, made the pictographs by applying a dark-red pigment to the rock. Some figures appear to be painted by hand; others, like the ethereal apparition of the larger-than-life-size ghost-like figure, are characterized by a spatter technique. These abstractions are believed to signify supernaturals, or shamans, rather than mortal men, implying that the site was revered as a holy place.

Awed by this stark and tactile evidence of the sacred in the world, Connor removes all clues of human existence and centralizes the figures. By photographing at a time of day when the sun cast a strong shadow beneath the overhanging rock, and by orienting her camera vertically, she suggests that the figures are standing beneath a vaulted ceiling.

BMC

ABELARDO MORELL
B. 1948

Camera Obscura Image of Times Square in Hotel Room, 1997

Gelatin silver print, 32⅜ × 39⅝ in. (82.2 × 100.7 cm)

Signed, dated, and inscribed on label: *CAMERA OBSCURA IMAGE OF /
TIMES SQUARE IN HOTEL / ROOM, 1997 / ABELARDO MORELL*

Copyright 1997, Abelardo Morell

P1997.31

In 1962 the teenaged Abelardo Morell emigrated from Cuba to New York City. In 1977 he earned a scholarship to Bowdoin College, where Professor John McKee introduced him to photography; he went on to receive his M.F.A. from the Yale School of Art in 1981. Morell's early work is documentary in style, but with the birth of his son in 1986, he began photographing familiar objects, attempting to explore them from a child's perspective. As a professor of photography at the Massachusetts College of Art in Boston, he rediscovered the camera obscura as part of a class demonstration in 1991. On sabbatical that year, he photographed a series of complex interior views using the technique. Morell has received grants, including a Cintas Foundation Fellowship (1992) and a Guggenheim Fellowship (1993). In 1997 the New York Times *invited him to participate in "Assignment: Times Square," a project conceived by the newspaper to record the renovation of the famous district through the eyes of several photographers. His books include an edition of Lewis Carroll's* Alice's Adventures in Wonderland *(1998), which incorporates a series of twenty photographs using cutouts of the characters in that story.*

NEW YORK CITY'S TIMES SQUARE is the epicenter of Broadway, a place where commerce and entertainment collide and coalesce. Brimming with humanity day and night, it offers a surreal cityscape that bombards the senses.

Visitors to New York want a convenient hotel, located close to the action, and the Marriott, which provides the site for this photograph, certainly delivers. Here in the intensely stimulating core of the city, Abelardo Morell carefully covered all the openings in this hotel room with black plastic, except for a three-eighths-inch hole in one window; the result mimics the inside of a camera. He also has turned back time to the seventeenth and eighteenth centuries when the camera obscura (in Latin, "dark chamber") provided both an invaluable aid to picture making and an amusing, if disorienting, party game. Into the room streams the world in all its color and much of its detail; the hyperreality of Times Square reflected upside down fills the ceiling and walls.

Where Canaletto, Vermeer, and other painters used the camera obscura as a tool to trace what they saw and thus facilitate perspective, Morell has photographed its visual effect. Setting up a camera next to the window hole, he made a two-day exposure that caused the room clocks to project blank faces and the extraordinarily busy intersection of Broadway and Seventh Avenue to appear eerily empty of people and traffic. Providing a perfect metaphor for the disorientation of travel, the effect suggests a blend of the work of Edward Hopper (1882–1967) and Lewis Carroll's *Through the Looking Glass* (1872).

JR

KEITH CARTER
B. 1948

View from the Bed, 1998

Gelatin silver print, 15¼ × 15⅜ in. (38.7 × 39 cm)

Signed, dated, and inscribed on reverse, lower left: *VIEW From The BED KEITH CARTER 1998*

Copyright 1998, Keith Carter

P2000.7

Born in Madison, Wisconsin, Keith Carter grew up in Texas, observing his mother making portraits in her Beaumont photography studio. In 1970 he received a degree in business from Lamar University in Beaumont; a reawakening to photography soon followed. He participated in workshops with the photographers Wynn Bullock (1902–1975), Paul Caponigro (b. 1932), and Henry Holmes Smith (1909–1986). By 1977 he was operating his own photographic studio in Beaumont and had been accorded his first solo exhibition, at the Tyler Museum of Art in Tyler, Texas. Four years later he was awarded a National Endowment for the Arts Fellowship. His books include From Uncertain to Blue *(1988),* The Blue Man *(1990),* Mojo *(1992),* Heaven of Animals *(1995), and* Bones *(1996). A retrospective exhibition,* Keith Carter Photographs: Twenty-Five Years, *was organized in 1997 by Southwest Texas State University, San Marcos, and shown at the Wittliff Gallery there; it was accompanied by a book. His most recent book,* Holding Venus *(2000), comprises mainly views made outside the United States. Carter, who teaches and exhibits widely, currently holds the Walles Chair of Art at Lamar University.*

"I'M LOOKING FOR A POETRY OF THE ORDINARY... the mysteries of the human spirit," wrote Keith Carter. "I'm trying to create a dialogue with life, to learn what being human is all about."[1] By directing our attention to mundane objects, he makes what lacks distinction seem miraculous and confirms the presence of the magical in daily life. Carter's imagery is representative of a growing number of photographers who focus on emotional and spiritual content in their work, abandoning the formal concerns of modernism and resurrecting some of the tenets of pictorialism and symbolism. Accordingly, Carter adheres to the artist's mission to delineate beauty in everyday reality, not just in views traditionally defined as beautiful.

Reproduced in his book *Holding Venus* (2000), this image represents a turning point in Carter's career. While his earlier images and books are associated with an East Texas regionalism, the work in this volume clearly evinces a geographic departure that builds on a more universal, metaphorical foundation. Carter reveals in the photograph here a fragile world that, though scarred and spent, still glows with an ethereal inner life.

BMC

1. Keith Carter, *Holding Venus* (Santa Fe: Arena Editions, 2000), n.p.

All photography is by Rynda Lemke and Steven Watson of the Amon Carter Museum, except for the following:

Michael Bodycomb
Plates 37, 46, 49, 51

Ezra Stoller Associates
Amon Carter Museum, 1961

Photographers unknown
Amon G. Carter, ca. 1938
Amon G. Carter, ca. 1910
Will Rogers and Amon G. Carter, ca. 1930
President Franklin D. Roosevelt and Amon G. Carter, 1944
Georgia O'Keeffe and Mitchell A. Wilder, 1966

Patricia Junker is curator of paintings and sculpture at the Amon Carter Museum. She is the principal author of *John Steuart Curry: Inventing the Middle West* (1998), for the Elvehjem Art Museum, University of Wisconsin–Madison, and coauthor of collection catalogues for the Fine Arts Museums of San Francisco and the Smith College Museum of Art. Her 1990 exhibition catalogue for the Memorial Art Gallery of the University of Rochester, *Winslow Homer in the 1890s: Prout's Neck Observed*, was awarded the 1991 Henry Allen Moe prize for scholarship by the New York State Historical Association.

Barbara McCandless, curator of photographs at the Amon Carter Museum, is the author of *Equal before the Lens: Jno. Trlica's Photographs of Granger, Texas* (1992). She is coauthor of *Photography in Nineteenth-Century America* (1991), *New York to Hollywood: The Photography of Karl Struss* (1995), and *Singular Moments: Photographs from the Amon Carter Museum* (2001), all three of which were produced for the Amon Carter Museum.

Jane Myers is chief curator at the Amon Carter Museum. She is the author of *Revealed Treasures: Works on Paper from the Amon Carter Museum* (2001). She is coauthor of *Stuart Davis: Graphic Work and Related Paintings with a Catalogue Raisonné of the Prints* (1986) and *George Bellows: The Artist and His Lithographs, 1916–1924* (1988), both produced for the Amon Carter Museum. She is also coauthor of the exhibition catalogues *The Paintings of George Bellows* (1992), for the Amon Carter Museum and the Los Angeles County Museum of Art, and *The Shores of a Dream: Yasuo Kuniyoshi's Early Work in America* (1996) for the Amon Carter Museum.

John Rohrbach is associate curator of photographs at the Amon Carter Museum. He is a contributing author to *Paul Strand: Essays on His Life and Work* (1990). He is the author of the exhibition catalogue *A Passion for Birds: Eliot Porter's Photography* (1997) and coauthor of the exhibition catalogue *Eliot Porter: The Color of Wildness* (2001) and *Singular Moments: Photographs from the Amon Carter Museum* (2001). All three books were produced for the Amon Carter Museum.

Rick Stewart is director of the Amon Carter Museum. His publications for the museum include *Charles M. Russell: Sculptor* (1994), which won the National Cowboy Hall of Fame's Western Heritage Award for Outstanding Art Book. He is coauthor of the exhibition catalogues *Eyewitness to War: Prints and Daguerreotypes of the Mexican War, 1846–1848* (1989), which was named the Outstanding Publication of the Year by the American Historical Print Collectors Society, and *Carl Wimar: Chronicler of the Missouri River Frontier* (1991).

The Amon Carter Museum was established through the generosity of Amon G. Carter, Sr. (1879–1955), to house his collection of paintings and sculpture by Frederic Remington and Charles M. Russell; to collect, preserve, and exhibit the finest examples of American art; and to serve an educational role through exhibitions, publications, and programs devoted to the study of American art.